Also by Henry Horenstein

Black and White Photography: A Basic Manual
Beyond Basic Photography
A Dog's Life *(with Pierre Le-Tan)*
Racing Days *(with Brendan Boyd)*
Spring Training
Go, Team, Go
A Cat's Life *(with Pierre Le-Tan)*
Fashion Photography: Patrick Demarchelier *(editor)*
The Photographic Essay: William Albert Allard *(editor)*
Hoops *(with Brendan Boyd and Robert Garrett)*
Sam Goes Trucking

THE PHOTOGRAPHER'S SOURCE

A Complete Catalogue

By Henry Horenstein

with Russell Hart, Lauren Lantos, Sean Callahan, and Ronna Berezin

Designed by Melissa Tardiff

A POND PRESS BOOK
A FIRESIDE BOOK

PUBLISHED BY SIMON & SCHUSTER INC.
NEW YORK LONDON TORONTO SYDNEY TOKYO

This book is for Lorie Novak.

SIMON AND SCHUSTER/FIRESIDE
SIMON & SCHUSTER BUILDING
ROCKEFELLER CENTER
1230 AVENUE OF THE AMERICAS
NEW YORK, NEW YORK 10020

DESIGNED BY MELISSA TARDIFF

MANUFACTURED IN THE UNITED STATES OF AMERICA

10 9 8 7 6 5 4 3 2 1
10 9 8 7 6 5 4 3 2 1 PBK

LIBRARY OF CONGRESS CATALOGING-IN-PUBLICATION DATA
HORENSTEIN, HENRY.
 THE PHOTOGRAPHER'S SOURCE: A COMPLETE CATALOGUE/ HENRY HORENSTEIN.
 P. CM.
 "A POND PRESS BOOK."
 "A FIRESIDE BOOK."
 INCLUDES INDEX.
 ISBN 0-671-68162-1. — ISBN 0-671-64591-9 (PBK.)
 1. PHOTOGRAPHY—APPARATUS AND SUPPLIES—CATALOGS. I. TITLE.
 TR197.H67 1989
 770—DC20 89–33950 CIP

Contents

Acknowledgments

This book was a collaborative effort by many dozens of people. I am extremely grateful to all of them. Russell Hart researched and wrote the sections on equipment. Sean Callahan interviewed the Viewpoint contributors and put down their thoughts. Lauren Lantos and Ronna Berezin spent many months researching, checking facts, and collecting photographs, with much help from Stephanie Yoffe. Melissa Tardiff made an incredible amount of information look good and accessible in a remarkably efficient manner. Diane Taraskiewicz made sure that the text was readable and accurate. Yoon Sook Kim helped make the production go smoothly and quickly.

Special thanks also to Steve Brettler and Elaine O'Neil, who read and reread the manuscript and were always available with their suggestions and ideas. Also, thanks to my patient editor, Laura Yorke, and to Sol Skolnik and Dan Farley.

Thanks, too, to all the Viewpoint contributors: Elisabeth Biondi, Steve Brettler, Marisa Bulzone, Rudy Burger, Janet Swan Bush, John S. Butsch, Carla Carpenter, Raymond H. DeMoulin, Peter Galassi, Tom Kennedy, Jay Maisel, Karen Mueller, William E. Parker, Henry Scanlon, Wayne Takenaka, and Stan Trecker. And thanks to the many photographers, institutions and organizations, agencies, and manufacturers who contributed photographs, as well as their staff, who provided much of the information in the book.

Others who were especially helpful include Sheri Blaney, Jim Dow, Ed Earle, Mark Fisher, Debra Friedman, Bill Gallery, Christina Holz, Allen Hess, Lou Jones, Elise Katz, Rodger Kingston, Mary McCarthy, Jack Naylor, Eric Roth, Jacquie Strasburger, Dan Van Ackere, and Barbara Yoffee.

And Mikkel Aaland, Pam Allara, Andy Anderson, Richard Anderson, Todd Anderson, Jan Arnow, Pierre Apraxine, Karl Baden, Robert Baker, Lynda Barckert, Laurie Barrow, Thomas Barrow, Doug Beasley, Tom Beck, Gigi Benson, Steve Benton, Denise Bethel, Jennifer Bishop, Laura Blacklow, Julia Blinn, Ken Bloom, Michael Blowen, Keith Boas, Gary Bogue,

Tim Boole, Janet Borden, Melody Bostick-Sullivan, Barbara Bosworth, Lynn Bowe, Rodney Boyd, Beverly Brannon, Ed Braverman, Nathan Braulick, Lisa Brody, Cindy Brown, Deborah Brown, Peter Brown, Stephen R. Brown, Rick Brunello, Bill Burke, Steve Burke, Scott Busby, Jeff Byrd, Bill Cann, Tom Carabasi, Ellen Carrey, Jean Caslin, Frances Chavez, Catherine Chermayeff, Carl Chiarenza, Rich Clarkson, Wade Clutton, Dennis Cody, A.D. Coleman, Joy Conley, Doug Cooke, Charles Cooper, Will Counts, Andrea Couture, Barbara Crane, William Crawford, Darryl Curran, Nancy D'Antonio, Andrew Davidhazy, Keith Davis, Fred Demerest, Lisl Dennis, Dave Denoma, John Divola, Jim Domke, Jim Dozier, Anita Douthat, Tim Druckrey, Doug Dubois, Michael Eastman, Owen Edwards, Terry Eiler, Laura Elliot, Fred Endsley, Andrew Epstein, Dan Escobar, Peter Essick, Joe and Mary Farace, Michael Faubian, Sandi Fellman, David Featherstone, Paul Fineberg, Steven Finson, Rick Fisher, Valorie Fisher, Susie Fitzhugh, Carl Fleischhauer, Roy Flukinger, Sharon Fox, Ruth Fremson, Jana Frieband, Jerry Friedman, Marianne Brunson Frisch, Tom Frost, Jim Fuller, John Fuller, Bill Gallery, Anna Ganahl, David Gibney, Jim Goldberg, John Goldberg, David Graham, Peter Grant, Allen Green, Don Gruber, Claudia Gropper, David Diaz Guerrero, Ann Guilfoyle, Susan Hacker, Siegfried Halus, Thomas Hardin, Alex Harris, Bob Hedin, Robert Heinecken, Lynn Henry, Paul Hester, Debra Heimerdinger, Barbara Hitchcock, Jenny Horenstein, Jason Horowitz, David Horvath, Graham Howe, Bob Hower, Karen Hymer, Chris Ipsan, Mary Ison, Jim Jager, Bill Jay, Kim Jew, Bill Johnson, Mark Johnstone, Katherine Jones, David Joyce, Mary Judge, Harla Kaplan, Barbara Karant, Gus Kayafas, Nancy Kaye, Sharon Keim, Peter Keough, Teri Keough, Roshini Kempadoo, Geof Kern, Bern Ketchum, Peter Kinner, Jim Klein, Simon Kilmurry, Ken Kobre, Chris Kohler, Connie Komack, Betsy Kommer, Ed Kostiner, Paul Krot, Bill Kuykendall, Lillian Lambrecht, Dorie Laughlin, Jeff Lantos, Drew Levitan, Sharon

Liebowitz, Silvio Lim, Norman Lipton, Janet Lorenz, Nancy Lutz, Alex Maclean, Debra Santa Maria, Anne Marsden, Scott Martin, Richard Maurer, Ralph McKay, Forbes McMullin, John McWilliams, Tim Mendelsohn, Andrew Meredith, Gary Metz, Avery Meyers, Arthur Meyerson, Tressa Miller, Jan Mishel, Suzanne Mitchell, Jim Morgan, Doug Munson, Robbie Murphy, Gina Murtagh, Bea Nettles, Beaumont Newhall, Gary Nickard, Duane Nilfen, Kenda North, Lorie Novak, Vicki Oliver, Tom O'Neil, Paul Owen, Olivia Parker, JoAnne Paschal, Tom Patton, Claire Peeps, Marcia Taylor Pepper, Paul Peregrine, Stephen Perloff, Mark Pevsner, Keith Piascezny, Terry Pitts, Davis Pratt, Dick Raphael, April Rapier, Bill Rauhauser, Bill Ravanesi, Kathy Reeseman, Gary Regester, Bernie Reilly, James Reilly, Andy Reisberg, Becky Reisberg, Eric Renner, John Reuter, Barbara Jo Revelle, Mrs. Arthur Rich, Jr., Don Roe, Stephen Rose, David Ryan, Richard B. Salzburg, Bill Sanders, David Scheinbaum, Kate Schlesinger, David Schonauer, Richard Schultz, Nicholas De Sciose, Danny Schweers, Doug Scott, Kristine Scott, Allan Sekula, John Sexton, Steve Simmons, Ann Simmons-Myer, Harold Simon, Frank Siteman, Neal Slavin, William Smalling, Jr., Scott Smith, Nancy Soloman, Jerry Spagnoli, Karen Speerstra, Joe St. George, Maren Stange, Robert and Sura Steinberg, Bill Stettner, Jamie Stillings, Jim Stone, Evon Streetman, Bill Strode, Mary Strubbe, Mary Virginia Swanson, Jerry Takagawa, Dan Tally, Lucy Taylor, Ron Terner, Emily Terry, Duke Thiele, Jack Thomas, Carey Thornton, Jean Tucker, Donald Velder, Michael Verbois, David Vestal, Stephen Vitiello, Laura Volkerding, Doug Walberg, Carol Walker, Julie Walker, Melanie Walker, Anne Walsh, Colin Westerbeck, Suzanne Williamson, Paul Wilson, Ron Wohlauer, Michael Yockel, Bill Youmans, Cheryl Younger, Dan Younger, Richard Zakia, Phil Zimmerman, and Janet Zweig. I hope I didn't miss anyone. Thank you all.

Introduction

At the beginning, it seemed a simple enough idea—to compile a sourcebook of photographic things and places for serious amateur photographers and pros. People had done similar kinds of books before, but most limited their scope to, say, museums or equipment. My idea was to ferret out, distill, and combine information from a variety of sources into one volume that represented all things photographic.

While the idea was simple, the execution was anything but. To begin with, there were a lot of decisions to make—most obviously, what to include. Selectivity was not only advised, but required; since there was no way to include everything, I decided to feature certain products, companies, institutions, and so forth and to list others, trying to be complete whenever possible. When completeness wasn't possible—there are far too many stock agencies, for example, to list them all—I tried to provide a representative sample.

The final decisions as to what to feature and list were mine, but I received a lot of help from knowledgeable individuals, all of whom were very generous with their time as they were asked such pertinent questions as, "What do you think are the best schools for photojournalism?" and "What artists' books should be mentioned?"

Another obvious problem was timeliness. A book of this sort inevitably becomes dated. Companies move or go out of business; new products are introduced and old ones replaced. Oddly, I didn't see this as too major a problem. *The Photographer's Source* is a book for people seriously involved in photography, not consumers who use a camera only for the occasional snapshot. As such, the featured products are mostly professional-quality models, and these change less often than point-and-shoot models do. Also, even when a product is discontinued by its manufacturer, it remains useful and often sought-after in the used-equipment marketplace. As for schools, collections,

photo centers, and the like, while there is change, much of it is gradual. Still, this book will need updating on a regular basis, and I plan to do so if it finds a large enough readership.

Pricing was a more immediate problem. When available, list prices have been noted, and these not only change but rarely represent the actual price paid. Almost all photo products are discounted, sometimes heavily. Still, I decided to note prices for their comparison value—that one product, for example, might be twice as expensive as another seems like useful information. I trust that readers are sophisticated enough to take these prices at face value.

Books and other publications are also fairly volatile. They have a way of becoming unavailable, and new ones are always replacing them. Despite this, I decided to include some books that are already out of print if they are particularly useful and somewhat available. Magazines and journals are another matter. Most of the established ones stick around for a while (though just a short time ago the venerable *Modern Photography* folded), and I felt the newer, more eclectic ones, despite their often uncertain futures, were worth mentioning. Some of these will regrettably be gone by the time you read about them.

One feature I hope you'll like are the Viewpoints, which are personal opinions, spread throughout the book, from knowledgeable people about their area of expertise. These include individuals who are well established in their field discussing current and future issues (for example, Peter Galassi of the Museum of Modern Art talking about where fine-art photography is headed) as well as those just starting out in their careers (such as Wayne Takenaka discussing what it's like to be a photoassistant). I hope you'll find their opinions as illuminating as I did, but I stress that they are, as the news editorials say, the views of the individuals and not of management.

CAMERA EQUIPMENT

Professional 35mm Cameras

Most of today's 35mm cameras are point-and-shoot models designed for amateur photographers. These virtually guarantee technically good pictures with a minimum of effort. They feature automatic film loading, automatic exposure, and automatic focusing. It's amazing how often these cameras manage to deliver on their promises; about 80 to 90 percent of the pictures they produce are well exposed and in focus.

But pros need even better odds than that. They must have full control of such factors as exposure and focus. They must also have equipment that can take a beating, and they need more than just a camera body and some lenses—they need complete systems with a wide selection of accessories and parts.

Although professional cameras satisfy these needs, they are becoming increasingly automated. But unlike most consumer models, they rarely change dramatically. With occasional modifications, the basic systems stay intact for many years. When a change does occur, the manufacturer generally strives to keep older equipment, especially lenses, compatible with the new models. A professional system is a major investment involving multiple bodies, lenses, and accessories; buyers deserve assurance that its components will be useful for years to come.

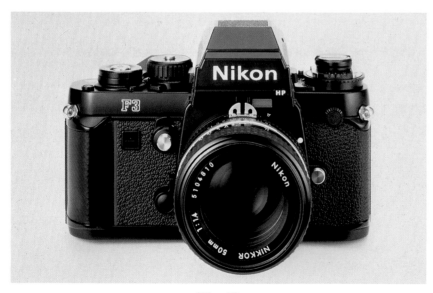

Nikon F3.

NIKON F3

Nikon equipment first appeared in the United States during the Korean War, when photographers covering the conflict for *Life* magazine brought combat-tested Nikon lenses home from Tokyo. Although these photographers used the lenses on their Leicas, Nikon S rangefinder bodies were on U.S. dealers' shelves by 1953.

In 1959, after the last obstacles to convenient single-lens reflex (SLR) design were overcome, Nikon introduced the pioneering Nikon F camera. This rugged, modular package has evolved through four generations of F-series cameras. The company is betting that its latest model, the heavily computerized autofocus F4 (see page 7), will carry it into the 1990s, but for now the F3 is the pro's camera of choice.

Like most current SLRs (and unlike the original, all-mechanical F), the Nikon F3 relies on a good deal of electronic circuitry. Its complex inner works are protected by a die-cast aluminum-alloy chassis—one reason it's favored by pros for hazardous duty. But what really makes it a professional camera is the versatility and availability of its parts. Nikon offers an arsenal of interchangeable lenses ranging from a 6mm f/2.8 fisheye (a monstrous chunk of glass that weighs 11½ pounds and covers an angle of 220 degrees) to a 2,000mm mirror telephoto that weighs almost forty pounds. Then there are the twenty-two interchangeable viewing screens, six viewfinders, motor drives, power winders, and more obscure accessories such as radio remote-control triggering devices and intervalometers for time-lapse photography.

The F3's viewfinder shows almost 100 percent of what will end up on film; most viewfinders show much

less—usually about 90 to 95 percent. This accuracy is particularly important to photographers who print the full-frame negative. Add a very responsive professional services group that caters to customers' needs (see page 104), and you'll understand why so many pros favor the Nikon F3. The F3 (body only) lists for $1,295.

Nikon, 623 Stewart Avenue, Garden City, NY 11530. (800) 645-6687; (516) 222-0200.

CANON F-1

For professional photographers working in 35mm, Canon is the main alternative to Nikon, and the F-1 is the flagship model. In some respects, it's a more complete package than the Nikon F3. It offers two selective metering patterns, in addition to the standard center-weighted averaging (the Nikon has only center-weighted averaging). One selective pattern is called "central area" metering, the other "center spot"; the narrow angle of acceptance of either permits more precise local light readings without the need to close in on the subject. (Certain viewfinder screens must be used, however, to obtain these patterns.)

The F-1 meter's sensitivity range is also somewhat greater than that of the F3, on both the high- and low-light ends. And unlike the F3, the F-1 offers shutter-priority autoexposure (provided a motor drive or power winder is attached to the camera), in addition to aperture-priority autoexposure and metered manual mode. Some pros feel that shutter priority is more useful than aperture priority, because it offers greater protection against image-degrading camera shake.

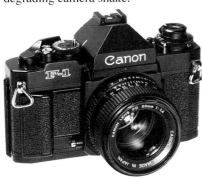

Canon F-1.

A Throwback

The Pentax K1000, a camera with a cult following, is reliable and time-tested. It's an excellent choice for a student or beginner because it doesn't bury basic principles and camera controls under a blizzard of bells and whistles. The K1000 is also very cheap, listing with a normal lens for $290 and generally available for less than $200.

The K1000 is a very sturdy, bare-bones camera—a completely mechanical model that uses battery power for metering and offers metered-manual-exposure control only. To get the correct exposure (or what any full-field averaging system deems to be correct), you adjust the shutter speed and lens aperture until a moving needle in the viewfinder falls into place. This "match needle" design was for years the standard exposure indicator, before light-emitting diodes (LEDs) and liquid crystal displays (LCDs).

Shutter speeds on the K1000 run from $\frac{1}{1,000}$ second—speedy enough to freeze all but the fastest action—to one second, which is adequate for most low-light photog-

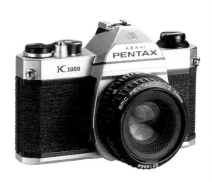

raphy, even with slow film. Longer exposures can be manually timed with the camera's B (for bulb) setting, which keeps the shutter open as long as the shutter button is depressed. The shutter-speed dial and the few other controls on the K1000 are traditional in layout and design. The camera's lens mount accepts any of the many good-quality Pentax K-mount lenses.

The K1000 is a true dinosaur, and, as such, seems bound for extinction. But it's been around so long that, even if discontinued, there are plenty of lenses and accessories in circulation to keep it alive long after Pentax sells the last one.

Pentax, 35 Inverness Drive East, Englewood, CO 80112. (303) 799-8000.

Furthermore, while the F3's shutter is fully electronic throughout its range, the F-1's shutter works mechanically from $\frac{1}{90}$ second all the way to the camera's top speed of $\frac{1}{2,000}$ second, plus bulb. This means that the Canon, unlike the Nikon, lets you shoot at any speed within that range even if the batteries are dead.

The F-1 offers all the other niceties you'd expect from a professional camera, such as exposure compensation (plus or minus two stops in $\frac{1}{3}$-stop increments) and depth-of-field preview.

The F-1 body lists for $1,095. Canon's lenses are roughly equal in quality to Nikon's, and their list price is about 10 percent cheaper. However, Nikon offers a few more choices in

lenses and accessories, and more used Nikon equipment is generally available. Canon, like Nikon, has an active professional-services policy (see page 104).

Canon, One Canon Plaza, Lake Success, NY 11042. (516) 488-6700.

LEICA R5

The German-made Leica is the Mercedes of 35mm SLRs. Even more costly than the rangefinders (currently the M-series, see next page) that made the company's name, and roughly three times more expensive than the Nikon F3 or Canon F-1, Leica's R-series cameras are superbly crafted, rock-solid machines that remain staunchly conservative in design.

Both current models, the R5 and

R6, share the Leica lens system, considered by many to be the best optics available anywhere. Unfortunately, Leica's lenses are as pricey as its camera bodies. The 50mm f/1.4 lens lists at $2,250; the comparable Nikon lens is $372.50. On the extreme end, the 800mm f/6.3 Leica Telyt lens lists for a breathtaking $23,700, and was recently promoted by a rather unusual give-away—a free Volkswagen.

The R5 is the series' current flagship model. An R6 is available, but it doesn't have as many features as the R5 and works mechanically rather than electronically.

As a system, the R5 is not as attractive as either the Nikon F3 or the Canon F-1, for several reasons. The primary one is the much more limited

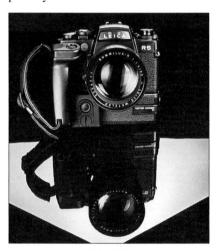

Leica R5.

selection of lenses and accessories. More minor disadvantages include the noninterchangeable pentaprism, which forces you to change viewing screens through the open lens-mounting flange of the camera. Also, Leica's professional service support policy is not as extensive as those of Nikon or Canon.

On the plus side, the R5 packs more exposure options than either of its competitors. Most notably, it has a rather unusual variable programmed autoexposure mode that you can customize. The R5 also offers four other exposure modes: metered manual, plus three automatic ones (one shutter-priority and two aperture-priority).

Leica USA, 156 Ludlow Avenue, Northvale, NJ 07647. (201) 767-7500.

Leica Rangefinders

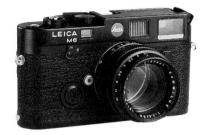

Leica M6.

Rangefinder cameras focus by means of a measuring device coupled to the camera lens. When you look through the viewfinder, you see two superimposed images. As you turn the lens, the two images come together only when the subject is in focus.

Such cameras were once popular with both professional and amateur photographers, but with the advent of useful 35mm SLRs, most pros phased out their use of rangefinders. SLR cameras allow more accurate through-the-lens viewing and accept more accessories, most notably a much greater variety of lenses. In the amateur market, rangefinders have been replaced by autofocus point-and-shoot models.

Although a few rangefinder cameras are still made, only one has a significant audience among serious photographers—the Leica M-series. (The name "Leica" comes from the *Lei* in Leitz, the optical firm that markets it, and the *ca* in camera.) The first Leica came to market in 1924, and subsequent models became popular tools of photojournalists. Prominent early champions included Henri Cartier-Bresson and André Kertész. In 1954, the M-series began with the M3. Since then, various models, some specialized, have progressed to the M6, the most recent incarnation.

The M6 is a mechanical camera with manual focusing that lists, body only, for $3,375. It has six bright line frames for six focal-length lenses (28, 35, 50, 75, 90, and 135mm) and selective through-the-lens spot metering (previous M-series Leicas, except for the M5, required attaching a Leica MR meter, or a separate hand meter).

All Leica M-series cameras are extremely well designed and manufactured; they're small, very quiet, and have excellent optics. But, like the M6, they're expensive and limited. They work best when equipped with lenses that are slightly wide to slightly telephoto (particularly 35mm to 90mm), but their viewfinders don't accommodate very short or very long lenses. Also, M cameras don't offer nearly as many lenses or other accessories as most SLR models do; for example, the winder for the M6 provides three frames per second, half as fast as a motor drive for a Nikon, Canon, or other good SLR.

Though used by pros, Leica cameras are particularly appreciated by serious amateurs and fine-art photographers who value high quality over the versatility that SLR systems offer. They are especially favored by "street photographers" who shoot in the tradition of Leica-users Robert Frank and Garry Winogrand.

Interest in Leica equipment among collectors is quite high, and used Leicas fetch high prices. Many books have been written about Leicas both past and present, and enthusiasts pride themselves on knowing obscure facts about the company and its offerings.

Leica USA, 156 Ludlow Avenue, Northvale, NJ 07647. (201) 767-7500.

Autofocus SLR Cameras

Snapshot cameras that focus automatically have been around for a while, but serious autofocus (AF) photography began with the Minolta Maxxum 7000, introduced in 1985. This was the first 35mm AF SLR model, and, as such, signaled an attempt by manufacturers to turn committed photographers into autofocus believers.

Still a fledgling technology, autofocus has come a long way in a very short time, with recent introductions redressing many of its early deficiencies. Some photographers have embraced the concept, but many others have been vehement in rejecting it, particularly the high-end users—serious amateurs and pros.

Why the controversy? A camera system that you never have to focus would seem to have its advantages. No longer would you miss opportunities because you were too slow—or inept— to focus sharply before exposure.

In part, the skeptics are simply conservative; they're satisfied with what they've got and suspicious of new technology. But, mostly, autofocus systems are not yet good enough. They simply don't work as well and reliably as manual-focus models do, at least not for professional purposes.

They're getting better all the time, however, and some think the latest generation of autofocus cameras will bring about widespread acceptance. Camera companies are betting the bank on it; most of their newest camera and lens products incorporate autofocus features. They're hoping to drag professionals along for the ride—screaming and hollering, if necessary.

What's Wrong With Autofocus?

Serious photographers want as much image control as possible. They may use automatic exposure, for example, but reserve the right to switch into manual mode at any time. Some refuse to use autoexposure at all. Then there's the vocal minority who don't like meters built into their cameras and prefer separate hand-held meters.

If there's still some resistance to autoexposure, which has been with us for a while now, it's understandable why some photographers resist automatic focus. They see it as yet another step away from individual control. While most autofocus systems can be focused manually, they work most smoothly on automatic.

Control, while important, would be less of an issue if autofocus systems worked better. The main problem is that they are less flexible than non-autofocus systems. For example, so-called one-shot, or focus-priority, systems won't let you shoot unless the target is perfectly in focus. Unfortunately, autofocus systems may take time to find that focus, particularly if the subject has insufficient contrast or brightness. While the lens racks back and forth searching for focus, the decisive moment—whether the fleeting expression on a friend's face or a great catch in a football game—may be lost. With manual focus, you can take the picture even if it isn't critically sharp, so you have a better chance of capturing the decisive moment.

Also, because autofocus systems target the central part of the viewfinder, primary subjects not placed there may be rendered unsharp. This is a severe limitation for creative photographers who want to control where the subject falls within the frame—the rather basic

matter of how to compose a picture. You can minimize this problem by framing the subject so the area you want in focus is in the middle, locking in that focus by pressing lightly on the shutter button, then recomposing the picture before shooting. This works, but it's awkward.

Last but not least, autofocus cameras can have trouble with moving subjects. Even if the camera can focus on a moving subject, by the time the exposure is made the subject may have moved out of focus. Some autofocus models offer a continuous or action-priority mode in an attempt to deal with this problem, but all this does is allow you to take a picture regardless of whether the autofocus system keeps up with the subject—still potentially resulting in an out-of-focus image.

Many of these limitations have been addressed by the new generation of autofocus SLRs, such as the Minolta Maxxum 7000i and Nikon F4 (see below). But even though these cameras have made solid progress toward solving the problems, they still have a way

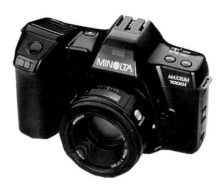

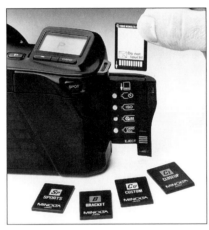

Minolta Maxxum 7000i (above) with drop-in expansion cards (below).

to go before serious amateurs and pros turn in their manual-focus equipment.

MINOLTA MAXXUM 7000i
Minolta, the leader in SLR autofocus technology, introduced the concept and was the first to refine it in the Maxxum 7000i—the *i* stands for intelligent. One of the camera's distinguishing features is its redesigned autofocus target system. Rather than a tiny horizontal slit in the middle of the viewfinder indicating where the camera will focus, the 7000i uses three sensors to target the focus, arranged in the shape of a wide H. The sensor that detects the closest subject area determines what the lens will focus on. Because these sensors cover an area twelve times larger than that typically covered by a single sensor, there's a far greater chance that at least part of a sensor will land on the subject area you want in focus. But there's no guarantee; if your main subject is extremely off center, it's still best to lock-in focus where you want it, then recompose—or focus manually.

In addition to having three sensors,

Autofocus Lenses

The optical glass of a lens used to be its most expensive component, far outweighing the cost of its barrel and focusing mechanism. Autofocus lenses have changed that equation. Elaborate gearing makes autofocus lens barrels costly to produce, while computer-aided lens design and advanced manufacturing techniques have made good optical glass relatively cheap.

The focusing motor that drives an autofocus lens ordinarily sits in the body of the camera. But some lenses have built-in motors for use on non-autofocus cameras, and special adapters can allow older lenses to work in autofocus mode on current AF camera bodies. An important advantage of built-in motors is that they have adequate power to drive their lens efficiently—long lenses require more power than shorter ones to focus with optimum speed.

Most current autofocus lenses are zooms. You might assume that combining autofocus hardware and typically bulky zoom design would make lenses into clunkers, but extraordinary advances in optical design (including the use of aspheric elements, which means fewer elements) and improvements in autofocus efficiency have combined to make today's autofocus zooms remarkably compact and light.

Oddly, a sticky point with these lenses is the ease of manual focus—or lack of it. Situations arise in which even the avid autofocuser might want to revert to the old-fashioned way. With most SLRs, you have to throw a switch on the camera body to get into manual mode, which means taking your eye away from the camera for a split second. Also, focusing manually with most autofocus lenses is an awkward process because of the skimpy size and placement of the focus ring (it's often at the far end of the lens barrel). Further, such rings typically lack the inertial drag of those on conventional lenses; they feel too loose, making the exact focus spot harder to find and maintain.

Some autofocus systems permit easier manual focus than others. For example, the manual-focus rings on some Nikon autofocus lenses are wider and tighter, making them feel more like conventional focusing rings. The focusing ring on many Canon lenses is positioned closer to the center of the barrel. And some of Minolta's new Maxxum lenses have a rubberized, deeply knurled ring, covered by a sleeve that slides back and forth for manual or autofocus operation.

Auto Everything

Polaroid cameras not only have autofocus and autoexposure, but autoprinting—they create self-developing prints within a minute or two, as you watch.

The most current high-end Polaroid cameras are the Spectra and Onyx lines. They are essentially the same camera, but the Onyx features a see-through casing. Both lines include special-edition models that cost a little more but provide return privileges. Any photographs you don't like can be sent back for new film—with no limitation on returns for four years with the Spectra SE (list price $225) and eight years for the Onyx SE, (list price, $280).
Polaroid, 575 Technology Square, 9P, Cambridge, MA 02139. (617) 577-2000.

Polaroid Onyx.

it, then recompose—or focus manually.

In addition to having three sensors, the Maxxum 7000i focuses in a quicker and more positive way, without the sluggishness and seemingly endless searching of many older autofocus models. The camera uses a more efficient series of light, compact lenses, many of aspherical design. These lenses can also provide faster operation on older Maxxum bodies.

Another important 7000i improvement is its "predictive mode"—a complex solution to the problem of moving subjects. The camera locks focus if the subject is still, but if it detects any subject movement—a change in its position in the frame or distance from the camera—it unlocks focus and corrects

it. Even if the camera sees movement as you're pressing the shutter button, it calculates where the subject will be when the shutter opens and adjusts focus accordingly. The camera also adjusts its segmented metering system to assign the most importance to the primary subject, wherever it may fall.

The Maxxum 7000i earns its "intelligent" rating with its range of small drop-in cards, which boost the capabilities of the basic camera in much the same way as expansion boards do in a personal computer. These optional ¾×⅛-inch cards slip into a slot in a hinged door on the right side of the camera body. They program the system for a variety of functions, such as automatic exposure bracketing.

The list price of the Minolta Maxxum 7000i is $726—body only. *Minolta, 101 Williams Drive, Ramsey, NJ 07446. (201) 825-4000.*

NIKON F4

The F4 is much more than simply an autofocus camera. With a bloodline that includes the F, F2, and F3—long the 35mm SLRs of choice for pros—the versatile F4 has been carefully designed to carry on a long and successful tradition.

The F4's autofocus system is impressive. It's sensitive enough to focus down to a light level of EV-1, and with a Nikon Autofocus Speedlight can focus even under pitch-black conditions. (See page 24 for an explanation of EV numbers.)

Like the Minolta 7000i, the F4 has a predictive mode for tracking moving subjects. The F4 also has a proprietary matrix segmented metering system that reads and interprets light from five sections of the viewfinder for extremely accurate exposure readings even under difficult lighting conditions, and automatically adjusts for vertical compositions. Most in-camera meters use only the central portion of the viewfinder to provide all or most of the reading. (The F4 offers both center-weighted and spot-metering options as well.)

The F4 accepts virtually all F-mount Nikon lenses, and offers manual-focus electronic rangefinding with

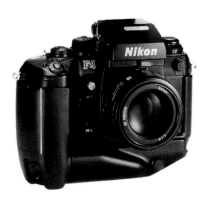

Nikon F4.

them. A green diode in the viewfinder lights up when focus is achieved, particularly useful when shooting in low light. The matrix metering also works with the older style lenses.

The F4's motor drive is built in, and can deliver as many as 5.7 frames per second. However, the camera makes remarkably little noise, and a film-advance mode aptly called "continuous silent" moves the film along at a modest, but even quieter rate of one frame per second.

The F4 is the high-end choice—both in features and price. Without lens, it costs $2,427 (list price). *Nikon, 623 Stewart Avenue, Garden City, NY 11530. (800) 645-6687; (516) 222-0200.*

Other Autofocus SLR Cameras

CANON EOS 1
CANON EOS 620
CANON EOS 630
CANON EOS 650
CANON EOS 750
CANON EOS 850
CHINON CP-9AF
MINOLTA MAXXUM 3000I
MINOLTA MAXXUM 5000I
NIKON N2020
NIKON N4004S
NIKON N8008
OLYMPUS OM77AF
PENTAX SF1N
PENTAX SF10
RICOH MIRAI
VIVITAR DAF
YASHICA 200-AF

Medium-Format Cameras

Combining some of the high image quality of large-format equipment with much of the convenience of 35mm, medium-format cameras accept 120- and 220-size roll film (220 provides twice as many exposures as 120). They come in a variety of types. Medium-format models most favored by studio photographers, who must shoot quickly and repeatedly but need precise control of composition, are single-lens reflex (SLR) cameras; as with 35mm SLRs, these reflect the image formed by the lens to an eyepiece for viewing.

Many of the more interesting medium-format cameras are rangefinders, which handle composing and focusing through a separate window—a design that eliminates the need for a reflex mirror (which in a medium-format camera is much larger than in a 35mm and thus more likely to create image-degrading vibration). Also, roll-film backs are available for view cameras, allowing the photographer to use camera movements such as tilts and swings to control perspective and focus (a few medium-format models do allow limited camera movements).

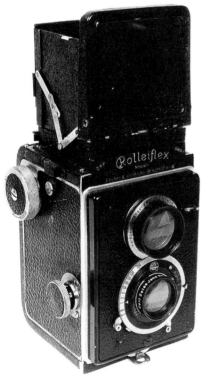

¯The original 1928 Rolleiflex twin-lens reflex, the camera that made medium-format photography popular (courtesy Jack Naylor collection).

Film Formats

Medium-format cameras differ from 35mm and 4×5- or 8×10-inch systems by the wide variety of film formats they can use. Discounting oddball cameras, such as panoramic, stereographic, and half-frame models, the standard 35mm image measures 24×36mm (about 1×1½ inches); 4×5-inch and 8×10-inch cameras produce images that are just those sizes. The most familiar medium-format image size is 6×6cm, or 2¼×2¼ inches (the actual image area is about 56mm square), made popular by the old Rolleiflex twin-lens reflex camera and still widely used in SLR models such as the Hasselblad.

However, many photographers feel uncomfortable composing within a square image shape. (While a square can be cropped to a rectangle, this wastes a significant part of the film area.) To satisfy them, manufacturers offer several medium-format cameras with rectangular alternatives—6×4.5cm, 6×7cm, 6×8cm, 6×9cm (the same aspect ratio as 35mm), 6×12cm, and even a whopping 6×17cm.

Naturally, the format affects the number of exposures on a roll; the smaller the format, the more frames will fit. The familiar 6×6cm (2¼ inch square) format yields twelve shots on size 120 roll film and twenty-four shots on size 220. The economical 6×4.5cm format produces fifteen exposures on 120 and thirty on 220, running them lengthwise across the film. With 6×7cm, you get an even ten on 120 and twenty on 220, while 6×9cm produces only eight and sixteen, and the oddball 6×12cm only six and twelve. The 6×17cm format is a real film gobbler: it yields only four shots on 120 roll film and eight on 220.

Twin-Lens Reflex

The traditional image of medium format is a photographer hunched over, face buried in the waist-level viewfinder of a twin-lens reflex (TLR) camera. TLRs have a distinctive double-lensed look. The upper lens, with a focal length that matches the lower

shooting lens, provides reasonably accurate framing and very accurate focusing without a bulky, expensive reflex mirror. The German Rolleiflex, introduced in 1929, was the original TLR. The company left the field for a while, but recently re-released a model of the old design—the 2.8GX (list price, $2,890 with lens). The Yashica

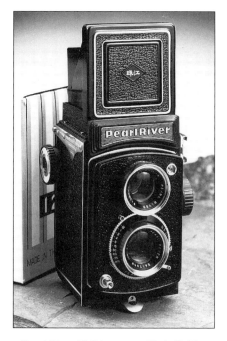

Pearl River TLR (courtesy Chris Gelder, The Maine Photographic ReSource).

MAT, a bare-bones model, is used widely in schools. It has recently been discontinued, but is still available in some mail-order catalogs for about $200 to $250. Even less expensive are the very basic Huazhong TLR and Pearl River TLR, Chinese imports with a list price of about $125; the overall quality of these models is suspect, but you can't beat the price.

TLRs are hardy machines, and their 2¼×2¼-inch format produces sharp results and large prints with relatively little graininess. (The film graininess is the same as with 35mm films, but less enlargement is required for equivalent size prints so graininess is less apparent.) TLRs are of simple construction; since the top lens is used for viewing and focusing, they need no reflex assembly or focal-plane shutter. But they have plenty of limitations—most glaringly their lack of lens selection.

Most TLRs have fixed lenses, ruling out wide-angle and telephoto options (though for a while Rolleiflex made separate fixed-lens wide-angle and telephoto models). The most successful exceptions are cameras from Mamiya, which began making TLRs in 1957 and is now the only manufacturer with a major commitment to this type of camera. Mamiya currently offers two full-system models, the modest C220f (list price, $755 with 80mm lens) and the more automated and professional C330S ($986). Both offer a wide assortment of lenses and other accessories.

SLR Cameras
Medium-format SLRs have several advantages over TLRs. All SLR cameras, whatever the format, let you see virtually what the lens sees; TLRs show a good approximation, but for critical framing, especially at close range, they're not as accurate (because of parallax—the difference between what the viewing lens sees and the taking lens takes). More importantly, SLRs are systems—they offer a wide selection of lenses and other accessories. Most SLRs also have changeable film magazines so you can switch film type in mid-roll, or have an extra magazine ready for continuous shooting with little interruption.

On the down side, because they require a moving mirror assembly (and many require a focal-plane shutter), SLRs are relatively large, bulky, and noisy. In addition, SLRs are a lot more expensive than TLRs.

Medium-format SLRs come in two basic body types. The least common, represented by the Pentax 67, is similar to a 35mm SLR, with the film transported laterally by a crank on the top. You might think this would encourage a rectangular image, but the German-made Exakta 66 is a square-format SLR with similar styling. These cameras offer interchangeable lenses, but not changeable film magazines. The more popular body type, represented by the Hasselblad, is deeper than wide, because the film sits in a detachable magazine behind the main body. The

film winds from top to bottom, so the crank, in models without motorized advance, is on the side.

SLR Choices
Medium-format SLR cameras mostly produce negatives or slides that measure 6×4.5cm, 6×6cm, or 6×7cm. Several companies vie for market share in the various formats. These are the main contenders.

BRONICA
Bronicas are competitively priced and versatile. The company makes one model in each of the popular formats—the ETRSi for 6×4.5cm (list price, $2,636 with 75mm lens and film magazine), the SQ-A for 6×6cm ($3,101 with 80mm lens and magazine), and the GS-1 for 6×7cm ($3,440 with 100mm lens and magazine). Each has its own line of lenses, viewfinders, focusing screens, and other accessories. The SQ-A is also available in a motorized version, the SQ-Am.
GMI Photographic, 1776 New Highway, P.O. Drawer U, Farmingdale, NY 11735. (516) 752-0066.

EXAKTA
Exakta is a West German manufacturer with a long tradition, but its cameras have not been as popular in the United States as most SLRs. The Model 66 (list price, $2,248 with 80mm lens) is a basic, all-manual 6×6cm camera that looks like an oversized 35mm. Designed for the beginning medium-format photographer, especially for on-location work, the Exakta has fine Schneider optics, but its choice of accessories is somewhat limited.
Exacta, 400 Crossways Park Drive, Woodbury, NY 11797. (516) 496-8505.

FUJI
Fuji has a major commitment to medium-format rangefinders (see page 11); the company's only SLR offering is a studio camera, the GX680, discussed in detail on page 19.
Fuji America, 800 Central Boulevard, Carlstadt, NJ 07072. (800) 843-5976; (201) 507-2500.

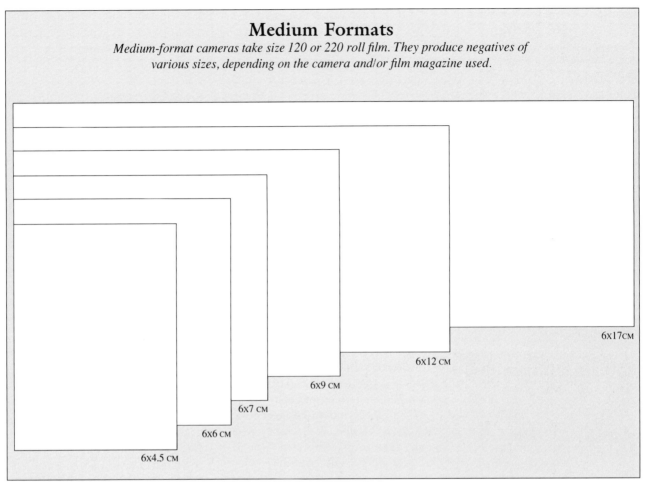

Medium Formats

Medium-format cameras take size 120 or 220 roll film. They produce negatives of various sizes, depending on the camera and/or film magazine used.

6x17cm

6x12 cm

6x9 cm

6x7 cm

6x6 cm

6x4.5 cm

HASSELBLAD

The camera that went to the moon, the Hasselblad is the quintessential medium-format SLR. Originally designed in the 1940s as a modular system with interchangeable lenses, film magazines, and prism viewfinders, it represented a radically different concept compared to the TLRs that preceded it. Hasselblads are extremely well designed and versatile. They are also expensive—along with the Rolleiflex, the costliest medium-format SLRs.

Fiercely committed to its original 6×6cm format, Hasselblad has chosen to offer variants of this basic style rather than expand into other formats (although it does offer film magazines in vertical and horizontal 6×4.5cm formats). The company offers the classic and relatively basic 500C/M (about $3,650 with 80mm lens and film magazine); the 2000FCW with its super fast (1/2,000 second) electronic-focal-plane shutter (about $5,400); the 503CX, an updated 500C/M with a dedicated flash

system (about $3,990); and its cousin, the 553ELX, with a motorized body (about $4,830). Hasselblad also makes the 903SWC (see below). The company offers the largest selection of accessories and lenses of any manufacturer in this category, including many items not made by its competitors, such as a wirephoto transmitter and photogrammetric surveying systems. It also

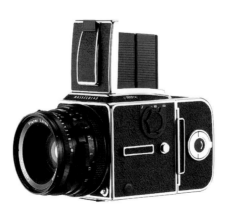

Hasselblad 503CX.

makes a 6×6cm projector.
Victor Hasselblad, 10 Madison Road, Fairfield, NJ 07006. (201) 227-7320.

MAMIYA

Mamiya makes workhorse systems, well built and relatively inexpensive. The M645 Super ($1,675—body, normal lens, and film magazine) is a highly electronic camera for the 6×4.5cm format. Mamiya also makes 6×7cm models—the basic RB67 (with normal lens and magazine, $2,213) and the electronic RZ67 ($2,919). All Mamiya equipment features a wide range of accessories, including a particularly full complement of lenses.
Mamiya America, 8 Westchester Plaza, Elmsford, NY 10523. (914) 347-3300.

PENTAX

Pentax has two entries in the medium-format category. The Model 67 (list price, $1,653 with normal lens) looks and acts much like an oversized 35mm, except that it shoots 6×7cm

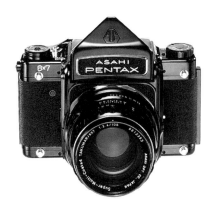

Pentax 67.

images. Its nineteen interchangeable lenses—35mm fisheye to 1000mm telephoto—are more than most competitors offer. The design of the 67 doesn't allow for interchangeable film magazines.

The Pentax 645 is a neat 6×4.5cm model, highly electronic with a built-in motor drive, which offers a choice of twelve lenses from 35mm to 600mm, including a zoom. With a normal lens and film magazine, the 645 lists for $2,258.
Pentax, 35 Inverness Drive East, Englewood, CO 80112. (303) 799-8000.

ROLLEIFLEX

The introduction of the Rolleiflex in 1929 was an important event in photographic history. Rolleiflex's TLRs became the standard cameras for many professional shooters until Hasselblad popularized the medium-format SLR and Nikon brought out its 35mm SLR.

While it currently makes a TLR (see above), Rolleiflex offers several SLR 6×6cm models (as with Hasselblad, 6×4.5cm magazines are also available). These cameras compare favorably to Hasselblad's; they are both high in quality and expensive. They're also a bit more innovative.

The current Rolleiflex offerings include the basic 6002 (list price, $2,995 with 80mm lens and film magazine) and the more versatile 6008 ($3,920)—both are motorized and have sophisticated flash-exposure controls. There's also the SL 66SE ($6,450), which has a built-in tilting bellows for controlling depth of field

and a wide range of accessories, including highly regarded Schneider and Zeiss optics. Rolleiflex offers thirty-four lenses, including two macro zooms, two perspective controls, and the fastest lens for medium-format work (an 80mm f/2).
HP Marketing, 16 Chapin Road, Pine Brook, NJ 07058. (201) 808-9010.

Viewfinder/Rangefinder Models

After the decades spent developing today's highly sophisticated and flexible SLRs, it seems odd that the hottest new category of medium-format cameras is the relatively basic and limited viewfinder/rangefinder type. Some use a viewfinder to approximate what the lens sees; others have rangefinders for critical focus; a few make you estimate the focus. Most don't have interchangeable lenses and few have electronic or automatic features, such as motorized film advance. Some are so basic they don't even have built-in light meters.

What these cameras do offer is light weight, quiet operation, simplicity of use, and relatively low cost. These are particularly attractive features if you want a medium-format camera you can hand-hold with ease; most SLRs are relatively heavy and awkward to use without a tripod.

Although these cameras may seem a bit outdated, current models are actually quite sophisticated—in a low-tech sort of way. The level of construction is generally very good, and the lenses are of high quality. If you like shooting with a Leica M-series camera, you'll love these. Here are the current options.

FUJI

Fuji, the major player in this category, offers several models. The GS645 series cameras, as their name suggests, produce a 6×4.5cm image; the long dimension runs across the width of the film. Though extremely compact and well built, they do take some getting used to. They must be held vertically to produce a horizontal shot, because

they are designed like traditional 35mm cameras, with the film transported laterally.

There are two models in the GS645 series. The GS645S, with a fixed 60mm lens, slightly wide for this format, has a curious sort of crash bar encircling the lens (list price, $619). The GS645W has a wider-angle 49mm lens ($565). The former has a built-in rangefinder, while the latter focuses by estimation. Both models have built-in meters.

The Fuji GW670II (list price, $817), GW690II ($817) and GSW690II ($862) cameras provide image areas of 6×7, 6×9, and 6×9cm,

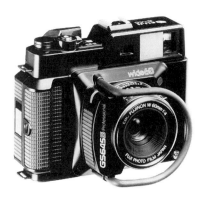

Fuji GS645S.

respectively, although their body configuration is almost identical. The long dimension of the image runs laterally, as in a 35mm camera. All have built-in rangefinders but no internal meters. The GW670II's fixed lens is a 90mm Fujinon; the GW690II has a 90mm lens, very slightly wide-angle for the format, and the slightly more expensive GSW690II has a 65mm lens, comparable to a 28mm lens in 35mm.

The Fuji G617 Panorama may be the most unusual camera of this type. Designed for architectural, aerial, and landscape shooting, its 105mm f/8 lens produces a very wide angle-of-view on its 6×17cm image. For a camera producing such a large image, it is surprisingly easy to hold and handle. It lists for $2,870.
Fuji America, 800 Central Boulevard, Carlstadt, NJ 07072. (800) 843-5976; (201) 507-2500.

HASSELBLAD

SLRs are its bread and butter, but Hasselblad does make a viewfinder medium-format model, the 903SWC. This is a fixed-lens, very wide-angle camera with excellent optics and manual controls. It uses an optical viewfinder for composing the image and has no internal meter. The price is about $5,390.

Victor Hasselblad, 10 Madison Road, Fairfield, NJ 07006. (201) 227-7320.

LINHOF

A long-established maker of fine view cameras and other equipment, Linhof makes two panoramic models that can be hand-held—the Technorama 612II ($7,586 with 65mm lens and optical viewfinder, and $7,511 with 135mm lens and finder), which yields a 6×12cm image, and the Technorama 617S ($6,300) for a longer 6×17cm image. The former is unique in offering interchangeable lenses of 65mm and 135mm. Both models are extremely well made, as befits their high price. Linhof also makes the Technikardan 23 view camera for 6×9cm format.

HP Marketing, 16 Chapin Road, Pine Brook, NJ 07058. (201) 808-9010.

MAMIYA

Mamiya makes the only cameras in this category with three interchangeable lenses. The new Mamiya 6 is a 6×6cm model with manual and aperture-priority automatic exposure. It is extremely quiet and has a viewfinder that changes as the lenses change. The list price of the Mamiya 6, without lens, is $1,450; lens prices are $1,120 for the 75mm, $1,385 for the 50mm, and $1,525 for the 150mm.

Mamiya also continues to sell its rather archaic Universal Press camera—an awkward box of a type that used to be popular with wedding photographers and some photojournalists. It is oversized and bulky as modern cameras go, but the quality is good, and it has interchangeable lenses and film backs—unusual features in cameras of this type. The list price is $890, with a 100mm lens.

Mamiya America, 8 Westchester Plaza, Elmsford, NY 10523. (914) 347-3300.

Plastic Cameras

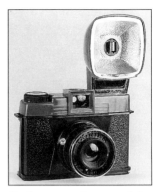

To call them medium-format cameras may be stretching the point, but plastic cameras, of which the Diana is the best known, do take size-120 roll film. They have had a cult following since the late 1960s, with some teachers using them to emphasize seeing over technique. Plastic cameras have virtually no controls, leaving you free to explore visual issues without worrying about such mundane matters as focus and exposure.

Dories camera (courtesy Brian Vandenbrink, The Maine Photographic ReSource*).*

Most medium-format cameras are more expensive than comparable 35mm models, but the list price for the Banner, Diana, Dories, Stellar, and similar all-plastic cameras is under $10—complete. True, the image quality is not up to a Hasselblad's. But that's what devotees love. Variously described as playful, innocent, casual, and haphazard, photographs from plastic cameras are typically sharp in the middle and increasingly soft around the edges.

It's hard to find new plastic cameras these days; the Banner is the most popular one currently made. However, the Diana and Dories, for now discontinued, do show up from time to time in schools and flea markets. Probably the key distributor of plastic cameras is the Maine Photographic Workshops, through its mail-order catalog *ReSource*. It sells the Banner complete with an instructional guide prepared for the Dories when it was being produced.

ReSource, Rockport, ME 04856. (800) 227-1541; (207) 236-4788.

See pages 56, 202, and 206.

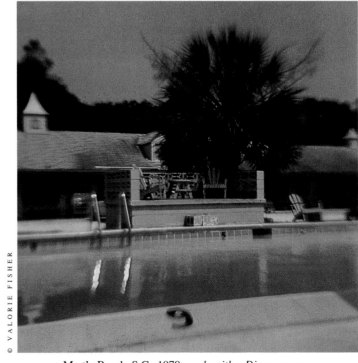

© VALORIE FISHER

Myrtle Beach, S.C., 1979, *made with a Diana camera.*

Field Cameras

Of the many large-format cameras available today, perhaps the most popular one accepting 4×5-inch film (though 5×7-inch, 8×10-inch, and other models are available) is the field camera. The field camera's design has changed little since the days of wet-plate photography. It's still a portable, flexible box with adjustable front and rear standards that move along a geared focusing track. The standards are connected by a bellows. Today's field cameras are often as pleasing for their looks as for the high image quality delivered by their big negatives (or transparencies).

Most current models are constructed of fine hardwoods such as ebony, mahogany, rosewood, and cherry, with hardware of brass, stainless steel, or even titanium. All collapse into a compact suitcase-like package. With most models, the front standard and bed (if extended) rack back into the deep rear standard, the front standard folds down parallel to the camera's base, and the hinged rear standard folds down in turn. This manageable form makes the field camera ideal for location work, when the camera must be carried to the subject in the field.

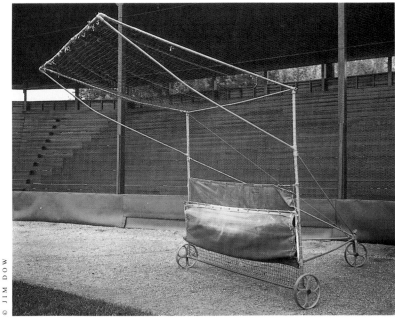

Batting Cage, American Legion Field, Jamestown, N.D., 1981.

Field Camera Features

The field camera's construction and collapsibility distinguish it from the large-format studio camera, even though both are considered view cameras. But whereas the studio camera generally sits on a monorail—a single tubular or squared-off bar to which the camera is secured and along which both standards track—the field camera runs along two geared rails built into its base. This base often incorporates two or three telescoping sections, allowing the standards and bellows to stretch out to accommodate long lenses. The camera's design and generally lighter construction somewhat limit the kinds of perspective- and focus-control movements—swings, tilts, shifts, rises, and falls—that are often essential for studio photography. But with the exception of architectural work, the need for such adjustments is generally less extreme on location than in the studio.

As with any view camera, you compose and focus the subject on a field camera's ground glass, which is part of the rear standard of the camera. You focus by adjusting the distance between the front and rear standard, using knurled knobs on each side of the camera base. With a monorail studio camera, either the front or the rear standard adjusts for focusing; with most field cameras, only the front standard moves back and forth.

Field cameras have become more popular and more sophisticated—or as sophisticated as their time-honored design will permit. In recent years the most significant change—increasing the camera's movement abilities—has addressed the main cause for user dissatisfaction with field cameras. For example, Wisner recently added a rear-standard rise movement to its camera,

offering a perspective control previously achieved only in a limited way by lowering the lens on the front standard.

The features of field camera models vary considerably. The lightest 4×5-inch models weigh about three to four pounds and offer great portability, but they're more susceptible than heavier models are to wind-induced vibration in outdoor work. Also, though not necessarily a function of their weight, lighter cameras tend to have more limited features, such as noninterchangeable bellows with a relatively short draw and minimal rail extension. This rules out using lenses even as long as 300mm (roughly equivalent to a 105mm lens in 35mm).

Heavier field cameras weigh almost twice as much; they are more stable and more capable of longer rail extension and bellows interchangeability. For example, such cameras let you use a bag bellows instead of the standard-issue accordion type for wide-angle work, allowing a full gamut of perspective control movements. Generally, field cameras with interchangeable bellows also come with a very long standard bellows.

Field cameras also vary as to how close together you can position the two standards. This distance affects how short (wide) a lens you can use. Most models will accept a 65mm lens; shorter lenses such as 47mm may require a recessed lens board, which positions the lens between the front and rear standard.

DEARDORFF

Deardorff's been making the classic field camera since the turn of the century. The company is essentially a two-person shop, run by Jack Deardorff and an assistant. Don't expect modern conveniences and innovation from these cameras. Do expect impeccable quality and support in a time-proven design. A Deardorff camera is a thing of beauty, crafted of Central American mahogany, brass, steel, aluminum alloy, and bronze.

Deardorff buffs—and there are plenty of them—love to tell stories

One of the first 8×10-inch Deardorffs (courtesy Jack Naylor collection).

Wista 4×5-inch DX (courtesy The Maine Photographic ReSource).

Wisner 8×10-inch Technical Field.

about the camera's legendary toughness. There's the one about the Deardorff that fell off the Staten Island Ferry, only to be fished out a year later in nearly perfect working order.

The most popular Deardorff is a 5×7-inch model with a 4×5-inch reducing back. It weighs a hefty seven pounds and folds with extraordinary ease into a fairly bulky 4×9¾×9-inch package. But it's so smoothly designed and built that you barely notice the weight or bulk.

Deardorff cameras are expensive; the 5×7-inch model lists for $2,155 without a lens. The resale market is an active one, and experienced Deardorffs command a high price. The company also makes 8×10-inch, 11×14-inch, and even 16×20-inch models; other sizes can be made to order.

Deardorff is justifiably proud of its repair work. It keeps a huge inventory of original parts on hand. If your thirty-year-old model needs some body work, the shop may have a supply on hand of the same wood—or very close to it—that was used in the camera's original manufacture.

Recently, Deardorff has had financial troubles and has sold its designs to Komomura, a Japanese manufacturer. A new model is in the works, which will be similar to existing models. Deardorff is still doing warranty and repair work.
J. Deardorff Photographic Products, 76 South Lassalle Street, Aurora, IL 60505. (312) 629-2637.

WISNER TECHNICAL FIELD
This camera represents an imaginative effort to transcend some of the traditional limitations of field-camera design. The Wisner Technical Field has the structural integrity and a wide enough range of movements to make it useful for exacting studio work. The 4×5-inch model (Wisner also makes models in all sizes, from 4×5 to 20×24 inches) has a full twenty-three inches of rail extension and sports a twenty-eight-inch bellows of burgundy kid leather on the outside and black silk (to absorb reflections) on the inside. Its remarkable stretch equips it for long

The Polaroid 20×24

In 1948, the original Polaroid cameras brought to consumers "instant," 3¼×4¼-inch, sepia-toned prints with scalloped edges. Today, Polaroid makes a camera that creates an instant 20×24-inch print—in color. But, unlike the earlier models, it's not for mass consumption.

In fact, only five 20×24 cameras exist—three in the Boston/Cambridge area (the company's home base), one in New York City, and one in Offenbach, Germany. In New York, the camera is located in a studio and rents by the day for $900. This charge includes a technician and the use of the studio and its lighting equipment. Each exposure costs $25 extra.

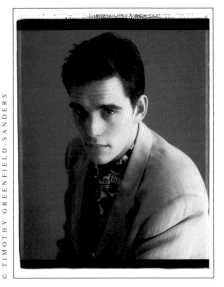

Portrait of actor Matt Dillon, made on the Polaroid 20×24 camera, for a New York *magazine ad for Barney's clothing store.*

takes about three minutes—is seductive enough that many pros use it for jobs they might otherwise shoot on conventional materials.

Many fine-art photographers, both promising and well known, have used the 20×24 for personal work over the years. Some receive time courtesy of Polaroid's active artist-support programs (see page 120). Others pay for the studio time themselves, or their galleries help pay, if the work is deemed saleable.

The 20×24 produces incredibly detailed prints. They are contact prints, so no enlargement is required to achieve the large scale and there is no grain. Some photographers have exploited this quality in pho-

The technician and studio are absolutely required; as you might imagine, this is no point-and-shoot model and running it is a complex operation. The camera weighs 235 pounds. But despite its dimensions, it takes the same film as Polaroid's 4×5-inch Type 59 material, widely used by pros for testing exposure and lighting in the studio. As with the smaller formats, processing occurs through a roller system in the back of the camera.

The 20×24 is used for wide-ranging commercial and fine-art projects. The originals it produces are large enough to work well as display prints. The advantage of immediate feedback—exposure through finished print

tographs made on location (a task that involves a crew of assistants, a truck, and an electrical generator), but most work within the camera's physical constraints, fabricating their subjects in the studio.

Polaroid has an even bigger camera—a 40×80-inch monster located in Boston's Museum of Fine Arts, and rarely used by outsiders. The Museum Camera, as it's called, is actually a *camera obscura*—a room with a lens. The film is positioned on the back wall, behind the lens, and exposure is made by light from a battery of strobes illuminating the subject.

Andy Warhol with the Polaroid 20×24.

Chuck Close photographing Lucas Samaras with the 20×24.

telephoto lenses and also allows close-up work. Furthermore, the five extra inches of bellows enables full perspective- and focus-control movement, even at full extension. You can exchange the bellows for a bag type, allowing the extreme movements with wide-angle lenses that architectural photographers often need.

The Wisner Technical Field's other specifications are impressive. It has 2 inches of front rise, 1⅛ inches of front fall, and 1½ inches of rear rise—the latter a patented feature that permits fuller vertical correction, without tilting the camera, when shooting down on a subject. The camera offers both the customary base tilts and axis tilt with both standards, so you can make tilt adjustments to either standard without refocusing (or resizing) the image. The front-axis tilt is limited only by the bellows; rear-axis tilt is geared, and can be adjusted significantly backward. (Wisner makes the only wooden field camera with a geared axis tilt in the rear.) The front and rear base tilts are more than adequate for most applications, as are the front and rear swing.

Some Other Popular Field Cameras

BENDER VIEW
CALUMET WOOD-FIELD
EBONY SV45
IKEDA
LINHOF TECHNIKA
NAGAOKA
OSAKA
SINAR F
TACHIHARA
TOYO FIELD
ZONE VI

At 6½ pounds, the 4×5-inch Wisner is heavy as field cameras go. Base list prices, without lens or lens board, are $1,395 (4×5 inch) and $2,695 (8×10 inch).
Wisner Classic Manufacturing Company, Box 21, Marion, MA 02738. (508) 748-0975.

WISTA DX

A solidly constructed, beautifully finished camera, available in both 4×5-and 8×10-inch models, the Wista DX is especially suited for those who don't require extreme movements or very long lenses. The camera's bellows is noninterchangeable; with full rail extension, the 4×5-inch model stretches to twelve inches, which means that the longest lens it can take is about 200mm (300mm if focused only at infinity). The Wista's front rise is 28mm, as is its front fall; no rear-standard rise or fall are possible. Base tilts on both standards allow for more extreme vertical perspective correction when the camera itself must be tilted. Lateral shift is possible only with the rear standard, but both the front and rear standards allow a limited amount of swing.

The Wista DX is lightweight—it weighs just over three pounds—and built of seasoned rosewood with brass hardware. Without a lens, its list prices are $896 (4×5 inch) and $2,260 (8×10 inch).
Fotocare, 170 Fifth Avenue, New York, NY 10010. (212) 741-2990.

Schneider Lenses

Many companies make good lenses for field and other view cameras, but Schneider lenses have led the competition for years. They have very high resolution and excellent image coverage ratings. In addition, Schneider lenses feature highly accurate Copal shutters and are remarkably free from both image and color distortion. (Almost all view cameras have shutters in each lens, not in the camera body.)

Of course, much the same could be said of Schneider's competitors—namely Fuji (Fujinon), Nikon (El-Nikkor), Osaka, and Rodenstock. Part of what distinguishes Schneider is its longtime commitment to large-format photography—it's been a top lens maker since 1914. In other words, Schneider is *the* name brand. Here's the product line:

Symmar S. This is Schneider's flagship lens, offering a normal—or slightly long—focal length for the 4×5-inch and 5×7-inch formats. Current Symmars include the popular 150mm f/5.6, as well as a 120mm f/5.6, a 135mm f/5.6, a 180mm f/5.6, and a 210mm f/5.6.

Super-Angulon. A wide-angle lens, featuring extremely wide field coverage to allow full camera movements. Super-Angulons come in 90mm f/5.6 and 90mm f/8, the most popular wide models, and also in 65mm f/5.6, 75mm f/5.6, 120mm f/8, 165mm f/8, and 210mm f/8.

G-Claron. These affordable lenses are compact and lightweight, partly due to their relatively small maximum lens opening, and so are particularly well suited for field-camera use. The design somewhat resembles that of the fabled Goerz Dagors. G-Clarons come in the following sizes: 150mm f/9, 210mm f/9, 240mm f/9, 270mm f/9, 305mm f/9, and 355mm f/9.

Apo-Artar. An excellent longer lens for 4×5-, 5×7-, and 8×10-inch field cameras, especially for landscape and copy work. This sharp lens is also a good choice for product or other studio applications, and is available in 240mm f/9, 360mm f/9, and 480mm f/11 focal lengths. This lens was originally made by Goerz in many focal lengths, up to sixty inches.

View Camera Publications

Examples, The Making of 40 Photographs, by Ansel Adams, New York Graphic Society, 1983.
You can pick any Ansel Adams book for the definitive technical and aesthetic argument in favor of view-camera photography—extraordinary sharpness with lush tonalities and maximum image control—but this one combines photographs and text in a way that both informs and delights. Some of Adams's finest images are beautifully reproduced, with the master's ruminations on how they were made.

A User's Guide to the View Camera, by Jim Stone, Little, Brown, 1987.
Written for photography students, this book is authoritative, well illustrated, and remarkably easy to understand for such a potentially complex subject. It covers the subject in detail, from the history of view cameras to their use, and provides infor-mation on processing, storing, and printing large-format negatives. The chapters on view-camera lenses are particularly full and useful.

View Camera: The Journal of Large-Format Photography, Box 18-8166, Sacramento, CA 95818.
A nicely produced bimonthly magazine, *View Camera* covers both technical and creative issues for the large-camera user, with book and product reviews, news, and occasional classified listings. It has excellent illustrations, both portfolio and how-to in nature, including occasional color. (See page 197.)

View Camera Technique, by Leslie Stroebel, fifth edition, Focal Press, 1986.
For many years, Stroebel's book has been the definitive text on this subject. *View Camera Technique* is extremely thorough and technical, making it a better book for the intermediate and advanced view-camera user than for the beginner. It includes thickly illustrated chapters on camera movements, image size, angle of view, perspective, image formation, lens types, film types, filters, exposure, and much more.

Other Publications

The Camera, by Ansel Adams, New York Graphic Society, 1980.

Photography with Large Format Cameras, Kodak Publication No. 0-18, Eastman Kodak, 1988.

Using the View Camera, by Steve Simmons, Amphoto, 1987.

The View Camera: Operations and Techniques, by Harvey Shaman, Amphoto, 1986.

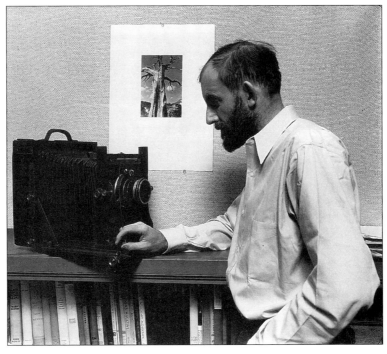

Self-portrait of Ansel Adams with field camera, ca. 1936 (courtesy Ansel Adams Publishing Trust).

Special Cameras

The great majority of photographers shoot 35mm. They use their cameras to create snapshots, personal art work, or travel pictures, or for professional work such as photojournalism or fashion photography. But some professionals—and the occasional serious amateur—have special needs. They may be shooting under unusual conditions, or simply want a different effect. Dozens of specialized cameras on the market can fill these kinds of needs; here are a few of them.

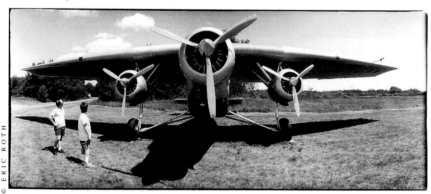

Maine Plane *(above), taken with a Widelux F7 (left).*

WIDELUX F7

Recently discontinued, the panoramic Widelux F7 can still be found in some stores and through used equipment outlets. It shoots 35mm film, but it's a very different animal from the average 35mm camera. Where the lens sits on a normal camera, the Widelux has a shallow, cylindrical protrusion with a narrow slit on one side. Lurking inside the slit is the lens. When the camera's shutter is fired, the slit travels around the cylinder, along with the lens, to expose the film in a 140-degree sweep—so wide that the camera must be held carefully to avoid recording the fingers of the photographer. The inside of the camera is just as strange. Because the lens travels in an arc, the film is transported around a curved, rather than a flat, film gate.

You pay a price for the Widelux's incredible angle of view—distortion. Straight lines at the edges of the frame will bow outward on film. Objects photographed straight-on will seem to bulge in the middle. The extent of this distortion depends a lot on the subject; the more straight lines, the more apparent the distortion will be. Subjects with few lines, such as landscapes, can appear almost normal.

But the distortion on film isn't as extreme as it looks through the camera's top-mounted optical viewfinder, which shows significantly less than the film actually records. The Widelux produces a 24mm×58mm negative—the same height as a normal 35mm negative, but more than half again as long. To print or project Widelux images, you need an enlarger or projector that accepts at least a 2¼×2¾-inch image and, preferably, a glass carrier to keep the negative flat.

The Widelux has only three shutter speeds: ½50, ½125, and ⅟15 second; these result from variations in the speed at which the slit moves. Because the film is exposed sequentially, however, the camera can be reasonably hand-held at ⅟15 second. At that slow speed, some interesting effects occur with moving objects— those traveling in a direction opposite the lens's movement get compressed, and those traveling in the same direction stretch out.

The fixed 26mm f/2.8 lens only stops down to f/11. This can result in overexposure when higher-speed films are used outdoors, even at the camera's top shutter speed. The solution is to use slower films (or a neutral-density filter, though fitting a filter on this lens is difficult).

Because the lens is a fixed-focus type, you have to rely to some extent on the lens aperture to control image sharpness. At f/2.8, for example, the closest object the lens will render reasonably sharply is about five feet away. As with any lens, stop down for more depth of field.

The Widelux was also produced in a larger version, the Model 1500, which accepts 120-format film but is otherwise similar to the F7. Its larger format means that the long dimension of the film is a full five inches, and the resulting negative or transparency will require a 4×5-inch enlarger for printing. Neither model has a built-in light meter. The Widelux F7 sells for about $800, and the 1500 for about $2,000.

Fuji GX680

The Fuji GX680 may be the most ambitious mid-sized SLR ever built. It combines the convenience of medium-format—the format of choice for many studio pros—with some of the image-control potential of large-format cameras. As in a view camera, the lens is mounted on a front standard connected to the main body of the camera by a rail and bellows. This arrangement gives the GX680 the same movements that a view camera's front standard offers: rise and fall, tilts and swings, and lateral shifts.

The GX680's off-axis movements—the rise, fall, and shifts—afford a limited measure of perspective control: 15mm of rise or shift, 13mm of fall. But perhaps just as important to the studio photographer are the camera's front-standard tilt and swing (both 12 degrees), which allow the angle of the plane of focus to be adjusted for situations when stopping the lens down for better depth of field won't do the trick, or is impossible.

In other respects, the camera is as well appointed as the most sophisticated 35mm "system" electronic SLR, down to its liquid-crystal film-status display. Exposure control is the advanced through-the-lens, off-the-film type for both on-camera flash and ambient light. Film advance is motorized at one frame per second, with automatic rewind at the end of the roll. As in a view camera, each of the GX680's interchangeable lenses comes with a built-in electromagnetic shutter controlled by a knob on the main body of the camera.

The standard lens is a 135mm f/5.6 EBC Fujinon (a little longer than normal for the camera's format, which may reflect its intended studio applications). Accessory lenses include 80mm, 100mm, 125mm, 150mm, 180mm, 210mm, 250mm, and 300mm focal lengths. Fuji plans to introduce a relatively short 65mm lens to correct the lack of significantly wide-angle lenses, a deficit that has made the camera less attractive to architectural photographers who might otherwise embrace it for its perspective-control

capabilities.

The GX680's film format is 6×8cm, falling between the aspect ratios of 35mm and 6×7cm. Interchangeable 120 and 220 roll-film magazines are available, the former offering nine exposures per roll, the latter, eighteen. The magazine rotates to select horizontal or vertical composition. The Fuji

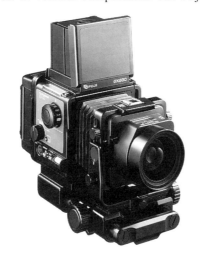

Fuji GX680.

Nikonos-V.

system also includes interchangeable finders, bellows (both the bag and long types), focusing screens, and extension rails. The list price for the GX680 body is $1,918.

Fuji America, 800 Central Boulevard, Carlstadt, NJ 07072. (800) 843-5976; (201) 507-2500.

Nikonos-V

For underwater shooting, Nikonos cameras from Nikon are the next best thing to sealing your conventional camera in a watertight housing.

They're certainly easier to use, with oversized controls for operation with gloved hands.

The latest generation, the Nikonos-V, incorporates a feature that makes underwater shoots easier still: dedicated through-the-lens, off-the-film flash metering (for use with the waterproof SB-102 and SB-103 flash units). Metering for ambient light also occurs through the lens, via a second cell that reads light reflected off the blades of the camera's vertical electronic shutter. The shutter is controlled by a knurled top-deck dial and spans 1/30 to 1/1,000 second, plus B. Exposure control is either metered-manual or aperture-priority autoexposure, in which you select the aperture and the camera chooses the shutter speed needed for correct exposure.

The Nikonos focuses by estimation; you refer to a distance scale on the front of the lens and turn a knurled knob on the right side of the lens. Compared to today's autofocus SLRs, this arrangement may seem a bit awkward, but so is shooting underwater. Most underwater photographers use wide-angle lenses to keep the camera-to-subject distance short, so the depth of field will usually cover small errors in estimation.

The magnifying effect of water is the other reason for using wide-angle lenses. The Nikonos's standard 35mm f/2.5 U.W. Nikkor lens, for example, is about equal in angle of view to a 50mm lens used on dry land. Used underwater, the 15mm f/2.8 is about the equivalent of a 20mm. Other available U.W. Nikkors for the Nikonos include a 20mm f/2.8, a 28mm f/3.5, and an 80mm f/4. An optical viewfinder is available for each lens that approximates its angle of view and has LEDs to indicate correct exposure, shutter speed, and flash status. The camera lets you shoot at depths to 160 feet, which should be sufficient for all but the most daring underwater photographers. The Nikonos-V lists for $620, without lens.

Nikon, 623 Stewart Avenue, Garden City, NY 11530. (800) 645-6687; (516) 222-0200.

Special Lens

Perhaps more than any other factor, the choice of a lens gives a picture its personality. Pick a wide-angle lens to portray the breadth of a subject, or a macro to render minute detail. Select a telephoto to isolate part of a subject, or a soft-focus lens to obliterate detail and create an impressionistic effect. No lens, however, can transform a subject it isn't suited to, and for every subject there's a lens that will do it most justice.

Yet so many photographers passively accept the severe limitations of the 50mm (or so) lens supplied with most 35mm SLR cameras. They may as well be shooting with a compact snapshot camera. In fact, some snapshot cameras, as simple as they may be, are more versatile than an SLR equipped with just a 50mm lens; many offer a dual lens (usually a slightly wide and a slightly telephoto) or even a zoom lens of modest range.

However, these simple cameras don't offer either the very wide-angle or long-telephoto focal lengths that can turn an ordinary image into a very good one. An SLR's interchangeable lenses make it the superior instrument for the serious photographer, but to realize this advantage you have to use accessory lenses. (In the following descriptions, focal lengths refer to lenses made for 35mm photography.)

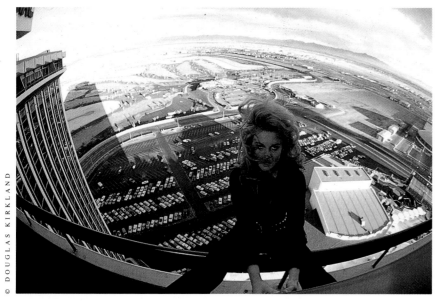

Ann-Margret, shot in 1969 for Look *magazine with a 16mm Nikkor fisheye lens.*

© DOUGLAS KIRKLAND

Ultra-Wide-Angle Lenses

Any wide-angle lens lets you include more of the subject from a given distance than a normal lens would, a great help if you can't get back far enough to capture, say, an entire landscape or interior subject. The shorter the focal length, the closer you can get to a subject and still fit it in the frame. With very short lenses, a few millimeters can make a big difference; for example, a 24mm lens has a much wider angle of view than the more familiar 28mm lens—with a far more noticeable effect on the image than the difference between, for example, a 100mm and 105mm lens, even though the difference in millimeters is about the same.

The wider the lens, the more dramatic and enhanced the view; this is the nature of wide-angle photography. However, with focal lengths shorter than 28mm or so, factors other than angle of view come into play. Extremely wide lenses call more attention to their optical properties, especially distortion.

The most obvious distortion is the convergence of vertical lines that occurs when the film plane isn't kept vertical to the subject, such as when the camera is angled downward or pointed upward. This distortion happens with any lens—it's a function of perspective rather than optics—but it's more pronounced with very wide-angle lenses because they let the photographer get in close to the subject.

At focal lengths much shorter than 20mm, many lenses exhibit barrel distortion—a bowing out of lines at the sides of the image. Such lenses are often called "fisheyes." Fisheye lenses can range from 16mm down to 6mm in focal length, giving angles of view up to 220 degrees in the case of a 6mm lens—so wide that, if you're not careful, you might include your own shoulders in the picture. The depth of field at focal lengths shorter than 20mm is virtually limitless. Also, the shortest fisheyes can't even produce a full-frame image; instead they yield a circular picture within a dark rectangle. This vignette effect is so dramatic that

it dominates the subject and should be used with discretion. But restraint may be difficult after you've dropped $1,000 or more to acquire a name-brand fisheye.

Barrel distortion can be eliminated from an ultra-wide-angle lens with a so-called rectilinear design, but it's an expensive proposition. For example, Canon makes an extraordinary 14mm rectilinear wide-angle lens, but its list price is nearly $2,000. In general, ultra-wide lenses should be considered strictly special-effects optics, and their high cost should be weighed carefully against the frequency of their use.

Mirror Telephoto

The mirror design is an ingenious solution to the problem of awkward, high-priced telephoto lenses. Because the size of a given lens aperture increases in proportion to focal length, fast telephotos—those that let in a lot of light—contain a considerable amount of optical glass. This makes them bulky, heavy, and expensive; a 500mm f/4 Nikkor lens costs $5,200.

Mirror (or catadioptric) lenses fold the focal length of the lens into three parts. They reflect light from the subject off a mirror that faces out from the camera end of the lens, back to a curved mirror at the front of the lens, then back again to the film. Mirror lenses are fat rather than long, and weigh considerably less than conventional telephotos because the mirrors weigh far less than the glass elements they replace.

Mirror telephotos aren't perfect; they offer only a single, small, fixed aperture—usually f/8 or f/11—which substantially limits control over the depth of field. (Exposure is controlled by varying the shutter speed.) This aperture is generally too large for the great depth of field available at the very small apertures commonly provided by conventional telephoto lenses. Mirror lenses frequently demand a tripod, because the maximum f-stop is so small that you need a slow shutter speed. Their optical quality is rarely as good as that of comparable telephotos

of conventional design. Also, because the rear-facing mirror sits directly in the center of the lens, mirror telephotos sometimes have the unfortunate side effect of rendering out-of-focus highlights as distracting donut shapes.

Despite these negatives, mirror telephotos enjoy great popularity because

6mm Nikkor fisheye lens.

2,000mm Nikkor f/11 mirror lens.

of their price and compactness. The 500mm f/8 Nikkor mirror telephoto, for example, lists for $867.50, or about 15 percent of the cost of the conventional 500mm f/4 Nikkor. It weighs just under two pounds and is about 4½ inches long, while the 500mm f/4 Nikkor weighs almost seven pounds and is about 15½ inches long. And even though the optical quality of mirror telephotos may be inferior, their compactness lets you hold them by hand without image-degrading camera shake (assuming there's enough light for a fast shutter speed).

Macro Lenses

Macro lenses, designed for close focusing, are used widely by nature photographers who like tight views of plants and insects, as well as for wide-ranging tasks from copying artwork to

shooting architectural details. Some macros can create a life-sized image of a subject on film (1:1); others render one that's half life-size (1:2).

The beauty of macro lenses is that they make close-up shooting remarkably easy, sparing you the awkward alternatives—extension tubes and bellows units—as well as the potentially image-degrading effects of accessory close-up lenses. Also, macro lenses can do everything most other lenses do, such as focus all the way to infinity, so some photographers use them in lieu of their normal—or slightly telephoto—lens. Most macros rate very high in optical quality. On the negative side, they cost more than standard lenses of comparable focal length and they don't open as wide. A standard 50mm lens has a maximum aperture of greater than f/2 (about f/1.8 or f/1.4), but the average 50mm macro is an f/2.8 or f/3.5.

The most common macro lenses come in 50mm or 55mm focal lengths, and some manufacturers also offer 100mm or 105mm versions. Longer macros are often more practical for tight close-ups, because they let you set up the camera farther away from the subject. A few macro lenses are available in oddball sizes, such as 90mm and 200mm.

Most current zoom lenses have macro capability, an important improvement. Standard zooms can't focus as closely as fixed lenses of the same focal length. However, true macros can generally focus as much as two to four times closer than can macro zooms, which must often use an awkwardly long focal-length setting to get even that close.

One problem inherent in macro photography is limited depth of field; with any lens, the closer you focus, the less the depth of field. The only solution is to use a small aperture, and macro lenses generally close down to a smaller aperture than conventional lenses do—around f/32—for just this reason. Of course, smaller apertures usually require slower shutter speeds, and generally call for a tripod to prevent camera movement.

Perspective-Control Lenses

The reason photographers use a view camera, aside from the high quality of its large-format film, is to gain control of the image through the movements the camera permits—specifically, the ability to change the relationship of lens plane and film plane in ways other than the distance between them (which is what you do when you focus). Under normal circumstances, in 35mm photography, the lens and film are in a fixed relationship, and no such image control is possible—unless you use a perspective-control, or PC, lens.

A classic use for view cameras and PC lenses is architectural photography. When you point a camera up to include the top of a building, the sides of the building seem to converge toward the top, a distorted effect called keystoning. This distortion is not caused by the lens (although it's worse with wide-angles because they let you get closer and thus shoot from a more extreme angle); an image keystones because the film plane and the subject plane (the facade of the building) are not parallel to each other. With a view camera, you can correct this distortion—even if it's fairly extreme—by a series of movements. If shooting 35mm, you can use a PC lens and shift it to gain some of the same control. (Even so, view cameras remain more flexible than 35mm cameras with PC lenses where the amount of control is limited.)

A perspective-control lens mounts on the camera as any other lens does, but its optical component can be shifted. The lens rotates in eight directions to handle various perspective problems and for vertical or horizontal shooting. For example, if a tree prevents you from photographing a building head-on, you can sometimes set your camera up to one side of the tree and avoid it by shifting the lens.

Because perspective control distortion is more apparent with wide-angle lenses—and because architecture is a primary application—PC lenses generally come in 28mm or 35mm focal lengths; Olympus offers a 24mm model. Canon's versatile model shifts *and* tilts, whereas most just shift. Shift-

ing controls perspective, while tilting sharpens image focus.

Most PC lenses have a maximum aperture of f/2.8 and a high price—about twice as high as that of comparable standard lenses. One reason for their stiff price is that the lens must not only shift on its mount but also project a particularly large image circle, since

it's meant to be used off-axis.

Other disadvantages of PC lenses include their lack of automatic diaphragm control; you have to manually open the lens for framing and focusing, then manually stop down for shooting. To ease this awkward maneuver, PC lenses have a special set ring that lets you stop down quickly to your preselected shooting aperture.

Also, a PC lens disables a camera's full-aperture metering system, so you must either perform in-camera metering with the lens stopped down or use a separate hand-held meter.

Ultra-Fast Lenses

Lens speed refers to the size of a lens's maximum aperture. Fast lenses open wide—generally to an aperture greater than f/2—while slow lenses have a small maximum aperture—say, f/2.8 or less. All this is relative, of course. Long telephoto and ultra-wide-angle lenses are slower than most, so, for example, the 300mm f/2.8 lens, a popular model for sports photographers, is considered quite fast as telephotos go.

Using computerized lens design and mass-production techniques, manufacturers can now make very fast lenses that are optically sharp, compact, and affordable. This substantial progress has been reversed somewhat in the rush to produce today's popular zoom lenses—the design of which precludes large maximum apertures.

Ironically, today's fast films have made slow lenses more practical for low-light shooting. Still, some situations demand an ultra-fast lens, such as extreme low-light work and dim-light shooting with slower films or at high shutter speeds. Faster lenses also provide a brighter viewfinder image for framing and focusing on a camera with through-the-lens viewing, such as an SLR. Focusing can be much easier with a fast lens partly because you're viewing at maximum aperture, and a wider maximum aperture has shallower depth of field, causing the image to appear to pop right into focus. (On the flip side, when shooting at maximum aperture, precise focus is that much more critical.)

Lenses that used to be considered fast, such as a 50mm f/1.4, are now commonplace. Every manufacturer makes one, and many also make a 50mm f/1.2. Leica even makes a 58mm f/1 lens for its M series rangefinder cameras. This lens, the Noctolux, is a considerable hunk of glass that lists for $2,970.

Zooms

Today's hottest lenses are zooms, single lenses that offer an adjustable range of focal lengths. You can find both wide-angle and telephoto models. Some popular sizes include 35mm–70mm, 70mm–210mm, and 28mm–85mm.

Of course, the great advantage of a zoom lens is its ability to take the place of several lenses, but there are disadvantages, primarily size and weight; zoom lenses are relatively unwieldy. Additional complaints include small maximum apertures, poor optical quality, and high cost.

While these are serious faults, current zoom models have improved vastly over early zooms on all counts. However, comparable fixed-focal-length lenses are still more compact, better optically, less expensive, and faster. Besides, do you really need the fifty or more focal-length choices a 28mm–85mm lens offers? Still, you can't beat the convenience, especially when traveling, and zoom lenses are an increasingly good choice for many photographers.

Exposure Meters

Photography lore has it that ancient studio photographers determined film exposure by the extinction method, stopping the lens down until the ground-glass image on their view camera reached a familiar level of dimness. Exposure calculation has come a long way since then, but the goal remains the same: Make sure, with every exposure, that roughly the same amount of light reaches the film, regardless of the brightness of a subject.

Lens aperture and shutter speed—the values most meters translate light into—are the means of achieving this consistency. In rough terms, a sunny beach scene needs a small aperture and/or high shutter speed, and a city at dusk needs a wide aperture and/or slow shutter speed, but both should reflect the same amount of light to the film. An exposure meter will tell you exactly what combination to use.

Meters built into SLRs and other cameras have taken much of the guesswork out of exposure. Many modern cameras pick up where the meter leaves off, automatically setting aperture and shutter speed according to a predetermined exposure program. But many photographers still rely on hand-held meters, unwilling to relinquish total control to the camera. Also, separate meters remain essential for the many professional systems that lack built-in meters, such as view cameras, and for metering flash light and determining color balance.

Gossen Luna-Pro.

Meter Types

Of the several types of exposure meters, two are most common—those that measure light reflected off a subject (reflected-light meters) and those that measure the light falling onto a subject (incident-light meters). Other meters determine flash exposure and color temperature. Of all of these, reflected-light meters are by far the most popular.

To take a reflected-light reading, you point the meter at the subject; in-camera meters almost always measure reflected light. An incident-light reading is generally taken by placing the meter at the subject and pointing it toward the camera (or at a point somewhere between the camera and the light source). Each type of meter has its advocates, but both are reliable when properly used.

Hand-held reflected-light meters generally cover an angle of view of thirty or more degrees. The angle of view with a through-the-lens meter varies, depending on the focal length of the lens.

One type of reflected meter called a spot meter measures an extremely narrow angle of light, usually one degree. Spot meters let you take reflected-light readings at specific parts of the subject—a highlight on a face, or the shadow under a rock—without getting too close to the subject. You can take such localized readings with any reflected meter, but you must move in close to do so. Spot meters cut down on the running back and forth.

To get an incident-light reading, the meter's light-sensing cell must have a diffusing dome over it. Some hand-held meters measure both reflected and incident light, providing a dome that slides over the cell for an incident reading.

Using a Gray Card

Exposure meters are calibrated to provide a reading that produces a middle gray value on photographic film—the average of the light they read. They work on the assumption that most subjects contain approximately equal amounts of dark and light values, and that by averaging these a meter will suggest the correct f-stop and shutter speed.

For most subjects, this is a reasonable assumption, which is why through-the-lens meters in SLR cameras (and hand-held reflected-light meters) give reliable results most of the time. However, many subjects don't conform to expectations. When they don't, reflected-light exposure meters can be very inaccurate.

Problems occur when subjects have mostly light or mostly dark values. The meter simply averages what it sees, providing readings that render both light and dark subjects gray. For light subjects, this means underexposed film; for dark subjects, overexposure. A classic example comes from landscape work. When a subject includes a large, bright sky area—a very light value—the meter assumes that the overall landscape reflects more light than it does, and recommends an aperture/shutter speed combination that will result in underexposure in the non-sky portion of the image.

A gray card is a simple way around this problem. These smooth cards reflect 18 percent of the light that reaches them, a figure that approximates an average of reflected dark and light values—a middle gray. In effect, a gray card eliminates the influence of the light or dark values of the subject, making metering an objective matter.

Here's how it works. Place a gray card in front of the subject and meter the light reflecting off it. Make sure the card is in the same light that falls on the subject, and angle it to avoid glare. Get close enough to read only from the light bouncing off the card, but don't get so close that you cast a shadow on it. Take a reading using a hand-held meter or an in-camera meter with the camera in manual mode (avoid automatic) and use that reading without adjustment. If your meter works and you used the card correctly, that reading will provide an ideal average exposure for the available light conditions.

It's hard to use a gray card when

Exposure Value

Exposure value, or EV, is a term used to describe a given light level as it pertains to the exposure of a particular speed of film. EV refers to all the possible combinations of aperture and shutter speed that will produce correct exposure with those variables. For example, a light level of EV 15 with an ISO 100 film indicates that any of these exposures—1/250 second at f/11, 1/4,000 second at f/2.8, or 1/8 second at f/64—will produce a negative of equal density.

Each EV unit represents a halving or doubling. Thus, EV 8 indicates the presence of twice as much light as EV 7, requiring a smaller f-stop (by one stop) or a faster shutter speed (by one increment).

EV numbers can also describe the range of an exposure meter's sensitivity; the Gossen Luna-Pro, for example, gives accurate readings from EV −4 to EV 17 with ISO 100 film. More recently, EV numbers have been used to describe the light range within which autofocus systems obtain correct focus.

taking candid shots. But gray cards are very useful in studio situations, for portraiture, still-life, and copy work, when there's enough time to get out the card and make the reading.

Several companies sell gray cards. The familiar Kodak one measures 8×10 inches and comes in a package of two for about $8—one of the least expensive but highly useful camera accessories you can buy.

Metering Patterns

Camera manufacturers keep trying to make built-in meters more versatile and less susceptible to the pitfalls of averaging. Most of their efforts involve adjusting the metering pattern—the way the system weighs different subject areas in the viewfinder to calculate exposure. The earliest and still most common tactic is to make the pattern center-weighted, basing about three quarters of the reading on the middle of the viewfinder. Some center-weighted meters are slightly bottom-weighted as well to help avoid the undue influence of light from the sky.

Many cameras now offer more than one choice of metering pattern. The most common alternative is a modified spot reading, which measures light from a tiny circle in the center of the viewfinder. The angle of light acceptance varies with the focal length of the lens, but only with very long telephoto lenses does it approach the narrow capability of the popular one-degree hand-held spot meter.

Some cameras—the Olympus OM-4, for example—offer the option of a highlight- or shadow-based spot reading. The photographer positions the spot on a bright or dark value, and the camera automatically determines the adjustment needed for correct exposure. Such systems depend on the user's ability to recognize specific values, and, if not used with care, can cause grievous exposure errors.

The current trend in metering is the multipattern type, introduced by the Nikon FA. Such systems divide the viewfinder into zones, which the camera analyzes individually. This grants a measure of immunity to variations in subject brightness. If a zone includes, say, an overly bright sky, the system may virtually ignore it in its exposure computations, avoiding the all-too-common problem of underexposure.

GOSSEN LUNA-PRO

Gossen has long set the standard in hand-held light meters. The Luna-Pro, its flagship model, costs about $250 and runs off two mercury batteries.

The meter's cadmium sulfide (CdS) photocell drives a needle that registers a number on one of two numerical scales—one for bright light, the other for dim. The user then sets the indicated number on a dial, which in turn matches apertures (from f/1 to f/90) with shutter speeds (from ¼,000 second to eight hours).

The Luna-Pro measures either reflected light or incident light. Its sensitivity range covers EV −4 to EV 17 (see box on previous page). At low light levels, the needle moves slowly, and care must be taken to let it swing to its final position before locking it in with the toggle switch located on the side of the meter.

Five attachments equip the Luna-Pro for different applications; these attachments also work on most other Gossen meters. A variable-angle accessory lets you take narrow-angle spot readings, and a flexible fiber-optic probe allows readings from a view camera's ground glass. Two other units permit readings with the meter held flat against the subject for copy work and enlarger metering. The fifth attachment adapts the meter for use with a microscope.

The Luna-Pro SBC, a slightly different version, has a silicon-blue photocell, which eliminates the time lag and memory effects that can make CdS-cell meters awkward and even unreliable. The SBC model also uses a null system, in which the calculator dial connects to the indicating needle. (In the standard Luna-Pro, the dial is an independent adjustable scale.) Once the SBC takes a reading and you lock the needle in place with the toggle switch, you turn the dial until the needle lines up with the zero, thus pairing the proper combinations of aperture and shutter speed. Any subsequent light readings will display, in ⅓-stop increments, the extent to which that light varies from the initial reading. This meter is particularly convenient for assessing evenness of light in, for example, copywork setups.

The Luna-Pro F (F for flash metering) and Luna Lux both feature the

SBC's null metering. The Lux uses LED indicators rather than a needle and calibrated scale, and is the first meter since the redoubtable Weston model to have a zone-system scale. Other Gossen meters range from the high-end, flash- and ambient-reading

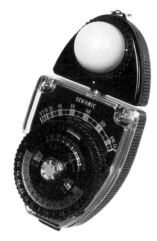

Sekonic Studio Deluxe.

Pentax Digital Spotmeter.

Ultra-Pro and Multi-Pro to the simple, tiny Pilot 2, which uses a selenium photocell instead of batteries.
Bogen Photo, 565 Crescent Avenue, Ramsey, NJ 07446. (201) 818-9500.

SEKONIC STUDIO DELUXE
Sekonic makes the quintessential incident-light meter. More than a million

Studio Deluxes have been sold since its introduction over twenty years ago, many to moviemakers because of its cinematic scales. Unlike the Gossen Luna-Pro, the Studio Deluxe needs no battery, relying instead on a selenium photocell. (Rather than resisting the flow of current produced by a battery, as CdS-cell meters do, the selenium cell generates a small electrical current in proportion to the light striking it.) Just as with the Luna-Pro, however, the exposure value is indicated by a needle and then set on a dial that aligns apertures and shutter speeds.

The Studio Deluxe has a large white diffusing dome mounted on a swiveling head for easy readout at various angles. You can convert it to take reflected-light readings by substituting a grid for the dome. The list price is $159, fairly inexpensive as hand-held meters go.

While the Studio Deluxe is a very solid and accurate meter, it lacks some of the high-tech features of newer models, such as Sekonic's own Digi Lite F. For example, the Studio Deluxe is not digital, and has a more limited range of shutter speeds and exposure values. Even so, it remains a good meter and an excellent value.
RTS Sekonic, 40-11 Burt Drive, Deer Park, NY 11729. (516) 242-6801.

PENTAX DIGITAL SPOTMETER
Many meter manufacturers make good spot-reading models, but Pentax has long offered one of the most popular and reliable units. The Digital Spotmeter (Pentax also makes an analog version) has an extremely narrow one-degree angle of light acceptance and features a pistol grip, a viewfinder for targeting the area to be measured, and a longish lens. The list price is $523.

This meter measures light taken through its lens, which is corrected for flare to prevent distorted readings of shadow areas surrounded by brightness. A small, circular target in the viewfinder indicates what's being measured; you take readings by pulling a trigger-like control on the pistol grip.

A digital display in the viewfinder provides an EV reading for the measured light. Simply set the EV number on a ring located on the barrel of the meter's lens, and recommended f-stops and shutter speeds appear on the adjoining rings.

Spot meters are especially popular with photographers shooting large-format black-and-white film by the zone system, or by any other method that painstakingly adjusts the exposure and development of individual sheets of film to ensure control over all subject tonalities.
Pentax, 35 Inverness Drive East, Englewood, CO 80112. (303) 799-8000.

MINOLTA FLASH METER IV

Flash meters measure light from an electronic flash and provide an appropriate f-stop reading. With flash, the camera's shutter speed has a negligible effect on exposure, assuming it allows the shutter to synchronize with the flash output (usually 1/60 to 1/125 second or slower with an SLR). For the most part, unless the shutter speed is slow enough to record ambient light, only the light from the flash will have an appreciable effect on film exposure.

For years, Minolta has made the most widely used flash meters. Its latest generation, the Flash Meter IV, has a digital LCD indicator that can be illuminated in low-light situations by pushing a button. Simply set your film speed and shutter speed, then choose among several operating modes—cord (flash light with synch cord from the flash to the meter), noncord (flash light without using a synch cord), ambi (continuous daylight), and multi (accumulated flash bursts). The Flash Meter IV can separately display flash and available-light readings for determining lighting ratios. To take the reading, push the button on the side of the meter. If you've attached the flash synch cord, this will set the flash off and provide a reading. If you haven't, you must fire the flash independently, and the light will be registered accordingly. The LCD will indicate the rec-

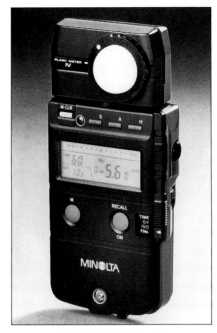
Minolta Flash Meter IV.

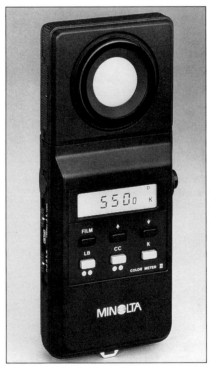
Minolta Color Meter II.

ommended aperture in tenths of stops.

Though intended for studio use, Minolta flash meters are widely packed by journalists and location photographers for use as incident-light meters in ambient-light mode. The list price of the Flash Meter IV is $795.
Minolta, 101 Williams Drive, Ramsey, NJ 07446. (201) 825-4000.

MINOLTA COLOR METER II

Accurate color balance is easily achieved in most bright daylight conditions, or when using strobe or photofloods (with tungsten film). When the light source is mixed or unusual, achieving good color becomes tougher. In a studio, you can run a test roll to see how the color looks. On location, when light is least predictable, you generally have to wing it, and that's when a color meter comes in most handy.

The Minolta Color Meter II is the model of choice. It measures the color temperature of the light and gives you a digital readout of Kelvin temperature and suggested filtration for accurate color balance. Simply set the type of film you are using (in Kelvin degrees—usually 5,500 for daylight or 3,200 for standard tungsten) and push a button on the side of the meter to get the Kelvin temperature of the light. Push the button again and the LED will display a numerical value representing recommended color-correction filters; another button push gets you a numerical value for recommended light-balancing filters. Turn the meter over and there's a chart to convert these numerical values to specific filters.

This specialized piece of equipment is invaluable if you're fussy about accurate color. It's also expensive—the list price is $1,060. If you plan to make the refinements a color meter allows, you'll need a set of gelatin filters, at another $150 to $200 or more.
Minolta, 101 Williams Drive, Ramsey, NJ 07446. (201) 825-4000.

Tripods

Even though tripods fulfill a seemingly simple purpose—to support a camera and lens—they come in an enormous variety of designs. This diversity results from the range of cameras and formats that tripods must support, and also from efforts by manufacturers to simplify and streamline them.

A variant of the tripod is the monopod—a support with only one leg. The monopod, popular with sports photographers who need to support long telephoto lenses, offers a compromise between the sturdiness of a tripod and the convenience of hand-held shooting, allowing you to use slower speeds than would normally be practical with hand-held shooting.

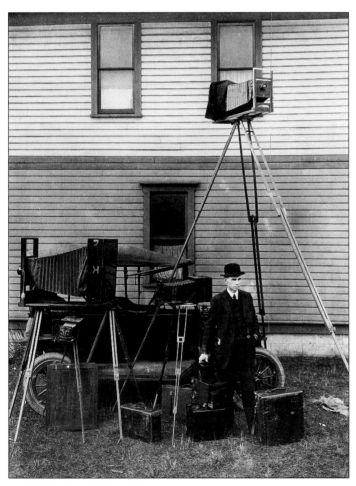

Photographer Darius Kinsey (1869–1945) with field cameras on tripods, ca. 1925 (courtesy Whatcom Museum Archive, Bellingham, Wash.).

Why Use a Tripod?

Some cameras are simply too big to hold by hand and must be placed on a tripod. But tripods also prevent camera shake when you need to use shutter speeds too slow for safe hand-holding. Slow shutter speed provides correct exposure in low-light conditions, but can satisfy creative purposes as well, such as blurring subject motion. A tripod will eliminate the effects of camera shake, which can range from slight image softness to a total blur.

Slow is a relative term. For example, the bigger the lens (generally, the longer the lens focal length), the faster the shutter speed needed to prevent shake (if you're holding the camera by hand). A rule of thumb is to use a shutter speed at least as high as the reciprocal of the lens focal length; for instance, set your shutter at $1/250$ second or higher with a 200mm lens. However, many subjects don't move—or don't move much— and thus do not require such a fast shutter. With a tripod, you can shoot at a much slower speed, even with long lenses. This increases your control of sharpness; the slower the shutter speed, the smaller the required aperture opening, and thus the greater the depth of field.

Tripods are also useful for precise compositional control, even at "safe" shutter speeds. View cameras must have tripods, because of the camera's bulk and also because its front and rear movements require precise orientation in relation to the subject. The controls on the tripod's head help you fine-tune these adjustments.

Choosing a Tripod

When buying a tripod, first consider its weight and size. It must be sturdy enough to handle the cameras and lens-

Cable Release

Cable releases let you trip the shutter without touching the camera—the final insurance against camera shake. They're an indispensable accessory for tripod use. Simple cable releases are mechanical, consisting of a wire inside a flexible tube, with a fitting on one end that screws into a threaded socket on the camera. When you press a plunger on one end, the wire extends into the socket and fires the shutter.

Many newer cameras do not have threaded shutter buttons, reflecting the popularity of electronic releases. Such releases plug into the camera elsewhere and use an electrical signal rather than mechanical pressure to trip the shutter. Other high-tech options include radio-remote releases for firing the shutter from a considerable distance (say, 200 feet away), and infrared systems that also trigger the shutter without a cord, but from a more modest distance.

Because they have moving parts, mechanical cable releases are more fragile than electronic ones. The spring wire inside the cable can shrink—a particular problem with long releases—and the locking tab, a small plate that holds the plunger down for time exposures, can also be ornery. When choosing a mechanical cable release, pay extra for a high-quality model. Professional cable releases are available from such companies as Gitzo and Linhof.

es you use. Although sturdiness is a function of design as well as of size, clearly large, bulky equipment such as a view camera or a long telephoto lens calls for a heavier tripod than, say, a 35mm camera equipped with a wide-angle lens.

If you use a variety of equipment, you may need both a heavy and a light tripod. You could get away with one large, sturdy model, but you won't want to haul around a heavy model if you're only shooting 35mm. Here are some other things to keep in mind when evaluating a tripod.

Leg sections. The number of leg sections can directly affect the sturdiness of a tripod. Models with more sections are more compact when collapsed, but generally less rigid in use. The most sturdy tripods have three sections; four-section models can handle lightweight equipment only.

Extension. A tripod's extension is the height at which it places the camera. Many tripods use a center-post extension to place the camera at eye level; a short extension may be fine, but a long one may adversely affect the overall stability of the tripod.

Some center posts slide up and down; others have gears. Gears make precise adjustments easier, but they are more vulnerable to damage, particularly to the cranks that drive them. Still, if you use heavy camera equipment, a tripod with gears provides safer and more exact adjustments.

Locking devices. To lock a tripod's leg sections in place, many photographers prefer the traditional threaded collar because it's hard to damage. Some tripod designs use clamping levers, which are faster to set up. On some tripods, the legs simply slide into position once they're unlocked, while a few models have set screws that lock the legs in place.

Heads. The head of a tripod is where the camera sits. Once the camera is in place, you can adjust the position and angle of the head for precise compositional control.

Many of the best tripods on the market offer interchangeable heads. The two primary head options are the ball-and-socket type and the three-way design. The former works well for general-purpose photography with a camera that can be easily gripped to make adjustments. Once the head is unlocked, the ball-and-socket assembly allows swift and virtually unlimited movement.

Three-way heads move along specific axes. They use locking arms—one for tilting the camera back and forth and the other for tilting it from side to side. Generally, each arm twists to lock the head in position, although some more awkward designs have separate locking nuts. For the third movement, the head can be panned. Because they allow more options for perspective control, three-way head designs are greatly preferred for studio, technical, and architectural photography. On the down side, three-way heads can be slow to work with because of all the movement possibilities.

Bogen

The wide-ranging Bogen line contains several solid, high-quality tripods at moderate prices. The tripod, legs, and head are sold separately, so you can mix and match to put together the best combination for your needs. The leg sections lock with clamps instead of threaded collars, in an attempt to minimize the grit that tends to slip between the cracks.

The Model 3020 is a good choice for small-format, medium-format, and light 4×5-inch cameras, such as field cameras. With its legs spread out and a

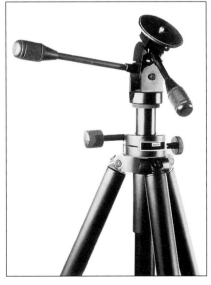

Tiltall.

Getting Down

Many photographers—particularly those shooting close-ups in nature—frequently need to position their cameras close to ground level. They usually need a tripod, but not all models will get down low enough to do the job. The traditional solution is to invert the center column (and thus the head), then mount the camera between the tripod's legs. This is an awkward arrangement at best, with the photographer's head wedged precariously between the tripod's legs for framing and focusing the subject.

The best tripods for this kind of shooting are those with legs that can spread wide, almost into a horizontal position. It looks odd—the tripod winds up flatter than it is tall—but it works.

In spreading the tripod, the center post may bump into the ground at a certain point. Gitzo offers two solutions—in some models a substitute short center post, and in others a post that comes apart for shortening. The Bogen 3020 also has a two-section post. With other models, some photographers opt to carefully cut off the offending part of the post with a hacksaw. This inelegant but effective solution has obvious disadvantages, which may be outweighed if you do most of your shooting from a low vantage point.

section of the convertible center post removed, this tripod can hold your camera as low as fourteen inches from the ground. The maximum shooting height, with full center-post extension, is seventy-three inches. The 3020 has a chrome or black anodized finish and a list price of $147.95.
Bogen Photo, 565 Crescent Avenue, Ramsey, NJ 07446. (201) 818-9500.

GITZO

The Mercedes of tripods, Gitzo offers over 100 models, including monopods, ladderpods, and monocolumns for studio work. It provides interchangeable heads and posts and a seemingly endless line of accessories, including such obscure items as a device that lets you mount the center post at a right angle for shooting from above.

Although Gitzo tripods are constructed of deep-anodized light metals, they are fairly heavy for their size. This weight, along with their tubular construction, makes them just about the most stable tripod you can buy.

The Studex Performance, one of Gitzo's most popular models, is fairly compact (just over six pounds and twenty-seven inches long when folded), but solid enough to support a 35mm camera with a heavy telephoto lens, or a light view camera. Its legs spread out for low-level work, but you'll need to substitute a shorter post to maximize this capability (see box). Like all Gitzos, the Studex Performance is expensive—about $400.

Perhaps the most unique Gitzos are the Safari tripods, used mostly for nature photography. These reverse the anatomy of a conventional tripod, putting the widest-diameter leg section at the bottom and the narrowest section at the top. This design, coupled with watertight joints, makes Safari tripods ideal for working in wet environments. In particular, the heavier lower leg sections make the tripod more stable in surf. Safari tripods come in four models, all decked out in army green; the smallest extends to fifty-eight inches, the largest, to seventy-four inches. A Safari monopod is also available.
Karl Heitz Inc., 34-11 62nd Street, Woodside, NY 11377. (718) 565-0004.

TILTALL

The classic Tiltall was built in a New Jersey basement for years, until the design was sold to Leitz in 1973. Now distributed by Uniphot, it's one of the rare tripods still made in the United States.

The Tiltall's appeal is its simplicity

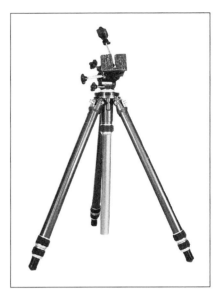

Gitzo Studex Performance.

and its solid yet lightweight construction, suitable for cameras from 35mm to 4×5-inch view or field models. It is made of black-anodized aluminum and has three leg sections that lock in place with traditional knurled collars. Two long knobs mounted in the collar at the top of the legs lock in panning movements and adjust the non-geared, sliding center post. Long and short stalks with knurled handles control front-to-back (90 degrees forward, 45 degrees back) and side-to-side (90 degrees left, 45 degrees right) movements. Twisting the stalks locks the adjustments.

The Tiltall reaches a height of sixty inches—seventy inches with the center post fully extended. The tripod is reasonably stable even when the post is completely extended. It weighs six pounds and is thirty inches long when compressed. The adjustable feet have a rounded rubber ring for traction on smooth surfaces; the ring twists up to expose metal spikes for stability in rough terrain.

As professional tripods go, the Tiltall is a basic one with no accessories (except for a carrying case). It's just a well-designed product at a moderate price—$189.95, list. Tiltall also makes a smaller model (the Junior Tiltall) and a monopod.
Uniphot, 61-10 34th Avenue, Woodside, NY 11377. (718) 779-5700.

Flash

Throughout the late nineteenth century, photographers used *blitzkriegpulver*—a gunpowder-like mixture that created a blinding flash of light when ignited—to provide enough brightness to expose their extremely slow glass plates. Flash photography has come a long way since then. In the 1920s, the flashbulb replaced the controlled explosion of flash powder and quickly found use in applications as varied as tabloid photography and family snapshots. Soon, Dr. Harold Edgerton began experimenting with stroboscopic light, and not long thereafter the first commercial on-camera electronic flashes appeared.

These first units were primitive handle-mount designs connected to the camera with a sync cord; they pumped out a fixed amount of light when fired. The photographer had to manually calculate the aperture needed for correct exposure, while readjusting the lens with every change in camera-to-subject distance. Thyristor circuitry eventually put an end to that awkwardness; an external sensor on the flash stops it when enough light has reflected back from the subject for proper exposure. This saves the photographer from having to constantly adjust the aperture, and it also conserves power, permitting more flashes per charge of the battery. The flash has now become not only a useful tool, but an easy one to use.

Dr. Harold Edgerton, inventor of the electronic flash, in a laboratory at the MGM studios, 1938 (courtesy Dr. Harold Edgerton).

Dedicated Flash

You can still buy flash units with an external light sensor, but the current rage in flash photography is dedicated flash. All major camera and flash manufacturers now offer these units. Containing much the same light-sensing, power-saving circuitry as thyristor models, dedicated flash sensors sit inside the camera body, generally just in front of and below the film plane and aimed back at it. They read the light reflected off the film while the shutter is open, then relay electrical signals to the flash to shut off power at the point of proper exposure.

Unlike nondedicated automatic flash units, which make you manually preset the lens aperture, dedicated-flash systems work in tandem with the camera and lens, automatically setting the aperture and shutter speed. These units frequently offer fill-flash capability as well, providing automatic exposure for flash use outdoors. Some dedicated systems let you use more than one flash unit at the same time, and others offer features such as autofocus-assist beams, which project a beam of patterned red light onto the subject to help the camera achieve focus when the light level is too low for automatic focusing.

Some flash units—dedicated or not—have an adjustable reflector inside the head. The position of the reflector can be varied so the angle of flash output matches the angle of view of the focal length of the lens in use. At the telephoto setting, for example, the beam is more focused, making its range greater—a useful side benefit with longer lenses, which are almost always used with subjects far from the camera. Some of the more sophisticated dedicated units adjust the reflector automatically for the focal length of the lens; when you set the focal length of a zoom lens, a motor moves the reflector to match it.

Sync Speed

The flash must synchronize with the camera shutter—that is, it must go off when the shutter is open—or the result

will be a partially exposed image. With the leaf-type shutters used in rangefinder and twin-lens reflex cameras and large-format lenses, the flash and shutter will synchronize at all shutter speeds. SLR cameras are more limited; most current SLRs allow flash sync only at speeds of 1/60 to 1/125 second and slower. At higher speeds, the second curtain of the focal plane shutter starts moving across the film surface to end the exposure before the first curtain has finished moving. If the flash then fires, the shutter will block a portion of the film from exposure.

Newer shutters allow higher shutter speeds with flash. For example, the Nikon F4 has a 1/250-second sync speed, available only in a few previous Nikon models. Olympus makes an unusual unit that creates exposure with repeated short pulses of light rather than a single burst, thus achieving flash sync at virtually any shutter speed.

The need to synchronize the flash at higher shutter speeds lies in the role of ambient, or existing, light in flash photography. Although shutter speed has no effect on the instantaneous light produced by the flash, at slower speeds the shutter lets in more ambient light, which can produce ghosting—a dim, blurred image of a moving subject outlining the sharp, frozen image from the flash. Using higher shutter speeds reduces or eliminates ghosting. Also, high speeds allow much more freedom in fill-flash situations to help you balance ambient light with strobe exposure (although with dedicated flash units you can now achieve this balance automatically).

Soft Flash
On-camera flash units have endless accessories, from ring lights (flash tubes surrounding the front of the lens) for shadowless close-up lighting to fiber-optic cables for controlled lighting of very small objects. Nikon's 120mm Medical Nikkor lens has a built-in ring-light flash.

Accessory makers are especially active in producing products that soften flash light, which can be quite harsh

Accessory Battery Packs

One of the biggest problems with on-camera flash units is too little battery power. For most professional units, you can buy an optional pack holding a large additional battery, either a rechargeable nickel-cadmium (Ni-Cad) or a non-reusable 510-volt battery. Several companies, notably Lumedyne Supercycler, make high-capacity, rechargeable units that offer very fast recycling and more uninterrupted flashes. But the company that has carved itself the deepest niche is Quantum.

Quantum's line of battery packs includes the Battery 1, a small rechargeable model for six-volt flash units (list price, $149), and Battery 2, a similar model for nine-volt systems ($156). They weigh about twenty-four and thirty ounces, respectively, and both provide up to 2,000 flashes per charge and recycle in about 1 to 3.5 seconds. Both require a power module for the specific flash used, which adds another $30 to $50 to the price.

Quantum also makes the Turbo Battery (list price, $272), which provides especially fast flash recycling and more flashes per charge. The Bantam Battery is tiny and cheap (list price, $79). It has the same recycling time as the Battery 1, but a smaller capacity.
Quantum Instruments, 1075 Stewart Avenue, Garden City, NY 11530. (516) 222-0611.

Quantum Turbo Battery.

if aimed directly at the subject. The traditional solution is to bounce light from the flash against a low ceiling or adjacent wall so that it reflects on the subject from a broad surface. If you do this when shooting color film, make sure the surface is white to avoid a color cast. Also, if your flash isn't dedicated and you're using it in an automatic mode, be sure that the sensor points at the subject—not at the reflecting surface.

Bouncing light off a ceiling or wall causes a significant loss of brightness due to the absorption of the surface and the extra distance the light must travel. If you're using an automatic flash with an external sensor and a choice of distance ranges, select a wider aperture setting than you normally would use for a direct flash. Also, be sure that the angle of the bounce directs the light to the front of the subject; if the flash is aimed at too oblique an angle, the light may fall behind the subject.

Various attachments are available to soften flash light (see box on next page). The simplest is a plastic diffuser, offered by many flash and accessory makers, that fits over the head of the flash. In a pinch, a piece of tissue paper taped to the head will also work. Diffusing the light will soften the shadows and also broaden the angle of the flash beam, useful for shooting with wide-angle lenses.

Many companies also make flash accessories for bouncing light, to eliminate the search for a ceiling or wall of suitable height and color (see box on next page). These products provide neat and reliable ways to bounce flash, though the light produced from such units is usually not as soft because of the relatively small size of the bouncing surface. Most work by angling the flash up and attaching a reflective surface to the flash. This surface may be as simple as a white card positioned at a 45 degree angle to the flash.

METZ 60 SERIES
Built strong and solid like most German photographic products, Metz flash units have been around for a long time

but are not as widely used as the Japanese incumbents, Sunpak and Vivitar (see below). This is partly because Metz now makes only professional and higher priced smaller flash units.

The main Metz entries are the 32, 45, and 60 Series, which differ mostly in power output. The 60 Series offers very serious output and requires an accessory shoulder battery pack. Its two models are the CT-1, an automatic unit, and the CT-4, for dedicated use. The former lists for $625 and the latter for $776, without accessories. *Bogen Photo, 565 Crescent Avenue, Ramsey, NJ 07446. (201) 818-9500.*

SUNPAK AUTO 622

Sunpak is one of the largest makers of on-camera electronic flash units. It makes several good units at all price ranges with a variety of power ratings and other features. At the top of its line is the Auto 622, a powerful professional unit that offers interchangeable heads, several battery options, and adjustable flash output from full to 1/128

Metz 60 CT-4.

Vivitar 285HV.

Flash Reflectors

Here are two of the many products that bounce light from on-camera flashes. Companies that make lightboxes for studio flash units, such as Chimera and Westcott (see page 53), also make smaller units for use with on-camera flash. These work well, but are relatively large and somewhat cumbersome.

LumiQuest. This unit consists of a folding template of reinforced vinyl, with Velcro strips attached to the flash to hold the reflector in place. The flash is angled upward so that it's completely vertical, and the surface of the inside reflector throws the light forward. The list price is $16.95 to $27.95, depending on the model ordered. *Quest Productions, 1142 East Commerce Street, San Antonio, TX 78205. (512) 224-6197.*

Sunpak. The Sunpak design uses a flat, umbrella-style reflector, held at a distance from the flash tube with a stalk mounted on a filter holder that slips over the flash head. The flash must be turned around so that it fires backward for proper operation. This causes much light loss, but the quality of the flash is extremely soft and virtually shadowless. List price, $22. *Tocad America, 401 Hackensack Avenue, Hackensack, NJ 07601. (201) 935-3225.*

Flash Diffusers

These are two of the many simple accessories available for diffusing the light from a flash.

Omni-Bounce. The Omni-Bounce is a snap-on translucent plastic cube available for a variety of flash units. It reduces light output considerably, but produces a very soft light. Its list price is $19.95. *Sto-Fen Products, Box 7609, Santa Cruz, CA 95061. (408) 427-0235.*

Air-Brella. The Air-Brella comes in two versions. The first, an inflatable plastic balloon, fits around the flash head to create a relatively large diffusing surface. With the second design, you mount the flash backwards on the camera and bounce its light off the reflective inner surface of the balloon. The list price for either version is $14.95. *Altrex New Ideas, 7500 Skokie Boulevard, Skokie, IL 60077. (312) 673-1580.*

power. In normal operation, the Auto 622 is an automatic, thyristor-type unit with an on-flash sensor, but you can convert it to a dedicated unit by adding remote cords and interchangeable modules. The list price for the basic unit with a standard flash head is $350. *Tocad America, 401 Hackensack Avenue, Hackensack, NJ 07601. (201) 935-3225.*

VIVITAR 285HV

Along with Sunpak, Vivitar makes the most popular brand of on-camera flash unit. For years, the Vivitar 283 has been the industry standard for traveling photographers who needed a portable unit that was lightweight, powerful, reliable, and affordable. The company still makes the 283, but the 285HV is about the same size and has a few extra features. The 285HV's list price is $159.95—$30 more than the list price of the 283. *Vivitar, 9350 DeSoto Avenue, Chatsworth, CA 91313. (213) 870-0181.*

Filters

An on-camera filter can produce very dramatic results. Effects such as soft focus, vignetting, or flaring can sometimes overwhelm the subject, but subtle filter changes can reinforce the photographer's original vision. For example, Ansel Adams shot many of his landscapes using a filter, usually to darken the sky and produce better separation of tonal values. Along with precise manipulation of negative exposure and development, filtration gave Adams a high degree of control over the look of his photographs—a control he needed to make prints that most closely matched his intent.

Filters can compensate for the inadequacies of film or the vagaries of lighting. They can help film render a subject more as we see it—to close the gap between the true color of light and the way the eyes and brain process it. Most fluorescent bulbs, for example, don't emit the full spectrum of light, and color photographs taken under such bulbs have a greenish cast. A CC30M (magenta) color-correction filter will eliminate that cast and render fluorescent-lit subjects more naturally.

How Filters Work

A colored filter allows light of its own and similar colors to pass through it to the film, but blocks light of other colors, particularly complementary colors. This is the case whether you're using black-and-white or color film. For example, a green filter blocks red light and admits a disproportionate amount of green, thus making grass lighter and red barns darker (with black-and-white film). A yellow filter reduces the amount of blue light reaching the film, causing blue skies to come out darker in a black-and-white print.

Some black-and-white photographers use a yellow filter all the time when shooting outdoors to compensate for the film's tendency to overrespond to blue light—a primary reason why blue skies look paler in a print than they do to the eye. Orange and red filters are also useful to black-and-white photographers, because they make blue bluer and cause white clouds to stand out against the sky.

A wide range of special-effects filters produce wild results, such as star patterns in highlight areas and prismatic multiple images. Be cautious if you experiment with such filters; their effects can quickly become tired and overstated.

Taken without a filter.

Same subject, shot with an 81A filter.

Taken without a filter.

Shot with a Cokin Multi Image 5 filter.

Glass Filters

Glass filters see widest use with 35mm equipment. These discs of optical-quality glass fit on the front of the lens. Some glass filters are almost clear and others provide neutral density, but most are dyed various colors to produce various effects. Brands vary in quality, but most produce similar results, whether made by the lens supplier or independent manufacturers such as Hoya or Tiffen. One company,

Filter Factor

Color filters block various amounts of light that pass through the lens to the film, according to color. But to some extent, filters absorb light of most colors and require some exposure correction.

Through-the-lens metering systems automatically adjust exposure for the presence of a filter, since the light that reaches them has already been filtered. But strong-colored filters may throw the reading off. This can happen when a subject contains too much color that is similar or complementary to the color of the filter. Similar colors may cause underexposed film; complementary hues cause overexposure.

If in doubt, refer to the filter's "filter factor." More widely used before in-camera meters became popular, this number indicates how much additional exposure is needed to compensate for the light loss caused by the filter. A 2× factor means exposure must be increased two times, or the equivalent of one f-stop. A 4× factor needs the equivalent of a two-stop change, and so forth. First, take a reading without the filter on the lens, then increase the exposure accordingly.

For systems such as view cameras, which don't have through-the-lens metering, the filter factor must be calculated independently every time an exposure is made (or held in front of a meter's sensor).

B + W, makes premium glass filters (see box).

Generally, you buy a glass filter according to the diameter size of the front of the lens. Most lenses take sizes such as 52mm, 55mm, and 58mm. Although lens makers try to standardize so that the same set of filters will fit all their lenses, standardization is practical only within a certain range of lenses—generally moderate wideangle to moderate telephoto. Longer lenses, faster lenses, ultrawide-angles, and many zooms require larger filters.

If your lens diameters vary, you might buy a set of filters to fit the largest lens, then use a step-down adapter ring to use them with smaller lenses. Some telephoto lenses, particularly fast ones with front-element diameters so large that a complete filter set would be prohibitively expensive, have a drawer to hold a very small filter (for example, 39mm) that slides in and out of the lens barrel.

Gelatin Filters

The largest selection of useful filters come as optical gelatins (also called "gels")—three-, four-, and six-inch squares made by Kodak. A clip-on or screw-in holder keeps gelatin filters rigid and in place on the front of the lens. The optical quality of these filters is superior even to that of the best glass filters. One set of gelatin filters will cover lenses of various diameters.

You can buy a complete range of gels to balance light and correct color, as well as neutral-density filters and those used for black-and-white shooting. Gelatin filters can be used in front of the lens or, with a view camera, attached to the lens's back element. They are a little more expensive than glass filters, and they're much more delicate. They're hard to clean—liquid will dissolve them—so they should be stored with care in their protective wrapping between uses.

Resin Filters

Filters made of optical-quality resin are used in much the same manner as gelatin filters; they require a special holder and can be stacked, although they are relatively thick so too much stacking should be avoided. Resin filters are much more durable than gels, and won't crack or shatter like glass filters. You can even polish away small scratches using toothpaste (the chalk in toothpaste is a mild abrasive). Like gels, one set of resin filters will work on lenses of various diameters.

A few manufacturers offer resin filters, including Sinar and Cokin. Cokin was the first company to introduce resin filters and still makes the most self-contained and varied line. Its filters are widely distributed (by Minolta) and packaged to make them easy to buy and use.

Cokin filters require an adapter ring that screws into the front thread of the lens head. A filter holder with slots for four filters slips over the adapter ring, and a coupling ring lets you add a second holder for even more filters. An optional hood snaps into the holder to minimize the flare that can result from stacking filters. The Cokin line covers an enormous range of black-and-white, color-correction, and special-effects filters, and the ease of stacking allows various combinations of these effects. Individual Cokin filters cost about the same as comparable glass filters.

B + W

Despite its somewhat misleading name, the B + W line includes an enormous variety of filters for color work, as well as a myriad of other uses.

Most glass filters are punched out of sheets of dyed glass—a process that may distort the glass and thus degrade the photographic image. B + W filters are sliced cucumber-like off cylinders drilled from dyed blocks of optical glass. After slicing, the filters are polished and given multiple antiglare coatings. Most glass filters have aluminum mounting rings, but B + W filters use solid black-anodized brass rings.

Inevitably, the price reflects the quality. B + W filters list for about twice the price of glass filters from independent manufacturers.

HP Marketing, 16 Chapin Road, Pine Brook, NJ 07058.

Camera Bags

A photographer is a beast of burden, despite the best efforts of manufacturers to make lighter, more flexible equipment. To be prepared for every possible picture-taking opportunity, you need to carry several lenses, an extra camera body or two, possibly a hand meter, various filters, a tripod, flash equipment, and an adequate supply of film. A well-designed camera bag not only accommodates this arsenal comfortably, but organizes it so that every piece of equipment is easy to find and get at.

The endless types of camera bags range from those that hold a single camera and lens with film to satchels designed to carry entire systems. There are also many special-purpose bags, such as those shaped to hold cameras with long lenses attached, plus photographic backpacks, tripod bags, convertible packs, and on and on. Other bags are designed to carry medium- and large-format equipment.

The most popular style of professional bag is sturdy and relatively light. Most are made from canvas or Cordura nylon, with foam-padded dividers held in place by Velcro strips for customizing the various compartments to suit specific equipment. Many companies besides the ones described in this section make similar bags. In particular, Tamrac and Tenba are two brands you should consider.

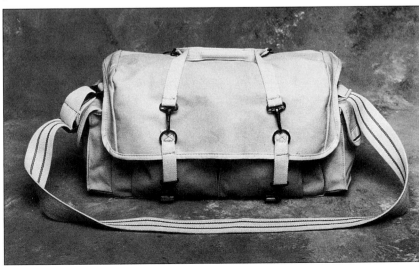

Domke F-1X.

DOMKE

Photojournalist Jim Domke pioneered the soft professional camera bag with his original Model F2 in 1976. Its modular divider system used stitched-on Velcro strips that allowed the user to customize the bag's interior. The bags in the current much-expanded Domke line aren't as heavily padded as some on the market. This means they offer somewhat less protection, but are also less bulky, lighter, and somewhat more affordable.

All Domke bags are made of cotton canvas with various degrees of reinforcement, and all have foam or neoprene-rubber padding. The original F2 is still around in a somewhat improved version (list price, $126). It has twelve adjustable compartments that hold at least two camera bodies with motor drives and up to ten lenses. Pockets on the front and sides of the bag hold film, meters, and miscellaneous small accessories.

Domke makes many other bags, including a larger, seventeen-compartment model (the F-1X—list price, $178), as well as smaller bags, various pouches, pads, straps, tripod and sling bags, and much more. Domke bags are particularly favored by photojournalists, and some are built to haul the long lenses mounted on cameras that many photojournalists favor.
J.G. Domke Enterprises, 950 Calcon Hook Road #3, Sharon Hill, PA 19079. (215) 522-0502.
See pages 51 and 219.

LOWEPRO

Lowepro offers a well-constructed, varied line of camera bags, including such unusual offerings as backpacks for the hiking photographer. These come with padded Velcro separators. Lowepro also makes the Elite Convert-

ible (list price, $88), a handy, compact bag.

A more conventional professional shoulder bag, the Magnum 35 (list price, $196), comes with a choice of three modular divider setups—one for standard 35mm systems, one for 35mm with telephoto lenses, and one for medium-format equipment. The bag's shell is constructed of woven Cordura nylon, its walls are ⅜-inch high-density closed-cell foam, and its bottom is ABS plastic—the material used in football helmets—sandwiched with an open-cell foam pad to distribute the effects of shock. In short, the Magnum 35 is one tough bag.

A long, large pocket on the front of the Magnum 35 is roomy enough for a changing bag and/or focusing cloth, and zippered side pockets store filters, meters, and film. The zippered top does not have the overlapping flap found on other bags; durable plastic buckles provide extra protection.
Lowepro, 21029 Itasca Street, Unit G, Chatsworth, CA 91311. (818) 718-6030.

Shipping Cases

Several companies make shipping cases for photographic equipment, but the Zero Halliburton may be the best known. This foam-lined case comes in nine sizes and styles; it's a superbly crafted suitcase made of prestressed aluminum alloy with a combination lock and two spring-loaded snap latches. Pelican makes a line of unbreakable, waterproof and dustproof cases that are quite lightweight, due to a space-age shell made of ABS structural foam resin. Tundra Sea King cases, made of fiberglass-reinforced plastic, come in nine styles, all waterproof and dustproof.

The most unusual shipping cases come from Lightware (similar ones are now available from Kiwi and Tenba). These offer excellent protection but are made of exceptionally light materials—a rigid inner shell with a foam lining and a covering of "ballistics material." Lightware cases have modular dividers and look like conventional

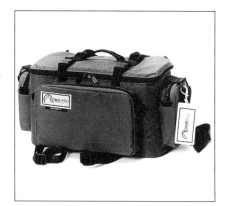
Lowepro Magnum 35.

Bazooby jacket.

Zero Halliburton shipping case.

luggage. Unloaded, they weigh three to six pounds (about one-fourth as much as metal cases such as the Halliburton, and half as much as plastic ones). They can haul eight to ten times their weight in equipment.

Lightware makes cases to accommodate many kinds of gear, including models for strobe heads and power packs from Norman, Speedotron, and Dynalite. Two medium-format cases, the 1420 (22×16×5 inches—list price, $260) and 1217 (14×19×8 inches—list price, $240) can also be used for 35mm or 4×5-inch systems. Either fits over or under an airline seat. The Cargo is a long case of similar construction, made for tripods, light stands, and flash heads.
See page 219.

Camera Vests

Aching shoulder joints are an occupational hazard of photojournalists, because conventional shoulder bags don't efficiently distribute the weight of heavy camera equipment, especially when you're moving around a lot. Vests or jackets with pockets for lenses, camera bodies, and smaller items make a lot more sense.

Domke offers both a vest and the $150 Cargo Coat; the coat is made of water-resistant polyester and cotton and has nine large Velcro-closure pockets and one zippered pocket. The Lion's Hollow Photojacket ($260) is another nicely made choice, and the Banana Republic vest ($78) will also do the job. The Bazooby, distributed by Photoflex, may be the most versatile jacket; for $164.95, you get fourteen pockets. The Bazooby vest lists for $69.95; this item offers twenty-two pockets, six of them lined with foam.

Photo vests and jackets don't have the capacity of large camera bags, and they can't easily carry outsized equipment such as long or very fast lenses—even camera bodies with motors attached may be pushing it. You may need a small shoulder bag in addition to a vest. Even so, a vest or jacket will distribute the load enough to provide some relief.

OTHER EQUIPMENT

Enlarging Equipment

Before the advent of the enlarger, photographic negatives could be printed only by contact. This meant, among other things, that a camera had to produce a negative as big as the final print. For example, expeditionary photographers of the nineteenth century who aspired to document the grandeur of the virgin landscape of the West used glass-plate negatives as big as 20×24 inches. The enormous size of the cameras needed to produce such negatives made shooting a cumbersome, time-consuming, and, at times, impossible affair.

When the basic requirements of enlargement were established—an artificial light source of reasonable strength and photographic paper of relatively high sensitivity—the use of smaller negatives, including the now-popular 35mm format, became practical. This in turn made possible free-roaming photojournalism, artistic street photography, and the other candid styles that have become so persuasive.

The first attempts at enlargement involved huge, elaborate mirror and condenser systems that directed sunlight from a roof-level vantage point through the negative. Because of the low sensitivity of photographic paper, these crude systems worked only on very bright days and required long exposure times. Today's enlargers are by comparison simple to use. They range from massive 8×10-inch models that cost thousands of dollars to compact 35mm machines worth a hundred dollars or more.

Kostiner easel.

Choosing an Enlarger

Enlargers come in two basic types: condenser and diffusion. Condenser enlargers direct light from an incandescent bulb through the negative with large lenses that focus the light into straight, parallel lines. Diffusion enlargers scatter the light with a translucent panel above the negative, so that the light passes through at various angles. Cold-light heads are also available; these essentially turn a condenser enlarger into a diffusion type (see page 45).

Each type has its advocates. In general, a condenser enlarger yields prints with higher contrast and a more pronounced grain than prints from a diffusion enlarger. Diffusion enlargers disguise negative flaws more readily, and even though diffusion prints show less grain, some photographers feel that the grain pattern is less sharp than that on prints from a condenser enlarger.

Many black-and-white photographers adjust the contrast of their negatives to suit one system or the other, giving them less contrast for condenser enlargement and more contrast for diffusion. Also, conventional wisdom says that medium-and large-format negatives print best on diffusion enlargers, while 35mm is best suited for condenser printing. Regardless, either type can produce high-quality prints on all size negatives. Color enlargers are generally diffusion types.

Shopping for an enlarger can be frustrating. Unlike cameras, which are widely displayed and handled, enlargers are rarely set up in stores the way they would be for actual use. Try out enlargers in the darkrooms at your school or in a friend's studio. Inevitably, budget will be a determining factor, but the size of the negative (or slide) you want to print significantly affects what you'll have to pay: the larger the film format, the greater the cost. Even so, you don't need the most expensive model; just make sure it's reasonably well constructed. You'll do better by investing in a high-quality enlarging lens; a good lens will have a greater effect on print quality than sophisticated hardware.

Consider first how you plan to use the enlarger. If you're a weekend printer who has to take over the bathroom or kitchen, pick a compact model that can be easily broken down and stowed away. Be careful when you move it, though; enlargers are easily thrown out of alignment. Those enlarging large-format negatives or transparencies will find such informal arrangements impractical and probably need to set up a permanent darkroom.

Inexpensive enlargers are often severely limited as to print size—or more accurately, magnification. Say you want to make a 16×20-inch print from a 35mm negative; you will need a long rail not offered by every brand of enlarger. To make large prints from 35mm negatives, you'll need a high-end model with a long rail, or one made for larger formats.

Enlarging Lenses

A good enlarging lens is as important as a good camera lens. There are a number of reputable manufacturers, many of which also make view-camera lenses. Some of the top brands are Beseler HD, Fujinon, El-Nikkor, Rodenstock Rodagon, and Schneider Componon S.

A variety of camera-lens focal lengths are used to alter the angle of view and image magnification, but enlarging lenses are generally fixed; a specific focal length is used with a given film format. The standard enlarging lens for 35mm film has a 50mm focal length, although slightly shorter lenses can be used as long as they provide adequate image coverage. The standard for 2¼×2¼-inch images is 80mm, although more rectangular medium-format image sizes such as 6×7cm and 6×9cm need a longer lens, generally a 105mm. To print 4×5-inch negatives and transparencies, use a 135mm or 150mm lens. You can always use a longer enlarging lens in each format, but it will cause the image size to be smaller, and thus lengthen exposure times since the enlarger head will have to be raised higher to achieve a given image size.

Lens speed isn't as important with an enlarging lens as it is with a camera lens. Fast 50mm enlarging lenses open to f/2.8; normal ones open to f/4. A faster lens gives you a brighter image to frame and focus. Generally, for printing, you should set smaller apertures—for example, f/8 or even f/11 with a 50mm lens—to insure corner-

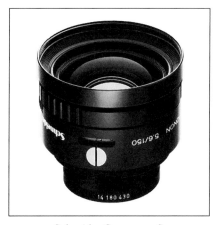
Schneider Componon S.

El-Nikkor.

to-corner sharpness and to compensate for small errors in enlarger alignment. In a pinch, a wider maximum aperture will shorten an overly long exposure time, provided the enlarger is perfectly aligned and you're using a glass carrier to keep the film absolutely flat.

Color Heads

A variation on the diffusion enlarger is a head designed for printing color negatives and slides. With most professional enlargers, you can substitute a color head for the existing head. Such heads bounce light through fade-resis-

tant cyan, magenta, and yellow dichroic filters into a mixing chamber. From there, the light is directed down to the negative through a diffusing panel. The color of the light—and thus the color balance of the resulting print—is determined by how far each of these filters extends into the light path. The position of the filters is controlled either mechanically or electronically by knobs on the outside of the head, or by controls on a separate panel timer.

A color head can also be useful with variable-contrast papers. The contrast of these papers varies with the color of the light to which they are exposed; yellow light produces low contrast and magenta light makes for high contrast. A color head can easily duplicate the effects of variable-contrast filters by varying the proportion of its yellow and magenta filtration. The appropriate setting will vary with the type of color head and paper used. For example, with Kodak-type dichroic filters, you get a grade-one effect when using Ilford Multigrade paper with an 85 Yellow and 42 Magenta, or a grade-three effect with 30 Yellow and 90 Magenta. The color head's single-point filtration calibration permits finer contrast control than is possible with the half-grade steps of variable-contrast filters.

Ilford makes a diffusion head specifically for variable-contrast work called the Multigrade 500. This head replaces the condenser assembly in various popular enlargers and is calibrated to provide half-grade steps of contrast. Adjustments are made with a countertop control panel connected to the head by a cable. The Multigrade 500 head has built-in neutral density, so exposure remains the same regardless of changes in contrast.

BESELER

Beseler makes two classic enlargers that have been around in some form for a long time. The 23CII, a medium-format enlarger, accepts film formats up to 6×9cm; the 45MXT is a large-format model.

The 23CII has a solid chassis and a long extension with an oversized base-

Beseler 45MXT, with Beseler/Minolta 45A enlarger light source.

Leica Focomat V-35.

board for large prints. Its list price of $541.50 is a bit expensive, but this model will survive years of regular use—and abuse; it's the enlarger of choice for many school darkrooms. A dichroic color head is available for an additional $633.50.

The 45MXT is found in many labs and used by serious amateurs and pros alike. It takes all negative sizes up to 4×5 inches. This enlarger is extremely sturdy and has motorized elevation controls for easy and precise control of image size. You can buy the 45MXT (chassis only, list price, $1,083.50) with the model 45M condenser lamphouse (an additional $416.50) for black-and-white work or a color head—either the standard Dichro 45S ($1,083.50), the Dichro 45 computerized color head ($1,833.50), or the Beseler/Minolta 45A enlarger light source ($2,833.50). The 45A is a microprocessor-controlled system that uses pulsed xenon flashtubes rather than continuous light to expose the print. Zone VI, a mail-order supplier, sells a modified Beseler 4×5-inch enlarger with a cold-light head for $1,295 (see page 57).

A recent and unusual addition to the Beseler product line is an accessory head that allows the 45MXT to print up to 8×10-inch negatives. Logically dubbed the 810, this head is substantially cheaper and more compact than conventional 8×10-inch enlargers. It contains its own cold-light source, and simply replaces an enlarger's standard condenser or color-head assembly. The 810 lists for $2,500; the 810MXT, a 45MXT chassis with the 810 head, is $3,417. An oversized baseboard (another $137.50) is recommended. *Charles Beseler Company, 1600 Lower Road, Linden, NJ 07036. (201) 862-7999.*

LEICA

Leave it to Leica to make the best designed—and most expensive— enlarger in its class. The Focomat V-35 is a rugged, high-precision unit that accepts 35mm and smaller formats. It comes with a choice of three interchangeable modules that slip into a slot

on the side of the head: a black-and-white module for printing with graded papers (list price, $3,180), a black-and-white variable-contrast module with built-in filters ($3,495), and a relatively low-tech color module ($3,555). All come equipped with a bright 40mm f/2.8 Leitz Focotar lens.

Leica enlargers have a unique auto-focus feature—once you've focused manually, the negative remains sharp regardless of what size you make the image. Negatives are kept flat with the help of a carrier that has glass on the top side only. (Glassless and two-sided glass carriers are also available.) This feature, along with the enlarger's superb lens and diffusion-like light, guarantees dead-sharp prints of even density from edge to edge.

The V-35 can make tiny enlargements of 3× to very large ones of 16×. That means you can print a 35mm negative from 2¾×4⅛ inches to 15×22½ inches (16¾×25, if not used on autofocus)—an unusually wide range—on a standard baseboard.

Leica USA, 156 Ludlow Avenue, Northvale, NJ 07647. (201) 767-7500.

OMEGA

Omega produces excellent enlargers roughly comparable to Beseler's in quality, features, and price. In particular, its redoubtable D-series enlargers have long been popular workhorses for pros and school photolabs. Almost one million D-series units have been sold, and the classic, variable-condenser D2-V is a hot item in the used market.

The current professional model is the Omega D5-XL (chassis only, list price, $1,075.50), available with either a condenser lamphouse for black-and-white printing ($539) or a dichroic color head, which changes the enlarger's name to the Chromega D5-XL ($1,198.75). The XL refers to the extra-long (57-inch) rail of the enlarger's chassis, which, together with its oversized 22×34-inch baseboard, permits on-baseboard enlargements of up to 20×24 inches from a 35mm negative. A slide-in mount accepts interchangeable lenses in focal lengths from 25mm to 150mm.

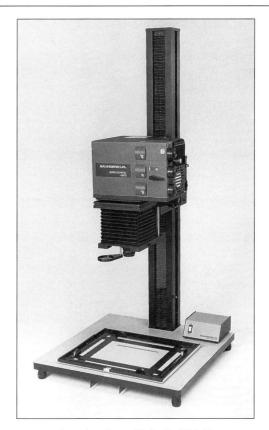
Saunders Super Dichroic 4500-II.

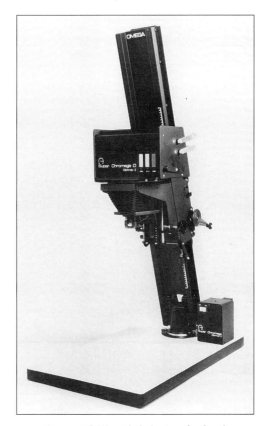
Omega D5-XL with dichroic color head.

To adjust the condenser system to suit the film format, you simply change the position of the variable condenser lens inside a panel on the front of the lamphouse. Five-inch-square filters for variable-contrast printing and other purposes can be placed on top of the variable condenser or on a heat-absorbing glass; this is preferable optically to placing filters under the lens.

The Super Chromega Dichroic II color head can be readily exchanged for the condenser lamphead for color printing. You can dial in 0 to 170 units of cyan, magenta, or yellow filtration using controls and numerical readouts on the head. The Chromega D5-XL enlarger comes with either a standard power supply or with the Chrome-gatrol, a combined power supply, voltage stabilizer, and timer.

R.T. Omega Industries, 1900 Hanover Pike (Rear), Hampstead, MD 21074. (800) 777-6634; (301) 374-6766.

SAUNDERS

Saunders makes a full line of enlargers (jointly with Japan's LPL enlarger company), in addition to the familiar four-way easel that has been a standby (see next page). The Super Dichroic 4500-II, a 4×5-inch model, is three enlargers in one: dichroic color (list price, $1,895), variable contrast ($1,875), and black-and-white diffusion ($1,599.95). All three capabilities share the same chassis and lamphouse, but small filtration modules slide in and out on a nylon track according to the type of printing you want to do.

The dichroic module offers dial-in stepless filtration up to 200CC in 1CC increments, with a light attenuator that reduces illumination for more f-stop/time flexibility, and a white light control for full illumination focusing. In variable-contrast mode, this module uses magenta and yellow dichroic filters, and its quarter-grade increments from grades 0 to 5 give more precise control over contrast than the half grades of conventional filters. Graduated neutral-density filtration eliminates the need for exposure correction when filters are changed. The black-and-white module essentially

Easels

At its simplest, an easel is just a device for holding printing paper flat and in a fixed position. It consists of a base, in which the paper is aligned, and hinged blades that mask the image and hold the paper down firmly by the edges.

There are many types of basic easels on the market. Some allow only one image size on a particular size of printing paper (for example, 7×9 inches on 8×10-inch paper). Others have a two-way design, in which the paper is held in place by the top and left-hand edges (where the width of the border is fixed—usually a skimpy $1/4$ or $3/8$ inch)—and the full dimensions of the image are controlled with adjustable blades on the other two sides.

Both types have problems. Fixed easels force you to fit your image into the same rectangle each time; that rectangle may be fine for an uncropped 4×5-inch negative but too square for 35mm—forcing you to crop off the wide dimension. The two-way easel isn't much better. To get a centered image, the two moving blades must be adjusted so that they match the borders produced by the fixed sides, making the two-way design only slightly preferable to a fixed easel.

Professional easels have four adjustable blades so the image can sit on the printing paper any way you choose, whether you crop or not. This type of easel brings the refinement of sharp, crisp edges and bright-white borders to an image of any size or format, thus giving the viewer the impression—or perhaps the illusion—of a well-crafted print.

KOSTINER

Kostiner makes the most versatile four-way easels. They come in four sizes for paper as large as 11×14 inches (list price, $149.50), 16×20 inches ($275), 20×24 inches ($375),

and 30×40 inches ($1,250, by special order). All but the smallest models can be delivered with optional vacuum bases, and all have slots to accept paper in standard sizes smaller than the maximum. Kostiner bases are flat black, to prevent light passing through the paper from bouncing back and fogging the print, and have an unusual square shape.

The square design helps in making vertical prints; you can position the negative so that the image faces you right-side-up as you expose the paper. Though this is a nice convenience, it may also introduce a problem. Some smaller enlargers don't have enough front-to-back depth on their baseboards to accommodate the square shape, causing the rail to obstruct the easel. This is a particular problem when using a relatively large easel to make a small print; assuming the enlarger has a slanted rail, which most do, the lens won't be as far out over the baseboard as it would be for making larger prints.

Kostiner easels are modular and offer a wide range of options and refinements. Blades can be removed and replaced; for example, two- or three-inch-wide blades can be substituted for the standard $1 1/4$-inch ones when you want to create wider borders without additional masking.

Perhaps the most interesting accessory for the Kostiner easel will appeal to photographers who routinely print a black line around the image area. Normally, this indicates that the image is uncropped, because to get the line you have to print a narrow portion of the clear base of the negative within the easel blades. But Kostiner's Pen-Line Liner masking attachment allows a black line to be printed around even a cropped image, via a separate white-light exposure. Conversely, a thin white line can be printed around images from transparencies. You can even

offset the line so that it falls outside the edge of the image.

The Reverse Border Printer, another Kostiner accessory, is really an easel in itself. It lets you control the tone of the border, also with a separate white-light exposure. You can get black or gray borders on prints from negatives, and white or gray borders on prints from transparencies. *Kostiner Photographic Products, 12 Water Street, Leeds, MA 01053. (413) 586-7030.*

SAUNDERS

Saunders set the standard for professional easels years ago. It now offers several heavy-duty four-blade models for varying print sizes—11×14 inches (list price, $219.95), 14×17 inches ($149.95), 16×20 inches ($374.95), and 20×24 inches ($499.95). All will accept paper smaller than their maximum, with slots in the base of the easel for positioning standard sizes.

The base of the Saunders easel is yellow, to make it easier to focus the image; still, as with any easel, you should place a blank sheet of printing paper in the easel for focusing.

The blades move easily via raised knobs (rotating knobs for the larger models) and image dimensions appear on a calibrated scale located on each of the easel's four sides. The blade assembly can be locked in an open position.

Saunders also makes a number of single-size easels, including the Salon models, which let you make a fixed-image-size print on the next larger size of paper—for example, an 8×10-inch print centered onto an 11×14-inch piece of paper. The company also makes a borderless multiprint easel capable of producing several prints on a single sheet of 8×10-inch paper. *The Saunders Group, 21 Jet View Drive, Rochester, NY 14624. (716) 328-7800.*

Black Line Printing

Some photographers like to print a black line around the edges of the print. The line comes from printing the edge of the negative within the borders of the easel; because the edge is clear, it prints black. The easiest way to achieve this effect is to use an oversized negative carrier—one for a negative larger than the one you're printing. The problem is keeping the negative flat. A glass carrier will guarantee this; otherwise, make a mask of black card stock and tape it to the negative carrier to make an opening slightly bigger than the negative but smaller than the film, so it will hold the film flat (the black stock minimizes reflections that might cause flare).

A better and more permanent solution is to use the correct size negative carrier and enlarge the opening using a flat file. File the carrier on all four sides, until the opening is big enough for the clear edge of the film to show through. Make sure the edges of the opening are filed smooth, or the carrier may scratch the negative. Finally, paint the filed-out parts of the carrier flat black.

Some negative carriers come with an opening that's a little small and crops in on the negative. These should be filed out so you can print as much of the negative as possible, whether you plan to leave a black line around the print or not.

Whether you use an oversized negative carrier or a filed one, set up your easel so the blades leave an opening about ⅛ inch larger than the negative. When you make your exposure, light will pass through the borders of the negative, creating a black line around the print.

A black line makes the statement that the photographer shot the picture "full frame"—without any cropping. However, with the Kostiner Pen-Line Liner, you can print a black line around even a cropped print (see page 42).

© HENRY HORENSTEIN

Jockey Excuse, *Keeneland, 1985.*

Cleaning Negatives

Dusty negatives are the bane of the darkroom. Once dust, dirt, and other particles land on a wet negative, they may become permanently embedded in the soft gelatin of the emulsion, and the white marks they leave in the finished print must be retouched or spotted out—a time-consuming and not always successful process. Treating film in an antistatic wetting agent after the wash cycle can minimize the problem. Also, film should be hung to dry in a dust-free environment or in a drying cabinet. Various companies make dust-control units that clean the darkroom air by ionization and other methods.

Embedded dust and other particles can sometimes be removed from the emulsion by swabbing with a surgical cotton ball and film cleaner. But be sure to use a cleaner specifically made for the type of film you are using—negative or slide, color or black-and-white. If that fails, try carefully resoaking the film in water, followed by another bath of wetting agent (or try soaking in film developer, such as Kodak Dektol diluted 1:1 with water, for twenty minutes, followed by fixer, a water wash, and setting agent).

Less stubborn dust will usually yield to a soft camel's hair brush or compressed air. Careful use of either can save hours of tedious spotting. A brush alone tends to simply push the dust around, and even though some brushes come with an attached bulb blower, even a good squeeze can't approach the strength of a blast of compressed air.

Dust-Off from Falcon Safety Products was the original compressed gas for cleaning negatives. Several clones are now available, and some cost less, but Dust-Off offers the widest variety of compressed-air products. The origi-

Dust-Off Plus.

nal Dust-Off has a simple chrome nozzle and a trigger-like valve control. The nozzle screws into a replacement canister (available in two sizes—12 and 24 ounces). The canister must be kept upright to avoid spraying the liquid propellant onto film surfaces, which can cause staining, or onto skin, which may cause a low-temperature burn. A flexible plastic hose with a nozzle is available to help reach spots that would otherwise require tipping the canister on its side; the hose slips directly onto the nozzle. Dust-Off II, available in 4-, 12-, and 24-ounce sizes, is similar to the standard Dust-Off, except that it allows the valve to be removed from a partially filled canister without the gas escaping (with standard Dust-Off, you need to empty the entire canister before removing the nozzle).

The Dust-Off Pro System is designed for permanent work spaces. It includes eight feet of flexible extension hose with a "pro-gun" nozzle. The complete unit lists for $69.95, with 32-ounce refill canisters listing for $21.95.

Dust-Off Plus is the latest generation; it contains none of the ozone-damaging chlorofluorocarbon (CFC) propellant in most compressed-air products. It uses a much less harmful propellant that requires a higher operating pressure, and thus has a redesigned nozzle that rotates 360 degrees, and also moves up and down in a 180 degree arc, so the can stays upright even when cleaning awkwardly positioned surfaces.

The original Dust-Off formula also comes in two smaller disposable sizes called Dust-Off Junior and Pocket Dust-Off, useful for blowing dust off lenses and cameras.

Falcon Safety Products, 25 Chubb Way, Somerville, NJ 08876. (201) 707-4900.

converts the enlarger to a standard diffusion-type system.

The Saunders Group, 21 Jet View Drive, Rochester, NY 14624. (716) 328-7800.

Cold Light Heads

Accessory cold light heads for enlargers have a cult following among serious black-and-white printers, especially large-format users. Though this popularity is fairly recent, cold light heads are basically a variation of diffusion enlargers. The head scatters the light in many directions, and thus avoids the pronounced grain and sharp contrast of condenser units, including highlights that need burning and shadows that need dodging. The diffused light also de-emphasizes dust, scratches, and other flaws in the negative.

Advocates claim that cold light heads produce a more delicate, full-toned print than conventional condenser enlargers do. Skeptics argue that the result is a flat print with less sharpness and mushy graininess.

Cold light heads replace the standard tungsten light on an enlarger head. You simply remove the condensers and drop the cold light head into place. (Because the cold-light unit completely replaces the lamphouse on a condenser enlarger, the height of the enlarger is considerably reduced, allowing greater degrees of enlargement in situations with limited headroom.) The narrow fluorescent tubing of the cold light head forms a grid pattern. The head generates relatively little heat (hence its name), and thus reduces the likelihood of negatives in a glassless carrier buckling and throwing part of the printed image out of focus.

Because of its high concentration of blue wavelengths, cold light is generally inappropriate for color printing (although some lamps are made for that purpose—see page 39). This extra blue also affects variable-contrast printing papers, which rely on color variations for contrast control.

Print contrast is probably the most dramatic difference between condenser

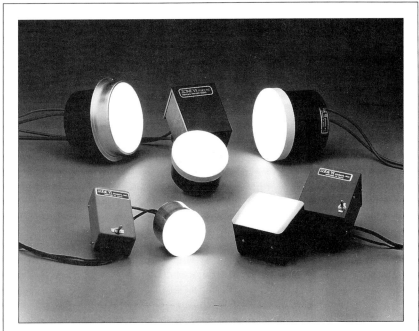

Zone VI's line of cold light heads.

and diffusion or cold light head enlarging. All other conditions being equal, a black-and-white print from a diffusion enlarger will have about one grade less contrast than a print made on a condenser enlarger. Conversely, contrast in prints from a condenser enlarger can be reduced by varying the contrast grade of the paper and developer type and by dilution. Also, in making matched prints with diffusion and condenser enlargers, the actual print contrast of the former must be made higher, thus undoing some of the argued advantages, including grain reduction. Diffusion printers often increase film development to obtain more contrasty negatives, and this can result in more grainy negatives.

The main sources for cold light heads are Aristo, through camera stores, and Zone VI, through mail-order (see page 57).

ARISTO

The principal maker of cold light sources is Aristo, which offers heads for many brands and formats of enlargers. These heads come equipped with a choice of lamps; you select the lamp according to personal taste and the

type of work you do. The W45 is a cold white lamp, providing 40 watts, equal in brightness to a 300-watt tungsten lamp, and the W31 emits a warmer light, recommended only for printing with variable-contrast papers. (Using this lamp demands a somewhat slower printing speed, however, than when using the W45 lamp filtered with a CC40Y or CP40Y filter for otherwise similar results.) The 7452 lamp, a full-spectrum daylight source, is a good general-purpose lamp and works well for color printing. The same can be said for the slightly pinkish W55, and many color printers prefer the added warmth of this lamp. Aristo also makes a high-intensity version of some of these lamps, which results in a printing speed about two-and-a-half times faster than with the standard lamp.

Among fine-art photographers, the cylindrical Aristo D-2 is the most popular of the company's cold light heads. This model accommodates all the lamp types described above and more. The head fits most Omega and Beseler 4×5-inch enlargers.

Aristo Grid Lamp Products, 35 Lumber Road, Roslyn, NY 11576. (516) 484-6141.

Color Processors

Until recently, photographers printing in color had to use tubes or some other awkward method for processing. Anybody who has spent countless hours waiting for prints to be completed while constantly monitoring and adjusting solution temperatures knows what a tremendous improvement tabletop color processors represent.

Until recently, automated color-print processors were expensive and required major space and plumbing commitments. Current tabletop models, while not cheap, are far more affordable and much easier to install and run. Once practical only for high-volume users such as professional photolabs, tabletop processors have become popular with fine-art photographers who want total control over the printing process. Even though the initial cost of the processor is high, the savings over custom printing can be significant.

Most tabletop processors work the same way (except for the Jobo system, see next page). Exposed paper goes inside a light-tight cover on one end and is automatically fed by rollers through the solutions. The various baths are maintained at the required temperatures within the very strict tolerances that color processing requires. While one print is being processed, you can move on to another task, perhaps preparing a test for the next image or exposing additional prints of the image being processed. With a tabletop processor, it's safe to do this and assume the equipment will provide prints with consistent color balance and density.

Tabletop processors must be carefully maintained for reliable results. This means monitoring the processing solutions using attached hoses, cleaning the roller assemblies (which lift out easily), and making sure everything is thoroughly rinsed and dried before its next use.

Color processing chemicals are more toxic than those used for black-and-white processing, so be sure to work in a well-ventilated darkroom, regardless of the brand of processor you use. See page 83 for information on health hazards.

BESELER

The Beseler Auto-16CP (list price, $7,700) is a basic but solid high-end processor that accepts color and black-and-white papers that measure between 3×5 and 16×20 inches. It has four processing tanks, the second and fourth suited for static baths or running-water washes; the second tank can also be used for the dye bleach in the Cibachrome process. The Auto-16CP can process up to seventy-four 8×10-inch color prints per hour. An optional dryer module ($1,750) and replenishment module (also $1,750) hook onto the processor.
Charles Beseler Company, 1600 Lower Road, Linden, NJ 07036. (201) 862-7999.

DURST

Durst's popular RCP line offers three models, each designed for printing up to a specific paper size. These processors need no plumbing so they can be set up on a counter top, and all are relatively compact and totally automatic. Though made primarily for color printing, RCPs will handle black-and-white resin-coated papers as well (especially the two larger RCP models).

The RCP20 handles papers as large as 8×10 inches (list price, $995), the RCP40 is for 16×20-inch or smaller prints ($4,995), and the RCP50 accepts paper up to 20×24 inches ($6,595). Accessory washer/dryer units are available for all models for less than $3,000 (though only a dryer is available for the RCP20). The RCP50 has electronic temperature control and automatic solution replenishment; these features are optional with the RCP40.
Nytek, 3182 MacArthur Boulevard, Northbrook, IL 60062. (312) 564-3070.

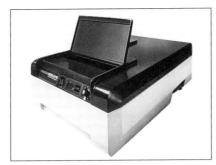

Beseler Auto-16CP.

Durst RCP40.

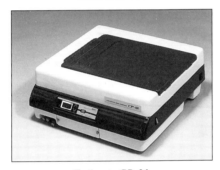

Fujimoto CP-31.

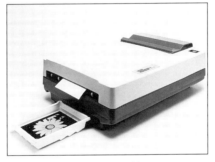

Ilford CAP-40.

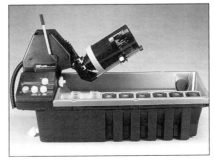

Jobo CPA-2.

FUJIMOTO

This relatively new entry among table-top processors, the Fujimoto CP-31, is both compact (23×25×10 inches) and affordable (list price, $3,249.95). Its small size is due mainly to the simple design of its lighttight paper feeder—the paper flops across the top of the unit and the lid closes over it.

The Fujimoto CP-31 accepts papers from 5×7 to 12×16 inches and incorporates three individually temperature-controlled solution troughs. The unit can handle Cibachrome and other positive-to-positive printing processes, as well as conventional C-prints and black-and-white resin-coated papers.
PSI Photo Systems, 7200 Huron River Drive, Dexter, MI 48130. (313) 426-4646.

ILFORD

The CAP-40 is built to use Ilford's proprietary Cibachrome print materials, which create prints by the dye-destruction process rather than the color couplers of conventional color processes. With the proper chemistry, you can also make Cibachrome prints in other tabletop processors (or, for that matter, in standard drums), so if you're planning to print both Cibachrome and C-prints, don't get this one. However, if you're strictly a Cibachrome printer, the CAP-40 is an ideal choice. For one thing, at a list price of $2,965, it's affordable as processors go. Its three baths process prints from 5×7 to 16×20 inches in only six minutes, and produces up to twenty-five 8×10s per hour.

The ICP-42 ($3,550) is a new model slated to replace the CAP-40. It has an improved feeder system, a stronger motor with variable speed control, and adjustable temperature control, allowing it to process C-prints and black-and-white resin-coated prints. A dedicated washer/dryer module ($3,092) can be attached for dry-to-dry printing.
Ilford Photo, 70 West Century Road, Paramus, NJ 07652. (201) 265-6000.

JOBO

Jobo's approach to tabletop processing is very different from that used by Beseler, Durst, Fujimoto, and Ilford; rather than roller transport systems, Jobo units use processing drums. Various sizes of color and black-and-white papers up to 20×24 inches are accommodated simply by changing drums. All sizes of roll and sheet film can also be handled in all Jobo processors, as long as they're equipped with accessory drums.

The Jobo drum sits on a motorized rotating base, and is fed by bottles of chemicals that sit in a tempered water jacket. The more elaborate models such as the ATL-2 (list price, $4,495) are microprocessor-timed, and an air-pressure system moves solutions in and out of each drum. You can program in various drum-rotation speeds and agitation patterns.

The less expensive models such as the CPP-2 ($1,395) and CPA-2 ($995) must be timed, filled, and drained by hand, although an optional lifting device lets you fill the drum without removing it from the unit and tip it up for draining. Both the CPP-2 and CPA-2 offer variable agitation speeds. The CPE-2 ($395), a scaled-down model, works in a similar manner but handles prints only as large as 11×14 inches.
Jobo Fototechnic, 251 Jackson Plaza, Ann Arbor, MI 48103. (313) 995-4192.

Print Washers

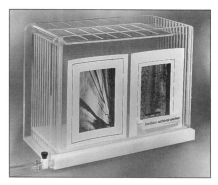

Kostiner.

After processing, prints must be well washed to eliminate traces of fixer and other chemicals. You can wash prints in a large tray by siphoning off the water and agitating them by hand so they don't stick together, but this is tedious and may damage the prints. Nor does it ensure a thorough wash. Many companies make print washers, and the mid-1970s saw a flood of highly efficient models as interest in archival processing (see pages 204–206) became widespread.

These washers, commonly dubbed archival washers, are acrylic boxes that hold prints in separate chambers and circulate water through to efficiently disperse residual chemicals. Their efficiency stems from how often the water is exchanged, rather than from the rate of flow. In fact, most archival-washer makers have tried to keep flow rates to a minimum to avoid wasting water.

Despite varying features, all washer models look very much alike—typically, a heavy-walled acrylic box with thin, slide-in panels that form about a dozen separate print chambers. A hose feeds into a narrow manifold at the bottom or side of the unit with small holes that send water to each chamber. Drainage occurs over the top edge of the unit, out the bottom, or both. Some washers have built-in overflow chambers to allow operation *sans* plumbing; others must be placed in a sink or used with a separate water-collection base.

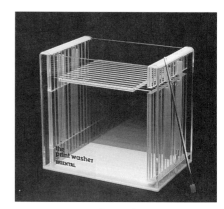

Oriental.

Gravity Works.

Wisner.

KOSTINER

Kostiner put one of the earliest acrylic-box washers on the market, and still makes one of the best. The washer fills from the bottom and discharges over a lowered edge at the top. As with other such washers, a sheet of grooved plastic sits on top of the dividers to keep prints from riding up out of the water in their chambers, and a plastic wand helps you prevent prints from sticking to the chamber walls.

Kostiner further addresses the sticking problem with a patented system of air and water dispersion and method of aeration, which is what distinguishes its washers from other available models. A valve in the water intake mixes air with the flowing water, stopping air bubbles from forming on the prints, and thus shortening the required wash time. Turning a knob on top of the valve controls the degree of turbulence. While some dispute the effect of turbulence on washing efficiency, there's no disputing its usefulness—a print can't be properly washed if it's stuck to the chamber wall.

Kostiner washers come in models for 11×14-inch prints (list price, $425), 16×20-inch prints ($525), and 20×24-inch prints ($650). A separate water-collection base is required for dry-surface use. The company also makes first-rate film washers (two models, listing at $32.50 and $45) and a pre-rinse tray ($138).
Kostiner Photographic Products, 12 Water Street, Leeds, MA 01053. (413) 586-7030.

ORIENTAL

Oriental's print washer is a fitting addition to its product line, given the popularity of the company's premium enlarging papers among fine-art printers. The Oriental design is manufac-

Gravity Works

This Wisconsin-based company has become a major player in the manufacture of professional darkroom products. Gravity Works distributes archival film and print washers under its own name and also builds print washers to specifications for Arkay, Calumet, and Oriental.

The Gravity Works AFW45 film washer (the same washer is sold as the Oriental AFW57) has an ingenious design that relies on siphoning. As soon as the washer fills up, suction begins and drains it, whereupon the washer begins to fill again, effecting a complete change of water every minute. You can stack as many as six 35mm film reels inside, and an accessory sheet-film basket ($24) holds twelve sheets of 4×5-inch film. The list price for the AFW45 is $70. (Gravity Works also makes several film washers for Calumet.)

Gravity Works print washers come in six models—8×10 inch ($225), 11×14 inch ($370), two 16×20-inch models ($465 and $595), and two 20×24-inch designs ($595 and $765).

Gravity Works, 1355 Williamson Street, Madison, WI 53716. (608) 251-8044.

Gravity Works film washer.

tured by Gravity Works and incorporates several unusual features. Many archival print washers fill from the bottom, but Oriental's water-injection manifold is on the side. Among other things, this design ensures that the washer will drain fully on its own. Some bottom-manifold washers must be tipped to drain fully, and may develop mold even if they're emptied after each wash.

The vertical manifold reflects Oriental's straightforward approach. After water enters each of twelve chambers through two holes, it moves horizontally across the prints and travels lengthwise to the far side of the washer for drainage both by bottom discharge and overflow from the top. An inside wall creates a narrow reservoir for the overflow, which drains through a hose. You can control the ratio between overflow and bottom discharge with a clamp on the bottom-discharge hose. The washer thus operates on a dry surface without the need for a separate water-collection base.

All the needed hoses and fittings come with the washer. You can choose models for 8×10-inch prints (list price, $309), 11×14 inch ($435), 16×20 inch ($551), and 20×24 inch ($761). Each accepts up to twelve full-sized prints, or more of smaller sizes.
Oriental Photo Distributing, 3701 West Moore Avenue, Santa Ana, CA 92704. (800) 253-2084.

Other Brands of Archival Washers

ARKAY
CALUMET
GRAVITY WORKS
WISNER
ZONE VI

Drying Screens

Prints passing through commercial dryers that use cloth belts leave residual chemicals that can eventually contaminate the drying process and lead to fading and staining. For archival care (see pages 204–206), serious photographers generally air-dry their prints on screens. Screens are not only safer but also far cheaper than good heated units. On the down side, prints take far longer to dry this way.

You can make your own drying screens from commercial fiberglass screening materials, sold by the foot in hardware and home-supply stores. First construct a narrow wooden frame of the required size, then carefully stretch the fiberglass across and secure it with staples along each side. Be sure to make the screen big enough so the prints won't overlap; build a screen at least 17×21 inches, for example, if you want to be able to dry a 16×20-inch print on it. Commercially made canvas stretcher sections, available in artists' supply stores, are a good quick-and-dirty alternative to wood for making the frame.

After the prints are fully washed, squeegee them carefully on a clean surface and lay them on the screen—face down for fiber-based paper, to minimize curling, and face up for resin-coated paper. Make sure that prints don't come in contact with the frame, and keep the screens dust- and lint-free.

These are two companies that make drying screens.

Kostiner. Kostiner, best known for its enlarging easels and archival print washers (see pages 42 and 49), makes ingenious collapsible drying screens that can be stored in a small tube. The sides quickly snap together to create a rigid frame for the fiberglass screening material. These easily stackable screens come in two sizes—a small one (outside dimensions, 20×26 inches) that holds four 8×10-inch prints, two 11×14s, or one 16×20 (list price, $24.95) and a large one (outside dimensions, 28×36 inches) that holds nine 8×10s, four 11×14s, two 16×20s, or one 20×24 ($34.95).
Kostiner Photographic Products, 12 Water Street, Leeds, MA 01053. (413) 586-7030.

Spiratone. This mail-order firm (see page 57) offers the Stack Rack Dryer—inexpensive though less elegant screens that dry prints just as well as Kostiner's screens. You can stack Spiratone screens by threading a plastic rod through holes on their edges; short lengths of plastic tubing slipped over the rod keep the screens apart. The screens dismantle easily for storage. Spiratone sells a set of three for $30, each measuring 20¾× 24¾ inches to accommodate eighteen 8×10-inch prints, six 11×14s, three 16×20s, or (just barely) three 20×24s.
Spiratone, 135-06 Northern Boulevard, Flushing, NY 11354. (800) 221-9695.

Kostiner print-drying screens.

Studio Lighting

Until recently, "hot" lighting—fixed, continuous sources such as quartz lights and photofloods—were a staple in every professional studio. Today such lights are rarely used, supplanted by feature-laden electronic flash units generally referred to as strobes.

There are many compelling reasons why strobe lights have become so popular. They don't generate heat, and the very short duration of the light burst ensures sharp images of moving subjects and all but eliminates camera shake as a factor. Strobes don't have the enormous, fuse-blowing electrical appetite of hot lights, and reasonably powerful battery-operated strobes eliminate the need for AC current, a power supply not always available for on-location shooting. Strobe lights also permit a unique effect that combines their motion-stopping abilities with the blur created by ambient light at relatively slow shutter speeds. The result—a sharp image superimposed on a soft one—is called ghosting and can create an intriguing and seductive effect.

Chimera lightbanks.

Strobe Choices

Many photographers use standard on-camera strobe units for location work, often securing them to a lightstand and bouncing them into umbrellas or through the diffusing panels of light-modifying devices. Domke (see pages 35 and 219) and Cougar Design are two companies that make hardware to easily secure flash units that attach to a hotshoe, such as the popular Vivitar 283, to an umbrella stem.

If a conventional on-camera strobe doesn't have enough power, consider the Norman 200B, a popular 200-watt-second portable unit powered by a rechargeable battery pack. Many photographers carry several units for location work rather than a single, larger studio strobe that has to be plugged in.

In the studio, a plug-in strobe provides far greater flexibility. Strobes that don't depend on battery power run continuously with more power and recycle more quickly. Such units range in power from 500 watt-seconds to a whopping 5,000 watt-seconds. Many photographers gang their power packs, firing more than one at a time to increase the output.

Generally, the more powerful the strobe unit, the heavier and bulkier it will be, although for a substantial premium you can buy extremely strong units that weigh no more than units providing half their power. Bigger strobes almost always provide the option of lower power settings; for example, you can usually set a 2,400-watt-second unit to produce 600 or 1,200 watt-seconds.

Although it's tempting to choose the smallest unit that seems to fit your needs, don't underestimate the advantages of additional power. There is no all-purpose system, so you need to consider many factors before making a

choice. One such factor is film format. When shooting large-format film, you need to use longer lenses than when shooting 35mm. Longer lenses have inherently less depth of field and must often be stopped down to achieve adequate sharpness. With strobe, the best way to create enough light with small apertures is by using a more powerful strobe unit—one that delivers more watt-seconds.

Also, consider whether or not you plan to modify the strobe light—and if so, how. If you bounce the light into an umbrella or otherwise diffuse it, you'll lose a significant amount of light in the process and need extra power to compensate for that loss. On the other hand, if you use strobes to do copywork with lights aimed directly at the subject, the light will be more efficient and you can get away with smaller, less powerful units.

BALCAR

Balcar is an old name in studio flash, but its strobes are quite innovative. They are part of an extensive system that includes various umbrellas, lightbanks, and other specialized lighting equipment. The company's French- and Swiss-made top-of-the-line professional units come in 800-, 1,200-, 1,600-, 2,400-, 3,200-, and 6,400-watt-second strengths. Each model has three plugs, with switches that distribute power in various ways among the outlets. You can regulate flash power continuously from full to one-sixteenth strength.
Tekno, 100 West Erie, Chicago, IL 60610. (312) 787-8922.

NORMAN

The power packs for Norman's plug-in strobe units come in strengths of 500, 800, 1,200, 2,000, and 4,000 watt-seconds. Each is bigger and heavier than the previous one in the series, except for the 4,000-watt-second unit, which is about the same size as the 2,000.

The latter, the Norman P2000XT, has a list price of $1,295 and is especially popular for studio work because it has the power for large-format work but can also produce more modest out-

Brittdome.

Balcar.

Other Studio-Strobe Makers

ASCOR
BOWENS
BRONCOLOR
CALUMET
COMET
DYNA-LITE
MORRIS
MULTIBLITZ
NOVATRON
PHOTOGENIC
PROFOTO
SPEEDOTRON

puts for 35mm shooting. The P2000XT has seven outlets, and you can split the power among heads in a variety of ways to control lighting ratios. An outlet on the side pumps the unit's full 2,000 watt-seconds of light

into one head (make sure you choose a head that has this capacity—the LH2000 or LH2400); outlets and power switches allow the light to be divided into 200, 400, 800, or 1,200 watt-seconds. Using rheostatic dials, you can approximate the effect of various ratios with the modeling lights. The Norman P2000D is a real workhorse and can withstand considerable abuse.
Norman Enterprises, 2601 Empire Avenue, Burbank, CA 91504. (818) 843-6811.

Lighting Software

The popularity of strobe lighting has spawned a relatively new product—lighting software, devices that control and soften light from a strobe. Such devices either bounce the light against a reflective surface or diffuse it through a translucent cloth scrim. Some products use some combination of the two methods.

The most familiar piece of lighting software—one that's been used for a long time with hot lights—is the umbrella, a light-softening surface whose parabolic shape reflects light more efficiently than a flat panel does. Umbrellas vary in efficiency; for example, some have a silver lining that reflects more light back with a more directional quality and creates increased subject contrast.

Some umbrellas are made of translucent fabric so that light can be aimed through them rather than bounced. This produces a soft but somewhat more directional light, such as that from a lightbank or softbox (see below). Some umbrella-style products combine the two effects, with one opaque reflective umbrella bouncing the light back through a second translucent umbrella.

In recent years, lighting software had progressed from the umbrella to the lightbank or softbox—a pyramidal box with a translucent diffusing screen at one end and an opening for the strobe head on the other. Rigid models are sold for studio use, and many photographers construct their own from

foam-core board and diffusion film. However, the most popular type is the collapsible, portable lightbank similar to the one pioneered by Chimera.

CHIMERA

Chimera took alpine tent designs as the inspiration for its highly successful line of lighting software. The company's lightbanks have a skeleton of steel or aluminum rods that are threaded through sleeves in each edge of the bank. These rods are held rigid by the tension created when their ends fit into the four corners of a speed ring, which mounts the lightbank on a specific strobe head. (You must specify the brand of strobe when purchasing the unit; Chimera makes speed rings for dozens of strobes.)

The walls of the box are made of an opaque material that's reflective on the inside, so it directs the strobe light into the box's translucent front face. In most models, a secondary diffusing baffle can be hooked into the middle for additional diffusion, creating softer light and lower subject contrast.

Chimera lightbanks come in many models, prices, sizes, and dimensions, from the 16×22-inch Pro II Bank (weighing less than a pound and listing for $65) to the 180×480-inch F2 Bank (250 pounds, $11,000). Speed rings for the studio strobes vary in price, but most list between $34 and $98.

When choosing a lightbank, consider that at any given distance from the subject, the larger the front face of a lightbank, the softer the light will be.

Lightbanks in Chimera's Super Pro line are available with a silver lining, which makes the light more contrasty and cooler than that produced by a like-sized bank with a white interior. Super Pro models also have a recessed front screen, creating a lip that varies in depth depending on the size of the bank. This lip helps control the light falloff and is particularly useful in tabletop setups using seamless backdrops.

Chimera, 1812 Valtec Lane, Boulder, CO 80301. (800) 424-4075; (303) 444-8000.

See page 218.

Westcott Metallized Blue Umbrella

Some photographic umbrellas have a gold reflective lining designed to warm the light bounced into them, usually to make portraits more flattering. Westcott takes the opposite approach, making an umbrella that cools the light down. This device raises the color temperature of a tungsten or quartz-halogen lamp from 3,200 degrees Kelvin to 5,600 degrees Kelvin, which lets you shoot daylight film with hot light without color-correction filters. The list price is $59.95.

F.J. Westcott, 1447 Summit Street, Toledo, OH 43603. (419) 243-7311.

PHOTOFLEX

The Brittdome, manufactured by Chimera competitor Photoflex, may be the most sophisticated approach to umbrella-style lighting to date. This device uses two umbrellas—one a translucent type, the other an opaque-silver bouncer. The stem of the shoot-through umbrella slides into the stem of the opaque one, which first threads through the umbrella hole on a strobe head mount. The head is usually aimed into the opaque umbrella, which reflects the light into the translucent umbrella, producing a double-barreled softening effect that's particularly flattering for portraits.

A translucent skirt stitched to the outside edge of the Brittdome's translucent umbrella wraps around the outside of the opaque umbrella and secures with drawstrings. This closes the gap between the two umbrellas, thus allowing the distance between them to be adjusted for greater control over the spread of the light. An opaque skirt can be wrapped around the translucent skirt to make the light more directional.

List prices for variously sized Brittdomes are $109.95 (thirty inches), $159.95 (forty-five inches), and $209.95 (sixty inches).
Photoflex, 254 East Hacienda Avenue, Campbell, CA 95008. (800) 826-5903.

Other Lightbank Makers

BALCAR
CALUMET
LARSON
PLUME
WESTCOTT

Mail-Order Sales

Most large cities have at least one professional camera store—a store that stocks a wide variety of quality products and materials at reasonable prices. In small cities and rural areas, however, the population may be too scattered to support such a store. That's when mail-order shopping becomes a necessity.

Aside from convenience, there are many good reasons to buy by mail. Many mail-order suppliers offer excellent prices and an enormous range of choices. Most retail stores concentrate on big-ticket items (such as cameras and lenses) and quick-turnover products (such as film and processing). Very few offer a wide selection of, say, archival products, chemicals in bulk, or hard-to-find photography books. But several mail-order companies supply all of these and more. Many advertise in magazines such as *Shutterbug* and *Popular Photography*.

The following catalogs are available free upon request, unless otherwise noted.

See pages 67, 85, and 201 for specialty mail-order suppliers.

FREESTYLE

Established in 1946, Freestyle specializes in film and paper, carrying a variety of brand names as well as some hard-to-find and exotic ones. A recent catalog included black-and-white film (in 35mm, 120, and 4×5-inch formats) made by Arista in England, color printing paper from Mitsubishi, a good selection of Oriental papers, Du Pont medical X-ray films, and several films and papers for the graphic-arts industry. Freestyle also sells such items as darkroom equipment and chemicals, dry-mounting presses and tissue, and various tripods.

Freestyle has a reputation for low prices, and offers inexpensive generic materials from all over the world. The catalog may describe products simply as "Europe's Finest RC Paper" or "Japan's Finest RC Paper." The quality of such materials may vary, but often you'll find an excellent product at a good value.

The company also buys generic films and papers in bulk and repackages them for sale at a good price (it specifies which products are repackaged, so read the catalog copy carefully). Discounts on Kodak and other brand-name products, unless repackaged, are generally less enticing.
Freestyle, 5124 Sunset Boulevard, Los Angeles, CA 90027. (800) 292-6137; (800) 545-1011 in California; (213) 660-3460.

LIGHT IMPRESSIONS

Light Impressions, a leading supplier of archival products and photography books since 1968, prints splashy catalogs full of first-rate products. You'll find a wide selection of storage boxes and cases for negatives and prints, high-quality slide-filing systems, lightboxes, print washers, chemicals for alternative processes, and such arcane items as bookbinding materials and cold-storage envelopes for color negatives, prints, and nitrate-based films.

The company also supplies a variety of frames and framing supplies, as well as acid-free mounting boards and papers in a good choice of colors, sizes, surfaces, and thicknesses. It will

cut mattes to your specifications.

When it was formed, Light Impressions was primarily a distributor (and even publisher) of photographic books. Its selection of books remains outstanding, and most are discounted. Prices on some other products are also cut, though not as deeply as they might be elsewhere—if you can find them elsewhere.

Light Impressions, 439 Monroe Avenue, Rochester, NY 14607. (800) 828-6216; (800) 828-9629 in New York State; (716) 271-8960.

See pages 85, 201, and 206.

PHOTAK

An unusual catalog in the guise of a newsletter, *PhoTak* provides accessories and information. It doesn't show much in the way of cameras, lenses, or major hardware—just items to make shooting "simpler and more productive," such as Domke camera bags and Quantum batteries.

The *PhoTak* newsletter appears every other month and costs $4 per year. It includes features and short takes on subjects ranging from computer information services to news briefs and product reviews, including products they like but don't sell.

PhoTak, Box 2104, Neenah, WI 54957. (414) 722-8733.

THE PHOTOGRAPHER'S CATALOG

For years, Calumet was best known for selling, mostly by mail, sturdy view cameras and lenses. It had the kind of products a school or a studio on a tight budget might buy—not fancy, but useful, and at reasonable prices.

More recently, Calumet has expanded both its product line and its mail-order business. It now produces *The Photographer's Catalog,* a fat volume of about 200 pages that's a good reference even if you don't intend to buy anything right away. The catalog includes a wide selection of products and describes each one thoroughly, along with the occasional technical tip.

The catalog lists more than 11,000 items for the professional photographer. It features house products (such as Calumet and Horseman view cam-

PRS Photographic.

The Photographer's Catalog.

ReSource.

eras and Caltar lenses), top brands (Schneider lenses, Polaroid film holders, Halliburton cases, Fuji cameras), and many items from smaller companies (Kostiner easels, Gravity Works print washers, Lightware cases). Products include cameras of all formats, film, paper, meters, enlargers and darkroom accessories, film- and paper-storage materials, and books. The selection of house and name-brand studio and lighting equipment is an especially broad one.

Calumet offers discount prices, and its service is quite good. Unlike many mail-order companies, it has personnel who can actually help with your technical questions and suggest products to fit your needs.

The Photographer's Catalog, Calumet, 890 Supreme Drive, Bensenville, IL 60106. (800) 225-8638.

PORTER'S CAMERA STORE

Porter's calls its tabloid-style mailing the "granddaddy" of photo catalogs. The company has been in the retail business since 1914, but didn't start its mail-order division until the late 1960s. The catalog is large (over 100 pages) and unpredictable, mixing high-quality products (Nikon cameras, Vivitar flashes, Saunders easels) with stuff more appropriate for the local five and dime (economic compass cutters, photo-note papers, picture-hanging kits). It also offers a wide selection of video equipment and accessories. Prices are discounted and competitive.

Porter's brims with inexpensive, low-end products, and you may have to wade through a sea of useless items to find some of its best offerings. But it's usually worth the wade. It carries a lot of useful products that the average camera store may not stock, such as Kodak Panalure paper (for black-and-white prints from color negatives) and inexpensive opaque plastic adhesive sheets (for sealing windows in temporary darkrooms).

Porter's Camera Store, Box 628, Cedar Falls, IA 50613. (800) 553-2001; (800) 772-7079 in Iowa; (800) 553-2450 in Alaska and Hawaii; (319) 268-0104.

High Volume at Low Prices

For some large camera stores selling conventional products such as cameras and lenses, mail order is an integral part of their business. Many offer a good selection of items at very competitive prices. Several have branched off into selling computer and electronic products.

Some of these stores maintain low prices to stay competitive in a tough professional market. Others achieve low prices by handling a tremendous volume of sales. And some deal heavily in the "gray market," buying from sources all over the globe and using fluctuations in currency values to make the best possible deals for themselves—and, hopefully, their customers.

Don't expect much hand-holding from mail-order businesses. You should know exactly what you want when ordering from these sources. Call or get a catalog (most publish one) and do some price shopping. For comparison, be sure of what you're getting at the quoted price—for example, ask whether the lens with the camera is made by the camera manufacturer or by an independent company, or whether the product includes a case or a strap, or if it carries a U.S. warranty from the camera maker. (Some manufacturers void their warranty for gray-market goods in an attempt to discourage the practice.)

ABE'S OF MAINE
17 East Grand Avenue
Old Orchard Beach, ME 04064
(800) 227-0400; (207) 934-4566;
(207) 934-5528

ADORAMA
42 West 18th Street
New York, NY 10011
(800) 223-2500; (212) 741-0052

B&H PHOTO
119 West 17th Street
New York, NY 10011
(800) 221-5662; (212) 807-7474

CAMBRIDGE CAMERA EXCHANGE
Seventh Avenue and 13th Street
New York, NY 10011
(800) 221-2253; (212) 675-8600

CAMERA WORLD
500 S.W. Fifth and Washington
Portland, OR 97204
(800) 222-1557; (503) 227-6008

EXECUTIVE PHOTO AND SUPPLY
120 West 31st Street
New York, NY 10001
(800) 223-7323; (212) 947-5290

FOTO CELL
49 West 23rd Street
New York, NY 10010
(800) 847-4092; (212) 924-7474

47TH STREET PHOTO
Mail Order Department
36 East 19th Street
New York, NY 10003
(800) 221-7774; (212) 608-6934

GOULD TRADING
22 East 17th Street
New York, NY 10003
(800) 367-4854; (212) 243-2306

HELIX
310 South Racine
Chicago, IL 60607
(800) 621-6471; (312) 421-6000

OLDEN
1265 Broadway
New York, NY 10001
(800) 223-1444; (212) 725-1234

STANDARD PHOTO SUPPLY
43 East Chicago Avenue
Chicago, IL 60611
(312) 440-4920

PRS PHOTOGRAPHIC

A wholesale catalog house for professional photographers, PRS Photographic offers a wide selection of darkroom and other equipment (but no cameras) and an enormous variety of Kodak materials (it carries only Kodak and Polaroid films and papers).

PRS Photographic is small and reliable, and its prices are excellent (popular Kodak films sell at 5 percent over cost). It's also quick, promising and delivering shipment of in-stock items within twenty-four hours. The catalog takes great pains to spell out terms and policies regarding orders, returns, and similar issues. PRS adds a 3¼ percent surcharge to credit-card orders and offers a 2 percent discount for prepaid orders.

PRS Photographic, Box 987, Plattsburgh, NY 12901. (518) 561-0939.

RESOURCE

Produced by the Maine Photographic Workshops, *The Maine Photographic ReSource* catalog offers both commonplace and eclectic products for the serious photographer. Its offerings are highly selective. For instance, *ReSource* doesn't carry all the high-quality enlargers available—just two of them (Beseler and Saunders). Its paper selection leans heavily toward premium brands, such as Kodak Elite, Ilford Galerie, and Agfa Portriga.

Many of the products available through *ReSource* come from small companies that have developed unique (or uniquely high quality) alternatives to better-known brands (a recent catalog devoted an entire page to Sprint chemicals and to Kostiner darkroom products).

Although *ReSource* supplies camera equipment and accessories, its strength lies in its selection of darkroom and archival products. It also has a good choice of books, and, for some reason, sells live Maine lobsters. Almost all the products are discounted, sometimes quite competitively.

ReSource, The Maine Photographic Workshops, Rockport, ME 04856. (800) 227-1541; (207) 236-4788.

See pages 12, 202, and 206.

SPIRATONE

Long known for its broad selection and low prices, Spiratone sells house lines of lenses, lighting systems, close-up and duplicating equipment, and other accessories. Most of the Spiratone-brand lines are low end and not of professional quality, but for occasional and noncritical use, they'll do. It's hard to beat the prices. Some examples: a 500mm f/8 mirror lens for $229.95, a vinyl tripod case for $9.95 (two for $17.95), and a copystand with lights for $94.95. Spiratone sells some other brand names (Lowell lighting, Kodak projectors, Quantum radio slaves), but its prices on these items, though discounted, are nothing special.

The Spiratone catalog does contain some gems, and many hard-to-find items. It offers a lot of inexpensive slide-duplicating systems, as well as a stabilization processor for RC papers (cheap at $249), an economical air compressor to eliminate dust from negatives and equipment, and some archival products such as fiberglass screens for air-drying prints.

Like so many suppliers of photographic equipment, Spiratone has expanded into video and computer products, carrying over its formula of basic equipment at low prices. Among its most interesting items in these areas are video printers, computer-imaging systems, and multi-image programming equipment for creating slide presentations.

Spiratone, 135-06 Northern Boulevard, Flushing, NY 11354. (800) 221-9695.

ZONE VI STUDIOS

Operated by photographer Fred Picker, Zone VI Studios runs workshops and sells products, mostly designed for the view-camera user. Many of the products are modified or designed by Zone VI or repackaged under the Zone VI name. Others, such as Schneider lenses, are name brands preferred by Picker and his staff.

The Zone VI catalog is not large, but it has a careful selection of quality products for shooting and darkroom work. Some of the more interesting

Porter's Camera Store.

PhoTak.

Freestyle.

Zone VI–brand products include archival print washers, a 4×5-inch field camera (modeled on the Deardorff), cold light heads for enlargers, and a complete system of black-and-white chemicals. Most of the selections are discounted.

Zone VI Studios, Newfane, VT 05345. (802) 257-5161.

See pages 152 and 197.

Quick Tips for Mail Order

1. *Use the toll-free number, if one is provided.*

2. *Pay with a credit card.*

3. *If you have a choice, order from an out-of-state supplier to avoid sales tax.*

4. *Make sure you provide complete information—product number and description—and receive the exact price and shipping costs.*

5. *Ask for an order-confirmation number and/or the name of the person with whom you are placing the order.*

6. *Inquire about the current availability of the products ordered. Are they in stock or on back order?*

7. *Request that the order be shipped in a way that's convenient for you to receive it. Most companies are set up to send by UPS, the post office, or Federal Express (for an additional charge).*

8. *Get an approximate shipping date and make a note to call back and ask about the order if it hasn't arrived by then.*

Viewpoint: Retailing

STEVE BRETTLER
PRESIDENT
E.P. LEVINE, BOSTON

"In my fifteen years in the photographic retail business, I've seen a lot of changes. We all know that cameras are becoming increasingly computerized. More and more functions are built into computer chips, allowing the equipment to handle such critical areas as calculating exposure and setting focus.

"This has many implications, not the least of which is that manufacturers can introduce new models more easily. They no longer have to retool totally; all they have to do is change the insides—the electronics. In part, this is what helps make our industry so manufacturer-driven. It was the success of the all-automatic point-and-shoot models that led manufacturers to autofocus SLR—not any expressed need from the SLR customer. They simply saw an opportunity to introduce the new technology in an area where it could make them more money. Point-and-shoot buyers don't need accessory lenses and accessories; SLR buyers do.

"Furthermore, camera makers are building-in an increasing number of 'gee-whiz' features in an attempt to one-up the competition. Again, they've just decided to go ahead and do it, not bothering to ask customers what they really want.

"In the 35mm world, the primary exceptions to this trend are Leica and Nikon. Both companies have been very responsive to the needs of their serious amateur and professional customers. Leica has a long history of listening, and its recent introduction of the R-6, a high-end all-mechanical system, is just one example of this attitude—introducing a nonautomatic model in this day and age is pretty revolutionary.

"Among Japanese camera manufacturers, Nikon is a small company, which makes its repeat customers particularly important. For years, Nikon has carefully tailored an image as the pro's company, but when it tried to force autofocus lenses on its customers a short while ago, it faced a rebellion. To Nikon's credit, it responded very quickly with such tactics as making sure its professional customers got priority delivery on the lenses they needed, and redesigning some autofocus lenses for better manual focusing.

"Oddly, after an initial mixed reception, serious photographers are embracing autofocus much more rapidly than many in the industry had anticipated. We saw much more negative response when the first autoexposure systems were introduced.

"Most of my customers are serious amateurs, fine-art photographers, and professionals. I see few real equipment innovations that address their needs. Certainly the Nikon F4 is big news, and European strobe manufacturers now offer some amazing, highly computerized units. However, the customer base for most medium- and large-format cameras, enlargers, and other upscale items is simply too small to justify constantly changing and upgrading existing models. Hasselblad, which makes the quintessential professional camera, has been selling the same basic model, with minimal improvements,

for twenty-five years. Deardorff cameras, despite their high price and serious competition from Wisner and others, enjoy enormous demand for what is basically eighty-year-old technology.

"Another reason for the lack of change is that the professional market is inherently conservative. Pros are very reluctant to mess with a system that works, and they may have many thousands of dollars tied up in lenses and other accessories. For a pro, upgrading from manual focus to automatic requires a serious financial commitment; it means buying a few camera bodies and maybe ten or twelve lenses, plus accessories.

"The past decade has seen the emergence of small, entrepreneurial companies fulfilling the needs of professional photographers. Companies such as Chimera, Kostiner, and Visual Departures are making products that larger companies hadn't thought of or bothered with. Most of these ventures were started by photographers, who were particularly well positioned to see specific needs. Chimera is an excellent example. Not only did it develop a whole line of lighting equipment, which others have since cloned, but in so doing it has helped create a new lighting aesthetic—that of soft, even light with minimal shadows.

"A big part of my business—and that of many retailers in the high end of the market—is selling used equipment. The profit margins are higher and the demand is incredibly strong, partly due to the high cost of new items and partly because of dissatisfaction with 'improved' products. Despite the general acceptance of autoexposure and autofocus, there's a thriving trade in manual equipment. I can always sell a good Nikon F2 or a Canon FTB at a good price."

MATERIALS

Special Films

Most photographers use very few types of film in their everyday work. However, there are hundreds of different films on the market; for example, Polaroid alone makes about fifty. Most of these films are pretty obscure, used for special applications in science, medicine, or graphic arts. But many can be used to achieve special effects in general-purpose shooting. A few films originally developed for special applications have become more commonplace—for example, infrared film has been adopted by fine-art photographers who like the feeling it evokes.

Computer imaging systems have rendered many special films obsolete, especially those made for technical use. Some face extinction as a result. Finding a particular film is another problem altogether; very few camera stores carry a wide selection. Try local professional dealers; if they don't carry what you want, they can probably order it. The following are some not-too-obscure special films that you should be able to find without much difficulty.

An image made with Polaroid Polachrome CS slide film.

KODAK BLACK-AND-WHITE INFRARED
Originally intended for technical photography, infrared film has found uses ranging from medical imaging to the analysis and authentication of old paintings. However, over the last two decades or so, the overwhelming proportion of infrared users have been fine-art photographers seeking the film's surreal effects: the unnatural rendering of nature, replete with white foliage and, due to filtration, dark, dramatic skies, with an unearthly halo surrounding the highlights. These tonal qualities are enhanced by a crystalline texture that results from the film's relatively high granularity.

Infrared film obtains these odd results because it is highly sensitive to wavelengths beyond the red end of the visible spectrum of light, and thus records heat as well as light. This means that hot objects are rendered very light by the film. But temperature isn't the only determinant of tonality. Many things in nature—living things, mostly—reflect a great deal of infrared light, and the film negative records them as areas of relatively high density that translate into light tones in the print.

Because infrared film retains considerable sensitivity to visible light, many infrared photographers use a #25 red filter (or a #87 infrared filter) over the lens to cut out blue light. This filtering, rather than the film itself, is usually what makes blue skies so dark in infrared shots. (The #87 filter produces a more contrasty effect than the #25, and is so opaque that you can't see through it. If you're using an SLR camera, you have to remove the filter from the lens to compose and focus the subject.)

Infrared film's strong tonal separation of vegetation and blue water makes it popular for aerial photography, for which it's sold in 70mm rolls; with care, it can be bulk loaded for medium-format work. But fine-art photographers generally use infrared in its 35mm format, partly because greater enlargement of the negative makes the film's grain more prominent. The film also comes in 4×5-inch and 8×10-inch

sheets whose delicacy and sensitivity to touch make them among the most easily damaged of films.

Even in rolls, infrared film requires extra care; in particular, beginners see their film fog a lot. It is so sensitive to light that the cassette must be taken out of its plastic canister only in complete darkness; you'll need a changing bag to shoot more than one roll in the field.

Infrared film does not have a rated film speed, as other films do, because light meters don't register infrared radiation. Kodak recommends certain starting exposures in the tip sheet supplied with the film, but these often result in overexposure. The film's unusual effects are best obtained in direct, bright sunlight, for which a good starting exposure is 1/250 second at f/11 with a #25A (medium red) filter. Increase exposure for hazy or late-afternoon sun by a stop or more; reduce exposure by up to a stop for especially bright snow or beach scenes.

You can vary the quality of the image through exposure, too; increasing exposure to produce a denser-than-normal negative can result in a softer, grainier final image. The choice of developer also makes a difference. Use undiluted Kodak D-76 developer for eleven minutes at 68 degrees for a long tonal scale, or undiluted Kodak D-19 for six minutes at 68 degrees for more contrast.

KODAK PROFESSIONAL BLACK AND WHITE DUPLICATING FILM

Like color-slide films, this film is positive-working—that is, it yields a positive image from a positive original and, more importantly, a negative image from a negative original. This allows you to produce duplicate negatives in one step rather than by the traditional two-step method, which involves making an intermediate film positive and can result in a duplicate with too much contrast.

Uses for this unique film include making copies by contact-printing fragile glass-plate negatives or old negatives on flammable (cellulose nitrate) film stock. You can also use Duplicating Film to create enlarged duplicate

The T-Grain Breakthrough

Film reacts to light through the silver-halide crystals in its emulsion. Generally, the larger the crystals, the greater the light sensitivity, and the "faster" the film—because large crystals have more surface area with which to trap the light. Before T-Max, fast films produced grainy results, thanks to those large crystals.

The solution arrived with Kodak's VR series of color negative films, the precursors to T-Max film. These films used tabular-grain technology, or T-grain—flat, tablet-like silver-halide crystals. T-grain crystals present a much greater surface area to the light, with much less volume, than do conventional crystals. This makes for more efficiency in capturing light, and therefore a higher effective film speed for a given grain size. A happy by-product of this technology is a thinner emulsion, which increases sharpness because it scatters less light. T-Max films are noticeably sharper than conventional films of comparable speed.

T-grain.

Conventional grain.

negatives for use in alternative print-making processes (see page 78), which require that the negative be contact-printed because of the low sensitivity of their emulsions.

Duplicating Film comes in sheets (4×5, 5×7, or 8×10 inches) and is processed in conventional chemistry (use a paper developer, such as Dektol). You can control contrast by varying the time in the developer.

Two things to keep in mind. First, the film may appear fogged, because it is heavily pre-exposed in the manufacturing process. This pre-exposure gives it the ability to reverse tones back to the original, but also creates a high base-plus-fog density. Try not to let this unusual appearance interfere with your judgment when deciding if the exposure is correct; a dark negative may print perfectly, while a negative that seems a little dense may, in fact, be underexposed.

Second, when you're fine-tuning the exposure, remember that, as with any reversal material, more exposure means less density and less exposure means more density.

KODAK EKTAR 25

This new film from Kodak—part of a family of films with speeds up to ISO 1000—is arguably the highest quality color-negative material available. It achieves its quality in part by a significant slowdown to ISO 25, which is two stops slower than the next slowest color-negative film (ISO 100). In fact, Ektar 25 is the same speed as the original Kodacolor film, introduced about fifty years ago.

Ektar's lack of speed makes it less than ideal for many applications, such as hand-held low-light or fast-action shooting. But for photographers seeking the ultimate in 35mm color image quality, it's unparalleled. The grain is virtually invisible, even at high degrees of enlargement, and images are very sharp due to a thinner emulsion that reduces light scatter. An 8×10-inch print from a good 35mm Ektar 25 negative could easily pass for a print made with a 2¼×2¼-inch negative from ISO 100 film.

KODAK FINE GRAIN RELEASE POSITIVE

A long-scale, continuous-tone emulsion coated on a transparent base, Fine Grain Release Positive looks more like a printing paper than a film. Its most obvious application is in making positive transparencies from black-and-white negatives (or, with trade-offs, color negatives). For example, you can enlarge a 35mm negative on Fine Grain Release Positive to create a black-and-white transparency for backlit display, or contact-print the negative to make a positive slide for projection. You can also contact-print an enlarged positive onto another sheet of Fine Grain Release Positive to make a large negative for contact printing.

The film can also make black-and-white internegatives from color or black-and-white positive transparencies. Say you have a positive slide from which you want to make a positive black-and-white print. Enlarge the slide onto Fine Grain Release Positive to the size you want for a final print. Then tray-process it in standard black-and-white chemicals under a safelight, and wash, dry, and contact-print the resulting internegative on conventional black-and-white paper. This technique works best with a black-and-white original, but a color slide can yield acceptable results.

Fine Grain Release Positive comes in several sizes (35mm, 8×10 inches, 10×12 inches, and 11×14 inches). It has no contrast grades, however, so contrast must be controlled by using different developers, by adjusting development time, or during the printing process. Straight Kodak D-11 developer produces a contrasty image, and Kodak Dektol diluted 1:1 creates more moderate contrast. But unless the original slide is of low contrast, straight D-76 is often the best choice, because it produces relatively low contrast, mitigating the buildup of contrast inherent in the duplicating process.

In addition to controlling contrast, you can burn and dodge in the internegative. This eliminates the need for such manipulations every time you make a print, and also preserves the full range of detail in the original. Remember that these effects work backwards in an internegative—highlights (dark in a negative) are dodged to prevent them from blocking up, and shadows are burned to increase density so they produce better detail when printed.

KODAK KODALITH ORTHO

Litho films, made by most film manufacturers, were originally developed for the printing industry. They reduce a continuous-toned subject to a high-contrast one—pure blacks and whites. Photographers use them routinely for non-silver processes, photosilkscreening, and photolithography, as well as to create a wide variety of special effects.

Kodalith Ortho is the most popular of the current litho films. It comes in several sizes, from 35mm to 30×40 inches (the 35mm version is called Ektagraphic HC slide film). It's easy to handle under safelight illumination and can be manipulated through exposure and development to simulate a continuous-toned image, even though it's primarily used for high-contrast work.

You can use Kodalith directly in the camera; just load and expose it as you would any other film. Its film-speed rating is variable, but it's slow, so start out at about ISO 10 and experiment. More commonly, photographers use Kodalith Ortho in the darkroom and handle it just like paper. Slip it under the easel or into a contact printer with the light side up and expose your negative, making a test strip to determine exposure. You can develop it in many film and paper developers, in reels or in trays; the choice of developer has a lot to do with the amount of contrast you want. Kodak recommends Kodalith Super RT developer for 2¾ minutes at 68 degrees, but, again, experiment.

KODAK T-MAX 100, T-MAX 400, AND T-MAX P3200

Kodak's T-Max black-and-white films are general-purpose materials that qualify as "special" because of the quality images they produce—particularly in light of the quantum jump they represent in improving speed-to-grain ratio. For years, film manufacturers have searched for ways to create emulsions with the finest possible grain and the highest possible speed. With black-and-white materials, their efforts seemed stalled at ISO 400 speed films, such as Kodak Tri-X. Then T-grain technology opened up whole new horizons.

Kodak now uses T-grain in many of its new films, most of them color-negative materials such as Vericolor 400 and Ektar 25 and 1000. (In some, T-grain layers are intermixed with layers of conventional grain.) But the technology has found its most enthusiastic support among black-and-white photographers, who now have three T-Max films to choose from: T-Max 100, T-Max 400, and T-Max P3200. The first two are available in several sizes—35mm, 120, 4×5 inches, 5×7 inches, and 8×10 inches—while the latter is available only in 35mm.

T-Max numbers indicate each film's recommended speed. The quality of all three is quite high. A print from T-Max 100 could pass for one from the now-discontinued Panatomic-X, while T-Max 400 prints can compare favorably with prints made from Kodak Plus-X and other conventional medium-speed films. Even a print from a carefully processed T-Max 3200 35mm negative shows only moderate graininess.

These films share several other characteristics unique to their emulsion technology. Their reciprocity failure—the progressive loss of sensitivity an emulsion undergoes at long exposure times—is much less than with conventional films, thereby reducing the exposure increase required to compensate for the effect. Thus, at long exposure times, the correct exposure for T-Max 100 is substantially less than that required by the nominally faster Tri-X (ISO 400). Also, the spectral sensitivity of T-Max films is more even than that of conventional films; in particular, their reduced sensitivity to blue results in more natural-looking unfiltered skies.

In processing, T-Max films are very development-sensitive; small time

changes can produce dramatically different results. Also, agitation is particularly important; make sure you agitate every thirty seconds, no more or less. Further, T-Max films require longer fixing times—usually twice as long as conventional black-and-white films—and may show a slight pinkish stain even with adequate fixation (the result of the high levels of sensitizing dye in the film).

KODAK TECHNICAL PAN

At ISO 25, Kodak Technical Pan is the slowest—and the finest grained—35mm black-and-white camera film available. Originally designed to yield a high-contrast negative, with special chemistry available in kits from Kodak, Technical Pan can also produce a full-toned negative highly suited for pictorial photography. In fact, this film comes remarkably close to simulating the smooth, grainless tonalities of prints from larger-format negatives. Technical Pan is also available in 120, 4×5-inch, and 8×10-inch versions.

To get the full benefit of Technical Pan, you must pay careful attention to your technique. Slow, finer-grained films reveal any lack of sharpness more readily than faster, coarser-grained films do, so be sure your lens is sharp and properly focused, and that no camera shake degrades the image. (Most photographers use a tripod with Technical Pan for these reasons.) Carefully follow the processing instructions, because among other things they call for reduced agitation to keep graininess and contrast to a minimum.

POLAROID POLACHROME CS

Polavision, Polaroid's failed instant movie-film technology, finally bore fruit in Polachrome, one of a line of 35mm instant transparency films. All these films can be exposed in virtually any 35mm camera and developed in a matter of minutes with a separate chemical cartridge that works in a special processing unit called the Auto-processor.

With Polachrome, color is formed through a very different technology than that used in the familiar E-6 pro-

© RUSSELL HART

Made with Kodak Black-and-White Infrared film.

Made with Kodak Kodalith Ortho film.

© HENRY HORENSTEIN

Made with Kodak Ektar 25 film.

High-Speed Shooting

New film technologies have most helped photographers who need super-fast-speed materials to shoot moving subjects. In general, the faster the film, the shorter the required shutter speed, and the sharper the image.

Kodak T-Max P3200 can be processed to speeds from EI 400 to EI 12,500; some photojournalists have even rated P3200 at the staggering speeds of EI 25,000 and 50,000. To achieve its high speed, P3200 requires longer-than-average development — a push. Pushing a film (increasing the development time to compensate for underexposure) can cause excessive graininess and contrast in a negative, as well as a loss of shadow detail due to the reduced exposure. Kodak minimizes these problems by using T-grain technology, and by making T-Max P3200 somewhat low in contrast to begin with. Thus, at EI 3200, you get a full-toned, relatively fine-grained negative with reasonable shadow detail.

When developed to EI 1600, the resulting negative is somewhat less contrasty than normal; at EI 800, it is low in contrast. On the other end, some sports photographers rate P3200 at EI 6400 for low-light action photography; this renders a snappy negative with a lot of contrast, well suited for newspaper reproduction.

Oddly, you can obtain excellent black-and-white results at EI 3200 by shooting with Konica SR-V 3200 color film, then enlarging the resulting negative onto panchromatic printing paper. Panchromatic is a full-spectrum paper, able to respond to all the film's color-dye layers (see page 66). SR-V 3200 has exceptional sharpness (though it uses a different film technology than does T-Max), and the result is a full-toned, moderately fine-grained print that compares favorably to a black-and-white print made from a T-Max P3200 negative.

© HENRY HORENSTEIN

Made with Kodak T-Max P3200, shot at EI 1600.

cess or Kodachrome slide films. The latter rely on the subtractive principle of color imaging, in which cyan, magenta, and yellow dye layers recreate a subject's colors by subtracting their complements from the light passing through the slide. The image is recorded in much the same way. In the subtractive process, the black-and-white silver image (in which the original record of the subject exists) gets bleached out after it serves its purpose (the production of dye densities, created by color couplers that are activated by development by-products).

In Polachrome film, and in the additive color process on which it is based, the color image results from thousands of tiny red, blue, and green filter elements built into the film. These filter the light before it reaches the film's black-and-white layer, and the latter is retained, along with the filter elements, in the final transparency. Such differences contribute to the distinctive look of Polachrome: Even when it's properly exposed, the image is much denser than that of a conventional transparency, and has a pronounced granular texture due to the relatively large size of the filter elements.

This look harks back to Autochrome, the first commercially viable color process, which gave its subjects a dreamy, impressionistic appearance. Some photographers have exploited this effect in large color prints—both reversal prints (such as Cibachrome) made directly from the slide, and C-prints from an internegative.

Polachrome also comes in a high-contrast version, designed specifically for graphics applications such as shooting off a computer monitor. This version may also be useful for subjects that regular Polachrome—an inherently low-contrast material—might render too flat. Standard Polachrome comes in 12- and 36-exposure lengths, but High-Contrast Polachrome is available only in 12 exposures.

Black-and-White Premium Papers

Black-and-white materials have been making a comeback in the past few years. By introducing many new products, such as T-Max films, manufacturers have begun to make quality black-and-white materials a priority. This was not the case in the mid-to-late 1970s, when all efforts were aimed at improving the color materials overwhelmingly favored by amateur photographers. Photographers doing serious black-and-white work were left with printing papers that were not only unimproved, but actually getting worse. Manufacturers began reducing the silver content in their papers to prevent soaring precious-metal prices from driving up the cost, and this meant weaker blacks and muddier prints. Combined with the convenience and popularity of resin-coated papers, these factors threatened to make high-quality black-and-white fiber-based papers an endangered species.

Things began to change in 1979, when Ilford introduced its Galerie line of papers. Since then, premium—that is, high-quality—black-and-white printing papers have become the rage. Although these papers are inevitably more expensive, the assumption, a seemingly correct one thus far, is that the serious photographer will pay more for a superior product.

Print made on Agfa Portriga Rapid paper.

A Premium Paper Primer

Premium papers, sometimes called exhibition papers, deliver visibly richer image quality than conventional fiber-based or resin-coated papers do. They generally come in a limited contrast-grade range, possibly because manufacturers assume that a photographer seeking high quality will have negatives of relatively consistent contrast. Also, the contrast grades of premium papers are usually more widely spaced, so contrast must be fine-tuned in the developer, either by adjusting dilution or time, or by adding chemical agents that increase or reduce contrast.

Premium papers vary in the contrast they provide at a given grade level, depending on the brand of paper. They also vary considerably in image tone, from Portriga Rapid's warmth to Oriental New Seagull's dead-neutral tone (which some photographers make even cooler by using selenium toner). The base color of the paper has a strong influence on the perception of image tone, particularly in highlights, where the base shows through the most. An emulsion coated on a warm base will appear warmer, particularly in the lighter values, than if it were coated on a pure white base.

Most premium papers are available only on double-weight stock. Some come in surfaces other than glossy, but most good printers prefer some degree of gloss because it enhances an image's tonal scale. Glossy fiber-based paper air dries to a fairly soft sheen, not the high gloss of ferrotyped or glossy resin-coated papers.

AGFA INSIGNIA

Insignia's image tone is very warm, similar to Agfa Portriga's (see below), but its base is pure white rather than the creamy off-white of its soul mate. This means that Agfa Insignia produces somewhat cooler highlights. Those who've had trouble getting enough contrast out of Portriga may opt for Insignia, because it comes in a wider grade range (1–4). Glossy is the only surface available, in sheet sizes from 8×10 to 16×20 inches.

AGFA PORTRIGA RAPID

This one's been around for a while, though it's never been officially dubbed a premium paper. Long a favorite of photographers who love warm tones, Portriga Rapid has a creamy paper base and a chlorobromide emulsion that is highly sensitive to manipulation, either through developer additives or toning. Available only in grades 1–3, it comes in glossy and semi-matte surfaces, in sheet sizes from 8×10 to 16×20 inches.
Agfa, 100 Challenger Road, Ridgefield, NJ 07660. (201) 440-2500.

ILFORD GALERIE

Galerie pioneered the premium paper business. It has a rich neutral black tone, with a very slight tinge of warmth, and comes in either a smooth glossy or matte surface, grades 1–4, in sheet sizes from 8×10 to 20×24 inches.
Ilford Photo, 70 West Century Road, Paramus, NJ 07652. (201) 265-6000.

KODAK ELITE

Elite features a cool, neutral black image tone and a bright white paper base. It also comes in grades 1–4 and

Panchromatic Papers

Panchromatic papers allow you to make good quality black-and-white prints from color negatives. If the negative is good, the results can be excellent, but these papers come in only one contrast grade, making and less-than-good negatives hard to salvage.

Kodak Panalure II RC. For years, Panalure was the only panchromatic paper available. The current version is resin coated, glossy, and warm toned. Panalure II Repro RC has the same characteristics, but is one grade lower in contrast, making it ideal for enlargements of copywork.

Oriental RP Panchromatic F. This relatively new paper is excellent. It has a glossy surface and is resin coated, producing a colder-toned print than Panalure II.

in sheet sizes from 8×10 to 20×24 inches. Available only in a high lustre surface, Elite is coated on what Kodak calls a premium-weight stock, heavier than normal double-weight.
Eastman Kodak, 343 State Street, Rochester, NY 14650. (716) 724-4650.

ORIENTAL NEW SEAGULL.

Extremely cool in tone, New Seagull is sometimes hard to find but is worth the effort if you like your prints crisp and snappy. It tends to be more contrasty at a given grade level than its competitors, and is available in grades 1–4 and sheet sizes from 8×10 to 20×24 inches in a choice of glossy or lustre surfaces.
Oriental Photo Distributing Co., 3701 West Moore Avenue, Santa Ana, CA 92704. (714) 432-7070.

ZONE VI BRILLIANT

Available only from Zone VI (see page 57), this silver-rich French-made paper has a neutral tone. It comes in grades 1–4 and sheet sizes from 8×10 to 16×20 inches. Brilliant's surface is glossy, but satin-like rather than shiny.
Zone VI Studios, Newfane, VT 05345. (802) 257-5161.

Variable-Contrast Papers

Premium papers are, for the most part, graded papers; you have to buy several packets of different contrast grades to gain full control of the printing process. Even then, you frequently must make some development adjustments to fine-tune a print. These limitations are responsible for the increased popularity of variable-contrast papers among black-and-white printers. Not only do these papers eliminate the need to stock different grades, but because the filters used to control contrast are calibrated in half steps, they permit fine and easy control over contrast. You can even achieve an extra measure of control by breaking exposure into two parts—expose through a high-contrast filter and also through a low-contrast one. This technique, called split-filter printing, gives good blacks and shadow separation while maintaining subtle midtones and highlights.

Ilford Multigrade FB. Multigrade FB is a high-quality fiber-based cousin to the popular Ilford Multigrade II. It has a wide contrast range and produces prints with a neutral black tone. Multigrade FB comes in double

weight (glossy, matte, or velvet surfaces in sheets from 5×7 to 20×24 inches) and single weight (glossy surface only, 5×7 to 16×20 inches). Even though it's made for Ilford Multigrade filters, Multigrade FB paper will work just as well with Kodak's Polycontrast III filter kit.

Kodak Polyfiber. Kodak makes the most widely used variable-contrast papers and also the greatest variety. Polyfiber is a neutral-toned, fiber-based paper, available in glossy, lustre, and matte surfaces from 5×7 to 20×24 inches in double weight. (It also comes in single weight.) Use either the Kodak Polycontrast II filter kit or Ilford Multigrade filters.

Oriental New Seagull Select VC. A variable-contrast version of the company's New Seagull G, Select VC provides cooler image tones. Unlike the somewhat warmer-toned Multigrade FB and Polyfiber, Select VC only comes in a glossy surface. Oriental New Seagull Select VC/RP is an almost identical paper, except that it is resin coated. It works with either the Kodak or Ilford filter system.

Darkroom Chemistry

Photographic chemistry has long been a rich source of myth and legend. Some devotees consider commercial chemicals inadequate and prefer to mix their own. This is understandable if you use a chemical such as the fabled Amidol print developer, favored by the likes of Edward Weston, or if you want to modify conventional formulas to, say, achieve more or less contrast. But for most common uses, there's really no need to mix chemicals from scratch.

Good standard formulas come in powdered and liquid form from a number of suppliers. Although powdered chemicals are more of a nuisance to handle and pose more of a health hazard (see page 83), they are generally cheaper—sometimes considerably so. Kodak makes a wide range of packaged chemicals, some available only in powdered form, including the very popular film developer D-76 and the somewhat expensive but useful low-contrast paper developer Selectol Soft. Otherwise, most of the best chemicals now come as liquid concentrates.

Liquid Chemicals

Like other suppliers, Kodak offers its liquid developers, stop baths, and fixers in various concentrations and sizes. Two ounces of its indicator stop bath, for example, make one gallon of working solution; the concentrate comes in sixteen-ounce and one-gallon sizes. Kodafix, a liquid hardening fixer, gets diluted 1:3 with water for film and 1:7 for paper. Kodak Rapid Fixer comes in a less concentrated strength but with the hardener in a separate bottle, which lets you reduce the recommended amount of hardener (or eliminate it altogether) for archival print processing. The Ektaflo line of chemicals includes paper developer (Type I for cold-toned papers, Type II for warm-toned papers—both mix 1:9 with water), stop bath (1:31), and fixer (1:3 for film and 1:7 for paper). All come in one-gallon cubes for high-volume use, such as in school darkrooms.

The many other makers of good liquid processing chemicals include Edwal, Heico, Ilford, and Zone VI. Ilford offers a line of chemicals specifically for archival printing. These include a super-concentrated fixer that dilutes 1:3 with water, making it a rather expensive proposition. But this formula requires only thirty seconds of fixation, and Ilford claims that a shorter fixing time means that the paper's fibers absorb less fixer and can be washed free of it more readily.

Mixing Your Own

For those who want to concoct their own formulas from scratch, here's a sampling of companies that supply photographic chemicals.

Sprint Systems

Sprint, a small, independent company, offers a complete line of standard, premixed liquid black-and-white photographic chemicals, as well as chemicals for color and non-silver alternative processes. These products come in one-liter bottles and four- and twenty-liter cubes as concentrates that dilute 1:9 with water. Sprint has paid ample attention to user sensitivities; it has substituted the developing agent phenidone for rash-inducing metol in its film and print developers, and Block, its indicator stop bath, has been buffered and vanilla-scented to mask its unpleasant odor.

Sprint chemicals have a long shelf life and high capacity (they make about sixty 8×10-inch prints per liter of working solution). Also, all the working solutions exhaust at about the same rate, and the stop bath changes color to indicate exhaustion. Short processing times make Sprint a good choice for school darkrooms.

Offerings include Standard (a Kodak D-76/Ilford ID-11 replacement film developer), Quicksilver (a cold-toned paper developer), Record (a high-speed fixer), Archive (a fixer remover), as well as direct-positive chemicals for reversal-processing of black-and-white negative film, a pyro-based film developer, and a print brightener that contains optical whiteners to make the paper base, and thus the print highlights, more reflective.
See pages 85 and 220.

BLUE MOUNTAIN PHOTO SUPPLY
Box 3085
Reading, PA 19604
(215) 375-7766

Viewpoint: The Industry

RAYMOND H. DeMOULIN
VICE PRESIDENT AND
GENERAL MANAGER
PROFESSIONAL PHOTOGRAPHY
DIVISION
EASTMAN KODAK COMPANY
ROCHESTER, N.Y.

"Silver-halide technology will be going strong well past photography's 150th birthday. It has provided beautiful images with exactness, brilliance, and quality—and it will continue to do so. But it will share the stage with electronic imaging. Film and electronics are not involved in a technology struggle: it's a synergistic relationship.

"Whatever the eventual marriage between film and electronics, film will remain the yardstick for measuring image quality. Electronic sensors simply cannot provide the pixel count that film can. A 35mm color negative contains some fifteen million pixels, and larger formats contain more. By contrast, the best electronic sensor currently available provides a resolution of only four million pixels.

"The future for film emulsion technology is open ended. The quality gap between electronic sensors and film became a chasm when Kodak introduced its Ektar professional and Ektapress Gold professional films. Our patented T-Grain emulsion has amplified the potential of the silver-halide crystal, altering the classic speed/grain/sharpness triangle by improving all three characteristics simultaneously.

"Improvements in such imaging characteristics as speed and sharpness are just a starting point. We can now make 'designer' films that satisfy the tastes of niche markets. For example, in fashion photography,

preferences change yearly. One year true color is in; the next, saturated color. Film manufacturers respond with a myriad of films. In 100-speed transparency material, for instance, Kodak offers two Ektachrome professional films—one with true color, the other with highly saturated color.

"Photographers who prefer black and white haven't been forgotten. The black-and-white palette today is photography's richest in terms of speed, grain, sharpness, spectral sensitivity, and resolving power. Existing-light photography has become existing-darkness photography with Kodak T-Max P3200 professional film—the photographic world's X-1 jet, breaking the speed barrier with exposure indexes up to 25,000.

"Film improvements will contin-

ue to shatter speed, image sharpness, and resolution barriers. Kodak scientists are studying a technique to 'ruffle' the surface of tabular grain crystals, doubling the surface area. This may mean that films with extremely fine grain can be made faster and that high-speed films will become finer grained. Photographic papers will shift toward more resin-coated papers with multiple contrasts. A recent example is the new Kodak Polycontrast III RC paper, which has an extended contrast range on the high end, outstanding D-max, neutral blacks, and brilliant whites.

"While most photographers will prefer film for recording images, they'll use electronics for image preview, manipulation, and enhancement. Equipment such as the Kodak Prism Electronic Previewing System will let photographers simultaneously capture on a floppy disk an image identical to the one captured on film. Such systems currently aim at the portrait market, but improved color monitors in the future will allow commercial photographers to electronically transmit images to an art director's desk.

"Electronics will also enter the studio as electronic image-enhancement systems. These systems will merge, crop, rotate, and clone images, as well as change color balance, saturation, and contrast. They will also be able to 'write' to color negative and transparency films."

THE PHOTOGRAPHERS' FORMULARY
Box 5105
Missoula, MT 59806
(800) 922-5255; (406) 543-4534
See page 85.

ZONE V
Stage Road
South Strafford, VT 05070
(802) 765-4508

ALTERNATIVES

Stereo Photography

Stereo, or stereoscopic, photography first appeared in the Victorian era, when it gave armchair travelers a heightened sense of the exotic places they were unable—or unwilling—to visit. The two images required were mounted side by side on a stiff card trimmed to fit a stereopticon viewer, which created the illusion of three dimensions. Over several decades, specialty photography companies produced countless millions of these stereo images, offering narrative vignettes and posed scenes in addition to the usual geographical fare. Nice examples of stereo cards can still be found at flea markets and antique stores for small change. Stereopticon viewers, which range from bare-bones versions to richly ornamented, plush-lined models, are harder to come by due to a surge of interest in the Victorian stereo fad among collectors and museums.

Modern incarnations of stereo photography include the familiar children's Viewmaster, with its rotating discs of tiny color transparencies, and the weird-looking Nimslo camera of the late 1970s (see page 72). Many other viewing systems and cameras have emerged over the years with varying degrees of success, but the allure of stereo photography currently rests with a small but loyal band of fine-art types, hobbyists, and historical buffs.

How Stereo Works

The three-dimensional quality of a stereo photograph results from much the same principle as stereo sound, in which two sources combine to produce the illusion of fullness. For a photo, two exposures are made of the same subject from vantage points several inches apart—a distance about the same as the separation between the pupils of your eyes. Subtle discrepancies between the two images provide the brain with cues to depth similar to those used in binocular vision.

The two pictures have to be sent individually to each eye—the left-hand image to the left eye, the right-hand image to the right—so that neither sees the other's picture. The shots must also be superimposed. A stereopticon accomplishes this with a baffle and prismatic lenses. A 3-D movie projects the two pictures separately through polarizing screens turned at right angles to one another. These correspond to the angles of polarizing screens mounted in viewing glasses, which ensure that each eye sees only the image intended for it.

Handmade Stereo

In recent years, stereo photography has enjoyed something of a renaissance among both fine-art photographers and serious hobbyists. Older models of stereo cameras are still traded and used, but you can create a stereo view with a conventional camera simply by taking two photographs in sequence of the same subject. For best results, brace the camera on a tripod or other platform so that when you move it (about three inches) to expose the second frame, the height of the camera will remain the same. A 35mm or 120 roll-film camera works best because the two adjacent negatives can be printed simultaneously, by contact if you use 120 roll film, or by enlargement with 35mm. When enlarging paired 35mm negatives, use a 4×5-inch or other large-format enlarger (and negative carrier) so both negatives can be printed at the same time. You'll need an enlarging lens with a focal

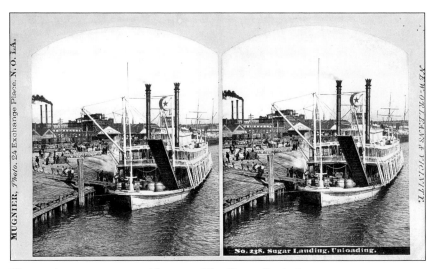

Nineteenth-century stereo card (courtesy Allen Hess collection).

length of at least 105mm to cover both negatives, as well as a glass-negative carrier to keep the film flat.

If the film advances from left to right, as in most cameras, expose the left-hand frame first; if it advances from right to left, expose the right-hand frame first. If the film moves from top to bottom, as in older square-format twin-lens reflexes, place the camera on its side so that the film is transported laterally.

If you use the method described above, choose fairly static subjects. If the subject moves between the two exposures, it will be difficult or impossible to resolve. Avoid very wide-angle lenses, because they cause shape distortions that may differ even with the slightest shift in position and make viewing difficult. When shooting with a 35mm camera, stick with lenses in the 35mm to 50mm range.

Whether you use a conventional camera or a stereo model, try to compose your pictures to accent near-far relationships. This will give closer subjects a more convincing sense of depth.

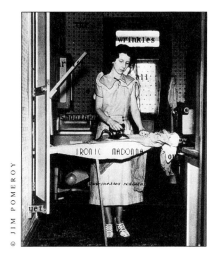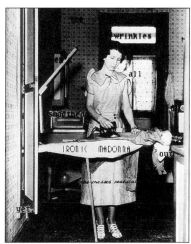

© JIM POMEROY

Ironic Madonna, *a contemporary stereo view.*

Stereo Support

The National Stereoscopic Association is affiliated with the American branch of the Stereoscopic Society, an international organization founded in 1893. Since its formation in 1974, the association has worked to promote the study, practice, and collecting of stereo photography. To that end, it supports a research facility—the Oliver Wendell Holmes Stereoscopic Library—and holds regional and national meetings. It also publishes *Stereo World,* an impressive bimonthly magazine replete with features on current stereo photography, good illustrations (often in color), history, technical tips, stereo news, and classified ads.

National Stereoscopic Association, Box 14801, Columbus, OH 43214.

Oliver Wendell Holmes Stereoscopic Library , Eastern College, St. Davids, PA 19087. (215) 341-5800.

Stereo World, 5610 S.E. 71st Avenue, Portland, OR 97206.

Stereoscopic Society, American

Classic Stereo

The heyday of the Stereo Realist camera coincided with the vogue for 3-D movies. The Realist, introduced in 1951, was distinguished by its three-eyed appearance; it had a matched pair of lenses with a circular viewfinder in between. The camera produced 28 stereo pairs on a 36-exposure roll of 35mm film, each image alternating with one from the next photograph on the roll. Most Realist photographers shot slide film, which they had processed and mounted in cards. The cards were displayed with a stereo projector or in a special viewer with its own AC-powered light source. Unfortunately, interest in the camera—and stereo photography—floundered. By the end of the 1950s, the Stereo Realist was no longer being made.

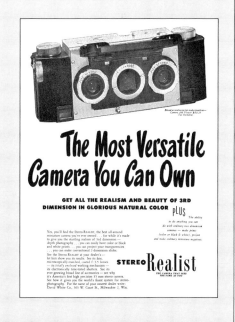

The Most Versatile Camera You Can Own

GET ALL THE REALISM AND BEAUTY OF 3RD DIMENSION IN GLORIOUS NATURAL COLOR PLUS

STEREO Realist

Branch, 1677 Dorsey Avenue, Suite C, East Point, GA 30344. (404) 766-2797.

Stereo Archive

The largest repository of original stereoscopic materials is the California Museum of Photography at the University of California at Riverside. It started as the collection of the Keystone View Company, and has grown to include some 350,000 glass plates and prints. A related collection has an important technology component with a good range of stereo cameras and related apparatus.
Keystone-Mast Collection, Museum of Photography, University of California at Riverside, Riverside, CA 92521. (714) 787-5214.

Stereo Books

These two fine books on stereo photography are a little hard to find. William C. Darrah's *The World of Stereographs* deals broadly with the history of stereo, including early experiments, mass production, and distinguished individual practitioners. It also has an encyclopedic section for collectors, breaking down subject matter into eighty categories such as railroads, Indians, floods, and architecture.

Points of View, edited by Edward W. Earle, curator of the Keystone-Mast Collection, examines the historical and social importance of the stereograph. This illustrated volume includes essays representing various points of view—from an art historian, sociologist, and American studies scholar.

The World of Stereographs, by William C. Darrah, 1977. Available from 2235 Baltimore Pike, Gettysburg, PA 17325.

Points of View: The Stereograph in America—A Cultural History, edited by Edward W. Earle, Visual Studies Workshop Press, 1979.

Stereo Supplies

Stereo equipment is hard to find. Camera stores and mail-order catalogs often stock one or two items; sometimes flea markets and thrift shops will have older pieces of equipment. The best single source is Reel 3-D Enterprises, which is doubtless accurate when it claims it has the "world's largest mail-order selection of 3-D supplies."

The company's catalog contains a wealth of products, as well as information on stereo and other three-dimensional imagery. You'll find books, viewers, projection equipment, camera accessories, and much more. Some offerings are available elsewhere, but much of the merchandise is exclusively distributed by Reel 3-D—for example, stereo-slide storage sleeves and photocopies of original stereo instruction manuals. A page at the end of the catalog answers common questions about stereo photography.
Reel 3-D Enterprises, Box 2368, Culver City, CA 90231. (213) 837-2368.

Failed Stereo

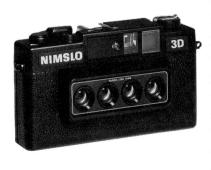

The Nimslo camera was a valiant attempt to revive 3-D photography. Introduced in 1979, this camera tried to create the quality of stereo imagery without the need for viewing paraphernalia, by recording four 35mm half-frame images through a quartet of matched lenses. The color negatives were then printed by the company (or a licensed lab) using a proprietary process involving a lenticular screen, much like the ones used on 3-D postcards. Unfortunately, the effect wasn't much more convincing than that. Combined with the high cost of processing, these lukewarm results made the Nimslo camera a short-lived phenomenon.

Still Video

Photo purists may not like it, but still video—photographs made with electronic-imaging technology—has arrived. Several systems are currently available for both consumer and professional use, and many more lurk in the wings.

Will still video replace the trusty camera and film? Probably not—at least not in the near future. Such systems face two major hurdles. The first is expense; most still-video consumer units cost about $800 for a point-and-shoot camera (without add-ons); mid-level systems run at least $2,000 to $3,000; and professional units cost a lot more. The second, more daunting problem is image quality. Still-video images don't come close to rivaling the sharpness, tonality, and color of images from conventional cameras and silver-halide-film technology.

Nevertheless, still video has found some applications for which low image quality is not a problem. When viewed on a monitor rather than on paper, still-video images look just fine, which bodes well for certain technical uses and especially for the consumer market. Newspaper photos taken with still-video cameras are currently acceptable, if not ideal. In just a few years, video technology has wiped out the use of motion-picture film in television news; still video may not be far from doing the same to newspaper photojournalism. You can bet that advances in the technology will continue rapidly, and that prices will drop as image quality improves.

How Still Video Works

A video camcorder records images on a moving magnetic tape, but still-video cameras use a two-inch floppy disk—a smaller version of the disks used in a personal computer. As in a camcorder, the electrical signals that represent the image are generated by a small charge-coupled device (CCD) located behind the lens, just where the film in a conventional camera would be. A CCD is an electronic chip packed with a dense grid of tiny light receptors, which convert light into an electrical signal proportional to the intensity of that light.

And that's the rub. You can only pack so many light receptors into a CCD. Most still-video cameras contain about 300,000 to 600,000 receptors, also called pixels (picture elements). Pixels form the building blocks of the video image; the more pixels an image has, the higher the picture quality. Although 600,000 sounds like a lot of pixels, it isn't enough to match the quality of a single frame of 35mm ISO 100 color-negative film, which delivers the equivalent of 18 million or so pixels.

Still-Video Offerings

The first still-video camera was the Sony Mavica, shown in prototype in 1981 and kept under wraps until it was finally introduced in 1987. Several companies now produce a variety of models, but none have established pre-eminence.

Consumer versions such as the Canon Xapshot and the Sony Mavica cost almost $1,000 and are sleek, binocular-style units that plug into a TV set for playback. They're the high-tech equivalent of a snapshot camera. Controls on the camera itself, or on a small playback module, allow forward

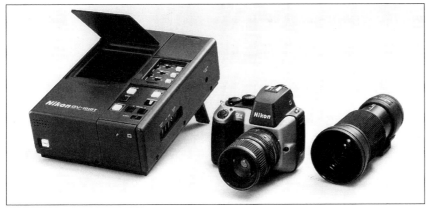

Nikon QV-1000C professional still-video system.

and backward movement, as well as selective search and erase operations. As with all still-video systems, the disk can be edited and pictures erased to leave space for new images. These cameras are otherwise completely automated, providing fixed focus and autoexposure, an automatic flash, and fixed-focal-length lenses.

Professional-level still-video cameras such as the Nikon QV-1000C, Canon RC-760, and Sony ProMavica are another story. These cost $5,000 or more, and are comparable to full-featured SLR systems. Such cameras have through-the-lens viewing via a reflex mirror, ground glass, and a pentaprism. (The amateur models have separate viewing windows, which aren't entire-ly accurate.) Pro cameras also feature a range of interchangeable lenses, including zooms, and look much like 35mm SLRs. They typically allow image recording in either low-resolution mode, which fits fifty images on the floppy, or in high-resolution mode, which stores twenty-five images on a disk. You can shoot ten or more frames per second. The Sony ProMavica even allows you to record sound as well as an image for electronic captioning.

Professional systems include all kinds of peripheral hardware, from thermal printers to modem-like devices for sending pictures over phone lines or by satellite. Such additions are cost-ly; the high price of the extra hardware needed to realize still video's full po-

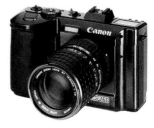

Canon RC-760 professional still-video system. The photograph above shows the image being transmitted over phone lines.

Still Video in the News

Many newspapers and magazine photographers are now using still-video equipment to photograph late-breaking news. *USA Today* is one such pioneering publication, using still video to cover important events such as the Olympics and political conventions. This photograph from the 1988 World Series is a good example. The photographer made the exposure with a Sony ProMavica camera, then transmitted it using a Sony transceiver along phone lines to *USA Today* headquarters. This took approximately five minutes. At headquarters, a hard copy was made on a Sony printer. The photograph appeared in the next morning's edition.

tential makes it available only to those with very deep pockets.

News publishing is one industry that has begun to take advantage of the technology. Several newspapers and magazines have already used the system to beat deadlines in covering important events such as the Olympics and superpower summits. Still video solves a problem inherent in photojournalism: the lag time between the taking of a picture and its reproduction. This delay is caused by the need to ship, process, and print conventional silver-halide film. A still-video picture, once taken, can be immediately transmitted via phone lines to the newspaper or magazine that needs it. With desktop-publishing technology, that image can be dropped right into the layout of a page, and separation films for photomechanical plates produced directly. On the more controversial side, once an image enters the system, it can be enhanced or manipulated by such means as altering its color and adding or eliminating content (see pages 75–77).

Image Processing

Though still-video camera systems are just being introduced to a broad market, computer technology has been quietly affecting photography for several years, from fairly mundane film and print processing units to truly revolutionary image-processing systems. Digital image processing, led by products from Scitex, Hell Graphics, and Crosfield, has the extraordinary (and some would say frightening) ability to manipulate an image, leaving no telltale signs of its work.

Such systems flawlessly retouch and alter photographs, quickly and with relatively little effort. Essentially, digital systems convert a photograph into numbers. An operator at a computer can display the digitized image on screen and go to work on it—intensifying or changing colors, increasing or reducing sharpness, and repositioning objects or changing their perspective or shape—or eliminating them completely. More incredibly, parts of different photographs can be seamlessly combined to create an entirely new image that never existed in the real world.

These systems are exciting creative tools, but they raise many practical and ethical questions. Who gets credit for an altered image? More importantly, who owns it and who gets paid for it? How much manipulation can a photograph take before it becomes a misrepresentation—not simply an "enhanced" image? Alteration may be fine if the intent is creative, but what about a news photograph?

Currently, image processing is used primarily by printers in their prepress operations for clients who can afford the high fees, such as advertising agencies. Time on a Scitex system costs hundreds of dollars an hour; a simple retouching job may take only a few minutes, but serious image manipulation requires several hours. However, new image-processing software for personal computers—largely the Apple Macintosh—has begun to bring the technology to smaller design studios and various desktop-publishing operations. It's just a matter of time before image processing will be within the means of photographers who would otherwise use conventional darkroom or elaborate slide-duplicating techniques to manipulate their photographs.

Image Processing for Personal Computers

Image processing on personal computers is now available for designers and photographers working in black-and-white and color. Black-and-white digitizing programs include Image Studio, the first such software for the personal computer, and Digital Darkroom. Both cost less than $500 and offer controls similar to those of black-and-white printing; you can adjust contrast and density (exposure) with a keystroke, and precisely define and selectively lighten or darken certain areas—the equivalent of dodging or burning.

A most interesting program, PhotoMac, not only offers control over image tonality, sharpness, shape, and perspective, but also lets you manipulate color. For example, using a mouse or the program's edge-seeking capability, you can "paint" areas with any color you choose while still retaining the image's underlying tonality. You can also place PhotoMac images into page layouts for desktop-publishing documents and create process-color separations ready for the printer. This is no pipe dream; PhotoMac software is currently working at several major daily newspapers.

PhotoMac costs only $695, but it requires a lot of computer power. You

This image was created using PhotoMac software and a Macintosh II computer, by combining five slides that had been scanned into the system.

© NORMAN PARKINSON / COURTESY OF TOWN & COUNTRY

Norman Parkinson was assigned to photograph model Odile Broulard toasting Paris's top ten bachelors for Town & Country *magazine. Unfortunately, she came down with the flu and was hospitalized. Through the magic of image processing, the shot did not have to be totally rearranged. Parkinson stood in for Odile and photographed the bachelors (top). Two weeks later, he photographed Odile in that location (middle). Editor Robert D. Clark brought the original shot along and positioned it with the Polaroid tests of the new shot to guarantee a fit. The two images were then seamlessly combined using a Scitex system.*

need a Macintosh II with at least two megabytes of resident memory, a high-resolution color monitor, and a forty-megabyte hard disk—a setup costing more than $8,000. You also need a color scanner, a very expensive peripheral at about $10,000. You can sidestep the scanner by using video images, such as those produced by a color still-video camera—but you'll need the camera and a special video board in your computer.

Black-and-white scanners cost considerably less, as does black-and-white image processing in general. However, it shares with color the exorbitant cost of high-quality output devices. Even expensive laser printers don't produce photographic-quality printouts. Color-slide "writers" let you send an image directly to color-slide film, but their cost can exceed $6,000. One solution is to take the floppy disk containing your digitized image to a copy center that offers either Linotronic printing ($5 to $10 per page) or color-slide writing (about the same price per slide).

In the final analysis, the quality you need in any photograph depends entirely on its application. A digital image is usually more than adequate for general reproduction methods that strain a photograph through a dot screen, such as in newspapers and magazines. For high-quality photographic applications, such as making prints for display, personal-computerized image processing still has a long way to go.

Digital Darkroom, Silicon Beach Software, Box 261430, San Diego, CA 92126. (619) 695-6956.

Image Studio, Letraset, 40 Eisenhower Drive, Box 281, Paramus, NJ 07653. (201) 845-6100.

PhotoMac, Avalon Development Group, 1000 Massachusetts Avenue, Cambridge, MA 02138. (617) 661-1405.

Viewpoint: Electronic Photography

DR. RUDOLPH E. BURGER
PRESIDENT
SAVITAR
SAN FRANCISCO

"Electronic photography has three significant advantages over film-based photography. It can store and retrieve images in databases, it allows rapid transmission of images via telephone and satellite, and it permits computerized image enhancement using, for example, Avalon Development Group's PhotoMac software (see page 75).

"There is nothing radically new about these functions; electronics just makes them more convenient. Whether you participate in the so-called electronic revolution will depend on whether you need—and can pay for—these services. The current still-video systems offered by Sony, Canon, and Nikon are really for photojournalists, government, and law-enforcement people who need to move an image quickly. Total systems, which include transceivers and other devices, cost between $20,000 and $30,000.

"The new, low-cost electronic cameras from Canon and Sony are another matter, and are more of a marketing investment by the Japanese consumer electronics industry than a practical tool for the amateur photographer. The Japanese are hoping that consumers will be content to see their snapshots on a TV, and thus help underwrite the expense of developing a practical electronic camera.

"The sensing device in these consumer video cameras resolves only about 200,000 pixels—enough information to display an image of acceptable quality on a TV screen. Transfer that image to a print, however, and you'll quickly see why manufacturers are not promoting devices that make hard copies of the electronic image. By comparison, a well-exposed 35mm ISO 100 color negative contains about twenty times more information.

"The only innovation that these cameras bring to the amateur is reusable media—you can record over the images on the disk. You can also see the image immediately on your TV, but immediacy didn't allow instant Polaroid film to displace Kodak. When you compare electronic imaging to traditional photography, there is no question that film is much better and cheaper. With one-hour processing labs, time isn't much of a factor either. The current generation of still-video cameras will not cause any serious defection from film-based cameras.

"Although the image-creating technology—the camera—is progressing relatively slowly, image processing is advancing rapidly in the form of computer software and devices to turn the digitized image back into printed matter and film. One of the keys to the popularity of black-and-white desktop-publishing was Canon's inexpensive LaserWriter engine. I expect to see a desktop color printer with near-photographic quality reproduction introduced very soon. The other key to unlocking image processing's potential is that the personal computer is becoming powerful enough to process color images. The computer will soon function in much the same way as the home darkroom once did.

"For the average photographer, the camera remains the key. The best electronic camera available has a 1.2-million-pixel resolution, which is still $\frac{1}{15}$ the power needed to compete with the information in a 35mm negative, and at least five years away from development. Current electronic imaging systems are good enough for newspaper images, since the amount of information they record fits the 85-line screen format of most newspaper separations. But try to take that image up to a magazine-quality reproduction, and the inadequacies become obvious; you still can't make an acceptable print from it, even when compared to the print from a simple point-and-shoot camera. We have a long way to go.

"When we get there, though, photographers may be surprised by what they find. Photography will remain a creative medium, but the areas in which a photographer will exert creative control will change.

"Eventually, a high-definition TV display on the camera will let you preview the image and judge whether the picture is what you envisioned, whether you can improve upon it, or whether it would be better to erase and retake the shot. Image-processing controls in the camera will allow you to eliminate defects, erase distracting backgrounds, correct for color shifts, and so forth—the kinds of things that only professionals can afford to do now by employing a retoucher.

"It will also be possible to correct out-of-focus pictures. If, for example, you shot a speeding car at too slow a shutter speed and wanted to fix a blurred area, you could calibrate the direction and speed of the car relative to the background. Inverting the equation will reconstruct the image into a sharp picture.

"This kind of technology already exists in computer software, and it's only a matter of time before microprocessors in the camera start using it. Image processing may sound a little intimidating today, but the photographers of tomorrow will regard it as just another accessory."

Non-Silver Processes

Modern photographic printing papers trap light with a silver-gelatin emulsion. Over the years, photographers have tried various emulsions, many containing metal compounds other than silver. In the spirit of experimentation that stamped the late 1960s and early 1970s, fine-art photographers rediscovered many of these older processes and started working with them. These processes thus attracted a small but loyal following that continues to flourish.

These techniques are referred to here—and elsewhere—as non-silver processes, though this is a misnomer since some of the emulsions do contain silver. They are also variously called hand-coated, antique, and alternative processes. Whatever their names, these processes resemble the art of printmaking as much as they do photography. They require a great deal of hand work, including such time-intensive steps as preparing the paper for coating, mixing the emulsion, and exposing the print for prolonged periods.

Why bother with non-silver printing? Commercially sold silver-gelatin papers are far easier to use and consistently produce excellent and predictable results—something that cannot be said about the widely fluctuating hand-coated emulsions. The main reason non-silver printers do what they do is the special look the process brings; they get a print with a richness and painterly quality that's very different from what silver delivers. Also, they prefer the hand work—the closeness to the materials—that non-silver processing requires. Many photographers also like the unpredictability and surprise of the non-silver process; as in printmaking, each print will diverge at least slightly, and more often widely, from the next.

Making Non-Silver Prints

Although they vary considerably, non-silver processes have certain steps in common. For example, most require that the negative be contact-printed rather than enlarged, meaning that it must be the same size as the desired print. If, like most photographers, you shoot in a small or medium format—such as 35mm or 2¼×2¼ inch—you must make an enlarged duplicate negative. Duplicating an original takes care and attention to the characteristics of the materials, but with practice a high-quality dupe can be made.

One method of making an internegative requires two steps: producing an intermediate film positive and, from it, a duplicate negative. For best results, most photographers first enlarge the original negative onto an orthochromatic or litho (for a high-contrast dupe) film to make the positive, then contact-print the positive on similar film to get the duplicate negative. It's also possible (and somewhat less expensive in terms of the amount of film used) to contact-print the original negative, then enlarge it to make the duplicate negative. This method is best avoided with an original 35mm negative because any problems, such as scratches on the glass used for contact-printing, will be greatly magnified. It will also increase the contrast of the dupe dramatically, which may be an advantage in some cases.

You can eliminate a step from this tedious process if you shoot a black-and-white positive, rather than a negative, for your original image. Such a slide made with Polapan CT (a 35mm positive instant-process film) or T-Max 100 film processed with a reversal kit can be enlarged directly onto sheet film such as Kodak Fine Grain Release Positive (see page 62), which is used under a safelight and processed in common black-and-white chemistry. You can enlarge a color slide onto sheet film in the same manner, but a panchromatic film such as Kodak Professional Copy or T-Max 100 should be used to translate color to black-and-white, and these films demand complete darkness. In any

case, make sure the film you use for the negative has a low speed, and set a small aperture on your enlarging lens; otherwise the exposure times will become unmanageably short.

By far the simplest method is to enlarge your original negative onto Kodak Professional Black and White Duplicating Film (see page 61) or Kodak LPD4 (for higher contrast results); both are orthochromatic (safe-light-safe) materials that give a reversed image—negative from negative—in one easy step, using conventional chemicals. Such film behaves very much like slide film. To increase density—say, to improve shadow detail—you decrease exposure. To reduce density, increase exposure. The appearance of a correctly processed negative made with Duplicating Film takes some getting used to; it has a very high base-plus-fog density, which means that even a well-exposed (and developed) sheet is dark and looks fogged.

Once you've prepared an enlarged negative and spread the non-silver emulsion onto paper, press the negative tightly against the paper (once it's dry), usually in a contact-printing frame, and expose it to a light source rich in ultra-violet rays. The best sources are direct sunlight or an exposure unit made for the purpose (see page 83). A sunlamp or quartz lights will also work, but both require much longer exposures. Exposure time is generally determined by opening one side of the hinged back of the printing frame and inspecting the exposed image.

One big advantage of non-silver printing is that the photographer can choose all sorts of supports for the emulsion—from a woven or rough-surfaced artist's rag paper to a smooth linen fabric. The image can then be drawn into, painted on, or sewn. Some nineteenth-century photographers incorporated their photographic images into quilts and pillows, a tradition that continues today.

Non-silver work inevitably calls attention to technique and raises questions about the artistic tools at the photographer's disposal. In his classic *The*

Kallitype quilt.

Gum-bichromate print.

Cyanotype.

© RUSSELL HART

Bromoil print.

© FRED BYRUM

Platinum print.

© DOUG MUNSON

Printing-out paper print (courtesy Chicago Albumen Works).

Keepers of Light (see page 84), William Crawford discusses this issue at length, arguing that photography's verisimilitude—its apparently seamless representation of reality—has caused the content itself to be ignored. This is an important issue for photographers using these processes; rather than hide the evidence of their craft, they want to celebrate it and make it an integral and intrinsic part of the image.

Bromoil

Developed in 1907, the bromoil process became so popular that stores sold bromoil printing papers. It was commonly used until the 1930s, but has since been relatively neglected. Bromoil appealed to the creative instincts of photographers with pictorialist leanings, largely because the image results from hand-applied ink. Detail can be added or subtracted at will, just as in a painting or drawing.

The bromoil process is quite different from other non-silver processes. It requires neither contact-printing nor an enlarged duplicate negative. You start with a conventional silver print, albeit a bit darker and with less contrast than usual. The image is bleached out with a special chemical that hardens the gelatin in proportion to how much silver it contains. When the bleached paper is soaked in water, the gelatin swells a lot at lighter tones (where it was hardened least by the bleach) and doesn't swell as much at deeper tones (where it hardened most). After blotting, the damp gelatin repels ink in the highlights and lighter tones, and accepts it in the shadows. You can apply the ink with a stencil brush or rubber brayer, but the inking technique takes a great deal of practice and makes bromoil an extremely difficult process to learn.

Cyanotype

Cyanotype is one of the earliest and simplest of the non-silver processes. The paper is coated with an emulsion of iron salts and exposed to light, which reduces the salts to iron com-

pounds. These compounds oxidize to produce a strong blue color (cyan). For processing, the paper is simply washed in water, eliminating any soluble iron salts and thus clearing the image's highlights.

Also called blueprints (not to be confused with architectural blueprints), cyanotypes are versatile and permanent. They can be made on nearly any base; cloth and fabric are particularly popular. You can vary the color of the image through post-processing bleaching and toning treatments.

Gum-Bichromate/ Kwik-Print

Popular in the late nineteenth and early twentieth centuries, the gum-bichromate process ranks with platinum as the most common of non-silver techniques. In some ways it's the quintessential pictorialist process. Though not as adept as some other processes at recording a negative's fine detail, gum-bichromate's potential for manipulation is almost without peer.

Gum prints are made up of layers of hand-applied pigment mixed into a gum-arabic emulsion, and can be altered in endless ways. Each layer is exposed, developed, and dried before the next layer is spread on. You can apply many layers, adding colors at your discretion. Contrast and tonality vary to encompass a wide range of results, from a subtle, full-toned photographic quality to a highlyimpressionistic treatment.

Kwik-Print is a commercial process originally used by printers to proof color separations. Distributed exclusively by Light Impressions (see page 85), it's a modern-day version of the gum-bichromate process, but is more versatile than its nineteenth-century cousin. For one thing, Kwik-Prints are generally made on a smooth vinyl base that doesn't change size when wet, and thus accepts many more coats of emulsion (and therefore offers more opportunities for manipulating color) than gum prints do. In general, Kwik-Prints are more consistent and predictable than traditional gum prints.

Three vintage platinum prints: J.M. Justice, Whalers in the Arctic, *1898.*

Garrigues, Bedouin Mother Nursing, *Tunis, ca. 1880.*

Bertillon print, New York City police department, 1880s (all prints courtesy Rodger Kingston collection).

Kallitype

A close visual cousin of the platinum print (see below), the kallitype was never as popular and has never been available as a commercial material. This is a little surprising, as the kallitype process is easier to use, more versatile, and less expensive than platinum. Part of kallitypes's lack of popularity may stem from its undeserved reputation as a nonpermanent process; in fact, a kallitype, which has an emulsion containing metallic silver, is about as permanent as a modern silver-gelatin print.

There are two ways to produce kallitypes. The simplest, called a Van Dyke or brownprint, is the most limited in tonality. It develops in water, just as the cyanotype does, but requires a hypo fix after development. The second, more preferable method uses a different sensitizing formula and permits image tones from black to sepia, depending on how the developer is formulated. This kallitype also develops in water and needs a fixer, as well as a separate clearing bath.

Platinum/Palladium

The platinum printing process was first patented in the 1870s and soon won such prominent supporters as Peter Henry Emerson, Frederick Evans, and Alvin Langdon Coburn. Commercial papers using platinum were manufactured into the early twentieth century. After World War I, platinum papers were replaced by palladium, a related emulsion, as platinum prices soared out of sight.

Unfortunately, palladium papers also became too expensive and were taken off the market in the early 1920s. A recent resurgence of interest in both processes has prompted several companies to begin marketing materials for platinum and palladium printing, and one—The Palladio Company—even makes a commercial platinum/palladium paper (see below).

What draws photographers to the process is its extra long tonal scale, which results in rich, beautiful prints with subtle gradations from deep shadows to bright highlights. Palladium prints are warmer than platinum ones; the only difference in formulas is the metal, so the two emulsions can be mixed together or layered to achieve an intermediate tone as well as some cost savings.

Because platinum paper is inherently low in contrast, it requires an relatively high-contrast negative for printing. You can manipulate the contrast to a small degree by varying the proportion of chemicals in the sensitizing solution.

Platinum/palladium's many positive qualities include the long-term stability of its emulsion. A platinum or palladium print will last indefinitely—or at least until its paper base starts deteriorating.

THE PALLADIO COMPANY

In 1988, The Palladio Company introduced Palladio Paper, the first machine coated platinum/palladium contact-printing paper available in over fifty years. The matte base stock is 100-percent rag drawing paper, and the coated paper comes in low-, medium-, and high-contrast grades.

To use Palladio Paper, you need either a contact- or vacuum-printing frame, some source of ultraviolet light (see page 83), and the appropriate processing chemistry. Test strips and instructions for in-camera exposure and development, as well as for converting and/or enlarging your existing silver negatives to negatives with the range and density suitable for platinum/palladium printing, are included with each package.

On the surface, the price seems higher than for making your own emulsions and chemicals—almost $10 a sheet including processing for the 9½×11½-inch paper. However, the process is quite consistent and controllable, so there's much less waste of time and materials than when working with hand-coated emulsions. The Palladio Company also sells a contact-printing frame, several ultraviolet exposure units (see page 83), and a negative duplication kit that provides an introduction to making enlarged negatives.

The Palladio Company, Box 28, Cambridge, MA 02140. (617) 547-8703.

Printing-Out Paper

First sold off-the-shelf in 1885, printing-out paper was available from Kodak as Studio Proof until it was discontinued in 1987. The paper was reintroduced the following year by Chicago Albumen Works (see below) which remains the sole supplier. Chicago Albumen's version provides beautiful prints that range from rusty brown to purple to warm black.

As the Kodak name suggests, printing-out paper was mainly used by portrait studios as a quick proofing paper, much as Polaroid sheet material is used today. Right after shooting, the studio would make a proof, and if subjects approved they would place their order. The proofs were typically allowed to fade and thrown out. However, if toned, fixed, and washed, the material can produce beautiful permanent prints, with a tonality unmatched by any modern paper.

Printing-out paper is exposed by contact-printing with an ultraviolet light source—the sun works well—and therefore needs no darkroom. The image simply appears during exposure; you can monitor its progress by opening the hinged back of a contact-printing frame. When the print has reached the desired density, it's removed from the frame, toned, and fixed.

Chicago Albumen Works' Printing-Out Paper, made in France by R. Guilleminot Boespflug & Cie., is a single-weight, fiber-based paper that has a glossy surface. It comes in a 100-sheet box for $75. A kit for making printing-out paper by hand is available from The Photographers' Formulary (see page 85).

CHICAGO ALBUMEN WORKS

This unique company was started in Chicago in 1976 by Joel Snyder and Doug Munson to produce fine prints from historical negatives. The goal was to make prints that looked exactly like the originals—a goal that required both

sophisticated understanding and working knowledge of several ancient processes. The company's first efforts involved albumen, an early process that uses egg whites in the emulsion coating.

Chicago Albumen's high-quality work didn't go unnoticed. Soon it was making prints for museums and historical collections. In particular, it created beautiful prints by Eadweard Muybridge and William Henry Jackson for sale, from the collections of the Yosemite Natural History Association and the Colorado Historical Society. Exhibition prints followed for American Frontiers, a major show of Timothy O'Sullivan's work at the Philadelphia Museum. In perhaps its most visible effort, Chicago Albumen Works made the prints used by the New York Museum of Modern Art in its four definitive Eugène Atget exhibitions in the early 1980s.

In 1982, the company moved to western Massachusetts. There, besides continuing custom-printing projects, it imports and sells a fine printing-out paper (see page 82) and offers duplicating and negative conservation services for individuals and clients such as *National Geographic* magazine, the Library of Congress, and the National Archives.
Chicago Albumen Works, Box 379, Front Street, Housatonic, MA 01236. (413) 274-6901.

Exposure Units and Contact-Printing Frames

To expose non-silver papers, you must press your enlarged negative flat against the sensitized paper. If it's not perfectly flat, some areas on the print will not be sharp. The best way to ensure perfect negative-to-paper contact is to put both in a printing frame. Such frames have a hinged, two-part back section that lets you check a print's progress without affecting the registration of the paper and negative in the frame. Several companies make good frames, including The Palladio Company (11×14 inches—list $75), The Photographers' Formulary (8×10,

Health Alert

Working with any chemicals, particularly in powdered form, can cause health problems. Most photographic chemicals are reasonably safe, but some people are allergic or hypersensitive to them. Many chemicals used for non-silver work are even more toxic than those used in conventional film processing and printing, and some create toxic compounds when mixed together. These require special care. Before you start to work, read carefully all instructions and cautions packaged with the chemicals. Be sure to work in a well-ventilated darkroom. Wear rubber gloves when handling dry chemicals or solutions, and use a respirator with a dust filter for mixing powders. Also, do not wear contact lenses when handling these chemicals.

The Center for Safety in the Arts, formerly the Center for Occupational Hazards, is a national clearinghouse for research and education. It publishes many books and the monthly newsletter *Art Hazards News*. The center is located at 5 Beekman Street, Suite 1030, New York, NY 10038; (212) 227-6220. These are some of the best books available on the subject.

Making Darkrooms Saferooms: A National Report on Occupational Health and Safety, National Press Photographers Association, 1988. Available from 3200 Croasdaile Drive, Suite 306, Durham, NC 27705. (919) 383-7246.
This inexpensive ($6.50) guide to darkroom safety is aimed at photojournalists but applies equally to all photographers. It includes practical information on how to handle chemicals, toxicological tips, and firsthand experiences from photographers who have suffered from overexposure to photo chemicals.

Overexposure: Health Hazards in Photography, by Susan Shaw, The Friends of Photography, 1983.
Shaw writes clearly and authoritatively in this very specific guide. She discusses techniques as well as particular chemicals, including chapters on darkroom safety, black-and-white and color processing, historical processes, printmaking, and conservation and restoration. A thirty-six-page section discusses non-silver processes. This is must reading for any photographer.

Ventilation: A Practical Guide, by Nancy Clark, Thomas Cutter, and Jean-Ann McGrane, Center for Safety in the Arts, 1984.
Though not for photographers only, this book on a much-misunderstood subject is a welcome addition to the literature on health hazards. A well-ventilated workspace can reduce many health problems, particularly those related to inhaling dangerous fumes. Here you'll find information on basic principles of ventilation, hoods and ducts, and fans and air cleaning devices. The authors also clearly describe five ventilation-system designs, with diagrams.

Books on Non-Silver Processes

Classic Texts

Breaking the Rules: A Photo Media Cookbook, by Bea Nettles, second edition, Inky Press, 1987, Box 725, Urbana, IL 61801. (217) 352-6621. A step-by-step handbook on several alternative processes, including non-silver. It gives solid practical advice on such subjects as making enlarged negatives, Van Dyke printing, Xerography, photoscreen printing, cyanotypes, printing on fabric, and pinhole cameras.

Gum Dichromate and Other Direct Carbon Processes from Lartigue to Zimmerman
History and Practice of Oil and Bromoil Printing
History and Practice of Platinum Printing
Modern Carbon Printing
All by Luis Nadeau. Available from select mail-order firms or Box 1570, Station A, Fredericton, New Brunswick, Canada E3B 5G2. These self-published guides are practical and well written, and include a bit of history about the processes. Many of the most thorough source books were published 75 to 100 years ago, when non-silver processes were most popular. Even though the technology hasn't changed, recent discoveries and the availability of certain chemicals call for updated information. These books were written in the 1980s. Nadeau's *Encyclopedia of Printing, Photographic, and Photomechanical Processes,* explaining more than 1,300 processes, will be available soon.

The Keepers of Light: A History and Working Guide to Early Photographic Processes, by William Crawford, Morgan & Morgan, 1979.
Crawford's in-depth look at antique processes elegantly combines history and technique, giving the reader a broad perspective both on what has

been done and how to do it. This might be one of the best books on photographic technique ever published.

Photodiscovery: Masterworks of Photography 1840–1940, by Bruce Bernard, Abrams, 1980.
Even though a commercial color process wasn't available until Autochrome was introduced in 1907, photographs with color were being made all the time. In fact, images in various shades of brown, red, and blue were far more common than those in black and white. Bernard's sumptuous book makes that point definitively by showing a broad

selection of work made with various processes and reproduced true to their original, exquisite colors.

Also Worth Reading

Alternative Photographic Processes, by Ken Wade, Morgan & Morgan, 1978.

Artistic Photographic Processes, by Suda House, Amphoto, 1981.

The Gum-Bichromate Book, by David Scopick, Light Impressions, 1978.

Handbook of Alternative Photographic Processes, by Jan Arnow, Van Nostrand Reinhold, 1982.

Imaging with Light-Sensitive Materials, Visual Studies Workshop, by Deborah Flynn, 1978. Available from 31 Prince Street, Rochester, NY 14607. (716) 442-8676.

Instruction Manual for the Platinum Printing Process, by Thomas John Shillea, Eastern Light Photography, 1986. Available from 113 Arch Street, Philadelphia, PA 19106. (215) 238-0655; (215) 829-0641.

Kwik-Print, by Charles and Elizabeth Swedlund, Light Impressions, 1978.

New Dimensions in Photographic Imaging: A Step by Step Guide, by Laura Blacklow, Focal Press, 1989.

The New Photography: A Guide to New Images, Processes and Display Techniques for Photographers, by Catharine Reeve and Marilyn Sward, Prentice-Hall, 1984.

Photo Art Processes, by Nancy Howell-Koehler, Davis, 1980.

11×14, 16×20, and 20×24 inches, listing for $25, $33.20, $42.72, and $56), and Zone VI (8×10 inches —$75).

Non-silver emulsions require very long exposure times, which is one reason they must be contact-printed. The best light source for exposing these emulsions should be rich in the ultraviolet and blue light that cannot be produced by an enlarger. Sunlight qualifies, assuming that it is strong and direct, but the sun can't be counted on to shine just when you want to make a print. A sunlamp will also work, but is a relatively weak source of ultraviolet rays and therefore requires long exposures.

The most reliable option is an exposure unit made specifically for non-silver work. You can make your own by fitting a box with at least seven or eight unfiltered ultraviolet (black light) fluorescent bulbs spaced about one-and-a-half inches apart (the spacing is critical). Or, you can buy an exposure unit. The Palladio Company sells several units, all of which will expose prints up to 12×16 inches. The standard unit sells for $394 or $525 (the high-intensity version), while the vacuum-frame unit sells for $750 or $875 (the high-intensity version). The Aristo Platinum Printer sells for $880 and takes prints up to 11×14 inches (Aristo Grid Lamp Products, 35 Lumber Road, Roslyn, NY 11576. 516-484-6141.) The Nu-Arc 26-1K accepts prints up to 20×24 inches and sells for $1,198 (Nu-Arc Company, 6200 West Howard Street, Niles, IL 60648. 312-967-4400).

Alternative-Paper Suppliers

Palladio and P.O.P. are two commercially available precoated alternative papers. To delve into other alternative processes, you must mix your own emulsions and processing solutions from scratch. The following suppliers specialize in the necessary chemicals and other materials.

BOSTICK & SULLIVAN

Not simply a mail-order supplier, Bostick & Sullivan is a wide-ranging resource for platinum, palladium, and,

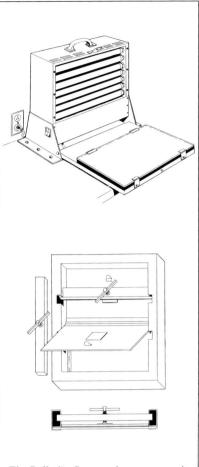

The Palladio Company's exposure unit (above) and contact-printing frame.

Other Suppliers of Photographic Chemicals

BLUE MOUNTAIN PHOTO SUPPLY
Box 3085
Reading, PA 19604
(215) 375-7766

LIGHT IMPRESSIONS
439 Monroe Avenue
Rochester, NY 14607
(800) 828-6216; (800) 828-9629
in New York State

SPRINT SYSTEMS OF PHOTOGRAPHY
100 Dexter Street
Pawtucket, RI 02860
(401) 728-0913

to a lesser degree, other non-silver processes. Its folksy catalog is filled with wisdom and invaluable information about these processes, such as detailed descriptions of each chemical used and its health-safety rating. Along with the chemicals to do the job, the catalog includes such products as printing papers and instructional books (many historical and unavailable elsewhere). *Loose Lumen*, the company's irregularly published newsletter, includes updated information and news from and about non-silver photographers. Bostick & Sullivan also maintains a telephone help line; call any weekday (4 to 7 P.M., Pacific time) for information about its products or platinum/palladium printing in general.
Bostick & Sullivan, Box 2155, Van Nuys, CA 91404. (818) 785-4130; (818) 988-6098.

THE PHOTOGRAPHERS' FORMULARY

Suppliers of chemicals in any quantity for virtually any imaginable photographic use, The Photographers' Formulary stocks hundreds of products, some commonplace and many quite obscure, such as dyes for retouching Cibachrome prints and holography film developers. The company offers both raw chemicals for mixing formulas from scratch and kits of prepackaged chemicals with detailed instructions, an excellent way to start experimenting with a process. Non-silver photographers can order kits for platinum, palladium, kallitype (both types), cyanotype, and gum-bichromate (classical and contemporary) processes. The catalog also offers a kit for making printing-out paper, as well as other items such as contact-printing frames and books. A newsletter, *The Formulary*, includes hard information on products, formulas, and health and safety matters, plus tidbits about the world of fine-art photography.
The Photographers' Formulary, Box 5105, Missoula, MT 59806. (406) 543-4534; (800) 922-5255.
See page 68.

Pinhole Photography

In the fourth century B.C., Aristotle observed that the small gaps in a tree's dense foliage cast the image of an eclipse of the sun on the ground below. Almost 2,000 years later, Leonardo da Vinci used a tiny hole punched in the wall of a darkened room to project an image of the outside world onto a sheet of paper opposite the hole. What Aristotle saw and Leonardo invented has come to be known as a pinhole image. Light rays reflecting from different points on the subject intersect when passing through a small opening; as the rays continue on the other side they form an upside down and backward image of the object that reflects them. Because a darkened space is required to see the dim pinhole image, da Vinci's creation was later christened the *camera obscura*, or "dark room." The *camera obscura* was used primarily by artists as a drawing aid, and a lens soon replaced the pinhole as its image-forming device. This was long before anyone figured out how to actually record the image.

By the end of the nineteenth century, pinhole imagery was embraced by pictorialist photographers for its soft, dreamy quality. In the ensuing decades, so-called straight photography became the prevailing style, but pinhole photography now claims a small but loyal fine-art following. A pinhole photographer's refusal to take pictures with a lens is a conscious rejection of the gadget-laden, decision-free equipment that camera manufacturers sell to consumers.

The Camera

Any lighttight container can be a pinhole camera; examples range from matchboxes to refrigerator cartons. They may be elegantly hand-crafted or crudely taped together. One photographer, Pinhole Resource founder Eric Renner (see page 88) has constructed an underwater pinhole camera out of a large pickle jar.

For many photographers, the physical form of the camera is as important as the image it creates. That form may even comment on the image; photographer Julie Schachter has used an industrial-sized Campbell's Soup can *cum* pinhole to make a portrait of Andy Warhol, and a Boraxo can to photograph Death Valley (a nod to the Boraxo-sponsored TV series "Death Valley Days"—see page 90).

A popular and inexpensive choice for making a pinhole camera is a Quaker Oats carton. This produces image distortion similar to that of a fisheye lens, but the cylindrical shape is hard to keep stabilized for the long exposures generally required. Many pinholers prefer square objects such as shoe boxes. Whatever you decide on, consider its suitability for film loading; a cardboard-box pinhole camera is generally a one-shot device that sends the photographer back to the darkroom after each exposure. To get more shots, some pinholers carry several loaded cameras.

Regardless of the method used, be sure you make the camera lighttight. To prevent internal reflections that could fog the film, spray-paint the inside of the box flat black. Plug light leaks with opaque black tape. Use tape to hold the film or paper in place behind the pinhole, or fashion a hinged film holder out of matteboard.

However you make the camera, you must consider the placement of the pinhole and the shutter. The hole is a tiny opening located where the lens would be—in the front of the camera opposite, and on a holder parallel to, the film plane. The shutter is a shield, often a piece of cardboard painted flat black, taped or otherwise positioned in front of the lens so you can lift it and

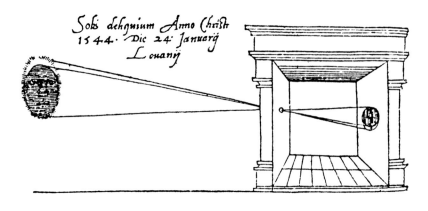

A camera obscura *observing a solar eclipse, 1545. Drawing by Rainer Gemma-Frisus.*

allow light into the camera.

Many photographers simplify the matter by using commercial cameras, replacing the lens with a pinhole; they favor view cameras because sheet-film negatives permit large contact prints.

The Hole

Every point in a given subject reflects rays of light in many directions (which is why you can move around an object and still see it). A lens gathers a wide cone of rays from each point and brings them to a sharp focus on the film plane, but a pinhole admits relatively few rays from each point. These rays comprise a small bundle that expands into a blob on the film—one of the reasons the pinhole image isn't as sharp as that of a lens.

Because it reduces the size of the bundle of light rays, a smaller pinhole can produce a sharper image—up to a point. If the bundle gets too small, diffraction (a loss of sharpness due to bending of the rays as they pass over the edges of the hole) begins to soften the image once again. Diffraction can also manifest itself in pictures taken at the smaller apertures on a camera lens. In fact, if a lens could be stopped down to the size of a typical pinhole (f/389, for example), it would yield an image not much different from the pinhole's—soft, with depth of field encompassing everything from an inch or two away to infinity.

Complicated formulas can compute pinhole sizes to yield maximum sharpness for a given pinhole-to-film distance (focal length); the chart on the next page spares you the math. Using a sewing needle guarantees image sharpness and establishes a specific f-number. Push the needle in until its widest part has passed through.

You can punch the needle through extra heavy aluminum foil or even a piece of an aluminum pie plate to make a quick and dirty pinhole. But the material of choice is flashing material or shimstock, which make for a cleaner hole and let you sand down created on the other side of the hole to minimize diffraction. Alternately push

Color Pinhole Photography

Willie Anne Wright's approach to pinhole photography is as unique as her images. Instead of using film in her homemade cameras, she makes 8×10-, 11×14-, and 16×20-inch images using Cibachrome paper, a reversal material designed for printing color transparencies. After an exposure, she takes the camera home, unloads it in her darkroom, and processes the sheet in tubes with the appropriate color chemistry. The result is a brilliant direct-positive image. Because Cibachrome paper responds to the tungsten light of an enlarger, Wright places color filters over the pinhole to warm the daylight so that her subject's colors will be correctly rendered.

ALL PHOTOS © WILLIE ANNE WRIGHT

Erika's Pool—Susan and Nicole *(above)*.

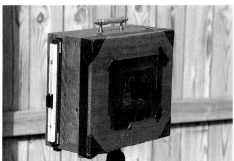

Willie Anne Wright's 8×10-inch pinhole camera (left).

Wright's 16×20-inch pinhole camera in action at Virginia Beach.

© JAY BENDER

A pinhole photograph.

the pin through and sand down the burr until you get a round hole; you can check for roundness with a loupe. After the hole is made, run the "lens" through a candle flame to line the edge of the hole with carbon black—to minimize light reflection, which could cause image only no-flare.

Hardware stores often sell shimstock in sheets or rolls; a thickness of .002 or .003 inch works best. Use opaque tape when you mount the piece of shimstock onto the camera. If any metal is exposed inside it, mask it off with black tape right up to the hole.

Pins and Needles

The easiest way to make a pinhole is to use a sewing needle. These are the recommended needle sizes (U.S.) to achieve the various hole diameters that correspond to specific focal lengths.

Focal Length	Sewing Needle
50mm	No. 14
75mm	No. 12
100mm	No. 11
125mm	No. 10
150mm	No. 9
200mm	No. 8
250mm	No. 7

Pinhole imagery is not inherently wide-angle, as some believe. It's just that many photographers try to minimize the pinhole-to-film distance to keep exposure times reasonably short. This gives their cameras a wide angle of view, which means, in turn, that they must place the camera closer to the subject to make it fill the frame. The resulting perspective tends to make close objects loom, just as it would with a wide-angle lens.

You can easily build a telephoto pinhole camera by making the pinhole-to-film distance long, relative to the film format. This will give the camera a narrow angle of view and cause less distortion, but you will usually end up needing longer exposures.

The Film

You can use virtually any kind of sheet film in a pinhole camera. Just place the unexposed sheet—in total darkness, of course—inside the camera directly behind the pinhole. Close up the camera, aim it at your subject, and open the shutter to make the exposure. When shooting pinhole, precise framing is out of the question.

The pinhole's small effective aperture demands much longer exposures than with a lens, even if you're using a fast film. Rather than fight this, many

pinholers work within the limitation by using photographic paper in place of film. The very long exposures this requires add movement to the softness inherent in pinhole photography.

Making paper negatives is a particularly handy approach when shooting in black and white. You can load the camera and process the paper by safelight, using different paper grades to control contrast. Resin-coated papers are a good choice because they contain relatively little fiber and give the image a less pronounced texture. They also dry flatter, which makes them better for contact-printing to make the positive. Cibachrome paper can also be used in camera; when processed, it produces positive color prints.

Paper negatives cannot be easily enlarged, so contact-printing is the only practical option (unless the negative is used as the final image). Thus, the paper used for exposure must be as

Stereo Pinhole

If you find domestic pinhole cameras too simple, try this one from Switzerland that shoots in stereo. Made of cardboard, it looks like a block of Swiss cheese and has two foil pinholes. It uses size 120 film and costs about $40.

3-D Foto World, Fach, CH-4020, Basel, Switzerland.

large as you want the final print—and a large print requires a large camera. Many pinhole photographers using conventional films make their negatives large enough for contact-printing anyway, because enlargement exaggerates the softness of the image.

All About Pinholes

Eric Renner is obsessed with pinhole photography—so much so that he's formed a nonprofit clearinghouse for information about his passion. Pinhole Resource is the ultimate support group for pinhole junkies. A $32.50 annual

membership entitles you to receive *The Pinhole Journal*, plus discounts on pinhole cameras.
Pinhole Resource, Star Route 15, Box 1655, San Lorenzo, NM 88057. (505) 536-9942.

Commercial Pinhole Cameras

If you don't want to build your own pinhole camera, you can choose from several commercial models. All these cameras are available from Pinhole Resource (see above), which also offers *Make Your Own Working Camera* ($15.95), a twelve-page book with die cuts that can be removed and used to construct a camera that takes size 126 cartridge film.

World Famous Lensless Camera. This fancy (as pinhole cameras go) and immodestly named camera is a wooden box that accepts 4×5-inch sheet-film holders or a Model 545 Polaroid film back. It comes in three focal lengths—75mm, 150mm, and 225mm—each with a .0156-inch pinhole. The company also makes an 8×10-inch model. Prices run about $45 to $115, postpaid.

Pinhole Camera Kit. This easily assembled kit turns into a 4×5-inch camera made of die-cut cardboard templates. You can adjust the camera's focal length with its three different-sized pinholes; one pinhole is included in the price ($8.95).

PinZip. Made for snaphooting pinholers, the PinZip accepts size 126 cartridge film—available in Kodacolor II or Kodachrome 64—and costs $11.95.

Pinhole Publications

These books and journals tell all you need to know to launch your career as a pinhole photographer.

The Hole Thing, by James Shull, Morgan & Morgan, 1974.
Shull's practical guide to how to make and operate a pinhole camera uses simple and whimsical illustrations to make its point. It's been around for a while, but that's the nice thing about pinholes—the technology never really changes.

Odd Pinhole Cameras

© ERIC RENNER

Plaster-face camera (above) and an image taken with it.

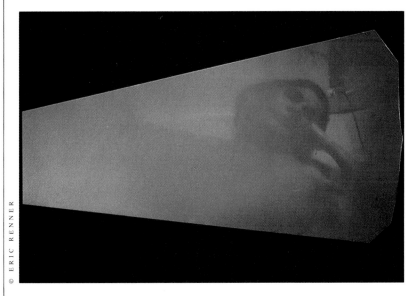

© ERIC RENNER

Nautilus camera (left) and an image taken with it.

How to Make and Use a Pinhole Camera, Pamphlet #AA-5, Eastman Kodak Company, 1986. Available from Eastman Kodak Company, Department 412-L, 343 State Street, Rochester, NY 14650.
At $1.00 (Kodak will send a single copy for no charge), this pamphlet is an excellent introduction to pinhole photography. It includes sections on assembling a camera, exposure, and processing, and includes simple and clear line drawings.

Optics, Painting, and Photography, by M.H. Pirenne, Cambridge University Press, 1970.
Though not strictly about pinhole photography, this book reproduces some excellent pinhole photographs. It is regrettably out of print.

The Pinhole Journal. Available from Pinhole Resource, Star Route 15, Box 1655, San Lorenzo, NM 88057. (505) 536-9942.
Published three times a year, this critical and technical journal is must reading for anyone interested in the field of pinhole photography. A subscription is free with membership in Pinhole Resource (see page 88).

The Visionary Pinhole, by Lauren Smith, Gibbs M. Smith/Peregrine Books, 1985.
This is a thorough overview of the breadth of work being done by fine-art photographers with pinhole cameras. *The Visionary Pinhole* includes many color and black-and-white reproductions, along with a history of the medium, including interesting (and amusing) photographs of unusual pinhole cameras.

Boraxo Pinhole

These photographs, part of Julie Schachter's Death Valley Daze *series, were taken with her pinhole camera, made from a Boraxo soap can.*

Junction Seating.

Furnace Creek.

Hand Coloring

In the nineteenth century, before scientists developed a viable color process, studio photographers began applying color by hand to photographs to achieve more realism. Black-and-white images were often adorned with highlights of color in buttons, eyes, and other small details, not to mention rosy cheeks. This practice was commonplace even with daguerreotypes, even though their smooth, mirrored surfaces weren't very receptive to coloring. The paper-based photographs that succeeded the daguerreotype accepted coloring more naturalistically, and even some stereo images and early motion-picture films were hand-colored.

The advent of Autochrome in the early twentieth century, and subsequent more practical color processes, spelled the beginning of the end for the hand-coloring trade. Though some studios continued to prefer the style and economy of hand coloring, their numbers slowly dwindled.

Like so many older processes, hand coloring has been resurrected by fine-art photographers who see it as an aesthetic device, not an attempt to render realistic color. Hand-coloring acts as a visual reference to earlier days and can also create a hyper-realistic image. Photographers have little control over what color film renders, but hand-coloring a black-and-white photograph gives them the kind of discretion that painters have always had over color.

Applying Color

Color can be added to a photograph with many types of dyes, paints, or pencils. Food coloring or watercolors, mixed with a wetting agent such as Kodak Photo Flo, can also be used. The trick is to find a method that gives you the color and texture you want and also adheres firmly to the surface of the print.

Several products—oils, dyes, and pencils—are sold specifically for hand-coloring. Whichever one you use, be sure to mix the materials so they remain somewhat transparent, because the original tones of a black-and-white image primarily control the intensity of the coloring. Colors do add some density, however, so it's best to start with a print that's a bit lighter than you would normally make it. It's also a good idea to keep the contrast of the image slightly high (as long as the print is light overall), since coloring will reduce contrast. The main thing to remember is that transparent colors hardly show over black; avoid dark areas in your print or when shooting, as much as possible.

Some photographers prefer warm-tone papers for hand-coloring, and may work on prints toned with various shades of brown. Others prefer to start with a cold-tone image. In either case, many leave parts of the image uncolored, an effect that plays up the image tone of the print itself. Uncolored parts of a cold-toned photograph can look quite blue, for example, if the applied color scheme is warm.

The surface of the printing paper is another important consideration. Resin-coated and other glossy papers are less suitable, because the color sits on the surface and doesn't penetrate into the paper's fibers. Most hand-colorists choose paper with a matte or

semimatte surface to ensure that the colors will be absorbed. There are no hard-and-fast rules, however. You can certainly use paper with an air-dried glossy surface; it will show brush strokes more readily and dry more slowly, so allow enough time to work with the color.

Paint can be applied with brushes, cotton swabs or balls, cloth or paper wipes, or whatever provides the control and evenness of stroke you desire. You can vary the intensity by altering the amount of color applied, but for the best tonality and clearest detail, keep the application fairly light. Most of all, hand-coloring requires constant experimentation with both the products and methods you use. Make extra prints of the image to be colored and prepare to throw several out until you achieve exactly what you want.

A contemporary hand-colored photograph.

Marshall's Hand-Coloring Products

Many products work well for hand-coloring, but most photographers use Marshall's Photo Oils and Photo Pencils. The oils come in five kits, from the introductory set (five colors for $17.95) to the master set (forty-six colors for $139.95). The pencils come in a starter (nine colors for $14.95) and regular set (fourteen colors for $19.95).

The company also makes several coloring solutions, including a varnish, an extender, and a precolor spray for treating resin-coated and other glossy prints so they accept coloring—all for less than $10. Marshall's products are available at camera stores and through many mail-order catalogs.

John G. Marshall Manufacturing Company, Box 649, Deerfield, IL 60015. (312) 478-7111.

A vintage hand-colored print (courtesy Rodger Kingston collection).

Other Materials

DR. P.H. MARTIN'S SYNCHROMATIC TRANSPARENT WATER COLOR
Salis International
4093 North 28th Way
Hollywood, FL 33020
(800) 843-8293; (305) 921-6971

BERG COLOR-TONE
Box 430
East Amherst, NY 14051
(716) 684-0511

JOBO PHOTO COLOR DYES
Jobo Fototechnic
251 Jackson Plaza
Ann Arbor, MI 48103
(313) 995-4192

SERVICES

Photography Centers

Because they work alone, photographers can easily become isolated—a problem common to both pros and serious amateurs who hold unrelated day jobs. Both need a place to find out what's going on in the outside world and meet others with common interests.

The local camera club used to be that place. Many such clubs remain active (see page 97), but their preeminent role has been taken over in many communities by universities and art schools, which sponsor visiting lecturers, offer courses, and exhibit photographs. Regular meetings of the local chapter of the American Society of Magazine Photographers or some other professional association also serve as activity centers, but only for a limited membership of working pros.

Most importantly, independent and nonprofit photography centers have been established in many communities during the last two decades. If you live near one, it's almost always worth joining. For a low fee (averaging about $25 annually), a center will keep you informed, usually via newsletter, of the photographic goings-on in your area. A few maintain darkrooms and most provide other services such as lectures, workshops, exhibitions, and publications.

Almost all photo centers focus on fine-art work. Many are small and local, but more ambitious centers have reached out to the national photographic community by publishing journals, holding innovative exhibitions, and awarding grants.

FILM IN THE CITIES (ST. PAUL, MINNESOTA)

The second largest media arts center in the United States, Film in the Cities, began in 1970 as an arts program for secondary school students. Though it opened its photography component the following year, FITC has remained close to its community roots. Its workshops and courses qualify for credit at local community colleges and universities, and it runs a variety of arts programs for children, physically handicapped people, and educators.

True to its name, Film in the Cities runs an extensive filmmaking program, including courses on video, sound, and screenwriting. The center offers exhibition space (the only gallery devoted exclusively to photography in the Twin Cities region), darkroom facilities, and educational programs—both ongoing courses and the Lightworks Workshops. Photographers who have lectured or taught at FITC include Eliot Porter, Beaumont Newhall, and Duane Michaels.

Every year since 1980, Film in the Cities has sponsored the FITC/McKnight Photography Fellowship Program, awarding a total of $55,000 annually to Minnesota residents. Along with its film and video grants, the center has given more than one million dollars in direct support to artists over the past decade.

Film in the Cities, 2388 University Avenue, St. Paul, MN 55114. (612) 646-6104.

See page 151.

FRIENDS OF PHOTOGRAPHY (SAN FRANCISCO)

Cofounded in 1967 by Ansel Adams, Friends of Photography has grown into the largest and one of the most comprehensive photo centers in the nation. Boasting more than 12,000 members, it moved in 1987 from Carmel to San Francisco, and its new headquarters, the $2.2-million Ansel Adams Center, has impressive galleries as well as a lecture hall and a bookstore.

Some centers try to explore the limits of photography, but Friends takes a more conservative approach. Though it

represents a wide variety of photography, much of its activity involves traditional areas such as documentary work, landscape, and portraiture.

Friends is best known for its excellent workshop program, but the center does a lot more. Each year it sponsors the Ferguson Grant and Ruttenberg Foundation Award, and it also conducts a first-rate publishing program. A $40 associate membership includes three books in the unique *Untitled* series (see page 179). Friends also has a members' print program. All levels of membership include a subscription to *re:view*, a monthly newsletter, and discounts on workshop tuition.
Friends of Photography, 101 The Embarcadero, San Francisco, CA 94105. (415) 391-7500.

See pages 125, 149, 208, 212, and 213.

INTERNATIONAL CENTER OF PHOTOGRAPHY
(NEW YORK)
The International Center of Photography is both a photo center and a major museum of photography. Some of its many programs include year-round courses and workshops, a lecture series, and a variety of special activities for the immediate community.

The center's 5,000 members benefit enormously from its New York location. Great photographers from all over the world spend time in the Apple, and can usually be talked into giving a lecture or workshop at the ICP.

Although it covers the breadth of photography, the ICP's programs and exhibitions lean toward photojournalism and professional photography. Courses emphasize fundamentals, such as shooting and darkroom technique. A well-maintained darkroom awaits those who take classes.

ICP/Midtown, a smaller exhibition space, was opened for the street traffic in mid-Manhattan. Both the Midtown and Fifth Avenue locations have gift shops with an excellent selection of photography books and posters.
International Center of Photography, 1130 Fifth Avenue, New York, NY 10128. (212) 860-1777.

Ansel Adams, cofounder of Friends of Photography.

re:view, *Friends's monthly newsletter.*

International Center of Photography/Midtown, 1133 Avenue of the Americas, New York, NY 10036.
See pages 106, 151, 201, 213, and 230.

PHOTOGRAPHIC RESOURCE CENTER
(BOSTON)
Affiliated with Boston University, the Photographic Resource Center serves one of the country's most active photo communities. It conducts an outstanding lecture and workshop series featuring internationally known photographers, and also runs two fine galleries. Though many of its exhibitions are very current and feature conceptual and interdisciplinary work, the center spans the entire field, with speakers and shows covering historical, contemporary, and professional photography.

The PRC is community oriented, but many of its programs are national in scope. It sponsors the Reva and David Logan Grants in support of photographic writing and the Godowsky Award for color work. Its quarterly journal, *Views: The Journal of Photog-*

raphy in New England, contains serious, often scholarly articles on subjects of broad historical and critical interest.

The center also publishes an excellent monthly newsletter that lists photo activities in the area, and provides information about grants, publications, and upcoming events. It maintains a library and holds regular portfolio-viewing nights, generally led by local photographers and teachers.
Photographic Resource Center, 602 Commonwealth Avenue, Boston, MA 02215. (617) 353-0700.
See pages 99, 125, 197, and 209.

More Photography Centers

ALLEN STREET GALLERY
(DALLAS)
Also called the Center for Visual Communications, Allen Street was formed in 1975 and is now primarily an exhibition space showing the work of both local and nationally known photographers. It also runs workshops, sponsors lectures, maintains a library, and publishes a newsletter *(ContactSheet)* with local community listings.
4101 Commerce Street, Box 26291, Dallas, TX 75226. (214) 821-8260.

ATLANTA PHOTO GROUP
(ATLANTA)
Founded in 1988, the Atlanta Photo Group is a small but growing organization with an active membership and a strong exhibition program.
495 Peachtree Street N.E., Atlanta, GA 30309. (404) 881-8139.

THE CENTER FOR PHOTOGRAPHY AT WOODSTOCK
(WOODSTOCK, NEW YORK)
A full-service center, offering a gallery, lectures, slides, videos, and movies, and publishing a journal *(Center Quarterly)*. CPW started in 1977. It represents a diversity of photography, but emphasizes the work of innovative fine-art photographers, filmmakers, and video artists. The center has a year-round educational program, highlighted by its nationally oriented summer workshops, and maintains a dark-

room for its members. It also offers one of the best members' print programs around.
59 Tinker Street, Woodstock, NY 12498. (914) 679-9957.
 See pages 125, 152, and 195.

CENTER FOR EXPLORATORY AND PERCEPTUAL ART
(BUFFALO, NEW YORK)
CEPA, born in 1974, is a showcase center for contemporary photography. It focuses not so much on photography itself, but rather on the interdisciplinary nature of the medium, particularly as it relates to video, film, performance, and computer-generated images. CEPA serves as a community center, sponsoring lectures, maintaining a gallery, and running an artist-in-residency program. It publishes a nicely produced journal *(CEPA Quarterly)* and an occasional artist's book.
700 Main Street, Buffalo, NY 14202. (716) 856-2717.

DAYTONA BEACH COMMUNITY COLLEGE PHOTOGRAPHIC SOCIETY
(DAYTONA BEACH, FLORIDA)
Associated with the Southeast Center for Photo/Graphic Studies, the DBCC Photographic Society has an active outside membership and offers workshops, lectures, and shows. It spans the breadth of photography, representing pros as well as artists. The society's publication is called *Newsletter,* but it's really a journal with good articles and interviews as well as local news.
Photo Center, Box 2811, Daytona Beach, FL 32115. (904) 255-8131, ext. 3450.
 See pages 145 and 196.

EN FOCO
(BRONX, NEW YORK)
Begun as an informal collaborative in 1974 by a group of Puerto Rican photographers, En Foco has expanded to encompass educational programs, exhibitions, and publications. Though its roots are Hispanic, it serves the needs of all community-based photographers. En Foco's programs include a slide registry (an archive featuring the work and resumes of member photogra-

International Center of Photography.

phers) and exhibitions in public places. Its publications include a bimonthly newsletter called *Critical Mass* and a quarterly, *Nueva Luz,* which presents the work of photographers from America's minority cultures.
32 East Kingsbridge Road, Bronx, NY 10468. (212) 584-7718.
 See page 196.

HOUSTON CENTER FOR PHOTOGRAPHY
(HOUSTON)
Founded in 1981, the HCP has grown rapidly and runs an active community-based program of exhibitions, films, lectures, and workshops. It publishes a quarterly journal *(Spot)* and awards annual fellowships to Houston-area photographers. The center also has a members' print program.
1441 West Alabama, Houston, TX 77006. (713) 529-4755.
 See pages 125 and 197.

IMAGE FOUNDATION
(HONOLULU, HAWAII)
The Image Foundation does not have its own building, but the group does have active programming including monthly meetings, an annual exhibition, and an annual workshop (held at the volcano on the Big Island). Well-known photographers from the mainland ship in to judge the exhibition and give workshops.
Box 22665, Honolulu, HI 96822. (808) 949-7774.

IMAGES
(CINCINNATI)
Started in 1980 as a commercial gallery—the only photography gallery in Cincinnati—Images has evolved into a nonprofit regional photo center. Exhibitions remain its bread and butter, but Images also brings in guest lecturers, runs workshops, and publishes a newsletter for its 200 or so members.
328 West Fourth Street, Cincinnati, OH 45202. (513) 241-8124.

THE LIGHT FACTORY PHOTOGRAPHIC ARTS CENTER
(CHARLOTTE, NORTH CAROLINA)
Founded as a cooperative in 1972, the Light Factory is now a very active nonprofit organization with over 500 members. It runs a nationally oriented gallery and a variety of educational programs, including lectures and workshops. Though it focuses on fine arts, the Light Factory's programs are quite diverse and include participation from the documentary and professional photography community. Darkroom space is available for members, as is *Community Voice,* a fine newsletter published five times per year.
311 Arlington Avenue, Charlotte, NC 28232. (704) 333-9755.
 See page 125.

LIGHT WORK
(SYRACUSE, NEW YORK)
This extremely active photo center has a members' darkroom and two galleries. It sponsors workshops and a grant program for individual photographers, curators and historians in the region. It also publishes a journal, *Contact Sheet,* five times per year. Light Work's unique residency program invites twelve to fifteen photographers a year to spend a month working in Syracuse; they get free room and board, plus a $1,000 stipend. Applications for residencies are encouraged.
316 Waverly Avenue, Syracuse, NY 13244. (315) 443-2450.

LOS ANGELES CENTER FOR PHOTOGRAPHIC STUDIES
(LOS ANGELES)
The LACPS, established in 1974 to ex-

Camera Clubs

Camera clubs are the original photo centers. Such clubs were first formed soon after the invention of photography, in the mid-nineteenth century. Over the years, some very influential figures in photography have been camera club members. For example, the New York Camera Club, established in the 1880s, counted George Eastman and Alfred Stieglitz on its early membership rolls.

Camera clubs serve a variety of functions. All hold regular meetings, which generally include a slide lecture or discussion, often from a club member and sometimes from a visitor. These meetings provide an excellent opportunity to show work to others and get feedback, as well as to get technical and product information and opinions. Some camera clubs publish newsletters; others offer darkroom facilities and regular courses; many run galleries or sponsor exhibitions. Most participate in local, regional, national, and even international competitions. A few clubs award scholarships.

There was a time when anyone interested in photography as a hobby (or a profession) joined a camera club, and many outstanding photographers learned their trade this way. Today, the role of such clubs has been challenged and often usurped by schools, workshops, galleries, and other photo centers.

Still, there are tens of thousands of members and hundreds of local chapters in the United States alone, and camera clubs remain quite popular overseas. The typical membership includes serious amateur photographers of all ages, from young adults to retirees.

Camera clubs are autonomous units. Anyone can start one; you don't need a charter from a higher authority. However, the point of camera clubs is to help photographers get together with other enthusiasts, and most active clubs belong to regional organizations such as the New England Camera Club Council and the Greater Washington (D.C.) Council of Camera Clubs.

The Photographic Society of America (PSA), while no longer formally related to camera clubs, is a national organization with strong historical ties to the camera club world. PSA used to be called the Associated Camera Clubs of America, and its members include a great many camera-clubbers as well as unaffiliated amateur and professional photographers. PSA has several divisions to satisfy the diverse interests of its membership, including travel, photojournalism, and nature.

Like a local camera club, PSA involves its members in regular competitions and hands out a lot of awards. It also has a significant educational bent, providing such services as a speakers bureau and a variety of instructional materials. Members also receive a monthly journal *(The PSA Journal)* and an opportunity to attend regional meetings and an annual convention.

Organizations similar to PSA exist in many other countries; the Royal Photographic Society in the United Kingdom is particularly notable.

Photographic Society of America, 3000 United Founders Boulevard, Suite 103, Oklahoma City, OK 73112. (405) 843-1437.

At left, Camera Club of New York members party in the darkroom at the turn of the century. The announcement above is for an exhibition celebrating the club's centennial.

hibit the work of emerging photographers, presents a varied program of exhibitions, lectures, symposia, and workshops. It also keeps a slide registry of members' work and offers a patron print program. Its annual auction features the work of over 300 photographers and is a major event in the Southern California photo community; actor Richard Gere has served as the honorary chair of the auction benefit committee.
1052 West 6th Street, Los Angeles, CA 90017. (213) 482-3566.
See page 125.

MICHIGAN FRIENDS OF PHOTOGRAPHY
(DETROIT)
This photo center has a statewide membership of about 200. It holds regular meetings and publishes a monthly newsletter (September through June) and a very nice critical quarterly, *Michigan Photography Journal* (which actually comes out three times a year). The center has no permanent exhibition space, but does put together shows—mostly with a regional bent—to travel throughout the state. It also sponsors a speakers program.
Box 3048, Trolley Station, Detroit, MI 48231. (313) 831-5334.
See page 196.

PHOTOGRAPHIC CENTER OF MONTEREY PENINSULA
(CARMEL, CALIFORNIA)
This group now occupies the Sunset Cultural Center, the former home of Friends of Photography. Actually, Photographic Center somewhat resembles the pre-expansion Friends. It runs exhibitions and workshops, has a members' print program, and publishes a short but informative newsletter. The center stresses the large-format landscape/still-life style so closely associated with the Carmel/Monterey area.
Box 1100, Carmel, CA 93921. (408) 625-5181.
See pages 125 and 151.

SAN FRANCISCO CAMERAWORK
(SAN FRANCISCO)
Artist-managed and dedicated to con-temporary photography and related media (such as film, video, and performance), SF Camerawork runs an outstanding gallery and lecture series with nationally known speakers. It also maintains a good reference library, sponsors occasional workshops, offers a members' print program, and publishes a quarterly journal, *SF Camerawork*. Every December the group holds a popular print auction.
70 Twelfth Street, San Francisco, CA 94103. (415) 621-1001.
See pages 125 and 197.

SANTA FE CENTER FOR PHOTOGRAPHY
(SANTA FE, NEW MEXICO)
Serving the Santa Fe and Albuquerque photography communities, this center nevertheless has a national membership of 220. It holds workshops (mostly low cost and locally oriented), cosponsors exhibits (it has no permanent space), and publishes an informative quarterly journal with a healthy calendar-of-events section.
Box 8183, Santa Fe, NM 87504. (505) 471-6128.

TEXAS PHOTOGRAPHIC SOCIETY
(AUSTIN, TEXAS)
A volunteer organization with about 400 members, TPS holds regular monthly meetings, sponsors exhibitions and yearly competitions, and publishes a journal *(Photoletter)* and a monthly newsletter *(Contact Sheet)*.
Box 3109, Austin, TX 78764. (512) 462-0646.

TORONTO PHOTOGRAPHERS WORKSHOP
(TORONTO)
The Toronto Photographers Workshop is devoted to contemporary photography. It operates two galleries (The Photography Gallery and Gallery TPW), runs lectures, holds monthly meetings, and maintains a resource center with an archive of books, periodicals, and slides. *Views*, published five times per year, includes articles of general interest as well as news of local photo happenings.
80 Spadina Avenue, Toronto, Ontario, *Canada M5V 2J3. (416) 362-4242.*
See page 197.

THE URBAN CENTER FOR PHOTOGRAPHY
(DETROIT)
An activist organization involved with urban issues, the Urban Center for Photography bears more resemblance to a street-theater guerrilla group of the 1960s than to a slick photographic-arts organization of the 1980s. With no permanent exhibition space, it shows work where it can, sometimes with permission in community clubs, bars, and churches, and sometimes ad hoc in public and private buildings—such as the infamous Demolished By Neglect project in 1987.
Box 32617, Detroit, MI 48232. (313) 961-6061.

VISUAL STUDIES WORKSHOP
(ROCHESTER, NEW YORK)
Although it's essentially a school, the Visual Studies Workshop has some of the elements of a photo center, including exhibitions and lecture programs. Established in 1969, it is one of the oldest and most innovative photo organizations in the country. Its founder and director, Nathan Lyons, has always been interested in work on the cutting edge of photography. This shows in the workshop's emphasis on artists' books, video, performance, and computer imaging. The Visual Studies Workshop publishes *Afterimage*, an influential fine-art journal.
31 Prince Street, Rochester, NY 14607. (716) 442-8676.
See pages 136, 193, and 198.

WASHINGTON CENTER FOR PHOTOGRAPHY
(WASHINGTON, D.C.)
Formed in 1986, the WCP sponsors workshops, lectures, and exhibitions, and also holds regular portfolio nights for members to show their work and talk about it. Its quarterly newsletter/journal, *WCP Source*, carries articles, reviews, and interviews, as well as an activities calendar.
1609 Connecticut Avenue N.W., Washington, DC 20009. (202) 462-3038.

Viewpoint: Photography in the Community

STAN TRECKER
DIRECTOR
PHOTOGRAPHIC RESOURCE CENTER, BOSTON

"The small art centers in this country emerged in the 1970s, when they were called 'alternative spaces,' as places to serve contemporary artists who were not part of the local museum or commercial gallery culture. Most of the centers specializing in photography concentrate on contemporary work, except when a unique opportunity arises to present historical work of particular relevance to their community.

"A critical artistic problem facing photo centers today is the diversity of forms that photography is taking, including the trend toward electronic imaging. Centers must deal with the presentation of larger, more complicated works, whether mural-sized pieces, holography, or computer-generated graphics. The challenge is to effectively present these works to the public. Fortunately, we at the Photographic Resource Center built our new space with fourteen-foot ceilings, but most art-center galleries cannot handle many of the large pieces generated today.

"Another artistic question centers must resolve is how far to travel down the path of non-silver images. I think it is appropriate and challenging to mount shows that incorporate media such as film and video; it's part of our charter to help our audience understand where the medium is going. At the PRC, we try to put work in the proper context by using wall labels, informational handouts, or an accompanying article in our newsletter.

"Nonartistic challenges have also become greater and more sophisticated over the last few years. With no growth in federal funding for the arts, and in some cases little state funding, small arts organizations have had to become very competitive and use professional marketing and promotion techniques to survive. When I started at the PRC in 1980, it employed two people, and I spent most of my time making sure the newsletter got out and that lectures were scheduled. Now I spend 80 percent of my time on financial affairs and fundraising. Given the present economic climate and the competition for philanthropic dollars, I'm not sure that it would be possible to start this kind of grass-roots organization today.

"One of the reasons the PRC has survived is that we've clearly defined who we are and what we do. When Chris Enos started the center in 1976, one of her guiding principles was to avoid duplicating what other organizations were doing. We don't hold classes or regularly do historical shows, for example, because the local teaching institutions and museums do those things quite well. The first thing Chris did was start a newsletter, because the strongest response she got from people was their need for information. We also offer lectures with guest speakers and occasional one-day workshops. When we moved into a new space in 1985, we added a permanent gallery where we can show work on a continuing basis. I hope we haven't strayed too far from our original concept, which has always been based on the needs of the local photographic community."

Associations

AMERICAN SOCIETY OF MAGAZINE
PHOTOGRAPHERS

The American Society of Magazine
Photographers (ASMP), the premier
association for professional photogra-
phers, was founded in 1944 by several
prominent magazine shooters, includ-
ing W. Eugene Smith and Philippe
Halsman. Its membership has since
broadened to admit working photogra-
phers in all specialties, including edi-
torial, advertising, corporate, industri-
al, architectural, and fashion. ASMP
now claims over 5,000 members. Its
stated goals are "to improve the cir-
cumstances of the working photogra-
pher; to safeguard and protect their
interests; to maintain and promote the
highest standards of performance and
ethics; and to cultivate friendship and
understanding among professional
photographers."

Photographers with special interests, either professional or ama-
teur, can keep up with news, trends, and business issues by join-
ing a professional association. Some photography associations
are broad based; others represent arcane specialties. Most pro-
vide limited services, but some are activists for their members.
For example, when the IRS began to apply the unpopular uni-
form-capitalization rule to photographers in 1987, the American
Society of Magazine Photographers launched a lobbying drive
which, after a long struggle, helped reverse that decision.

ASMP is one of the few photo-
graphic associations that restricts
membership. To qualify as a general
member, you must be an active pho-
tographer with at least three years of
professional experience, and must also
be sponsored by two current members.
Applicants submit evidence of their
experience to a panel of ASMP mem-
bers in a portfolio review.

A good association can be a real bargain. Membership dues
are usually (though not always) modest, and in return photogra-
phers can expect such goodies as a newsletter or other publica-
tions, new-product information, and association-sponsored
activities such as seminars, lectures, and conferences. Some
associations offer health insurance, as well as advice on market-
ing, legal issues, and business practices.

As an activist association, ASMP
works hard for its members' inter-
ests—and, as a result, the interests of
all photographers. Aside from its key
role in eliminating the uniform-capi-
talization tax ruling, ASMP has been a
vociferous advocate for such key
issues as stronger copyright protec-
tion. The group also provides mem-
bers with business and legal advice
and self-promotional opportunities. It
has a small but excellent publishing
program, which includes a monthly
newsletter *(ASMP Bulletin)* and occa-
sional reports on business, legal, or tax
issues. The *ASMP Business Practices
Book* and *ASMP Stock Photography
Handbook* are indispensable guides to
the practical sides of professional pho-
tography.

© YVONNE HALSMAN

*An early meeting of ASMP founders, held in Philippe Halsman's studio, ca. 1944.
Left to right: Herb Giles, Bradley Smith, Halsman, Bernard Quint, and Arthur Rothstein.*

Another benefit of ASMP member-
ship is involvement in one of its thirty
or more local chapters. These usually
meet regularly, bringing together

members of the regional photography community for such events as lectures from out-of-town speakers, slide presentations, and social hours. This is a good way of making and maintaining business contacts and personal friendships, plus keep up on industry gossip.

Annual dues for full members are high as professional associations go—$225, plus a $100 initiation fee. Special memberships are available for less established photographers, students, teachers, and clients. This is one association anyone involved with professional photography—on any level—should consider joining.

American Society of Magazine Photographers, 205 Lexington Avenue, New York, NY 10016. (212) 889-9144.

See pages 157, 166, 171, 172, and 194.

ADVERTISING PHOTOGRAPHERS OF AMERICA

A relatively new force, the Advertising Photographers of America was started in 1981 by prominent ASMP members who felt that the broader organization was not adequately addressing the needs of those working in advertising. These needs include billing issues, extended rights, and model and talent fees. APA now has a membership of approximately 1,200.

Apart from APA's narrower focus, the two associations are similar, and many APA members also belong to ASMP. APA's stated goals echo those of ASMP: "To promote the highest standards of business practices within the industry, and to promote an awareness and understanding of the part advertising photographers play within the creative community."

APA's publishing program includes a useful bimonthly newsletter from the New York chapter and an excellent book, *Assigning Advertising Photography,* somewhat similar to the *ASMP Business Practices Book.*

APA full members ($300 per year) generally work for themselves, but the group offers associate memberships ($150) for advertising photographers just starting out and assistant memberships ($75) for photographic assis-

ASMP Bulletin, *a monthly newsletter.*

News Photographer, *published monthly by the National Press Photographers Association.*

tants; teachers and students can also join ($50). Members get the newsletter, can attend local and national meetings, and receive special bulletins on business and legal issues. An annual ball and awards party is held in New York every year, and is a major event on the photo society calendar.

APA has six local chapters in New York, Los Angeles, San Francisco, Atlanta, Chicago, and Miami; the New York, Chicago, and Los Angeles chapters are the most active. Each chapter is set up to be autonomous so it can better respond to the specific needs of that region's photographers.

Advertising Photographers of America, 27 West 20th Street, New York, NY 10011. (212) 807-0399.

See pages 171 and 195.

AMERICAN SOCIETY OF PICTURE PROFESSIONALS

Founded in 1967, ASPP is an association that's more about photography than for photographers. Most of its members work as picture editors, researchers, and librarians in publishing and advertising. Designers, curators, and other professionals who work with photographs also belong, and more and more photographers are joining, especially those who sell their work for stock.

With a membership of about 600, ASPP is primarily resource-oriented, not activist. It publishes a good quarterly newsletter, *The Picture Professional,* and holds a national meeting and trade show annually in New York City. Local chapters in New York, New England, Chicago, San Francisco, and Washington hold regular meetings that include programs on industry trends and issues; a typical meeting might include a presentation on such subjects as new technologies, picture management, picture collections, copyrights, permissions, or picture rates. You might also hear a photographer talking about and showing his or her work.

American Society of Picture Professionals, Box 24201, Nashville, TN 37202.

See page 195.

NATIONAL PRESS PHOTOGRAPHERS ASSOCIATION

National Press Photographers Association members are newspaper photographers and others working in photojournalism, such as magazine and television photographers, free-lancers, photo editors, and photojournalism teachers. Since its birth in 1946, the group has grown to about 8,500 members with approximately thirty local chapters throughout the United States and Canada.

NPPA is a very active organization, perhaps best known for its annual award competitions. It publishes a good monthly magazine, *News Photographer,* as well as a semimonthly newsletter. Members can also take advantage of NPPA's wide-ranging educational programs and job-placement services.

National Press Photographers Association, 3200 Croasdaile Drive, Suite 306, Durham, NC 27705. (800) 289-6772; (919) 383-7246.

See pages 139, 196, and 212.

PROFESSIONAL PHOTOGRAPHERS OF AMERICA

Created in 1880, Professional Photographers of America is the oldest continuing association of photographers. With about 15,000 members, it may also be the largest. Membership is open to portrait, wedding, yearbook, advertising, commercial, and industrial photographers, as well as to educators and service specialists such as lab technicians.

Most visible for its large annual trade show, PP of A publishes *Professional Photographer* and *Photomethods* magazines and provides its members with a wide variety of benefits, from several group-insurance options (including hard-to-get equipment insurance) to the Ms. PP of A Photogenic Contest (honest).

PP of A is also heavily involved in educating its membership. It operates the Winona School of Photography in Mount Prospect, Illinois, and is the guiding hand behind the Fellowship of Photographic Educators.

Professional Photographers of Ameri-

An ASPP regional newsletter.

The Professional Photographers of America monthly newsletter.

ca, 1090 Executive Way, Des Plaines, IL 60018. (312) 299-8161.

See pages 134, 188, and 222.

Related Associations

AMERICAN INSTITUTE OF GRAPHIC ARTS
1059 Third Avenue
New York, NY 10021
(212) 752-0813

AMERICAN PHOTOGRAPHIC ARTISANS GUILD
524 West Shore Drive
Madison, WI 53715
(608) 255-5787

AMERICAN SOCIETY OF PHOTOGRAPHERS
Box 52836
Tulsa, OK 74158
(918) 743-2122

AMERICAN SOCIETY OF PHOTOGRAMMETRY
210 Little Falls Street
Falls Church, VA 22046
(703) 543-6617

ASSOCIATION FOR MULTI-IMAGE INTERNATIONAL
8019 North Himes Avenue
Tampa, FL 33614
(813) 932-1692

ASSOCIATION OF INTERNATIONAL PHOTOGRAPHY ART DEALERS
93 Standish Road
Hillsdale, NJ 07642
(201) 664-4600
See page 125.

BIOLOGICAL PHOTOGRAPHIC ASSOCIATION
1 Buttonwood Court
Indianhead Park, IL 60625
(312) 246-9116

FELLOWSHIP OF PHOTOGRAPHIC EDUCATORS
7551 Long Lake Road
Willmar, MN 56201
(612) 235-6413
See page 134.

THE NATIONAL STEREOSCOPIC
ASSOCIATION
Box 14801
Columbus, OH 43214
See page 71.

THE NEW YORK PHOTOGRAPHERS'
ASSISTANTS COALITION
Box 1919
Murray Hill Station
New York, NY 10156
(212) 727-1749
See page 144.

PHOTOGRAPHIC SOCIETY OF AMERICA
2005 Walnut Street
Philadelphia, PA 19103
(215) 563-1663
See page 97.

PHOTO MARKETING ASSOCIATION
INTERNATIONAL
3000 Picture Place
Jackson, MI 49201
(517) 788-8100

PICTURE AGENCY COUNCIL OF
AMERICA
4203 Locust Street
Philadelphia, PA 19104
(215) 386-6300

PROFESSIONAL WOMEN
PHOTOGRAPHERS
17 West 17th Street, #4
New York, NY 10011
(212) 255-9678

SOCIETY FOR PHOTOGRAPHIC
EDUCATION
Box BBB
Albuquerque, NM 87196
(505) 268-4073
See pages 134 and 195.

SOCIETY OF PHOTOGRAPHIC
SCIENTISTS AND ENGINEERS
7003 Kilworth Lane
Springfield, VA 22151
(703) 642-9090

WEDDING PHOTOGRAPHERS
INTERNATIONAL
Box 2003
Santa Monica, CA 90406
(213) 451-0090

The ASMP Honor Roll

In 1961, ASMP decided to honor "the great and lasting contribution make to photography by colleagues, past and present." Here are the inductees and the dates they were so honored, plus a list of honorary members.

1961	Man Ray
1962	Roy Stryker
	Alexey Brodovitch
	Edward Steichen
	Will Connell
1963	Dorothea Lange
	Walker Evans
	Cecil Beaton
	Paul Strand
	George Hoyningen-Heune
1964	Margaret Bourke-White
1965	André Kertész
1966	Ansel Adams
	Brassaï
1967	Dr. Roman Vishniac
	Bill Brandt
1968	Beaumont Newhall
1969	Fritz Gruber
1970	W. Eugene Smith
1971	Ernst Haas
1972	Henri Cartier-Bresson
1975	Cornell Capa
1978	Barrett Gallagher
1980	Gjon Mili
	Ben Rose
1984	Eliot Porter
1985	Gordon Parks
1986	Brett Weston

Honorary Members
Berenice Abbott
Imogen Cunningham
Justice William O. Douglas
Lisette Model

WHITE HOUSE NEWS
PHOTOGRAPHERS ASSOCIATION
101½ South Union Street
Alexandria, VA 22314
(703) 683-2557

WILDLIFE PHOTOGRAPHY
ASSOCIATION
Box 691
Greenville, PA 16125

Professional Services

Professional photographers occupy a warm place in the hearts of camera manufacturers. They buy a lot of equipment, usually top of the line, and they use it all the time, so it frequently needs repair and replacement. Professional photographers are also brand loyal. Once they buy into a particular camera and lens system, they rarely change; it's too expensive to do so.

Smart manufacturers take special care of their professional customers. They offer various one-time and ongoing support programs such as seminars, targeted publications, and easy equipment-leasing. A few offer free membership in a professional-service club, which provides benefits such as free short-term equipment rentals and priority repair service.

To qualify for preferential treatment, photographers must prove their full-time professional status. Depending on a club's policy, this requires submitting some combination of tearsheets, a letter from an employer, or personal recommendations from fellow club members.

NIKON PROFESSIONAL SERVICES

For years, Nikon has carefully nurtured its reputation as *the* supplier of equipment for professional photographers using 35mm. It has done so by offering sturdy, high-quality cameras and lenses with a wide assortment of accessories, and backing them up with unique services. For example, at major sports and news events, such as the Kentucky Derby or space shuttle launches, you'll see a Nikon van filled with spare parts and staffed by professional technicians. Their mission: to fix stuck shutters and replace busted motor drives and jammed lenses.

In 1973 Nikon started Nikon Professional Services (NPS), the model for the clubs from other manufacturers that followed. For its 11,000 members, NPS provides a worldwide network to speed equipment repairs, give advice about technical matters, and loan what's needed to replace broken equipment or finish a specific job. Say you're going on a short assignment to photograph wildlife, and you don't want to invest in a 600mm lens. NPS will lend it to you—if you're a member—at no charge. That's not a bad deal, since membership is free to qualified pros.

Recently, photographers ran into a severe shortage of certain Nikon equipment because production of autofocus cameras and lenses had taken priority over production of non-autofocus equipment. Nikon customers, especially professionals, were up in arms. Nikon responded by giving NPS members preferential treatment, dramatically cutting the waiting time for delivery of hard-to-find items. This kind of response is what keeps a lot of pros shooting with Nikons.
Nikon Professional Services, 623 Stewart Avenue, Garden City, NY 11530. (516) 222-0200.

Professional Treatment

The following companies will treat you right if you're a professional who uses their equipment.

BRONICA PROFESSIONAL SERVICES
1776 New Highway
Farmingdale, NY 11735
(516) 752-0066

CANON PROFESSIONAL SERVICES
National Technical Department
One Canon Plaza
Lake Success, NY 11042
(516) 488-6700

LEICA
156 Ludlow Avenue
Northvale, NJ 17647
(201) 767-7500

MAXXUM PROFESSIONAL ASSISTANCE
Minolta
101 Williams Drive
Ramsey, NJ 07446
(201) 825-4000

VERY IMPORTANT PHOTOGRAPHER PROGRAM
Olympus
Crossways Park
Woodbury, NY 11797
(516) 364-3000, ext. 258

COLLECTIONS

Museums

The 1960s and 1970s were boom years for photography in museums. Before that, it had received little respect; most curators strongly disputed photography's claim as an art form. Fortunately, the influential dissenters included New York's Museum of Modern Art, which began collecting photography in 1930 and founded a substantial department under the guidance of David McAlpin and Beaumont Newhall in 1940. The Modern's strong support for photography—and its success with it—has been a major factor in the subsequent wide acceptance of photography by other museums.

These days, hundreds of museums show and collect photography. Most are all-purpose institutions that feature painting, drawing, sculpture, and other arts, but several museums concentrate exclusively on photography. Some even have strong historical collections that include the equipment, letters, diaries, and other personal effects of influential photographers.

George N. Barnard, Burning Mills, Oswego, N.Y., *1851, from the collection of the International Museum of Photography at the George Eastman House.*

INTERNATIONAL CENTER OF PHOTOGRAPHY

Though relatively small, the International Center of Photography (ICP) *seems* like a big place. It plays host to an enormous buzz of activity. The exhibitions are important, widely discussed, and well attended. The public programs are popular—lectures, classes, workshops, and films.

Started in 1974 by Cornell Capa (brother of Robert), for years the ICP concentrated on photojournalism (the stock and trade of the brothers Capa). In the past ten years or so, its focus has changed to embrace all photographic styles, though it still shows a lot of photojournalism.

The ICP's permanent collection consists of more than 10,000 photographs from over 800 photographers. It also maintains some photographers' archives (filmed interviews, correspondence, and so forth). The focus is decidedly on the twentieth century and includes Berenice Abbott, Lewis Hine, Robert Capa, and contemporary work from Ralph Gibson, Lewis Baltz, and many others. The ICP also has an important resource library with over 6,000 volumes, many rare.

ICP/Midtown, a new satellite gallery, is a smaller place, with 12,000 square feet devoted to public space, including exhibition galleries and a screening room for showing films and videos. Both locations have excellent bookstores.

International Center of Photography, 1130 Fifth Avenue, New York, NY 10028. (212) 860-1777.

International Center of Photography/Midtown, 1133 Avenue of the Americas, New York, NY 10036.

See pages 95, 151, 201, 213, and 230.

INTERNATIONAL MUSEUM OF PHOTOGRAPHY

Located in a building attached to Kodak founder George Eastman's mansion, the International Museum of Photography (IMP) is the preeminent museum of photography and film in the United States, and perhaps in the world. Since its founding in 1949 as

both a research facility and a public space, the IMP has developed several major collections.

The photographic collection has about 350,000 prints and negatives, representing photographers from the beginning of the medium to the present. It includes a rare signed daguerreotype by Louis Daguerre, a copy of Fox Talbot's *Pencil of Nature* (the first major book to be illustrated with photographs), one of the largest collections of Lewis Hine's negatives, as well as major samples of the work of Eadweard Muybridge, Alvin Langdon Coburn, Edward Steichen, Julia Margaret Cameron, and Minor White. Recently, the American Society of Magazine Photographers established the first archive of commercial photography at the IMP.

Unlike many photo museums, the IMP represents all types of photography, not simply fine-art work. The collection contains an unsurpassed nineteenth-century component that includes enormous archives of French photography from this period (the world's largest), as well as major sections from the Civil War, the U. S. Geological Survey, and pioneering portrait photographers Southworth and Hawes. You can also see premier pieces from other key nineteenth-century figures such as O. G. Rejlander, Gustav Le Gray, Henri Le Secq, Maxime DuCamp, and on and on.

The IMP's technology collection

The IMP in a Book

Masterpieces of Photography from the International Museum of Photography, by Robert A. Sobieszek, Abbeville Press, 1985.

It's hard for one book to give a strong sense of the vast collections of the International Museum of Photography, but this one takes an excellent stab at it. A striking selection, Sobieszek's book is tightly edited and beautifully produced.

Museum Publications

Many museums have publication programs. Members of the California Museum of Photography receive some of the best produced and most interesting catalogs and journals.

consists of more than 11,000 cameras and related photographic and cinematographic equipment, from the Giroux model of the 1839 camera used by Louis Daguerre (built by his official camera maker—the only example in North America) to the camera custom-built for the U. S. space program.

Although it has an impressive exhibition program, the soul of the IMP is its role as a research facility, backed up by its film collection (more than 7,000 motion pictures) and its library (over 27,000 volumes on photography and film). The entire photography collection is being cataloged onto optical laser discs for quick and efficient access. Also, the IMP publication program boasts an excellent journal *(Image)* and several scholarly books and catalogs.
International Museum of Photography at the George Eastman House, 900 East Avenue, Rochester, NY 14607. (716) 271-3361.
See pages 150 and 196.

Museum of Modern Art
Built with care over the past sixty-plus years, the photography collection at the Museum of Modern Art (MOMA) is one of the most selective and important in the world. It includes most major photographers and many of their most notable images. A visit to the permanent collection, which fills six galleries, feels like a trip through the history of photography—an apt feeling, as MOMA has done so much to make it. Its shows, such as The Family of Man, The Photographer's Eye, The Work of Atget, and countless others (see page 108), have been incredibly influential. If this museum had never existed, we would all view the history of photography quite differently.

An Influential Museum

Here are some of the many important exhibitions shown at the New York Museum of Modern Art over the years. A quick glance should explain why MOMA has had such an enormous effect on the history of photography. Many of these photographers received their first national exposure at MOMA, and several of the exhibitions have been preserved as books.

Walker Evans: American Photographs (1938)

New Acquisitions: Photographs by Alfred Stieglitz (1943)

Birds in Color: Photographs by Eliot Porter (1943)

Helen Levitt: Photographs of Children (1943)

Paul Strand: Photographs, 1915–1945 (1945)

The Photographs of Edward Weston (1946)

The Photographs of Henri Cartier-Bresson (1947)

Four Photographers: Lisette Model, Bill Brandt, Ted Croner, and Harry Callahan (1948)

Roots of Photography: Hill, Adamson, Cameron (1949)

Color Photography (1950)

The Family of Man (1955)

Steichen the Photographer (1961)

Harry Callahan and Robert Frank (1962)

Ernst Haas: Color Photography (1962)

The Photographer's Eye (1964)

André Kertész: Photographer (1964)

Dorothea Lange (1966)

Jerry N. Uelsmann (1967)

New Documents: Photographs by Diane Arbus, Lee Friedlander, and Garry Winogrand (1967)

Brassaï (1968)

August Sander, 1876–1964 (1968)

The Animals: Photographs by Garry Winogrand (1969)

East 100th Street: Photographs by Bruce Davidson (1970)

E. J. Bellocq: Storyville Portraits (1970)

Diane Arbus (1972)

Lee Friedlander (1974)

Harry Callahan (1976)

William Eggleston (1976)

Before Photography: Painting and the Invention of Photography (1981)

The Work of Atget: Old France (1981)

The Work of Atget (ii): The Art of Old Paris (1982)

Big Pictures by Contemporary Photographers (1983)

Irving Penn (1984)

The Work of Atget (iii): The Ancien Régime (1985)

The Work of Atget (iv): Modern Times (1985)

Henri Cartier-Bresson: The Early Work (1987)

Garry Winogrand: Figments From the Real World (1988)

Eugène Atget, Marchand abat-jours, *1899–1900, from the collection of the Museum of Modern Art, New York.*

John Szarkowski, director of the department of photography at MOMA since 1962.

In fact, despite the impressive size and quality of its holdings, it's the influence of the museum that photographers most talk about. New exhibitions are widely anticipated and much discussed. To be shown or collected at MOMA is a major step in the career of any fine-art photographer.

Mindful of this responsibility, the museum's photography curators, John Szarkowski, Peter Galassi, and Susan Kismaric, keep an unusually open policy of looking at unsolicited work. They spend every Thursday morning reviewing portfolios—without the photographer present. The procedure is simple: Bring in the work anytime Monday through Wednesday (10 A.M. to 5 P.M.) and pick it up after Thursday. Don't expect a written response; they see too many portfolios.

Aside from MOMA's collection and exhibition programs, the museum maintains an active research library (the Erna and Victor Hasselblad Study Center), which is open to photographers and scholars by appointment, and publishes excellent fine-art books. And lest we forget, the MOMA gift shop is one of the busiest in New York at Christmas—an excellent source for photography (and other art) books, posters, and postcards.

Museum of Modern Art, Photography Department, 21 West 53rd Street, New York, NY 10020. (212) 708-9400.

See page 178.

NAYLOR MUSEUM OF PHOTOGRAPHY

One of the world's great collections of photographica sits below ground in a suburban Boston home. This private collection owned by Thurman (Jack) Naylor contains an amazing number of rare and unusual pieces of equipment, prints, and memorabilia.

Most people's idea of a hard-to-move item in the basement is an old furnace or water heater. For Naylor, it's a 642-pound Atomic Camera made by Kodak to photograph the explosion of a hydrogen bomb. He's also got the Mamouth Plate, at 11×14 inches the world's largest daguerreotype camera; the first 35mm camera, made in 1903; Margaret Bourke-White's personal col-

One of the most curious pieces in the Naylor Museum of Photography is the Doppel Sport Pigeon Camera, used in World War I. Here we see a ceramic statue of a German soldier releasing a pigeon with camera (top); a photograph taken by pigeon and camera (middle); and the camera strapped to the photographer (courtesy Jack Naylor collection).

From the ICP collection: Lewis Hine, Ellis Island Madonna, *ca. 1905.*

Ruth Orkin, Lauren Bacall, *1957.*

Edward Steichen, Experiment in Negative Color, *ca. 1940.*

lection of cameras; and an extensive collection of spy cameras.

Among the collection's oddities is the Doppel Sport Pigeon Camera. Used in World War I by the Germans, these tiny cameras were strapped to the breasts of homing pigeons who flew over the French lines taking photos with the help of a timer and a spring-loaded device. It was the rare camera—or pigeon—that survived.

The Naylor Collection has hundreds of similarly unusual items, but the bulk of it is solid and serious. One exhibit follows the technological progress of the medium, from its prehistory to the development of roll film. Another is a replica of an 1860 portrait studio. Still other exhibits honor the careers of Leopold Godowsky and Leopold Mannes, inventors of Kodachrome, and Dr. Harold Edgerton, creator of strobe photography.

Naylor's collection of photos and memorabilia is also impressive—from historical and contemporary prints to George Eastman's suicide note. The museum is not open to the general public, but requests for visits from groups and scholars are welcome. *Naylor Museum of Photography, (617) 731-6603.*

Other Museum Photography Collections

AMON CARTER MUSEUM OF WESTERN ART
3501 Camp Bowie Boulevard
Fort Worth, TX 76113
(817) 738-1933

ART INSTITUTE OF CHICAGO
Michigan Avenue and Adams Street
Chicago, IL 60603
(312) 443-3600

CALIFORNIA MUSEUM OF PHOTOGRAPHY
University of California
Riverside, CA 92521
(714) 784-3686

FOGG MUSEUM
Harvard University

32 Quincy Street
Cambridge, MA 02138
(617) 495-9400

J. PAUL GETTY MUSEUM
401 Wilshire Boulevard
Santa Monica, CA 90401
(213) 458-9811

MENIL FOUNDATION
3363 San Felipe Road
Houston, TX 77019
(713) 622-5651

METROPOLITAN MUSEUM OF ART
Fifth Avenue and 82nd Street
New York, NY 10028
(212) 535-7710

MUSEUM OF THE CITY OF NEW YORK
1220 Fifth Avenue
New York, NY 10029
(212) 534-1034

MUSEUM OF CONTEMPORARY PHOTOGRAPHY
Columbia College
600 South Michigan Drive
Chicago, IL 60605
(312) 663-5554

MUSEUM OF FINE ARTS
465 Huntington Avenue
Boston, MA 02115
(617) 267-9300

MUSEUM OF FINE ARTS
1001 Bissonnet
Houston, TX 77005
(713) 526-1361

MUSEUM OF PHOTOGRAPHIC ARTS
1649 El Prado, Balboa Park
San Diego, CA 92101
(619) 239-5262

NEW YORK HISTORICAL SOCIETY
Print Room
170 Central Park West
New York, NY 10024
(212) 873-3400

THE OAKLAND MUSEUM
1000 Oak Street
Oakland, CA 94607
(415) 273-3401

Viewpoint: Fine-Art Photography

PETER GALASSI
CURATOR
MUSEUM OF MODERN ART, NEW YORK CITY

"I think it's inappropriate, not to mention arrogant, for a curator to predict where photography is going. Defining the future of photography is the job of the people who make photographs, and the best of them are often the ones who reach the most unexpected definitions. The curator's job is to follow, with as open a mind as possible.

"The past decade has created interesting new challenges for young photographers. Both in the work itself and in the market—two very different things—there has been more and more exchange between serious photography (as traditionally defined) and the other arts, especially painting. One symptom of this exchange is the explosion of big photographs, on the scale of paintings.

"In such work, I see a new sense of possibility and freedom. Photographs need not be little gray rectangles under mats, and the photographer is not locked into a narrow tradition defined, say, by Edward Weston and Cartier-Bresson. In the market, the growing presence of a wide range of photographic work presents a healthy challenge to photographers (or 'artists who use photography'—I don't put much stock in the labels) to learn from and compete with the arts at large.

"This challenge has already produced some very impressive, innovative work. I think it has also begun to create a fresh attitude toward so-called traditional photography. Wouldn't it be wonderful, for example, if more people realized that Lee Friedlander—even though he makes little gray rectangles under mats—is not only one of our best photographers, but also one of our best artists."

PHILADELPHIA MUSEUM OF ART
Alfred Stieglitz Center
26th Street and Franklin Parkway
Philadelphia, PA 19130
(215) 763-8100

PRINCETON UNIVERSITY
The Art Museum
Princeton, NJ 08544
(609) 452-5827

SAN FRANCISCO MUSEUM OF MODERN ART
401 Van Ness Avenue
San Francisco, CA 94102
(415) 863-8800

U.C.L.A. RESEARCH LIBRARY
Department of Special Collections
405 Hilgard Avenue
Los Angeles, CA 90024
(213) 825-4879

UNIVERSITY OF NEW MEXICO
University Art Museum
Fine Arts Center
Albuquerque, NM 87131
(505) 277-4001

Private and Public Archives

Corporations and individuals are important buyers of photography, but their efforts pale beside the collections of private and public institutions. A corporate collection of 1,000 photographs may be considered large, but several of the institutions described below have holdings numbering in the hundreds of thousands, and even millions.

Some institutions specialize. The University of California at Santa Barbara, for example, has a huge collection of aerial photographs, while the University of Louisville's Photographic Archives targets documentary work. State historical societies and public libraries frequently house important regional collections, and some institutions are best known as repositories of the work of a single or a very few important photographers, such as the Knight Library at the University of Oregon for its large Doris Ulmann archive.

All the organizations listed here have major photography collections, and some also collect photographica—memorabilia and equipment of historical value. Some also have the archives of photographers, including letters, diaries, financial records, possessions, and other personal effects.

Edouard Baldus, Pavillon Richelieu, Nouveau Louvre, *Paris, ca. 1855, from the Collection Centre Canadien d'Architecture/Canadian Centre for Architecture, Montréal.*

CANADIAN CENTRE FOR ARCHITECTURE

The collections at the Canadian Centre for Architecture (CCA) consist of drawings, books, and photographs dedicated to world architecture, both past and present. It's a unique and varied collection—the largest of its kind in the world.

The centre's interest in photography is based on its belief that photographs "broaden the perception of architecture," by revealing an individual response to a building (or location) and at the same time providing specific information about that building and its place within the rural or urban context. As a result, the photographs in the CCA's collections were chosen both for their aesthetic value as well as for their value as historical artifacts and documentation.

The collections span the entire history of photography and represent photographers from all over the world, particularly the United Kingdom, France, Italy, Canada, and Germany. There are large holdings of well-known and obscure photographers, including Edouard Baldus, Robert MacPherson, Frederick Evans, Félice Beato, Weiner Mainz, and Bernd and Hilda Becher.

Americans are also covered, in great numbers, from the nineteenth-century photographers of the West such as Isaiah Taber and Carleton Watkins, through the Great Depression with Walker Evans and Berenice Abbott, up to modern times with Lee Friedlander and William Clift. The common link of these diverse images is their focus on buildings, signs, interiors, urban landscapes, or any subject that has architectural significance, regardless of the photographer's original intent.

For a good peek at some of the collection's nearly 46,000 photographs, see *Photography and Architecture* by Richard Pare, published by the CCA in 1982 and distributed in the United States by M.I.T. Press.
Canadian Centre for Architecture, 1920 Rue Baile, Montreal, Quebec, Canada H3H 2S6. (514) 939-7000.

CENTER FOR CREATIVE PHOTOGRAPHY

Dedicated to the acquisition of fine-art contemporary photography, the Center for Creative Photography (CCP) started with a bang in 1975 by acquiring the archives of Ansel Adams, Wynn Bullock, Harry Callahan, Aaron Siskind, and Frederick Sommer. Since then, the CCP has added major collections from the likes of W. Eugene Smith, Edward Weston, Paul Strand, Weegee, Laura Gilpin, Paul Caponigro, Jerry Uelsmann, and Robert Heinecken. All told, the center holds the work of more than 1,200 important photographers, almost all of them twentieth-century artists.

The CCP houses over 40,000 master prints and has one of world's largest libraries of photography publications. But the center's strength is its huge archive of private letters, notes, and artifacts. You can read what Ansel Adams wrote to Georgia O'Keeffe or snoop into Gene Smith's financial records. You can also view equipment, materials, and personal effects—including Edward Weston's suitcases, wedding ring, and grocery lists.

This attention to detail makes the CCP the place to go for original research. The center makes every effort to disseminate its collections and keep them as accessible as possible. It runs a substantial exhibition and publishing program and, with an appointment, visitors to Tucson can walk in and spend a couple of hours per day perusing original prints.

Center for Creative Photography, University of Arizona, Tucson, AZ 85721. (602) 621-7968.

See pages 118 and 177.

LIBRARY OF CONGRESS

This collection is staggering in its size and breadth—over nine million exposures, an incredible visual record of international scope. The photographs date roughly from 1850 to 1985 and came to the library through a variety of sources—mostly copyright deposits and gifts from corporations, private collectors, and photographers.

The best-known component of the

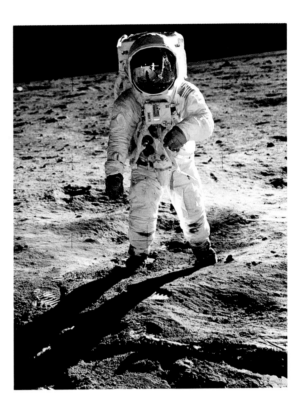

Above: Neil A. Armstrong, Astronaut Edwin E. Aldrin, Jr., walking near lunar module, *1969.*
Below: Apollo 17 View of Earth, *1972. Both photographs from the NASA collection.*

Joseph Nicéphore Niépce, L'Héliographie, *1826, Gernsheim Collection, Harry Ransom Humanities Research Center.*

Mathew Brady, General William T. Sherman, *ca. 1864–65, from the National Archives.*

Camera used by Samuel Morse in his early experiments, ca. 1839–40, from the Smithsonian Institution.

John W. Draper, daguerreotype of his sister Dorothy, ca. 1840, the collection of the Smithsonian Institution.

E.O. Goldbeck, New York Yankees, San Antonio, Texas, March 31, 1922, *from the photography collection of the Harry Ransom Humanities Research Center, University of Texas at Austin.*

Library of Congress collection is the Farm Security Administration/Office of War Information (FSAOWI) file, widely known as FSA. This file contains some 107,000 images from Walker Evans, Dorothea Lange, Russell Lee, and others hired by FSA administrator Roy Stryker to document life during the Great Depression and the beginning of World War II. Normally, federal policy keeps photographs shot for the government in the National Archives (see below), but Stryker lobbied successfully to send the FSA file to the Library of Congress, where the public has easier access to it.

Other gems in the library's collection include more than 10,000 of Mathew Brady's Civil War pictures, Lewis Hine's work with the National Child Labor Committee, and the Seagrams' County Courthouse archive. Over 4,000 original master photos span the history of photography from daguerreotypes to contemporary fine-art work, a collection noted for its technical and historical, as well as its aesthetic, interest.

You can order your own prints of many of the library's photographs and start your own collection, inexpensively. This service applies to photographs in the public domain, including all the FSA images and many others.

To order prints, send the Library of Congress negative number to Library of Congress Photoduplication Service, Washington, DC 20540. Commercial 8×10-inch prints cost about $7 each; exhibition-quality 8×10-inch prints are $26. To get the negative number, you can go to Washington and personally inspect their files. If you can't make the trip, cite the page of a publication in which a particular photograph appears. You can also look up negative numbers for prints published in Library of Congress compilations (see page 116) or through microfiche titled *America 1935–1946* or microfilm titled *FSAOWI Collection,* both available in many major libraries.

If you can't find the negative number for the photograph you want, the Library of Congress staff will research as many as ten prints for you. Send

Depression Images

Official Images: New Deal Photography, by Pete Daniel, Merry A. Foresta, Maren Stange, and Sally Stein, Smithsonian Institution Press, 1987.

To photographers, images of the Great Depression inevitably conjure up thoughts of Roy Stryker's sterling photographic unit at the Farm Security Administration. But how many realize that several other government agencies also hired photographers to document that difficult period? The quality of the work created by these non-FSA photographers was quite high.

In *Official Images,* a revisionist history of sorts, the authors explore the photographic efforts of five agencies—the Farm Security Administration, the Department of Agriculture, the Civilian Conservation Corps, the National Youth Administration, and the Works Progress Administration. The scholarly but readable text is accompanied by a fine selection of photos, and negative numbers for most appear in an appendix.

them a photocopy of the image, along with the caption, author, title, and page number of the publication in which it appears.
Library of Congress, Prints and Photographs Division, James Madison Memorial Building, Room 337, First Street and Independence Avenue S.E., Washington, DC 20540. (202) 707-6394.

NASA
The National Aeronautics and Space Administration's public affairs department maintains a complete visual record of manned space travel from the late 1950s to the present. You've seen many of these images of the moon, earth, planets, and astronauts. The collection includes some amazing photographs, and you don't have to be a space buff to appreciate them.

The NASA archives are open for public viewing, and you can order individual images for private use, at $3.75 for a black-and-white print and $8 for color. Send the file number and a money order (no checks) to Space Photographs, at the address below. NASA's *Photography Index,* which describes some of the images in the collection and provides file numbers, is available at no charge.
National Aeronautics and Space Administration, 400 Maryland Avenue S.W., Washington, DC 20546. (202) 453-8375.

NATIONAL ARCHIVES
Started in 1934 and second only to the Library of Congress in size, the National Archives contains close to six million items, including a massive collection of photographs. This collection is as eclectic as it is enormous, including much of Mathew Brady's Civil War photographs; pictures from the western expansion of the United States by William Henry Jackson, Timothy O'Sullivan, and others; as well as endless images of war, Indians, ships, and so forth. The archives also contain the popular Army Signal Corps collection; a huge collection captured from the Germans after World War II, including the work of official Nazi photographer

Books With Library of Congress Numbers

Here are most of the books—in print and out—that supply Library of Congress negative numbers along with their photographs. Use these numbers if you want to order prints from the library.

America's Yesterdays: Images of Our Lost Past Discovered in the Photographic Archives of the Library of Congress, by Oliver Jensen, American Heritage, 1978.

An American Exodus: A Record of Human Erosion, by Dorothea Lange and Paul S. Taylor, Arno Press, 1975.

Carnegie Survey of the Architecture of the South: 1927–1943, by Frances Benjamin Johnston, Chadwyck-Healey, 1985.

A Century of Photographs, 1846–1946, Selected From the Collections of the Library of Congress, by Renata V. Shaw, Library of Congress stock number 030-000-00117, 1980.

Documenting America, edited by Carl Fleischhauer and Beverly Brannan, the University of California Press, 1988.

Dorothea Lange: Farm Security Administration Photographs, 1935–1939, from the Library of Congress, by Dorothea Lange, Text-Fiche Press, 1980.

Dust Bowl Descent, by Bill Ganzel, University of Nebraska Press, 1984.

FSA Photographs of Chamisal and Penasco, by Russell Lee, New Mexico, Ancient City Press, 1985.

In This Proud Land: America, 1935–1943, as Seen in the FSA Photographs, by Roy E. Stryker and Nancy C. Wood, New York Graphic Society, 1975.

Just Before the War: Urban America from 1935 to 1941 as Seen by Photographers of the Farm Security Administration, Rapid Lithography Company, 1968.

A Kentucky Album, edited by Beverly W. Brannan and David Horvath, University of Kentucky, 1986.

The Middle East in Pictures, by Eric Matson, Arno Press, 1980.

Official Images: New Deal Photography, by Pete Daniel, Merry A. Foresta, Maren Stange, and Sally Stein, Smithsonian Institution Press, 1987.

Photographs by the Wright Brothers: Prints from the Glass Negatives, Government Printing Office, #030-014-00003-1, 1978.

Roy Stryker: The Human Propagandist, edited by James C. Anderson, Photographic Archives: University of Louisville, 1977.

A Vision Shared: A Classic Portrait of America and Its People, 1935–1943, by Hank O'Neal, St. Martin's Press, 1976.

Walker Evans: Photographs for the Farm Security Administration, 1935–1938, U.S. Library of Congress, Prints and Photographs Division, Da Capo Press, 1975.

Washingtoniana: Photographs; Collections in the Prints and Photographs Division of the Library of Congress, by Kathleen Collins, Library of Congress, 1989.

Photographs from the FSA Collection at the Library of Congress

Walker Evans, Houses, Atlanta, Ga., *March 1936. Negative number LC-USF 342-8057.*

Dorothea Lange, Plantation Owner, Clarksdale, Miss., *June 1936. Negative number LC-USF 34-9599.*

Russell Lee, Tenant Purchase Clients at Home, *Hidalgo County, Tex., February 1939. Negative number LC-USF 34-32010.*

Arthur Rothstein, Dust Storm, Cimarron County, Okla., *April 1936. Negative number LC-USZ 62-11491.*

Walker Evans, Wash Room in the Dog-Run, *Hale County, Ala., 1936. LC-USF 342-8133.*

Carl Mydans, Migrant Cotton Workers, Criptendon, Ark., *May 1936. Negative number LC-USF 34-6322.*

Heinrich Hoffman and the photo albums of Eva Braun; and an environmental document of the 1970s commissioned by the Environmental Protection Agency, modeled after the Farm Security Administration photographs from the Great Depression.

The National Archives pulls together photographs from 150 government agencies. Although much of the work comes from the federal government, a great many photographs were obtained from private sources—for example, the entire files from the *New York Times* Paris Bureau.

This collection is open to the public, but its organization makes casual browsing difficult. There is no central index; photographs are filed according to the government agency that assigned or inherited them.

Like the Library of Congress, the National Archives will make prints to order at a modest price if you can identify the image by negative number, or by a photocopy accompanied by the published reference.

National Archives and Records Administration, Still Pictures Branch, Pennsylvania Avenue at 8th Street N.W., Washington, DC 20408. (202) 523-3236.

SMITHSONIAN INSTITUTION

A required stop for photo-history buffs, the Smithsonian Institution is an enormous repository of apparatus, accessories, images, and data. It has an impressive print collection, but what shines is its amazing collection of photographica. Established in 1846, the Smithsonian is one of the oldest archives in the United States and one of the largest in the world.

The photographic exhibition area of the Smithsonian, called the Hall of Photography, illustrates the development of the medium. You'll find period displays, such as a room from Lacock Abbey (Fox Talbot's laboratory) and a facsimile of Roger Fenton's mobile van (used as a darkroom to produce his memorable Crimean War photographs). The collections also include original cameras used by Talbot and Samuel Morse, as well as the first cam-

Edward Weston, Nautilus Shells, ca. 1947 (courtesy the Center for Creative Photography).

era used in outer space.

Smithsonian Institution, Division of Photographic History, National Museum of American History, Room 5715, Washington, DC 20560. (202) 357-2059.

UNIVERSITY OF TEXAS

Since its formation in 1964 with the acquisition of the collection of photo historians Helmut and Alison Gernsheim, the photography collection of the Harry Ransom Humanities Re-search Center has steadily grown into an enormous and unusual archive, currently containing about five million images. The center also has a large library of photographic publications and a substantial amount of equipment, manuscripts, and materials. Most of the collection is open to the general public; prearranged appointments are preferred.

The center has plenty of historical shots, many quite rare, including an 1826 heliograph by Joseph Niépce (see page 114), credited as the first photograph ever taken (it took eight hours to expose), plus lovely examples of work by Julia Margaret Cameron, Francis Firth, Paul Martin, Lewis Carroll (five

personal albums), Maxime DuCamp, and many others. The twentieth century is represented by the likes of Edward Weston, Alvin Langdon Coburn, Edward Steichen, Sir Cecil Beaton, Albert Renger-Patzsch, and Henri Cartier-Bresson.

Some of the work in the collection focuses on social and military history. You'll find the popular panoramic views of E.O. Goldbeck (c. 1910–1980) and the documentary work of James H. Hare, which forms a collection of more than 1,000 images from turn-of-the-century wars, including the Spanish-American and Russo-Japanese conflicts, as well as the Mexican Revolution and World War I. The Smithers collection is a striking document of life in the trans-Pecos region. The center also has a large literary collection containing family snapshots and other photographs of D.H. Lawrence, George Bernard Shaw, and others.

Harry Ransom Humanities Research Center, University of Texas, P.O. Drawer 7219, Austin, TX 78713. (512) 471-9124.

Other Major Collections of Photographs

NATIONAL PORTRAIT GALLERY
Smithsonian Institution
F Street at 8th N.W.
Washington, DC 20560
(202) 357-1300

UNIVERSITY OF CALIFORNIA
Map and Imagery Laboratory
The Library
Santa Barbara, CA 93106
(805) 961-4049

UNIVERSITY OF LOUISVILLE
Photographic Archives
Ekstrom Library
Louisville, KY 40292
(502) 588-6752

UNIVERSITY OF OREGON
Knight Library
Special Collections
Eugene, OR 97403
(503) 686-3077

Corporate Collections

Fine-art photographers would be in big trouble if they sold their work only to individuals and museums; there just aren't enough such buyers to go around. Fortunately, many companies have art collections, and some of these collect photography. In terms of size and quality, some corporate collections rival those of good small and medium-sized museums.

The impetus to collect frequently comes from a powerful individual at the company who is personally interested in photography. However, corporate collections generally involve more than personal interest. An association with the fine arts is a popular and effective public relations tool—a way to prove good "corporate citizenship."

Most companies claim that their collecting activities are not fueled by investment considerations. Indeed, art can be a risky investment at best, especially from unknowns. Still, work from established artists almost always appreciates in value.

Some corporations stow their collections away in vaults, lending them out occasionally for exhibition or publication. A few maintain public galleries. Still others use their art as decoration, and pepper their halls and executive offices with it.

Generally, corporations use an outside consultant to help them decide what to buy, but some employ an in-house curator. The companies listed here have major collections, and most are a hard sell. (Some have stopped collecting actively.) Many photographers who sell to corporations are represented by galleries or agents, who do a very convincing job of presenting their work. However, many smaller companies collect on a more modest scale, often through a design firm contracted to spruce up corporate offices. Such companies may be a more likely target for less established photographers.

CHASE MANHATTAN BANK

The Chase Art Program is a massive collection of more than 12,000 pieces of art, encompassing paintings, drawings, prints, textiles, folk art, sculpture, and photographs. It was established in 1959 with a charter to acquire "museum quality works of art for use in the offices of the Chase Manhattan Corporation." Indeed, art from the collection may end up at any one of 350 or so Chase offices worldwide.

The photography collection began in 1974 and has grown swiftly. It currently numbers over 2,000 pieces, with no particular emphasis. There are both older and contemporary images by well-known photographers (such as Berenice Abbott, Ansel Adams, Francis Firth, Eadweard Muybridge, Cindy Sherman, and William Wegman), as well as fine historical views by unknowns.

Chase is not an easy collection to crack. Unsolicited portfolios are not encouraged; if you do send work, don't expect it back. The program will keep submissions for future reference and respond only if it's interested in purchasing the work.
Chase Manhattan Bank, Art Program, 410 Park Avenue, New York, NY 10022. (212) 223-6130.

FIRST BANK

First Bank has one of the most active and innovative corporate art programs, consisting of more than 2,800 works with some 750 or more photographs. The bank takes its stated commitment to the "interface between art and its public" very seriously, and the collection is shown regularly in four public galleries.

First Bank wants its employees to be involved in and informed about the art program, and the bank tries to break

the rules about what kind of art is considered "appropriate" for the workplace. When a piece of art is installed, a petition by six or more employees can banish it to "controversy corridor," an area off-limits to customers. If at least six employees file a petition in support of the work, it returns to the public area. The petitions arguing for and against the piece are posted to stir employees' interest.

The collection itself is very contemporary. It includes a few old-timers such as Lisette Model, but has far more works by the likes of Joel Peter Witkin than Ansel Adams. Young shooters should take special note; a quick look down a list of First Bank collectees reveals plenty of emerging and unknown photographers.

Another First Bank innovation is its special grant program. Although these grants go mainly to preselected artists, the bank does fund the occasional photographer-initiated proposal, generally to advance a specific project. The collection encourages unsolicited submissions. Send slides, not original prints, for a first viewing.

First Bank, Division of Visual Arts, 120 South Sixth Street, Minneapolis, MN 55402. (612) 343-1809.

GILMAN PAPER

Gilman's may be the world's most important private collection of photographs. It's huge, with over 4,000 images, but it's the quality and breadth of the work that makes it special. The collection preserves some of the finest early examples of the art, from Fox Talbot, Louis Daguerre, and Hill and Adamson to Lewis Carroll, Julia Margaret Cameron, and Nadar.

Gilman Paper has also amassed major selections from the photographic surveys of the 1860s (Timothy O'Sullivan, Carleton Watkins), the Civil War (Mathew Brady, Alexander Gardner, O'Sullivan), the Photo-Secession (Edward Steichen, Frederick Evans, Gertrude Kasebier), and plenty of twentieth-century stars (Man Ray, Brassaï, Eugène Atget, Edward Weston). In short, the Gilman Paper collection represents a veritable *Who's Who*

The Word on Corporate Collecting

ARTnews publishes a hefty reference work, the *ARTnews International Directory of Corporate Art Collections,* which features over 1,200 corporations that buy all kinds of art, including photography. The directory lists such information as contact people, the size and character of the collection, and the review policy for submissions. There is an enormous amount of information and cross referencing here, making this an indispensable guide for those trying to break into the corporate marketplace, as well as for researchers, curators, and critics looking for hidden resources. It costs $89.95.

For more timely information, a monthly newsletter, *Corporate ARTnews,* reports on developments in corporate collections, such as which companies have collected what type of art recently, and how they're handling their acquisitions.

ARTnews, 48 West 38th Street, New York, NY 10018. (212) 398-1690.

of photography.

The collection emphasizes the first 100 years of photography, so contemporary photographers are not represented. With the exception of Robert Frank, no post–World War II photographers are represented.

If you want to see selections from this marvelous collection, get a copy of the book *Photographs from the Collection of the Gilman Paper Company,* written by Gilman curator Pierre Apraxine and published by White Oak Press (1985). Of course, you'll have to clear out a corner of your library, and your bank account; the book weighs thirty-five pounds and costs $2,500.

Gilman Paper Company, 111 West 50th Street, New York, NY 10020. (212) 246-3300.

HALLMARK CARDS

The Hallmark Art Collection began in 1949 and includes work by such prominent painters and sculptors as Charles Sheeler, David Smith, Edward Hopper, and Louise Nevelson. In 1964, the company moved into photography by acquiring 141 pieces by Harry Callahan. Today, ably guided by curator Keith F. Davis, the Hallmark archives house a representative sample of more than 2,100 prints by over 230 photographers.

This collection is mostly twentieth century and American, with a great abundance of established photographers. Callahan remains the most collected of Hallmark photographers, with 274 prints, followed closely by André Kertész with 232. Other photographers well represented include Clarence John Laughlin (120), Henri Cartier-Bresson (112), Todd Webb (152), Lewis Hine (49), and Edward Weston (41).

The collection is not open to the public, but Hallmark shows the work widely in traveling exhibitions and publications. Despite the emphasis on the history of twentieth-century photography, Hallmark regularly considers work by leading contemporary artists. Send slides, rather than original prints.

Hallmark Cards, Collections and Archives #284, Box 419580, Kansas City, MO 64141. (816) 274-5298.

POLAROID

Polaroid maintains a collection of over 6,000 photographs with a significant historical component, featuring classic works from Ansel Adams (a longtime Polaroid consultant), Walker Evans, Edward Weston, and the like. The great majority of the photographs represented were taken using instant materials.

Part of the collection was generated overseas by Polaroid in Amsterdam, and much of this work is daring and experimental by U.S. standards. Although the collection's early American photographs are mostly landscapes, portraits, still-lifes, and other traditional subjects, recent work is more on the cutting edge, much of it shot on Polaroid's unique 20×24-inch

Zeke Berman, Table Study, *1983*
(courtesy Reader's Digest collection).

Jan Groover, Untitled #4, *1978, 20×24 Polaroid*
(courtesy Polaroid collection).

Barbara Kruger, Untitled, *1987*
(courtesy First Bank collection).

Charles M. Bell, Chief Nez Perce
(courtesy Gilman Paper collection).

camera (see page 15).

Polaroid has an active traveling exhibition and publishing program to show off its collections, including an ongoing series of books and shows entitled *Selections*. Even though the company supports many established photographers, as well as artists who use photography (such as David Hockney, Chuck Close, and Lucas Samaras), Polaroid is famous for encouraging younger and emerging shooters. The company's collection program, which has wound down considerably in recent years, remains fairly freewheeling; it buys some photographs outright and barters film and materials (including time on its giant cameras) to acquire others.

Polaroid Collection, Publicity Department, 575 Technology Square, Cambridge, MA 02139. (617) 577-2038.

READER'S DIGEST

A long and generous donor to the arts—cofounder Lila Wallace was one of the first corporate art collectors—Reader's Digest fosters a large collection with a very broad scope, encompassing over 4,000 paintings, sculptures, drawings, prints, and photographs. The collection's photography section of more than 1,000 images is primarily contemporary, and includes work by such people as Frank Gohlke, Robert Mapplethorpe, and Joel Meyerowitz.

A permanent installation graces the corporate headquarters, but the photography component doesn't usually travel. Play Ball, a recent show of baseball art including photography, is a recent and pleasant exception.

Photographers may submit slides for consideration. Include a letter, resume, and stamped, self-addressed envelope for safe slide return. Be patient; a response may take several months.

Reader's Digest, Corporate Art Department, Pleasantville, NY 10570. (914) 241-5492.

SECURITY PACIFIC

Security Pacific, a major bank on the West Coast, has an important art col-

A Corporate Book Project

Cray Research makes supercomputers, the world's fastest machines, which see use in such applications as defense, weather forecasting, fusion research, and industrial design. It's a very successful company, so when CEO John Rollwagen wanted to indulge his passion for photography, he had no problem shaking $100,000 or so from the corporate budget. Rollwagen asked photographer Lee Friedlander to record Cray's story—its people, factory, and environs—and turn the resulting photos into a book.

Cray gave Friedlander free reign, and the result is no ordinary corporate publication. *Cray at Chippewa Falls* is a very personal vision—a document of everyday life, with rural landscapes framed and obscured by trees, photos within photos, self-portraits, and all the elements that make Friedlander one of the reigning luminaries of the fine-art photography world.

The book's production is as fine as the photographs. It was printed in 1987 at Franklin Graphics in Providence, Rhode Island, with tri-tone negatives handmade by Richard Benson. The initial printing of less than 6,000 copies went mostly to Cray employees as a gift commemorating the company's fifteenth anniversary. The rest of us will have trouble finding a copy; it was never meant to be sold to the public, and the stock is now depleted. Still, it occasionally shows up in mail-order catalogs that feature photography books, priced at about $200.

lection of more than 9,000 pieces. About 1,250 of these works of art are photographic prints, representing many acknowledged masters such as Imogen Cunningham, Edward Curtis, Jacques-Henri Lartigue, Eliot Porter, and Aaron Siskind.

Contrary to its name, Security runs a certain amount of risk by investing in contemporary and emerging photographers. Frames of Time and Context, a recent exhibition, included work by several nontraditional photographers. The same can be said of No Fancy Titles, which featured the unusual work of Eileen Cowin and John Divola. Both shows spawned a handsome catalog.

Aside from sponsoring exhibitions and publications, Security Pacific has a generous policy of lending work from its collection to other shows. Employees are also allowed to choose images to spruce up their offices.

Photographers wishing to submit work should send slides and accompanying material, but not originals. The selection committee meets every month or so, but a response may take longer due to the large number of inquiries.

Security Pacific National Bank, Cultural Affairs, 333 South Hope Street, H9-65, Los Angeles, CA 90071. (213) 345-5102.

Other Corporate Collections

ATLANTIC RICHFIELD
515 South Flower Street
Los Angeles, CA 90071
(213) 486-8666

BANKAMERICA
CRE Art Program #3021
555 California Street
San Francisco, CA 94104
(415) 622-1265

BECTON-DICKINSON AND COMPANY
1 Becton Drive
Franklin Lakes, NJ 07417
(201) 848-7301

CITICORP/CITIBANK N.A.
Citicorp at Court Square
Eighth Floor
Long Island City, NY 11120
(718) 248-1864

COCA-COLA
P.O. Drawer 1734
Atlanta, GA 30301
(404) 676-3849

**CONTINENTAL ILLINOIS
BANK AND TRUST COMPANY**
231 South LaSalle Street
Chicago, IL 60697
(312) 923-6902

CRAY RESEARCH
608 Second Avenue
South Minneapolis, MN 55402
(612) 334-6473

EXCHANGE NATL. BANK OF CHICAGO
120 South LaSalle Street
Chicago, IL 60603
(312) 781-8076

FIRST BOSTON CORPORATION
12 East 49th Street
New York, NY 10017
(212) 909-2000

JOHNSON & JOHNSON
1 Johnson & Johnson Plaza
New Brunswick, NJ 08933
(201) 524-3698

**PAUL, WEISS, RIFKIND, WHARTON &
GARRISON**
1285 Avenue of the Americas
New York, NY 10019
(212) 373-2341

THE PROGRESSIVE CORPORATION
6000 Parkland Boulevard
Mayfield Heights, OH 44124
(216) 461-5000

JOSEPH E. SEAGRAM & SONS
375 Park Avenue
New York, NY 10152
(212) 572-7379

SHAKLEE CORPORATION
444 Market Street
San Francisco, CA 94111
(415) 954-2004

SOUTHLAND CORPORATION
2828 North Haskell
Dallas, TX 75221
(214) 828-7434

Harry Callahan, Mexico, *1982 (courtesy Hallmark Cards collection).*

William Eggleston, Peaches, *1971 (courtesy Chase Manhattan Bank collection).*

John Divola, Untitled, *1982 (courtesy Security Pacific collection).*

Collecting Photography

As early as one hundred years ago, photography was declared an art by its practitioners and interested observers. Only during the last ten or twenty years have collectors started believing them. As recently as the early 1970s, you could buy an original print by Ansel Adams for less than $100. Today, the same print would fetch many thousands.

Even though the value of photographs, particularly vintage prints, has risen markedly, it's still dirt cheap compared to that of other art forms. True, Weston's *Shell* (1927) recently sold for a tidy sum—$105,000—but van Gogh's *Irises,* the most expensive painting ever sold, went in 1987 for a king's ransom—$53.9 million.

The moral of this story is that if you want to collect art and are just a working stiff, photography is an affordable option. You can easily find the work of established, well-known photographers for under $1,000. If you want to take a chance on a talented unknown, you can do so at about $200 to $400. For those who simply enjoy good photography but have a cash-flow problem, the Library of Congress and other public collections sell prints for the few dollars they charge to reprint the negative (see pages 112–118). These won't appreciate in value, but you'll get to choose from enormous collections of photographs, many of them outstanding.

Publications on Collecting

These are some of the best books and magazines published on collecting photographs.

How to Buy Photographs, by Stuart Bennett, Phaidon-Christie's, 1987.
Part of a collectors' guide series published by Christie's auction house, this is the most up-to-date and complete book on the subject. It's also nicely produced. Specific photographers are rarely discussed, but chapters cover collecting taste and technique, specialization, buying and selling, and pitfalls. The book has a technical glossary and lists resources.

The Photograph Collector, The Photographic Arts Center, 163 Amsterdam Avenue, New York, NY 10023. (212) 838-8640.
Subtitled "The Newsletter for Collectors, Curators and Dealers," this is a monthly resource with news items and information on photography auctions (including print prices), courses, lectures, seminars, new portfolios being offered, archival techniques, and exhibitions. The eight-page offset publication costs a hefty $125 for a one-year subscription.

The Photograph Collector's Guide, by Lee D. Witkin and Barbara London, New York Graphic Society, 1979.
This excellent resource is regrettably out of date and out of print. However, it's still useful if you can find a copy, and includes a fine introduction to collecting photographs written by the late Lee Witkin, a pioneering gallery owner. Sections include the care and restoration of photographs, a collector's compendium of selected photographers, limited-edition portfolios, and on and on.

Jay Dusard, Cowboys, ORO Ranch, Arizona, *1980, one of the prints available from the* New Exposure *catalog (see page 127).*

The Photograph Collectors' Resource Directory, The Photographic Arts Center, 1989.
Strictly a book of listings and ads, both U.S. and international. This directory is most useful for its sections on where to buy photographic art, including galleries, private dealers, portfolio publishers, photographica dealers, booksellers, auction houses, and photographers who represent themselves. Other sections deal with museum collections, publishing, conservation, education, and photographic societies.

The Print Collector's Newsletter, 72 Spring Street, New York, NY 10012. (212) 219-9722.
Published every other month, *The Print Collector's Newsletter* covers issues related to the acquisition of prints and photographs. It includes features, reviews, and interviews. Continuing coverage of print auctions provides dates and locations of upcoming events, along with what was sold and for how much. A one-year subscription costs $54.

Good Prints Cheap

One sensible way to start a photography collection is to subscribe to members' print programs; the organizations listed below offer such programs. By contributing a certain amount, usually $200 or more, you receive an original print and a membership to the organization. Usually, you get to choose from a selection of several images from either well-established or promising talents. As an example, in past years Friends of Photography has offered prints of images created by Ansel Adams, Jerry Uelsmann, Minor White, and other outstanding photographers.

The membership is a nice bonus. Even if you don't live near enough to take advantage of their programs, most of these organizations publish a useful journal or newsletter, and some of them also offer free books and other benefits. Plus, you get the satisfaction of supporting some worthy photographic activities.

CENTER FOR PHOTOGRAPHY AT WOODSTOCK
59 Tinker Street
Woodstock, NY 12498
(914) 679-9957
See pages 95, 125, and 195.

Photo Dealers

The Association of International Photography Art Dealers (AIPAD) was founded in 1979 to encourage public support of art photography and promote confidence in photography dealers. Though small in size (fewer than 100), AIPAD's membership is large in influence. Members are gallery owners and private dealers who have been in business for at least three years, and include most of the major players in this field.
93 Standish Road, Hillsdale, NJ 07642. (201) 664-4600.

EYE GALLERY
1151 Mission Street
San Francisco, CA 94103
(415) 431-6911

FRIENDS OF PHOTOGRAPHY
101 The Embarcadero
San Francisco, CA 94105
(415) 391-7500
See pages 94, 148, and 208.

HOUSTON CENTER FOR PHOTOGRAPHY
1441 West Alabama
Houston, TX 77006
(713) 529-4755
See pages 96 and 197.

THE LIGHT FACTORY PHOTOGRAPHIC ARTS CENTER
311 Arlington Avenue
Charlotte, NC 28232
(704) 333-9755
See page 96.

LOS ANGELES CENTER FOR PHOTOGRAPHIC STUDIES
1052 West 6th Street

Los Angeles, CA 90017
(213) 482-3566
See page 96.

THE MUSEUM OF CONTEMPORARY PHOTOGRAPHY
600 South Michigan Avenue
Chicago, IL 60605
(312) 663-5554
See page 111.

THE PHOTOGRAPHIC CENTER OF MONTEREY PENINSULA
Box 1100
Carmel, CA 93921
(408) 625-5181
See pages 98 and 151.

PHOTOGRAPHIC RESOURCE CENTER
602 Commonwealth Avenue
Boston, MA 02215
(617) 353-0700
See pages 95, 197, and 209.

SF CAMERAWORK
70 Twelfth Street
San Francisco, CA 94103
(415) 621-1001
See page 98.

Collecting Photography Books

Photographers generally consider a book of their work as important as an original print. Definitive publications such as Walker Evans's *American Photographs* and Robert Frank's *The Americans* are excellent examples. Not only are they works of art in their own right, but they provide a far better overview of the photographer's work than a single original print can.

In short, excellent photography books have an intrinsic value. Since they are generally printed in short runs, in time they become sought after and often quite valuable. It's not uncommon for an out-of-print photography book to fetch hundreds of dollars; a few are worth thousands.

However, one nice thing about collecting photography books is that they are relatively cheap—certainly cheaper than collecting original photographs. Most well-produced books sell new in

Best-Selling Rare Photo Books

Swann Galleries, an auction house in New York City, specializes in rare books, photographs, and manuscripts. Here's a selection of photography books they've sold in recent years.

$29,800 Peter Henry Emerson, *Life and Landscape on the Norfolk Broads* (London, 1886), illustrated with original mounted platinum prints. Sold November 1986.

$12,100 William Henry Fox Talbot, *Sun Pictures in Scotland* (London, 1845), illustrated with original mounted salt prints. Sold October 1987.

$10,450 Paul Strand, *Camera Work,* Number 49/50 (New York, 1917), illustrated with photogravures. Sold November 1986.

$9,350 Francis Firth, *The Queen's Bible,* two volumes (Glasgow, 1862-63), illustrated with original mounted albumen photographs. Sold October 1988.

$6,380 Peter Henry Emerson, *Marsh Leaves,* De Luxe edition (London, 1895), illustrated with photogravures on Japanese vellum. Sold October 1988.

$3,960 Alvin Langdon Coburn, *London* (London and New York, 1909), illustrated with photogravures. Sold October 1988.

$1,320 August Sander, *Antlitz der Zeit* (Munich, 1929), illustrated with reproductions. Sold May 1988.

$825 Robert Frank, *The Americans* (New York, 1959), illustrated with reproductions and signed by Frank. Sold May 1987.

$412 Henri Cartier-Bresson, *The Decisive Moment* (New York, 1952), illustrated with reproductions. Sold May 1988.

$330 Irving Penn, *Moments Preserved* (New York, 1960), illustrated with reproductions and signed by Penn. Sold October 1988.

$250 Helmut and Alison Gernsheim, *The History of Photography* (New York, 1969), illustrated with reproductions. Sold October 1988.

Source: Swann Galleries Inc.

the $40 to $75 range.

When books don't sell, and many outstanding photography books don't, publishers "remainder" them—that is, they sell them for peanuts to a distributor, who in turn sells them to bookstores, which then discount the books, often heavily.

You have to be careful when buying remaindered books—or any books, for that matter—as investments. Most never appreciate in value. Buy only those books you like. That way, at the least, you'll get personal satisfaction from your purchases; if you profit, so much the better.

If you decide to buy photography books with an eye to their future value, here are some guidelines. Look for books in small editions and ignore best-sellers. A book like *A Day in the Life of America* has sold hundreds of thousands of copies, too many to have much future value. Collect the most expensive edition available; it will see the most appreciation. If there's a limited edition, get it, especially if it includes an original print; otherwise, buy the hardcover edition, unless the book is published only in paperback. Artists' books, which are personally produced in small print runs, qualify as limited editions, and, as such, are quite collectable (see pages 198–200).

Most photographers are happy to sign their books, and this will boost value. Buy finely produced, and thus expensive books; all things being equal, in the long run these will hold their value most, partly because they are well made and partly because they are usually printed in small editions. Handle your books with care; future worth depends in very large part on their physical condition.

If buying used books, do business with a reputable dealer. However, photography books can crop up anywhere, so be on the lookout at flea markets or second-hand bookstores. You're taking a chance investment-wise when buying this way, but you can find some excellent books at good prices. Get a first edition, not a reprint. Avoid mildewed books, or those with pages cut out or marked up, or those with a beat-up

dust jacket or binding. Finally, for pure investment purposes, choose books from well-known photographers. These represent more reliable investments, a little like buying blue-chip stocks. Although some unknowns eventually succeed, their books are rarely less expensive to begin with, so why take the chance? Unless, of course, you love their work—which, come to think of it, is the best reason to buy photography books.

Books and Prints by Mail

Here are some mail-order firms dealing solely with photographs and rare and out-of-print books.

JOHN S. CRAIG

Craig deals largely in photographica—antique cameras, stereo equipment, and the like. But he also maintains a huge inventory of manuals for obscure equipment, plus out-of-print books, mostly on technical matters.
Box 1637, Torrington, CT 06790. (203) 496-9791.

KINGSTON & ROSE

A catalog of mostly twentieth-century books, with the occasional journal, magazine, and original print. Many of the books are fairly recent, so prices are reasonable—mostly $100 or less. The catalog gives excellent descriptions of each item and its condition.
Box 233, Cambridge, MA 02238. (617) 484-7351.

ALBERT MORSE

Mr. Morse features out-of-print twentieth-century books, but he publishes no catalog so you'd better pretty much know what you want when you write or call. He has 1,500 to 2,000 books on hand and will search for that special title if he doesn't have it. Visitors are welcome, by appointment, and shipment can be arranged by phone.
320 Miller Avenue, Mill Valley, CA 94941. (415) 332-3571.

NEW EXPOSURE

Other dealers offer original prints by mail, but no one does it as slickly as

Christie's Top Ten

Auctions at Christie's have brought some of the highest prices ever paid for photographs. Here are the house's best-selling prints to date, with the prices they fetched. (These are all single prints; higher prices have been paid for albums or multiple images.)

$82,500 Edward Steichen, *La Cigale*, 1901, waxed platinum and gum print.

$55,000 Clarence H. White, *Boy with Camera Work*, 1903, platinum print.

$48,400 Clarence White and Alfred Stieglitz, *Miss Thompson*, 1907, waxed platinum print.

$39,600 Albert Sands Southworth, *Self Portrait*, c. 1848, half-plate tinted daguerreotype.

$37,400 Clarence H. White, *Portrait of Alfred Stieglitz*, c. 1906, waxed platinum print.

$37,400 Paul Strand, *Apartments*, New York, c. 1915, platinum print.

$33,000 Edward Weston, *Pepper*, 1930, gelatin silver print.

$28,600 Edward Weston, *Nautilus*, 1927, gelatin silver print.

$28,600 Man Ray, *Dos Blanc*, c. 1926, gelatin silver print.

$26,400 Edward Weston, *Margrethe with Fan*, 1914, platinum print.

Edward Steichen, La Cigale, *1901.*

New Exposure does, with its beautifully produced catalog, a toll-free order number, and an unconditional money-back guarantee if you change your mind. Most of the prints are made to order. Offerings include work from established and emerging photographers, including André Kertész, Jerry Uelsmann, and Barbara Morgan.
4807 North 70th Street, Scottsdale, AZ 85251. (800) 458-5749; (602) 990-2915.

Fred and Elizabeth Pajerski

For history buffs, these specialists in nineteenth-century photography stock about 5,000 volumes, many not easily found anywhere. Their stock includes a rich mix of new and used, in-print and out-of-print literature (books, exhibition catalogs, antiquarian materials, and so forth). The Pajerskis also offer some twentieth-century materials.
225 West 25th Street, Apartment 4K, New York, NY 10001. (212) 255-6501.

A Photographer's Place

A Photographer's Place may have the largest stock of photography books anywhere; it certainly has the most eclectic collection. A catalog published six or more times a year features a wild mix of new, used, out-of-print, and sale titles, many of which are hard (or impossible) to find elsewhere.
133 Mercer Street, New York, NY 10012. (212) 431-9358.
 See page 202.

Special Editions

Special Editions sells limited editions of prints from well-known photographers, at prices often below what galleries charge. For example, it recently offered *Century Plant* prints by Brett Weston, in an edition of 100, for $425. Other featured photographers include Barbara Crane, Jerome Liebling, Anne Noggle, and Cole Weston.
Box 512, Roslyn, WA 98941. (509) 649-2991.

The Witkin Gallery

Books have been an integral part of this fine gallery since 1971. The Witkin Gallery offers new and used

Homework for Auctions

Every year there are several public auctions of fine photography. The best ones generally occur at Sotheby's and Christie's, but other houses hold them as well. Rare photographs commanding high prices get the most publicity, but these sales also include more affordable prints with merit.

Auction prices, because they involve competitive bidding, are probably the best measure of the true value of a photograph. Anyone can attend, and a lot of savvy buyers are sure to show up.

If you're thinking of bidding, you'd better have a sense of what things are really worth. The most up-to-date auction sourcebook is *The Photographic Art Market: Auction Prices*, which appears in a new edition nearly every year. The current edition contains over 2,800 entries from eight auctions. Each entry lists the photographer's name, a title or description of what was sold, and the auction house that sold it, as well as the sale, date, lot number, print type, print dimensions, the dates when the image was shot and the print was made, and, of course, the price. The book is available from The Photographic Arts Center, 163 Amsterdam Avenue, New York, NY 10023. (212) 838-8640.

Auction Houses

These are the U.S. auctioneers that sell photography—prints, books, and photographica.

Butterfield & Butterfield
1244 Sutter Street
San Francisco, CA 94109
(415) 673-1362

California Book Auction Galleries
358 Golden Gate Avenue
San Francisco, CA 94102
(415) 775-0424

Christie's East
219 East 67th Street
New York, NY 10021
(212) 570-4730

The Fine Arts Company
2317 Chestnut Street
Philadelphia, PA 19103
(215) 564-3644

Harris Auction Galleries
873–875 North Howard Street
Baltimore, MD 21201
(301) 728-7040

Robert W. Skinner
585 Boylston Street
Boston, MA 02116
(617) 779-5528

Sotheby's
1334 York Avenue
New York, NY 10021
(212) 472-3595

Swann Galleries
104 East 25th Street
New York, NY 10010
(212) 254-4710

volumes, both in and out of print, including rare antique titles. You can stop by the gallery to look at the offerings, or order by mail. Witkin publishes two catalogs per year.
415 West Broadway, New York, NY 10012. (212) 925-5510.
 See page 124.

EDUCATION

Fine Art

At one time, photographers learned their trade from family, friends, camera clubs, or books. These days, most photographers spend at least some time at a school or workshop. Since the photography boom of the 1970s, it's hard to find a college that doesn't have a photography course, if not an entire program.

This diversity lets you choose your level of commitment. Continuing-education courses at local colleges are good for getting your hands wet; full-blown undergraduate and graduate programs will help you make a serious go of it.

The amount of education you need to become a full-fledged photographer depends on who you are and what you want to do. With hard work and a strong sense of purpose, you can learn the technique in a relatively short time. The required visual skills generally need a longer incubation period, and school is an excellent place for this to happen.

Schools generally fall into three categories: fine art, photojournalism, and professional. Most courses, unless otherwise billed, have a fine-art orientation. This is partly because most photography teachers have a fine-art background (teaching is one sure way they can make a living) and partly because photography courses are most commonly found in the art departments of colleges and universities.

Fine-art programs teach photography as a means of personal expression. Graduates generally develop an individual style and try to exhibit, publish, or sell their work. Grants from such groups as the Guggenheim Foundation, the National Endowment for the Arts and state arts councils will hopefully follow (see pages 207–217).

Even the most successful fine-art photographers find this a hard financial road. To support themselves, they usually find some outside source of income. Some take on commercial work, as a photographer's assistant and later as a professional. A great many opt to teach, and that's where graduate school comes in. In order to teach, you must have a degree, preferably an M.F.A. (Master of Fine Arts).

Photography and the Academy

Widespread photographic education at the university and graduate-school level is only about twenty-five years old, but already it's a fixed part of academic life. Schools that offer master's degrees in photography cultivate photographers, but they also develop thinkers—teachers, critics, historians, and so forth—who also happen to be photographers.

At the undergraduate level, many schools offer the B.F.A. (Bachelor of Fine Arts) degree. An important choice is whether to attend an art school, or a university with a photography program. Art schools tend to be less structured and often have students who are particularly motivated toward their work. However, any good photography department in a university has serious students, and provides more options for those who eventually decide against becoming a full-time artist.

More and more fine-art photographers are abandoning the art-as-personal-expression route and going into commercial work. This doesn't reduce the value of a fine-art education. In fact, it's arguably the best way to start a professional career, because you'll learn technical skills, a good visual and creative sense, and an abiding respect for the photographic image.

Whatever your goal, a fine-art program is ideal for those who want to learn their craft in a structured environment with others who share their passion. The schools listed below all have both undergraduate and graduate (M.F.A.) programs. There are many other excellent schools that offer only undergraduate fine-art programs.

CALIFORNIA INSTITUTE OF THE ARTS

Cal Arts has one of the most active fine-art photography programs in the country, and probably the most controversial. The school emphasizes theory and production; it's not the place to go if you want to learn technique.

On the theoretical side, the faculty falls into two distinct camps. The "Marxists" have a sociological bent, urging an expanded definition of art to

encompass issues involving literature, society, and culture. In the other corner are the proponents of mainstream contemporary photography, or postmodernism.

This schism tends to leave out those interested in straight photography, such as portrait, documentary, and landscape work. Students are strongly encouraged to combine photos with words, sculpture, performance art, video, and other media. Many students spend more time in the studio constructing an environment to shoot than in the field or darkroom making photographs.

The program's negative aspects include its location. Yes, it's in California, but Valencia is a town with little character and not much to recommend it (however, Los Angeles is only forty-five minutes away). The relatively large graduate program, about twenty-five students, causes some complaints about lack of studio space. Also, the school's strong emphasis on the graduate program can make undergrads sometimes feel shortchanged. Finally, Cal Arts is expensive, offering few scholarships and fellowships to lighten the load.

On the plus side, students enjoy an extremely committed faculty, a lot of visiting artists and teachers, much interchange among artistic mediums, and a highly charged and intellectually stimulating environment. Cal Arts stands squarely on the cutting edge of what's happening in photographic education and in art-photo circles.
California Institute of the Arts, 24700 McBean Parkway, Valencia, CA 91355. (805) 255-1050.

RHODE ISLAND SCHOOL OF DESIGN
The Rhode Island School of Design—known by its acronym as "riz-dee" (RISD)—is one of the top art schools in the country, and has been for decades. Its photography reputation was made with the presence of Harry Callahan in the 1960s and 1970s and Aaron Siskind in the 1970s.

RISD attracts extremely talented, motivated students and excellent teachers. Several of its full-time faculty

Student Work

Constance Wolf, Garbage, *California Institute of the Arts.*

Brenda Prager, Untitled, Berkeley, Calif., 1987, *San Francisco Art Institute.*

Robert E. Kelley, Untitled, 1989, *Rhode Island School of Design.*

were part of the Callahan-Siskind era, and many active part-timers have been added. A stimulating visiting-artist program brings a different photographer to the school every other week for close interaction with both graduates and undergraduates.

The photography program is tightly structured and totally fine-art oriented, with little in the way of practical instruction. It stresses critical theory, and graduating seniors and graduate students must produce a written thesis as well as a portfolio of photographs. The faculty is diverse, and students can pursue any style they please. At RISD, documentary photographers and conceptual artists can find common ground and support.

RISD's undergraduate division shines; a good upper-level undergrad can compete favorably with graduate students from many other programs. The photography department has a newly renovated building, and students can take courses in other departments (RISD has excellent programs in all the arts). Students also benefit from a liberal cross-registration agreement with Brown University, located a few hundred yards up the hill.

On the down side, tuition is very high, and Providence, while a booming small city, is no Manhattan. The winter months are dreary. Fortunately, the fall and spring seasons are beautiful, and the school is only an hour from Boston (and three hours from New York City). *Rhode Island School of Design, 2 College Street, Providence, RI 02903. (401) 331-3511.*

SAN FRANCISCO ART INSTITUTE
The San Francisco Art Institute is a pure art school with a solid tradition of photographic education. Its program was started in 1946 by Ansel Adams, and Minor White, Dorothea Lange, and Imogen Cunningham all taught here. True to the clichés about California, the school is loosely structured; if you're looking for academics, go elsewhere. Students learn first and foremost to be photographic artists, not thinkers about photography. The program accents interdisciplinary work,

History of Photography Programs

Scholarly study of the history of photography has become popular enough to justify several academic programs. Most are photography concentrations within an art history department. Typically, graduates go on to teach, write, and curate.

ARIZONA STATE UNIVERSITY
Art Department
Tempe, AZ 85287
(602) 965-9011

CALIFORNIA STATE COLLEGE
800 North State College Blvd.
Fullerton, CA 92634
(714) 773-3471

OHIO STATE UNIVERSITY
Department of Photography and
 Cinema
156 West 19th Avenue
Columbus, OH 43210
(614) 292-0404

PRINCETON UNIVERSITY
104 McCormick Hall
Princeton, NJ 08540
(609) 452-3000

UNIVERSITY OF ARIZONA
Department of Art
Tucson, AZ 85721
(602) 621-7570

UNIVERSITY OF CALIFORNIA
Art History Department
Riverside, CA 92521
(714) 787-1012

UNIVERSITY OF NEW MEXICO
Art and Art History Department
Albuquerque, NM 87131
(505) 277-5861

UNIVERSITY OF ROCHESTER
Art and Art History Department
Morey 424
Rochester, NY 14627
(716) 275-9249

and students combine photography with other media such as painting and performance art.

The Art Institute's relative lack of structure can be seen in a positive or negative light. For the self-motivated student, it's a big plus. The school has many creative resources and a great diversity of faculty and course offerings. But students with a less concrete idea of what they want to do may be overwhelmed by such freedom.

The faculty changes little from year to year, and many of the full-timers have been around for a while. Overall, the teachers are first rate and encourage a great diversity of work. Regular visiting artists help bring new perspectives and energies to the program.

Perhaps the biggest complaint at the institute is the lack of workspace for students. The school has experienced serious financial troubles in the past, but seems to be recovering from its worst problems.

The location is a big plus. San Francisco is lovely, albeit expensive, and the campus is special as well. Art Institute students are of a high caliber. Admission to the two-and-a-half-year graduate program is especially competitive, and about five to ten new students enter per class. The half year was added recently to some student consternation; it calls for a semester of independent study at full tuition. In general, tuition is about average for a private school. *San Francisco Art Institute, 800 Chestnut Street, San Francisco, CA 94133. (415) 771-7020.*

SCHOOL OF THE ART INSTITUTE OF CHICAGO
The Chicago Art Institute has a long-established program and offers a large department with a lot of diversity. The school is affiliated with one of the country's premier art museums, and students spend much time studying disciplines other than photography. There's little interest in commercial work. Instead, the primary emphasis is on doing photography, and secondarily on analyzing and criticizing it.

The faculty is excellent and varied.

Most of its members have been at the school for a long time, but a constant turnover in part-timers and visiting faculty provide a nice combination of stability and variety.

Though the program encourages various styles and approaches to photography, its reputation rests mostly on conceptual, manipulative, or otherwise nontraditional work. A recent graduate student said, "There are no rules here. Where I used to carry my work in portfolio boxes, now I can't carry it at all—it doesn't fit into any cases."

Admission is competitive and student quality quite high. Many graduates (and some undergraduates) are older and come from diverse backgrounds, adding a nice richness of experience to the educational mix. As at RISD, the undergraduate program here is especially strong.

The Art Institute is located in the heart of downtown Chicago, an exciting city with unpleasant winters but a wealth of excellent museums and galleries. In general, the school offers excellent facilities, though it lacks a shooting studio and cannot guarantee individual studios for its grad students. It has no campus *per se,* and most students live in the city in apartments or lofts; for a large city, Chicago is surprisingly affordable.

School of the Art Institute of Chicago, 280 South Columbus Drive, Chicago, IL 60603. (312) 443-3700.

See page 110.

UNIVERSITY OF FLORIDA/ FLORIDA STATE

These programs are small and first rate. Their tuition is less than half that of most good private schools for out-of-staters, and much less for Floridians. Graduate teaching assistants can earn a full tuition refund, unusually generous for a fine-art fellowship.

At the University of Florida, the more established of the two programs, the entire graduate department in photography consists of only six to eight students. The small faculty of three full-timers includes nationally known fine-art photographers with a strong commitment to teaching. Both under-

MFA Student Work

Len Follick, Untitled, *University of New Mexico.*

Lynda Barckert, Teach Them Well, *School of the Art Institute of Chicago.*

Jeffery Byrd, In a World Too Coarse to Touch, *University of Florida.*

Organizations of Photo Teachers

FELLOWSHIP OF PHOTOGRAPHIC EDUCATORS

Formerly called the Society of Teachers of Professional Photography, the Fellowship of Photographic Educators (FPE) began in 1977 but was fairly inactive until 1987. Most members teach in trade and professional schools. The FPE publishes a newsletter *(The Journal)* and is closely affiliated with the Professional Photographers of America.
7551 Long Lake Road, Willmar, MN 56201. (612) 235-6413.
 See page 102.

THE SOCIETY FOR PHOTOGRAPHIC EDUCATION

The Society for Photographic Education (SPE), the largest association of college-level photography teachers, is heavily oriented toward the fine-art end of photographic education. Even though the SPE is involved in technical concerns, its primary interest is in the aesthetic side and in supporting research and writing on photography. The group publishes *Exposure,* a monthly academic journal featuring articles on photographic history and criticism.

The SPE has eight regional chapters, all of which hold conferences in the fall. Every spring, the association conducts a national conference with well-known speakers, seminars, and talks on popular and arcane subjects. Many students, teachers, and photographers attend the national conference to search for hard-to-find teaching positions.
Box BBB, Albuquerque, NM 87196. (505) 268-4073.
 See pages 103 and 195.

Free Publications for Teachers

Kodak and Polaroid each publish quarterly newsletters for photography teachers. Both include stories about photographers and technical tips, as well as information about their publisher's products. The Kodak newsletter is a two-color job, while the Polaroid version is more flashy, with four-color reproduction and features on fine-art and professional photographers. Both use much space promoting their products and reporting on company-supported projects. Subscriptions are free to anyone involved in photographic education.

PHOTO EDUCATOR NEWSLETTER

Eastman Kodak Company
Professional Photography Division
Rochester, NY 14650

PHOTOEDUCATION:
A POLAROID NEWSLETTER FOR TEACHERS OF PHOTOGRAPHY

Polaroid Corporation
575 Technology Square, 9P
Cambridge, MA 02139

graduate and graduate students enjoy close faculty contact, and, as a particularly strong point, the program brings in many visiting artists for short stays, and as replacements when regular faculty members are on leave.

The program focuses strictly on doing, not thinking about, photography. One weakness is a dearth of courses in criticism and history. Another is a relatively loose structure (though some consider this a strength). Motivated students with a strong sense of purpose do far better here than those looking for direction.

Although supportive of diverse styles and interests, the program and its faculty have always had a particularly strong reputation for nontraditional work, including combining photography with other media. This is due in part to the university's art department, which forces students to explore other media. Graduate students must take art courses—either studio or history—other than photography.

The school's facilities are excellent—each graduate student has his or her own darkroom—but its location is isolated. Gainesville lacks the excitement of most cities or even large university towns, and is at least two-and-a-half hours from the nearest metropolitan center, Jacksonville. To combat this isolation, the faculty organizes field trips to faraway places, such as New York City.

In many ways, Florida State University is similar to the University of Florida. The faculty is small, excellent, and committed, and student work is, if anything, more experimental. A big difference is Florida State's location; Tallahassee is the state capital and a far more cosmopolitan city than Gainesville.
Florida State University, Department of Art, 221 FAB, Tallahassee, FL 32306. (904) 644-6474.
University of Florida, Department of Art, 302 FAC, Gainesville, FL 32611. (904) 392-0711.

UNIVERSITY OF NEW MEXICO

The University of New Mexico runs a strenuous and intense program that

stresses academics almost as much as studio work. The M.F.A. program demands a substantial written dissertation, course work in other media, and three graduate reviews before a panel of faculty from all fine-arts disciplines.

Students do their photography work pretty much on their own and meet regularly in seminars. In these long, involved sessions, they thrash out general issues of photographic interest, as well as review and discuss individual work. It's not for the weak or uncommitted. Students are expected to think hard about what they're doing, defend their work, and react intelligently to that of fellow students. Graduates say that these seminars form one of the best features of the program.

UNM is well known for its history-of-photography component, generally considered the country's finest, along with Arizona State's. The studio offerings are also first rate. Work is diverse, with an emphasis on the cutting-edge (sometimes arcane) side of fine-art photography, such as semiotics (combining images and text). The program shows a relative disinterest in traditional areas such as landscape and documentary photography.

The faculty is outstanding and very available to students. Some students complain of isolation; visiting lecturers and teachers are not a regular part of the program. But the school's facilities are excellent, and the area is a beautiful place to photograph and live in. *University of New Mexico, Department of Fine Arts, Albuquerque, NM 87131. (505) 277-2111.*
See pages 132 and 179.

Other Top M.F.A. Programs

ARIZONA STATE UNIVERSITY
School of Art
Tempe, Arizona 85287
(602) 965-9011

CALIFORNIA COLLEGE OF ARTS AND CRAFTS
5212 Broadway
Oakland, CA 94618
(415) 653-8118

CALIFORNIA STATE AT FULLERTON
State College Boulevard and Nutwood
Fullerton, CA 92634
(714) 773-3471

INDIANA UNIVERSITY
Department of Photography
Bloomington, IN 47405
(812) 855-0310

MARYLAND INSTITUTE COLLEGE OF ART AND DESIGN
1300 West Mount Royal Avenue
Baltimore, MD 21217
(301) 669-9200

OHIO UNIVERSITY
School of Art
Siegfried Hall
Athens, OH 45701
(614) 593-4288

PRATT INSTITUTE
200 Willoughby Avenue
Brooklyn, NY 11205
(718) 636-3768

ROCHESTER INSTITUTE OF TECHNOLOGY
1 Lomb Memorial Drive
Rochester, NY 14623
(716) 475-2616
See pages 143, 150, and 230.

SCHOOL OF VISUAL ARTS
Office of Graduate Admissions
209 East 23rd Street
New York, NY 10010
(212) 683-0600

SOUTHERN ILLINOIS UNIVERSITY
Department of Photography
Carbondale, IL 62901
(618) 453-2365

TYLER SCHOOL OF ART
Temple University
Beech & Penrose Avenue
Melrose Park, PA 19126
(215) 782-2700

UNIVERSITY OF ARIZONA
Department of Art
Tucson, AZ 85721
(602) 621-7570

Guides to Photographic Education

Every few years, both Kodak and the Society for Photographic Education (SPE) publish information about schools that teach photography. The Kodak guide is very broad, listing over 1,000 schools that teach courses in still, graphic arts, and motion-picture photography. This guide also surveys existing courses, with such information as the number of enrolled students in each specialty (basic photography, color, photojournalism, and so forth).

The SPE guide offers a profile of graduate programs, mostly leading to M.F.A. degrees, though by careful reading you can garner information about undergraduate classes as well. It lists the schools that offer programs, along with names of faculty members, application and enrollment numbers, and so on.

Both of these publications are useful and inexpensive, but neither one is revised annually and their information tends to become outdated. Still, if you're shopping for a school, they're worth a look.

A Survey of College Instruction in Photography
Kodak Publication T-17
Eastman Kodak Company
343 State Street
Rochester, NY 14650

Graduate Education in Photography in the United States
Society for Photographic Education
Box BBB
Albuquerque, NM 87196

Viewpoint: Photographic Education

WILLIAM E. PARKER
PROFESSOR OF ART AND HISTORY OF PHOTOGRAPHY
UNIVERSITY OF CONNECTICUT, STORRS

"Although it's difficult to prophesy trends in photo education, interdisciplinary training is on the rise. People no longer study photography exclusively. There is much more interest in all media, and we're getting rid of the idea of secular study in the fine arts.

"This greater integration doesn't mean that students are being trained to be masters of all trades. It does mean a greater acceptance of drawing, painting and 'installation work.' The latter can mix photography with other media, with less concern for the traditional look—prints hanging on a wall—and more interest in the work's 'environmentalization' and the way it addresses complex issues through a variety of media, including using lights and sound to help carry the artist's message.

"Not that printmaking is becoming a lost art; we will continue to teach the craft of fine printing and take students through the various formats and camera systems. That will always be part of any photography program. But what students eventually do with this knowledge will more often result in work far removed from traditional photography. The zone system is no longer sacrosanct; more important is the message the student wants to communicate.

"Another development is in the size of today's images. Increasingly, students are using materials that approach mural size. Prints smaller than 20×24 inches do not hold much interest; many prefer a gigantic scale. Also, the nature of the work is such that it forms links with social, psychological, political, or even anthropological viewpoints. Students are no longer interested only in making a personal photographic statement, but are reaching beyond that to say something about society as well.

"Fine-arts programs are typically called 'professional,' but I'm not sure any of them can actually prepare someone for a career. There has never been any guarantee of employment in this field. In recent years, however, students have a perspective that goes beyond getting a grant or a gallery exhibition, or—good lord—teaching. They have broader interests now. Institutional and environmental display and 'book arts' work is getting a lot of attention. Photography students are very aware of recent concerns with so-called postmodernist theories and issues such as deconstructionism. All of this gives them more options, more opportunities beyond private creative aims."

Photojournalism

Photojournalism is a popular career choice for budding photographers. Unfortunately, jobs are scarce. A spate of newspaper mergers and closings have reduced the opportunities for jobs on dailies, and many picture-oriented magazines have either folded or reduced their use of photography. The golden years of photo-filled magazines, such as *Life, Look, Collier's, Holiday,* and the *Saturday Evening Post,* are long gone—victims, in large part, of the rise of television. Of these magazines, only *Life* still exists, but in monthly rather than weekly form.

Nevertheless, if you're determined to be a photojournalist, forge ahead. It's hardly a growth area, but opportunities still exist. Be prepared for tough competition for jobs and be flexible in your career goals. If you're thinking about traveling worldwide to record events of international import, you may have to think again; successful shooters of this sort are rare indeed.

Still, somebody's got to do it. Many surviving newspapers are financially strong and do hire young photographers. Most magazines still need photos; in fact, recent years have seen a resurgence of opportunities with the growth of specialty magazines. Other openings for trained photojournalists can be found in corporations and public relations firms, and many photojournalists eventually make a successful transition to commercial photography.

Paul Anderson, Clarence White and Students, New York City, ca. 1916–17 (courtesy The Art Museum, Princeton University).

Training for Photojournalism

A good photojournalist needs technical know-how, interpersonal skills, and determination. Aggressiveness doesn't hurt, either. Whereas a news reporter can observe and interview people, then return to the office and write the story, a photojournalist must get the pictures on the spot, regardless of any difficulties that may crop up.

A photojournalism program can help you develop some of these abilities and traits. You'll study technical and editorial skills, and get to apply them on the school newspaper or as an intern in a real-life situation.

Photojournalism schools are career oriented, mainly geared toward newspaper work. Most have good contacts in the working world and can help their graduates land a job. Of course, if you're going to free-lance, photo editors don't really care where you went to school; they just want you to bring back newsworthy photos. A good school should teach you how to do that.

Photojournalism programs are almost always part of a larger school of journalism. Several first-rate journalism schools, such as Berkeley, Columbia, and Stanford, aren't included below because they either don't teach photojournalism, or they treat it as a minor subject.

UNIVERSITY OF MISSOURI SCHOOL OF JOURNALISM

This is *the* premier school of photojournalism in the country, and has been for a long time. It has an excellent faculty and a soundly structured program, but most of all it has a reputation—an extremely important factor when filing job applications.

Students come to Missouri from all

over the world, and from a variety of backgrounds. Many are mid-career photojournalists; others are just mid-career. There are teachers, accountants, and artists who want to become photojournalists. There are picture editors who want to shoot, and shooters who want to edit.

Photojournalism students at Missouri do a lot of writing and picture editing, skills that make them more capable and marketable journalists. The program stresses practical experience and has its own internship program. The local daily paper, *The Missourian,* is run largely by faculty and students.

The school is rather isolated in Columbia, a sleepy city of 65,000, located about 120 miles from both Kansas City and St. Louis. Academically, the university is not particularly strong, and the photo department needs more equipment and darkroom space, although, as one faculty member put it, "I've seen a lot worse at daily newspapers I've worked at."

Overall, Missouri's pluses far outweigh its minuses. The school is involved in several outstanding and unique programs, such as the Pictures of the Year Contest and the famed Missouri Workshop. Nearly every graduate student receives financial aid, and the school is a powerful magnet for visiting photographers and editors. This not only brings enormous talent to the students, but also provides a wealth of potential contacts for the inevitable job search.

University of Missouri School of Journalism, 100 Neff Hall, Columbia, MO 65201. (314) 882-6194.

See pages 151 and 212.

Other Top Photojournalism Schools

These schools offer undergraduate majors in photojournalism. Those marked with an asterisk (*) also offer graduate degrees.

ARIZONA STATE UNIVERSITY*
Walter Cronkite School of Journalism
 and Telecommunications

Center for Documentary Studies

Documentary photographers are close cousins of photojournalists; they often have similar styles and overlapping interests in such subjects as people, places, cultures, and events. However, documentary photographers generally work on long-term projects that study a subject in depth for books, academic research, personal expression, or magazine stories. Photojournalists almost always work on assignment for a newspaper or magazine, and, even though they sometimes work on longer projects, their bread and butter is news stories and events.

The Center for Documentary Studies at Duke University runs a unique undergraduate and graduate program. Formerly a part of the university's Institute of Policy Sciences and Public Affairs, it now stands on its own and is expanding its offerings into film, video, and various forms of documentary writing. This program attracts students from a variety of disciplines, and emphasizes doing rather than studying. Students spend much time in the field shooting a documentary project.

Documentary photographers, like photojournalists, are interested in the meaning of their subject, so writing often accompanies their photographs. The ideal final form is a book, and the Center for Documentary Studies's expanding publishing program has produced titles on such diverse subjects as southern family photos, South Africa, and children's chalk drawings.

Center for Documentary Studies, Duke University, 331 West Main Street, Suite 509, Durham, NC 27701. (919) 687-0486.

Tempe, AZ 85287
(602) 965-5011

CALIFORNIA STATE UNIVERSITY AT FRESNO
Department of Journalism
Fresno, CA 93740
(209) 294-2087

CALIFORNIA STATE UNIVERSITY AT LONG BEACH
Photojournalism Program
1250 Bellflower Boulevard
Long Beach, CA 90840
(213) 985-4981

INDIANA SCHOOL OF JOURNALISM*
Ernie Pyle Hall
Room 200
Bloomington, IL 47405
(812) 855-9247

KENT STATE UNIVERSITY
School of Journalism and Mass
 Communication
Kent, OH 44242
(216) 672-2572

OHIO UNIVERSITY
School of Visual Communications
Athens, OH 45701
(614) 593-4880

SAN FRANCISCO STATE
Department of Journalism
San Francisco, CA 94132
(415) 338-1689

SAN JOSE STATE UNIVERSITY*
Department of Journalism and Mass
 Communications
San Jose, CA 95192
(408) 924-3240

SYRACUSE UNIVERSITY*
Photography Department
School of Public Communications
Syracuse, NY 13210
(315) 443-2301

UNIVERSITY OF KANSAS
William Allen White School of
 Journalism and Mass
 Communications
Lawrence, KS 66045
(913) 864-4755

UNIVERSITY OF MINNESOTA
School of Journalism and Mass
 Communications
111 Murphy Hall
Minneapolis, MN 55455
(612) 625-9824

UNIVERSITY OF MONTANA*
School of Journalism
Missoula, MT 59812
(406) 243-4001

UNIVERSITY OF TEXAS AT AUSTIN*
Department of Journalism
Austin, TX 78712
(512) 471-1845

WESTERN KENTUCKY UNIVERSITY
Department of Journalism
Bowling Green, KY 42101
(502) 745-4143

Internships

Future photojournalists can get invaluable on-the-job training by taking an internship—short-term work for relatively little or no pay, but a lot of experience. Interns are thrown into the fray; they help organize assignments and files, work in the darkroom, and even edit and photograph. This experience is an excellent way to make contacts for that first job.

Formal internship programs publish very specific guidelines as to the level of intern they need and the kind of work they provide. Most are reserved for photography students only (some specify enrollment in a journalism program), and virtually all involve work on a newspaper. *National Geographic* is one of the few magazines that takes photography interns, but it doesn't encourage applications; it gets plenty without advertising. Each year, the National Press Photographers Association (see page 102) publishes a list of dozens of internship programs. Here are some of the best and most competitive.

ANCHORAGE DAILY NEWS
Box 149001
Anchorage, AK 99514
(907) 257-4200

Books on Photojournalism

Some of the following books are used as texts in photojournalism programs, and the others could be.

The Best of Photojournalism: Newspaper and Magazine Pictures of the Year, Running Press, 1989.
This annual compilation of the winners of the Pictures of the Year competition is cosponsored by the National Press Photographers Association and the University of Missouri School of Journalism.
 See page 212.

Documentary Photography, by Arthur Rothstein, Focal Press, 1986.
This text by the late photographer-editor-writer covers the theory and practice of documentary photography.

Eye of Time: Photojournalism in America, edited by Marianne Fulton, New York Graphic Society, 1989.
Fulton's book is a comprehensive survey of photojournalism, from Matthew Brady to today, well selected and reproduced.

From the Picture Press, edited by John Szarkowski, Museum of Modern Art, 1974.
Presenting selections from an exhibition at the New York Museum of Modern Art, this book has great photographs and interesting ruminations about such subjects as privacy, anonymity, and content.

Life: Classic Photographs, by John Loengard, New York Graphic Society, 1988.
The author, a former picture editor of *Life* magazine, gives a personal, thoughtful interpretation of some very familiar photographs.

Photojournalism: The Professional's Approach, by Kenneth Kobre, Focal Press, 1980.
This widely used text draws heavily on interviews with working photographers and editors, covering the breadth of photojournalistic issues.

Scott Martin, Syracuse University.

Ruth Fremson, an intern at the Washington Times.

Catherine Jones, University of Missouri.

THE GAZETTE TELEGRAPH
30 South Prospect
Colorado Springs, CO 80901
(303) 636-0265

THE HARTFORD COURANT
285 Broad Street
Hartford, CT 06115
(800) 524-4242

KANSAS CITY STAR AND TIMES
1729 Grand Avenue
Kansas City, MO 64108
(816) 234-4141

LOS ANGELES TIMES
Metro–Times Mirror Square
Los Angeles, CA 90053
(800) 528-4637

LOUISVILLE COURIER-JOURNAL
525 West Broadway
Louisville, KY 40202
(502) 582-4011

NORFOLK VIRGINIA PILOT
150 West Brambleton Avenue
Norfolk, VA 23510
(800) 444-1220

THE OGDEN STANDARD-EXAMINER
455 23rd Street
Ogden, UT 84402
(801) 394-7711

THE PALM BEACH POST
2751 Dixie Highway
West Palm Beach, FL 33405
(305) 837-4490

PHILADELPHIA DAILY NEWS
400 North Broad Street
Philadelphia, PA 15230
(215) 854-2000

THE PITTSBURGH PRESS
34 Boulevard of the Allies
Pittsburgh, PA 15230
(412) 263-1502

PORTLAND PRESS
6925 S.W. Alden
Portland, OR 97223
(503) 222-1045

Viewpoint: Photojournalism

TOM KENNEDY
DIRECTOR OF PHOTOGRAPHY
NATIONAL GEOGRAPHIC
WASHINGTON, D.C.

"*National Geographic,* by its very size and traditions, tends to be held as an example by many photojournalists—especially those who work in the newspaper field—and we seem to be caught in the middle of certain winds of change. Perhaps it's prophetic that this evolution is happening as the magazine begins its second century, but the tensions I feel are being felt throughout photojournalism in America.

"For nearly 100 years, a distinctive, homogenous vision has been a trademark of *Geographic* photography. It has its roots in the noble tradition of documentary photography and the magazine's need to clarify and explain the world in simple, straightforward terms with no ambiguities, with nothing left to the reader's imagination.

"But today's readers are much more visually aware. They have been saturated with images, not only in print but in movies, video, and advertising. We have to work harder to get the reader's attention, and to do that we're relying more and more on photographs that display personal expression. We increasingly look for photographers who have a unique way of seeing that will grab and hold the reader's eye.

"This implies subjective reporting, traditionally anathema in journalism. But the myth of journalism's objectivity is difficult to maintain. The idea that all biases get filtered out when someone points a camera in a particular direction and takes a picture at a specific moment is nonsense. Along with the visual sophistication of today's readers comes a skepticism that pictures not only aren't always utterly objective, but don't have to be. We all recognize that life has grown more complex; photographs should reflect that.

"I think we can publish more personal statements and not violate the trust of our readers if we're up front about our subjectivity. We can let them know our viewpoints in the pictures and supplement that in the captions. After all, our mission is to dispense photographers to all corners of the earth, ask them to be explorers, and tell us what they saw. You can't disguise the fact that we're asking for their vision of the world.

"The look of such pictures bears evidence of the art world. I would say that the younger photographers show the influence of Robert Frank, Garry Winogrand, and Lee Friedlander. They have borrowed from their impulses and are acting on them more vigorously than ever before. This doesn't mean that we will publish only that kind of work; it will increase gradually.

"As readers are confronted with more media and less time to consume it, many publications have been forced to simplify photographs to the point that they stand for very little. Many newspapers and magazines use photographs as icons or as devices like a headline to get attention, but to explain little else. I think we're debasing the coinage of photography by letting it stand for so little. This is an ominous trend—a de-evolution—that photographers and editors should speak out about. I hope we can make a case for a wider definition of photojournalism, one that goes beyond symbols and reflects the diversity, complexity, and richness of life."

THE PROVIDENCE JOURNAL
75 Fountain Street
Providence, RI 02902
(401) 277-7323

SACRAMENTO BEE
Box 15779
Sacramento, CA 95852
(916) 321-1000

SAN JOSE MERCURY NEWS
750 Ridder Park Drive
San Jose, CA 95190
(408) 920-5000

SEATTLE TIMES
Box 70
Seattle, WA 98111
(206) 464-2111

TOPEKA CAPITOL-JOURNAL
616 Jefferson Street
Topeka, KS 66607
(913) 295-1111

To receive an updated list, contact:

Director, Internship Program
National Press Photographers
* Association*
4980 Sodbuster Trail
Colorado Springs, CO 80917
(719) 591-9493



# EDUCATION

Professional Schools

If you see photography more as a career than as a vehicle for self-expression, consider studying at a professional school—one that offers training in the specialty that most interests you. Such schools offer many choices, from glamorous-sounding and potentially lucrative jobs in commercial, advertising, and fashion photography to more secure and conventional phototech jobs in hospitals and industry. Many photographers also work in the fields of wedding and portrait photography (these specialties often go hand in hand) as well as in photofinishing and manufacturing.

A professional school may be large, well equipped, and even part of a larger university, capable of providing a general education as well as career-oriented skills. But many are small and privately owned, offering concrete vocational training.

Most professional schools focus on technique. They teach you how to get the job done, and how to deal with clients; sometimes they teach general business skills as well. Developing an aesthetic sense is rarely a high priority, but some professional schools do offer fine-art courses. Many successful pros have a highly defined personal style, and a judicious mix of professional and fine-art courses may help you develop your own style.

Brooks Institute of Photography.

© MICHAEL VERBOIS

ART CENTER COLLEGE OF DESIGN

Founded in 1930 to prepare artists for the business world, the Art Center College of Design has grown from a small trade school in a makeshift Los Angeles facility to a world-class professional school on a 175-acre site in Pasadena. The average student is past college age and brings experience, maturity, and motivation to the school's educational mix.

Photography majors get plugged into a variety of visual-communication areas, in large part because the Art Center's offerings are so broad. Courses include advertising, environmental design, fashion illustration, film, graphics and packaging design, illustration, product design, and transportation design.

The school offers B.F.A. and M.F.A. degrees, but it trains few fine-art photographers. The emphasis is on fundamentals and creating photographs that motivate and sell. Over the years, the faculty has included many successful photographers and committed teachers; Ansel Adams taught here from 1941 to 1942. Most of the faculty remain professionally active.

The facilities are excellent, offering sophisticated color-processing units and studio equipment, all meticulously maintained. The school's proximity to Los Angeles is handy for tapping that city's active design and advertising community, as well as satisfying more mundane needs such as renting props for an assignment.

Tuition is high, but so are the day rates graduates will charge when they join the professional world. Most will enter that world armed with an outstanding portfolio and polished professional skills.

Art Center College of Design, Photography Department, 1700 Lida Street, Pasadena, CA 91103. (818) 584-5000.

BROOKS INSTITUTE OF PHOTOGRAPHY

Founded in 1945, Brooks Institute is a privately owned school, providing its 700 or so students with an outstanding education in these areas of professional photography: color technology, com-

mercial, illustration/advertising, industrial/scientific, media, motion picture/video, and portraiture.

The Brooks program is very structured and career based. Students must take liberal-arts courses such as English, mathematics, and economics, as well as practical courses such as accounting, marketing, and business computers. With a few exceptions, students earn a degree (B.S. or M.S.) or a diploma (a three-year program for those with a bachelor's degree).

Brooks has a striking diversity of students and graduates. Most are extremely motivated, but because enrollment is not highly selective the student level varies widely, as do career interests. Some go on to work in traditional portrait/wedding studios, others to fame and fortune in advertising and photojournalism. It's the rare Brooks graduate who doesn't wind up working somewhere in photography.

The school has three pristine campuses in Santa Barbara and boasts first-rate, extremely well-maintained facilities. The faculty is very professional, and many of its members are working photographers on a part-time basis. Santa Barbara is a beautiful small city on the Pacific, but at 90 miles from Los Angeles it's somewhat isolated. Tuition is reasonable for a private school. *Brooks Institute of Photography, 801 Alston Road, Santa Barbara, CA 93108. (800) 522-2259; (800) 522-2293 in California; (805) 966-3888.*

See page 151.

ROCHESTER INSTITUTE OF TECHNOLOGY

If there's a premier school of photography in the United States, the Rochester Institute of Technology is it. RIT has a wide diversity of high-quality programs, including an excellent M.F.A. program of about thirty-five students that sometimes gets overlooked in the avalanche of other offerings. These include biomedical photographic communications, film and video, imaging

Steven C. Finson, Brooks Institute.

Trish O'Rielly, Art Center College of Design.

Corey Meitchik, Cucumber 5× Magnification, *Rochester Institute of Technology.*

and photographic technology, photographic processing and finishing management, and professional photographic illustration (commercial, documentary, and editorial).

The School of Photographic Arts and Sciences at RIT has about 1,000 students. Its offerings are broad, and it is unparalleled in scientific and technological training. No other school offers this kind of education—a fact well appreciated by Eastman Kodak, a Rochester-based company, which hires a lot of its scientists and other workers from the ranks of RIT graduates.

RIT exhibits most of the traits of a school steeped in technology. Its programs are carefully structured, and the facilities and equipment excellent and well kept. Some say that RIT's structure is confining, but the school is creative and eclectic in its offerings; it has one of the few good holography programs around, as well as excellent courses in photographic preservation. A fairer complaint is its location in Rochester, a city of many fine resources but cold winters and steamy summers.
Rochester Institute of Technology, Office of Admissions, One Lomb Memorial Drive, Rochester, NY 14623. (716) 475-6631.
See pages 135, 145, 150, 205, and 230.

Other Schools With Professional Programs

The following is a mix of schools and larger university programs that offer a major in commercial photography. Many of these have good fine-art programs as well.

THE ART INSTITUTE OF BOSTON
700 Beacon Street
Boston, MA 02215
(617) 262-1223

COLUMBIA COLLEGE
600 South Michigan Avenue
Chicago, IL 60605
(312) 663-1600

Viewpoint: Photoassisting

WAYNE TAKENAKA
ASSISTANT, NEW YORK CITY

"Successful photographers generally have one or more full-time assistants. A studio manager coordinates studio activity, arranging for models, stylists, hair and makeup people, and so forth; in some studios, one person doubles as manager and assistant.

"The assistant takes care of the technical requirements, freeing the photographer to deal with artistic aspects. Obviously, the first assistant must have a working knowledge of lighting and exposure, cameras and lenses, and so forth. Some photographers also require that their assistants be able to process film and make quality prints in the darkroom.

"Many seasoned assistants feel, both from their own experience and from observing assistants just out of photography school, that attending school is a waste of time and money. Most graduates with a couple of years of schooling do not compare favorably with nonschooled assistants who have spent an equivalent amount of time working in a busy studio. Instead of going to a professional school, use the money to support yourself while assisting working photographers.

"Unless you can afford to spend countless hours and thousands of dollars on equipment, film, and pro-

cessing to learn the craft, assisting is probably the most efficient way to learn photography. You confront a variety of real-life situations from which you learn technique more thoroughly and quickly than you do in school. But the hours are long and the pay is low. Five years ago, I started assisting at $175 a week, working twelve-hour days. You have to appreciate the value of the learning experience, or you won't last very long. Some competent assistants to top photographers earn $400 to $600 per week, but as a rule assistants earn much less. I frequently work day and night, sometimes seven days a week. The job is often tedious, and taking orders from creative people is not always easy. Most photographers are much more temperamental than my current boss, Patrick Demarchelier.

"People looking for their first assistantship quite naturally want to work for a well-known photographer. Be advised that such positions are in big demand, and gaining them depends not only on having had previous experience, but also on having the right attitude and temperament, and on being in the right place at the right time. We prefer to hire people who have worked for two or three years at another studio; we don't have time to do a lot of on-the-job training. Some weeks, we get only three calls from people seeking assisting jobs; other weeks, we get

as many as three calls a day. If you can't get in with your photographer of choice, don't hesitate to start in a less glamorous studio, such as those specializing in catalog work; much can be learned there, and you'll accumulate experience for that choice assisting job in time.

"Consider assisting for two or three years. Some photographers assist for as long as six years, or more. At least part of your apprenticeship should be with someone whose work you admire. But don't neglect your own pictures; spend evenings and weekends working on your portfolio. I worked in a fashion catalog studio my first two years in New York. Although the pay was meager, they let me use the studio and equipment, and even provided film and processing. After a sixty-hour week doing other people's pictures, I would drag myself into the studio on weekends to do my own.

"One of the most frustrating things about assisting is having to constantly do someone else's pictures. Clients hire a gifted photographer for his taste and style, not his assistant's. The assistant must be content to handle the technical problems so the photographer can exercise his artistry without hindrance."

**DAYTONA BEACH
COMMUNITY COLLEGE**
Box 1111
Daytona Beach, FL 32115
(904) 255-8131
See pages 96 and 196.

FASHION INSTITUTE OF TECHNOLOGY
227 West 27th Street
New York, NY 10001
(212) 760-7675

**ORANGE COAST
COMMUNITY COLLEGE**
2701 Fairview Road
Costa Mesa, CA 92628
(714) 432-0202

PARSONS SCHOOL OF DESIGN
2 West 13th Street
New York, NY 10011
(212) 741-8912

PORTFOLIO CENTER
125 Bennett Street N.W.
Atlanta, GA 30309
(404) 351-5055

SCHOOL OF VISUAL ARTS
209 East 23rd Street
New York, NY 10010
(212) 683-0600

**SOUTHERN ILLINOIS UNIVERSITY
AT CARBONDALE**
Department of Cinema and
 Photography
Carbondale, IL 62901
(618) 453-2365

Vocational Schools

These are mostly small, privately owned schools that provide training in very specific professional areas.

**GOLDEN GATE SCHOOL OF
PROFESSIONAL PHOTOGRAPHY**
21 Goldengate Drive
San Rafael, CA 94091
(415) 258-0281

**HALLMARK INSTITUTE OF
PHOTOGRAPHY**
At the Airport
Turner Falls, MA 01376
(413) 863-2478

HAWKEYE INSTITUTE OF TECHNOLOGY
Admissions Office, Box 8015
Waterloo, IA 50704
(319) 296-2320

**NEW ENGLAND SCHOOL OF
PHOTOGRAPHY**
537 Commonwealth Avenue
Boston, MA 02215
(617) 437-1868

**NEW YORK INSTITUTE OF
PHOTOGRAPHY**
211 East 43rd Street
New York, NY 10017
(800) 453-9000; (212) 371-7050

OHIO INSTITUTE OF PHOTOGRAPHY
2029 Edgefield Road
Dayton, OH 45439
(513) 294-6155

**RHODE ISLAND SCHOOL OF
PHOTOGRAPHY**
241 Webster Avenue
Providence, RI 02909
(401) 943-7722

**THE SCHOOL OF
COMMUNICATION ARTS**
2526 27th Avenue South
Minneapolis, MN 55406
(612) 721-5357

**WINONA INTERNATIONAL SCHOOL OF
PHOTOGRAPHY**
350 North Wolfe Road
Mount Prospect, IL 60056
(800) 742-7468; (312) 298-6770

Professional Seminars

The Rochester Institute of Technology offers an extensive program of short seminars for professionals in printing, photography, and imaging science who want to supplement or update their skills. Run by the Technical and Education Center of the Graphic Arts, the seminars provide intensive study in a specific area usually related to the printing industry. The program draws about 4,500 attendees each year.

Most photographers won't be interested in the Commercial Web Offset Workshop, the Bar Code Implementation Seminar, or the Short Course in Printing Ink Technology. But there are a few gems, including instruction in some subjects not easily found elsewhere. Some examples include The Photograph Reproduced, and Preservation of Black-and-White Photographs.

These seminars, taught by working professionals, generally get rave reviews. However, they're expensive, seemingly aimed at those whose employers will pay. Tuition for a three-day workshop is about $600.

Most of the seminars run once or twice a year in Rochester, though a few are offered in New Jersey, Connecticut, and other locations in New York (including New York City). The *T&E News*, a monthly newsletter, describes upcoming seminars and reports on other matters related to the program.
Technical and Education Center of the Graphic Arts, One Lomb Memorial Drive, Rochester, NY 14623. (716) 475-2757.
See pages 150 and 205.

Viewpoint: Advertising Photography

MARISA BULZONE
EDITOR
GRAPHIS, NEW YORK CITY

"Advertising photography is a very cyclical business, because the advertising industry is constantly changing. Photographers who specialize in this area have to condition themselves to this fact. If you asked me the state of the art as I sit and evaluate the work of photographers, my answer could change practically every month.

"At *Graphis* we put out a spectacular annual issue, but that's deceptive. Every year I discover that a higher percentage of award-winning work was originally shot for personal reasons, not commissioned by agencies. This is a sad comment on the level of agency creativity, and reflects changes in the advertising business. With so many recent mergers, agencies are becoming a group of conglomerates. The bigger the company, the higher the costs, and the more conservative the attitude. This is not the best environment for creative, experimental work.

"There are some bright spots, however. Although the bigger New York–based agencies no longer support creative work as they once did, energetic agencies in smaller cities are now handling major campaigns and commissioning work built around the photograph. They use type sparingly but tastefully. They also use white space effectively. And there are some great photographs being made out there.

"Seattle is a hotbed of activity, as is San Francisco, Minneapolis and Chicago. A small agency in a smaller city has less overhead, fewer committees, more enthusiasm, and a greater emphasis on creativity. This isn't much solace for the New York–based pro, but it bodes well for those working outside the Big Apple. This is also a good argument for not moving to New York and trying to compete in an already crowded market.

"There seems to be a lot more photography being done on location these days, and less in big studios. Photographers are learning how to make dramatic use of existing light outdoors, or at least they're cleverly simulating it. The Nike shoe ads and those for Speedo swimwear are examples.

"I've also noticed a different attitude among younger photographers coming into the business. One called the other day to get a recommendation on an art director who was offering him a job. That may sound insolent, but I thought it was wonderful that he was taking that much care in plotting his career. He didn't want to waste his time doing hack work, and he would rather build a reputation on his work than on his billings. Such photographers, still in their twenties, are being very discriminating and quite intelligent in concentrating on building a good portfolio of assigned work.

"The younger people have a different attitude about electronic editing, too. They seem to accept without regret that their pictures will probably be retouched and combined with other images. It's not that they are abrogating responsibility for what's in the picture; they want to be involved in all aspects of the process. But they have embraced this technology, unlike their older colleagues who tend to fear it. It's part of the business now. Younger photographers are looking at the image in much the same way as the client—it's what's on the page that counts, and the steps it took to get there are immaterial. I think that's a positive attitude that will suit them well as their careers develop."

Workshops

Workshops may be the best way to study photography. Short and intensive, they're more efficient than full-time programs and perfect for those who have little free time but want to hone their skills. Workshops are also flexible. Most have a fine-art bias, but many offer instruction in journalism, advertising, and fashion.

Some workshops feel distinctly like summer camp. Generally located in the mountains or near water, they can be terrific places to spend time and make friends, not to mention network with other photographers. The teachers are usually working pros or fine artists, often famous ones. Many participants come to study with a photographer whose work they particularly admire.

Not all workshops are pleasant experiences; poorly organized programs, ego-driven teachers, and overly competitive fellow students are common complaints. Still, there's nothing quite like a good workshop experience. With few distractions, you can make big strides in your personal or professional work and have a great time doing it.

© WILLIE OSTERMAN

Photographers at the Rochester Institute of Technology workshops.

Choosing a Workshop

The abundance of excellent workshops can make picking one difficult. You should consider the obvious factors—convenience, expense, facilities, timing, educational goals—and also the enjoyment potential. Workshop students are generally quite serious about photography, but it's reasonable to consider the overall experience. You can find anything from a frenetic workshop in a large community of photographers to a laid-back camping trip to the Galapagos with ten other students.

Good instruction is really the key, and most workshops sell themselves largely on the quality of their faculty. "Master Workshops" abound, with famous photographers dropping in for a few days to teach. Some luminaries are outstanding teachers; others can barely speak, much less communicate effectively. The best teachers are not necessarily famous. This is particularly true if you want to learn a specific technique.

Studying with a "name" photographer makes most sense for those interested in improving their visual and interpersonal skills (dealing with subjects, clients, and so forth). Established pros may or may not be able to show you how to make a dye-transfer print, but they should be able to stimulate you—by example, by anecdote, and through answers to well-considered questions.

Word of mouth is the most reliable way to choose a teacher. If you don't know anyone who's attended a particular workshop, ask the staff at that workshop for the names of past participants to call for recommendations. Your local photography center (see page 94) may also be able to refer you to workshop veterans. You're about to spend a lot of money and maybe some

Bruce Davidson at the Friends of Photography workshops.

Lisl Dennis's Travel Photography Workshop.

precious vacation time, so do some research.

ANDERSON RANCH ARTS CENTER

In twenty years the Anderson Ranch Arts Center has grown from a small summer ceramics workshop into a nationally oriented arts program. Unlike many of the workshops described below, Anderson Ranch offers first-rate instruction in ceramics, woodworking and furniture making, painting, and printmaking as well as photography.

Not that photography gets short-changed. In 1986 Anderson Ranch built the Fischer Photography Center, a 4,700-square-foot facility containing excellent darkrooms and classrooms. The faculty is excellent, with ongoing instruction handled by a capable staff and special workshops run by well-known visitors such as Ralph Gibson, Roy DeCarava, Linda Connor, and Sam Abell.

Most of the photo workshops focus on fine-art photography, with a bit of documentary work and photojournalism thrown in. The program emphasizes black-and-white work, plus a lot of landscape photography and plenty of courses on craft. The lack of color darkroom facilities and professionally oriented workshops may discourage those wishing to explore more current styles and trends, but the varied arts programs help make Anderson Ranch diverse and interesting.

Located in the heart of the Rocky mountains, Anderson Ranch is a beautiful place to learn photography. Aspen, ten miles to the east, offers the lure of fine restaurants and shopping. *Anderson Ranch Arts Center, Box 5598, Snowmass Village, CO 81615. (303) 923-3181.*

FRIENDS OF PHOTOGRAPHY WORKSHOPS

In the tradition of Ansel Adams, who ran them for several years, the Friends of Photography Workshops are fine-art oriented. Unlike most workshops in which you sign up with one teacher, students get to study with several photographers during their stay. Recent

examples include Mary Ellen Mark, Yousuf Karsh, and Annie Leibovitz.

Students and faculty meet all day in small groups for discussions, print viewing, and demonstrations. At night, visiting faculty members present slide lectures. The hours are grueling, what with optional sunrise field trips and late-evening critiques.

The Friends workshops are held in several locations—all beautiful—near San Francisco and in the Pebble Beach area. Accommodations are good with such amenities as beautiful views of the Golden Gate Bridge, access to Point Lobos and the California coast, swimming pools, and so forth. However, the workshops concentrate on the creative end of photography and do not offer darkroom facilities.
Friends of Photography Workshops, 101 The Embarcadero, Suite 210, San Francisco, CA 94105. (415) 391-7500.
See pages 94, 125, 208, 212, and 213.

THE MAINE PHOTOGRAPHIC WORKSHOPS

The Maine Photographic Workshops, the country's best known and most ambitious workshop program, covers subjects for every taste, including landscape, portrait, architectural, fashion, studio, advertising, film, and video. Every week during the summer, it handles some 150 students in about ten concurrent workshops.

A staff of accomplished photographers and teachers is augmented by a dazzling array of famous photographers, each of whom gives a public lecture during his or her stay. Bruce Davidson, Arnold Newman, Burt Glinn, and Paul Caponigro were just a few recent visiting artists.

The program has good darkrooms and other facilities, a library, and an unusually fine all-purpose photography store. In Rockport, a lovely coastal town, you'll find galleries, a theatre, and nice restaurants. However, you won't need restaurants; the food at the workshop is excellent and varied (vegetarians take note), including a lobster and clambake every Friday evening.

Some complain that the Maine

Charles Traub workshop at The Center for Photography at Woodstock.

Trumpeter swans, Madison River, Yellowstone Park, National Audubon Society workshop.

© W. PERRY CONWAY

Workshop critique at the Anderson Ranch Arts Center.

© DAVID H. LYMAN

Paul Caponigro and the late Ernst Haas teaching at the Maine Photographic Workshops.

workshop is cliquish and overemphasizes the "star" value of its faculty. There may be some truth to that, but the program creates a large and richly varied environment, and the great majority of teachers and students come to work. If a few come to hobnob, that should be no deterrent to attending.
The Maine Photographic Workshops, Rockport, ME 04856. (207) 236-8581.
See pages 149, 208, 213, and 222.

ROCHESTER INSTITUTE OF TECHNOLOGY PHOTOGRAPHY WORKSHOPS

Given its expertise in applied photography, the primary draws at the RIT summer workshop program are its technical and practical offerings, such as holography, high-magnification photography, special effects, and dye transfer, as well as its studio, architectural, still-life, and business courses. Tucked away in this imposing structure is a small but solid selection of fine-art workshops.

Like the full-time courses, RIT workshops are no-nonsense events. Most of the teachers are regular RIT faculty. There are no famous visiting photographers, and nobody hangs out on the beach rapping. (For accommodations, the catalog suggests the dull old Rochester Hilton, located on campus.) The instruction is straight ahead and excellent; the facilities are outstanding.

While Rochester is hot and humid in the summer, it is a rich and varied city, particularly photographically. Kodak is there, and so is the International Museum of Photography (see pages 106 and 196); you could easily spend weeks just looking through that collection. As for the weather, remember that this is RIT; chances are excellent that the air conditioning will be working.
Rochester Institute of Technology, Technical Education, T&E Seminar Center, One Lomb Memorial Drive, Rochester, NY 14623. (716) 475-2757.
See pages 135, 143, 145, 205, and 230.

Other Workshops

ALPINE VISUAL ARTS
Box 480
William Avenue
Davis, WV 26260
(304) 259-5612

APPALACHIAN ENVIRONMENTAL ARTS CENTER
P.O. Drawer 580
Highlands, NC 28741
(704) 526-4303; (212) 526-2602

APPALACHIAN PHOTOGRAPHIC WORKSHOPS
Box 18837
Ashville, NC 28814
(704) 258-9498

BROOKS INSTITUTE OF PHOTOGRAPHY
801 Alston Road
Santa Barbara, CA 93108
(805) 966-3888, ext. 234
See page 142.

CALIFORNIA STATE UNIVERSITY
Photojournalism Workshop
Journalism Department
1250 Bellflower Boulevard
Long Beach, CA 90840
(213) 498-4981; (714) 643-8315

CHILMARK PHOTOGRAPHY WORKSHOP
Box 1125
Vineyard Haven, MA 02568
(508) 693-6603

CRESTED BUTTE NATURE WORKSHOPS
Box 1261
Englewood, CO 80150
(303) 935-0900

DAWSON INSTITUTE OF PHOTOGRAPHY
460 St. Catherine Street West
Suite 700
Montreal, Quebec
Canada H3B 1A7
(514) 866-6588

FOCUS WORKSHOPS
New School for Social Research
66 West 12th Street
New York, NY 10011
(212) 741-8923

INTERNATIONAL CENTER OF PHOTOGRAPHY
Education Department
1130 Fifth Avenue
New York, NY 10128
(212) 860-1754
See pages 95, 106, and 201.

ART KANE PHOTO WORKSHOP
111 Fifth Avenue
New York, NY 10003
(212) 529-7093
See page 163.

A Workshop Budget

Here's approximately what a week-long workshop at the Maine Photographic Workshops will cost you.

Tuition
 $450 to $650
Room and board
 $350/double room,
 $450/single room
Lab fee
 $65 to $85
Model fee
 $25 to $30, if needed
Supplies
 varies, about $100 to $300

LIGHTWORKS
Film in the Cities
2388 University Avenue
St. Paul, MN 55114
(612) 646-6104
See page 94.

MISSOURI WORKSHOP
School of Journalism
University of Missouri–Columbia
27 Neff Annex
Columbia, MO 65205
(314) 882-4882
See page 137.

NATIONAL AUDUBON NATURE PHOTOGRAPHY WORKSHOPS
613 Riversville Road
Greenwich, CT 06831
(203) 869-2017

NATURE PHOTOGRAPHY WORKSHOPS
2306 Cannonball Road
Greensboro, NC 27408
(919) 282-2329; (517) 676-1890

NEW ENGLAND PHOTO WORKSHOPS
30 Bridge Street
New Milford, CT 06776
(203) 355-8578

NEW YORK UNIVERSITY
Office of Summer Sessions
Tisch School of the Arts
111 Second Avenue
New York, NY 10003
(212) 998-1795; (212) 477-6430
See page 221.

NORTHERN KENTUCKY UNIVERSITY
Summer Photography Workshop
Highland Heights, KY 41076
(606) 572-5423

OWENS VALLEY PHOTOGRAPHY WORKSHOPS
Box 114
Somis, CA 93066
(805) 987-7912; (213) 225-1730;
(408) 659-3130

PALM BEACH PHOTOGRAPHIC WORKSHOPS
2310 East Silver Palm Road
Boca Raton, FL 33432
(800) 553-2622; (407) 391-7557

PHOTOGRAPHIC CENTER WORKSHOPS
Box 1100
Carmel, CA 93921
(408) 625-5181
See pages 98 and 125.

SOUTH FLORIDA PHOTOGRAPHIC WORKSHOPS
Box 3018
Boca Raton, FL 33431
(800) 323-3932

TRAVEL PHOTOGRAPHY WORKSHOP
Box 2847
Santa Fe, NM 87504
(505) 982-4979

THE UNIVERSITY OF COLORADO/BOULDER
Summer Photography Workshops

Department of Fine Arts
Boulder, CO 80309
(303) 492-6504

**UTAH STATE PHOTOJOURNALISM
WORKSHOP**
Utah State University
Department of Communication
Logan, UT 84322
(801) 750-1000

VISUAL STUDIES WORKSHOP
Summer Institute
31 Prince Street
Rochester, NY 14607
(716) 442-8676
 See pages 98, 136, 193, and 198.

WESTERN PHOTO WORKSHOPS
Box 1171
Telluride, CO 81435
(303) 728-4584

**WOODSTOCK PHOTOGRAPHY
WORKSHOPS**
The Center for Photography
 at Woodstock
59 Tinker Street
Woodstock, NY 12498
(914) 679-9957
 See pages 95, 125, and 195.

**YOSEMITE PHOTOGRAPHY
WORKSHOPS**
Ansel Adams Gallery, Box 455
Yosemite National Park, CA 95389
(209) 372-4413

ZONE VI WORKSHOPS
Putney, VT 05346
(802) 257-5161
 See pages 57 and 197.

Viewpoint: Photographic Workshops

CARLA CARPENTER
STUDENT

"What I liked most about the Friends of Photography Workshops was the diversity of the instructors. I took a portrait workshop taught by Yousuf Karsh, Jim Goldberg, Marie Cosindas, Greg Heisler, and Jay Dusard. The week was unbelievably stimulating and exhausting, primarily because they were all so different in their approach. In the morning, we broke into small groups and one instructor led an informal discussion, did a demonstration, or critiqued portfolios. In the afternoon, the same group of students met with another teacher, and in the evenings the faculty showed their own work and talked about it.

"Not only were the teachers diverse, but so were the students. They varied greatly in age and experience. Most had some darkroom training. Some were fine artists, while others were commercial photographers, photojournalists, and serious hobbyists.

"Most students stayed in dormitories. Though the quarters were a bit cramped, the benefits of living on campus far outweighed the inconveniences. All that was really needed was a bed to collapse in, as activities were planned from early morning to late evening. Also, in the dorms you got to know other students and discuss (and distill) what you'd learned during the day.

"Whether or not you have much experience in photography, you can get a lot out of these workshops. The people are very nice and the teaching assistants are first rate. The only drawback I can think of is that you get an incredible amount of information in such a short period of time. At night, it's hard to stop your head from spinning. But that's why I went, so I'd hardly call it a disadvantage."

BUSINESS

Self-Promotion

Successful photographers are often ingenious self-promoters. Sometimes this skill takes subtle forms—gallery and party attendance, strategic friendships, quiet gifts and favors—but there are more straightforward ways to promote yourself that stress talent rather than social skills. Primary among these is a mailing piece, usually a postcard, brochure, or poster.

For best results, you should do a mailing every few months, or as often as you can, featuring one or more strong examples of your work. Quality is important, but so is repetition. Send regular mailings of outstanding, and hopefully unusual images. Your recipients probably get dozens of mailings every week; yours must stand out from the rest or it will be ignored and discarded.

The best way to prepare a mailing piece is to have it done professionally by a designer. If you can't afford this, make individual prints and send them out with a printed reminder of where you can be reached.

Just because a certain promotion seems like a good idea doesn't mean that it is. A poster, for example, may look great, but art directors have only so much room on their walls. What doesn't fit might get tossed. Remember, the goal is to get the mailing seen *and* kept.

A good mailing list is as important as the promotion itself. Devise a system for keeping a list, either on typed labels, index cards, or, ideally, on a computer. Once you've got a system, you have to decide who will be included. Start with existing clients and anyone you know personally who should be informed about what you're up to. Then add important people in your specialty—curators and critics if you're in fine-art photography, art directors and producers if you work commercially. Trade mailing lists with colleagues, look up names and addresses in trade publications, and use the telephone book. You can also buy the names and addresses of prominent people in your field from a mailing-list broker (see page 159).

Creative Directories

Print advertising is a natural extension of self-promotion, but until recently photographers had few places in which to advertise effectively. Publishers now turn out yearly creative directories, sometimes called annuals or sourcebooks. Many directories feature photographers only; others concentrate on illustrators, designers, and other creative types. Some directories include sections for several categories of advertisers.

Creative directories work much like the yellow pages. The publisher sells space to a photographer—usually a single page or a two-page spread—in a slickly designed and produced book. The books are given away to qualified art buyers at advertising agencies, public-relations firms, design studios, magazines, publishing houses, sales promotion agencies, and so forth. Most publishers also sell their directories.

The idea is that art buyers will browse through these directories. Many consult them on a regular basis, as they're an excellent source of creative ideas as well as photographers.

Creative directories also make excellent study guides for students and beginning photographers. The books let you see who and what is out there—the best work, self-chosen by successful working pros.

Repeat ads in the creative directories testify that they work. In fact, many photographers advertise in more than one directory. The cost may seem high at a few thousand dollars per page, but if an ad draws a couple of jobs per year at a day rate of $1,500 or more, it will pay for itself and then some. In addition, the photographer usually receives one or two thousand reprints of the ad to use for direct-mail promotions or to leave with an art director after a visit.

Photographers from all over the country advertise in creative directories, not just those working in New York, Chicago, and Los Angeles. It's a way to get exposure and have a shot at big-budget jobs. It's also a useful tool for art directors on a tight budget. For example, if an art director in Chicago

needs a portrait of someone who lives in New England, using a photographer who works in that region will save on transportation costs. A directory lets the art director view the work of some local shooters and select one.

The allure of creative directories has become so strong that many photographers advertise in them simply for visibility and credibility, not because they expect the revenue generated to justify the expense. The fact that a photographer appears in, say, *The Creative Black Book* (see below) brings with it a certain panache—which, in turn, comforts those art buyers who want the security of a nationally advertised "name brand" photographer.

The key to an ad's success is a good photograph on a well-designed page. But, as with any type of advertising, repetition is important. You can't advertise just once and expect much response. Most photographers commit to run ads for several years in the same directory. Over time their work becomes familiar to buyers who peruse that directory over and over again. Also, directories have a long life as reference books; it's quite common to get new business from an old ad.

Most photographers aim their ads at a specific audience. If they want corporate jobs, they show only corporate work, even if they're equally adept at advertising or editorial assignments. In the limited space an ad provides, it's best to show work that will clearly define you, rather than risk confusing a buyer with several styles.

Opinions differ as to how many images you should show on a page. Photographers who show only one get a clean page and create a bold showcase for that photograph. Using multiple photographs gives a better indication of the breadth of a shooter's work, but makes for a busier presentation and is more expensive since directories charge extra for multiple separations.

A directory's distribution is obviously extremely important. You should evaluate not just how many go out, but who receives them. The more expensive directories claim wider and more effective distribution.

American Showcase.

Adweek Portfolio.

The Creative Black Book.

When choosing a directory for your ad, consider cost, distribution, format, market reach, and who else advertises in it. But also consider the directory's track record. In this volatile and competitive business, a lot of directory publishers have gone belly-up in the past few years, causing photographers to lose money, credibility, and the long-term support they expected when they originally made the commitment to advertise.

ADWEEK PORTFOLIO

This relatively new directory's association with *Adweek,* the popular trade magazine for the advertising industry, gives it automatic credibility. *Adweek Portfolio* is trying hard and becoming more successful, but it still runs a distant third in advertising pages and visibility to the more established *American Showcase* and *Creative Black Book* (see below).

Adweek Portfolio actually publishes seven directories, one each for illustration, design, TV/film/video, creative services, sales promotion, ad agencies, and, of course, photography. Each book, and the package as a whole, gets high marks for design. The 11×17-inch format of these handsome directories shows off visual material well.

Befitting its connection with *Adweek,* the photo directory is oriented toward advertising, though some corporate and editorial work is featured. Page rates are relatively inexpensive compared to the more established directories.

Adweek Portfolio, 49 East 21st Street, New York, NY 10010. (212) 529-5500.

AMERICAN SHOWCASE

The second most popular directory, *American Showcase,* is a slick, 9¼×11¾-inch book with excellent production values. Along with advertising photography, it features corporate and, to a lesser degree, editorial work. It's considered a bit more eclectic and less commercial than the competition.

American Showcase is well established—it first came out in 1978—and counts some of the top U.S. working

pros among its advertisers. Its rates are reasonable and its readership has wide-ranging interests. For these reasons, a growing number of photographers feel that an ad in *Showcase* draws the most response for the money.

American Showcase Inc. publishes several related publications, including a similar directory for illustrators, as well as *Archive,* a magazine featuring print, poster, and TV advertising from around the world. *Corporate Showcase,* another photography directory, appears just before annual-report season (about September 1) and targets corporate buyers more directly than *American Showcase* does by carrying executive portraits, documentary industrial work, and similar items. Some photographers grumble that publishing two directories confuses readers and reduces the effectiveness of an ad in one. Others advertise in both, feeling, along with the publisher, that two books distributed at different times of the year create twice the impact. *American Showcase, 724 Fifth Avenue, New York, NY 10019. (212) 245-0981.*

THE CREATIVE BLACK BOOK

The Creative Black Book is *the* directory to be in. This is partly because it's been around since 1970 and invented the directory business, but also because it reaches the right art buyers. Virtually everybody in the business uses it, and the *Black Book* features the work of some of the best and most successful photographers working today.

The *Black Book* has a heavy advertising bias and shows little corporate and hardly any editorial work. It's the most expensive directory, both to advertise in and to buy. But advertising jobs bring top dollar, so it's presumably worth paying a little more to get this kind of work.

Some photographers claim that the *Black Book* is unresponsive to their needs; others don't like its narrow, thick format (it measures 6¼×10¾ inches and packs nearly 1,000 pages). Even so, the *Black Book* remains the most successful creative directory. As one photographer recently put it, appearing in the *Black Book* is "the

Specialty Printers

Nearly any print shop can produce promotion pieces such as postcards, brochures, posters, and exhibition notices, but some specialize in work for photographers, designers, and illustrators. These full-service shops will set type, lay out the job, and print it to your specifications. You can still pick the type and dictate the look, but you don't need to hire a graphic designer. Such service is not very expensive, assuming you want a standard-sized piece. For example, $500 or so will buy 2,000 full-color postcards from most of these shops, including typesetting, layout, and shipping.

AMALGAMATED TECHNOLOGIES
267 Elm Street
Somerville, MA 02144
(617) 628-4025

ARTIST'S/PHOTOGRAPHER'S PRINTING COOPERATIVE
1745 Wagner Street
Pasadena, CA 91106
(818) 792-7921

DYNACOLOR GRAPHICS
1182 N.W. 159th Drive
Miami, FL 33169
(305) 625-5388

MITCHELL COLOR CARDS
2230 East Mitchell
Petoskey, MI 49770
(800) 841-6793;
(800) 221-1896 in Michigan

PATÉ POSTE
43 Charles Street
Boston, MA 02114
(800) 356-0002; (617) 720-2855

WALKERPRINT
285 West Broadway, Suite 340
New York, NY 10013
(212) 431-1121

ultimate status symbol." *The Creative Black Book, 115 Fifth Avenue, New York, NY 10003. (212) 254-1330.*

Regional Directories

The major creative directories include photographers from all regions of the country, but several regional ones cater to a local clientele. Regional directories generally include ads for related services such as design and illustration, and some are more slickly produced than their national counterparts.

A.R.
212 West Superior, Suite 400
Chicago, IL 60610
(312) 944-5115

ARIZONA PORTFOLIO
815 North First Avenue, Suite 1
Phoenix, AZ 85003
(602) 252-2332

BAY AREA CREATIVE SOURCEBOOK
470 Alabama Street
San Francisco, CA 94110
(415) 431-8080

CHICAGO CREATIVE DIRECTORY
333 North Michigan Avenue, Suite 810
Chicago, IL 60601
(312) 236-7337

CHICAGO TALENT SOURCEBOOK
212 West Superior
Chicago, IL 60610
(312) 944-5115

CREATIVE SOURCE
206 Laird Drive, Suite 200
Toronto, Ontario
Canada M4G 3W5
(416) 424-4820

CREATIVE SOURCEBOOK
2025 Eye Street, Suite 303
Washington, DC 20006
(202) 775-9045

FLORIDA CREATIVE SOURCEBOOK
1133 Louisiana Avenue
Winter Park, FL 32789
(407) 628-1926

NEW JERSEY SOURCE
Box 640
Ramsey, NJ 07446
(201) 825-0240

NEW YORK GOLD
150 Fifth Avenue, Suite 627
New York, NY 10011
(212) 645-8022

SAN DIEGO CREATIVE DIRECTORY
Box 83627
San Diego, CA 92138
(619) 231-1955

TWIN CITIES CREATIVE SOURCEBOOK
401 North Third Street, Suite 400
Minneapolis, MN 55401
(612) 338-9044

THE WORKBOOK
940 North Highland
Los Angeles, CA 90038
(213) 856-0008

WORKSOURCE
15 Mount Auburn Street
Cambridge, MA 02138
(617) 864-1110

A Business Library

Photographers are rarely trained as businesspeople, yet a few basic business skills can mean the difference between running a successful studio and job hunting. Here are some books that can help.

ASMP Professional Business Practices in Photography, edited by Arie Kopelman, American Society of Magazine Photographers, 1986. Available from ASMP, 205 Lexington Avenue, New York, NY 10016. (212) 889-9144.
This is easily the most important guide to running the business and legal side of your career as a photographer, regardless of your specialty. Compiled by the American Society of Magazine Photographers (ASMP) every few years, it provides endless information on business and legal matters.
Unlike some business guides, this one is quite specific and pulls no punches. One of the most widely read

Top Promoter

New York photographer Chris Callis creates simple and effective self-promotion pieces. These cards, each featuring a single Callis image, are sent out on a regular basis to current and prospective clients.

sections suggests day rates and other pricing guidelines for various photographic specialties. ASMP is an advocate for photographers and encourages payment at the highest possible scale. Unfortunately, this can be a little discouraging and even misleading for those photographers unable to command these rates.

The Art and Business of Creative Self-Promotion, by Jerry Herring & Mark Fulton, Watson-Guptill Publications, 1987.
Aimed at graphic designers, writers, illustrators, and photographers, this book contains useful information about such matters as advertising in creative directories and putting together a portfolio. Mostly the book features outstanding printed promotions in full-page color spreads. A typical page shows the promotional piece, accompanied by a short description. Most of the pieces take a conventional form (posters, calendars, and brochures), but some are unusual (3-D viewer, thematic book, and matchbox). All are well chosen and strikingly reproduced.

The Artist's Guide to Getting and Having a Successful Exhibition, by Robert S. Persky, The Photographic Arts Center, 1987. Available from 127 East 59th Street, New York, NY 10022. (212) 838-8640.
This authoritative book suggests ways to get the most exposure out of an exhibition, covering such matters as portfolios, contracts, budgets, announcements, publicity, openings, and reviews.

Gold Book of Photography Prices, by Thomas I. Perrett, Photography Research Institute Carson Endowment, 1989. Available from 21237 South Moneta Avenue, Carson, California 90745. (213) 328-9272.
This book offers specific suggestions for pricing a job, as well as a useful breakdown of miscellaneous billing practices, such as when to bill for a full day rather than half a day and how much to charge for travel, waiting, and research time.

The Photographer's Guide to Marketing and Self-Promotion, by Maria Piscopo, Writer's Digest Books, 1987.

Using a step-by-step approach accompanied by black-and-white and color photographs, author Piscopo concentrates on the overall strategy of marketing yourself, including self-promotion. Each chapter of this guide is succinct and includes information and advice from experts on such subjects as finding clients, cost-effective advertising, public relations, pricing, and photo reps.

Photographer's Market: Where and How to Sell Your Photographs, edited by Connie Wright Eidenier, Writer's Digest Books.

Annually revised, *Photographer's Market* contains a comprehensive listing of more than 2,500 buyers of photography; these markets include magazines, book publishers, advertising agencies, and greeting-card companies. Each item includes specific information on subject needs, how to submit photos, what the client pays, and related matters.

Photography for the Art Market, by Kathryn Marx, Amphoto, 1988.

Successful fine-art photographers are good self-promoters and marketers too, but their specific concerns and methods differ somewhat from those of professional photographers. This nicely illustrated book covers galleries, museums, collectors, books, cards, magazines, calendars, posters, and many other potential markets for fine-art photographers.

Professional Photographer's Business Guide, by Frederick W. Rosen, Amphoto, 1985.

A complete guide to setting up and running a photography business. This book stresses the importance of planning ahead and covers all manner of related issues, including choosing studio space and equipment, hiring help, and creating bookkeeping systems, along with interviews with successful photographers.

Self-Promotion Awards

Photo District News and Nikon hold an annual contest to reward and showcase photographers whose self-promotion efforts have been especially outstanding. Prizes, including Nikon equipment, are awarded in several categories including direct mail (card, mailer, or poster), print placement (creative directory or magazine), and ongoing campaign (new and established talents).

Photo District News, 49 East 21st Street, New York, NY 10010. (212) 677-8418.
 See page 185.

Photo Opportunity

Photo Opportunity, formerly called *Strategies,* used to publish marketing and self-promotion ideas for fine-art photographers. In its expanded form, this newsletter is an excellent general resource guide for any photographer on selling, publishing, and exhibiting photographs.

Photo Opportunity comes out bimonthly with listings of grants, exhibition opportunities, and selected art fairs, as well as articles on selling stock photos, handling taxes and other business matters, and breaking into specialty markets such as posters. It also interviews industry people and working photographers. A subscription is $24 and well worth it.

Photo Opportunity, Box 838, Montclair, NJ 07042. (201) 783-5480.

Professional Photographer's Survival Guide, by Charles E. Rotkin, Amphoto, 1982.

This freelancers' guide neatly balances a photographer's desires with the reality of the marketplace. In a very personal style, Rotkin discusses ways to earn the most from your work. Interviews with top pros provide different points of view and useful advice.

Promoting Yourself as a Photographer, by Frederick W. Rosen, Amphoto, 1987.

This practical book covers self-promotion for both professional and fine-art photographers. It includes a short section on well-done mailing pieces, but mostly concentrates on planning promotional campaigns, including a chapter on "manipulating the media."

Supporting Yourself as an Artist: A Practical Guide, by Deborah A. Hoover, Oxford University Press, 1985.

This inexpensive paperback ($7.95) is a fine guide through the maze of grant and fellowship applications, with good discussions of legal and other business issues, as well as project development. It focuses on fundraising, not on the gallery and museum market.

Other Business Books

The Business of Art, edited by Lee Evan Caplin, Prentice-Hall, 1982.

The Business of Photography, by Robert M. Cavallo and Stuart Kahan, Crown, 1981.

The Photo Marketing Handbook: International Marketing Directory for Photographers, by Jeff Cason and Peter Lawrence, Images Press, 1988. Available from 22 East 17th Street, New York, NY 10003. (212) 675-3707.

The Photographer's Almanac, by Peter Miller and Janet Nelson, Little, Brown, 1983.

Photographer's Business Handbook: How to Start, Finance, and Manage a Profitable Photography Business, edited by John Stockwell and Bert Holtje, McGraw-Hill, 1981.

Selling Photographs: Determining Your Rates and Understanding Your Rights, by Lou Jacobs, Jr., Amphoto, 1988.

Selling Your Photography: The Complete Marketing, Business, and Legal Guide, by Arie Kopelman and Tad Crawford, St. Martin's Press, 1980.

Names for Sale

These mailing-list brokers sell the names and addresses of commercial art buyers, such as art directors, designers, and corporate communications managers. Generally, such lists come printed on labels of various sizes, Rolodex cards, or computer paper.

ANDY AND BERT
43–39 158th Street
Flushing, NY 11358
(718) 358-8033

CREATIVE ACCESS
415 West Superior
Chicago, IL 60610
(800) 422-2377
(312) 440-1140

LABELS TO GO
American Showcase
724 Fifth Avenue
New York, NY 10019
(212) 245-0981

STEVE LANGERMAN LISTS
437 Elmwood Avenue
Maplewood, NJ 07040
(212) 466-3822
(201) 762-2786

Computer Software

Many photographers are notoriously bad businesspeople. They get into the field to make pictures, not deals. But bills must be paid, slides must be filed, client contact must be maintained, and expenses must be tracked—or you're out of business.

That's where the computer comes in. Photographic studios, like so many other small businesses, have switched from manual management systems to computerized ones. Some have had software customized for them, but most use standard accounting or business programs. The following programs are written specifically for professional photographers. Shop carefully; ask for literature, get a demo, and query users of the programs you're considering. The features of each vary widely. One might be excellent for stock photography, another best for a wedding studio.

THE ASSISTANT (I)
Shooting Star Software
Box 2878, Dept. P
Alameda, CA 94501
(415) 769-9767

THE B.O.S.S. (I)
Richard Pedrelli and Associates
845 Spring Valley Drive
Cumming, GA 30130
(404) 889-9827

INVUE (M)
HindSight
Box 11608
Denver, CO 80211
(303) 458-6372

MASTERPIECE (I)
Burrell Business Systems
1311 Merrillville Road
Crown Point, IN 46307
(800) 348-8732
(800) 472-8651 in Indiana

PHOTOBASE PLUS (I)
October Press Software
18 East 17th Street
New York, NY 10003
(212) 929-8750

PROBILL (I)
20/20 Software
17 Center Drive
Old Greenwich, CT 06870
(203) 637-9939

SILENTPARTNER (M)
Kevin Black
32 North Third Street
Wister Alley
Philadelphia, PA 19106
(215) 829-0911

THE STUDIO MANAGER (I)
PhotoSoft
754 Piedmont Avenue
Atlanta, GA 30308
(404) 872-0500

STUDIOPRO (I)
Kingman Data Systems
1519 Minnesota Avenue
Sioux Falls, SD 57105
(605) 335-8334

I—IBM compatible
M—Macintosh compatible

Viewpoint: Self-Promotion

JOHN S. BUTSCH
PRESIDENT
CREATIVE ACCESS, CHICAGO

"Commercial photography has become a very competitive business and a good portfolio is no longer enough. Photographers have to learn how to market their wares. Although marketing can be done in several ways, direct mail is one of the most effective.

"Too many photographers who undertake a promotional mail campaign don't really understand who they're trying to reach and how to speak to them. Often, photographers reproduce a pretty but irrelevant picture in their mailings instead of showing examples of work that solves problems.

"Another pitfall is giving too little thought to presentation. Photographers who just slip their latest tear sheet in an envelope and send it out fail to realize that the recipient has a highly developed graphic sense, good taste, and very little time. To get through to that person, you must have an elegant and interestingly designed package. Promotion involves more than pictures, however. The mailing should include some interesting copy on the envelope as well as inside—something other than

how great the photographer is. There also should be an easy and clever way for the reader to respond to your message, and you should have the right pictures ready for a presentation. All of these issues need to be thought out before you launch a direct-mail campaign.

"The purpose of a promotional mailing is not just to generate an assignment. It should be part of a long-term plan to create a group of regular clients who will support your business in a recession. These clients should also become your advocates among their peers, extending your client base beyond the people you reach through regular marketing methods. Simply buying a list and sending out cards is a waste of money. Direct mail is a very sophisticated business, and photographers should approach it as sophisticated businesspeople.

"Photographers who want to find work in advertising should look at trade magazines such as *Ad Age* or *Adweek*. There they will learn, for example, that the food industry is developing a lot of products for microwave ovens. Creating an interesting picture involving microwave cooking will get you more work than distributing your favorite sunset shot.

"Creative directories are another avenue for self-promotion, but that

market is changing. At last count, there were seventeen such directories, and what began as a convenience to the art director is becoming part of the problem. Photo buyers just don't have the time to go through all of these volumes, so the books are becoming more specialized. Photographers should carefully look at the directories to determine which best serve the specific market they're after. In general, I think the regional directories are a better investment, particularly if you're not trying to compete for national accounts out of New York.

"Other markets will be created by electronic imaging. As digital editing becomes more commonplace, photographers will be able to sell pieces of their images for use in composite shots that will be assembled electronically. This prospect scares most photographers, but the technology exists to do the proper accounting and prevent piracy. Some brave souls who recognize this tremendous opportunity will create and market images for this emerging sector of the business."

Stock Photography

Stock photographs are images licensed for use over and over again by design firms, ad agencies, magazine and book editors—in short, anyone who uses photographs as illustration. Every photographer has a backlog of stock photos, but not all are easy to sell.

Stock images that sell well have universal appeal. High drama, action, or emotion are good qualities, as is an upbeat or introspective feel. The subject matter may be timeless, such as a young couple taking a moonlit stroll, or timely, perhaps a young father bonding with a newborn. Technically, good stock photos are of high quality, with bold use of color or dramatic use of black and white.

How much a given image sells for varies, depending on how it's used. A black-and-white shot published as a half-page image in a textbook might bring $125. A color photograph in a full-page national ad is good for at least $1,500.

Some photographers sell stock on their own, but most rely on an agency to do it for them. Stock agencies handle marketing, editing, research, client contact, and billing. For their considerable efforts, they take a cut of the gross receipts, generally 50 percent.

Laser-disc image storage from The Image Bank (see page 163).

A Stock Best-Seller

Good stock photographs sell over and over again, sometimes to the most unexpected clients. This one by photographer Mark Keller, represented by the Four By Five stock agency, has been used by a Las Vegas hotel, a tire manufacturer, and lots of carpet companies. So far, it has been sold eighty times for a total of $29,953. Every year it grosses an average of $3,744 with an average sale price of $374. Its highest single sale to date was $1,250.

Source: Photography Best Sellers, *by James Ong, Moore & Moore, 1987.*

Portfolios On Disk

Most stock agencies work in a decidedly low-tech manner. Rather than traveling electronically, photographs get shuffled around by mail and courier. In a typical transaction, a designer or some other client calls or visits a stock house and asks to see images on a specific subject (say, a shot of Darryl Strawberry connecting for a home run) or photos that convey a particular feeling (tranquility, excitement, romance). A researcher at the stock house goes to the files and pulls out slides or prints to show the designer, who will hopefully pick one or more, have stats or prints made, and paste up a sample "comp" to show the client for approval. If the client doesn't like the image, it's back to the stock agency for another go-round.

This can be a long, involved, and costly process. It's also limited in many ways. The stock agency may have many more appropriate slides that the designer never gets to see. Also, pictures may be lost or damaged as they cycle among the client, stat shop, and agency.

Computer technology can help. Using a scanner, an agency can store photographs on a computer disk and show its wares on screen. The original image stays safely stored until rights have been sold and it's ready to be sent to a printer.

Like many high-tech ideas, this one has been limited by practical concerns—primarily the fact that storing photographs gobbles memory and standard personal-computer media (floppy and hard disks) don't have enough. Enter CD-ROM technology on laser discs.

Laser discs store information the same way their close cousins compact discs (CDs) store music. And they store lots of it—enough to hold about 50,000 digitized photographs. This means that a stock agency can put a library of images on a laser disc and sell it or give it to clients, who can then retrieve the images they choose. A client can ask to see all images related to, for example, horseracing or exotic flowers.

Digitized images also dovetail neatly into the current boom in desktop-publishing systems. A designer working on a computer could access an image from a laser disc and plug it right into the onscreen layout, then produce a finished comp for client approval.

This sounds simple enough, but it's expensive to digitize a library of photographs, and no one knows if enough photo buyers would use the system to make it worthwhile. Clients must have the right hardware, and because the technology is changing rapidly and no industry standard has been established, they're understandably reluctant to invest in a system that may soon be outdated. Another problem is the lack of software compatibility, as well as limited image resolution. For the stock agency, there's the question of how to control usage when a client can access images from a disc at will.

Still, CD-ROM has enormous potential. If nothing else, it provides a quick and convenient way to store and retrieve photographs for client viewing. Add the flexibility of desktop publishing with the probability that the kinks will eventually be worked out, and you have a powerful tool for graphic designers, publishers, photographers, and stock agencies.

Several top players in the stock business are betting heavily on this technology. Large agencies such as The Image Bank and Comstock already offer part of their libraries on laser disc, and you can count on other agencies to follow suit, if only to stay competitive.

Going Stock

Stock photography is a growth business for both agencies and photographers, and many photographers earn a good income from it. Some even shoot exclusively for stock, and most savvy pros at least consider the resale potential of an image whenever they shoot an assignment.

Signing on with a stock agency is the first step. Agencies are picky about the photographers they represent; it's time consuming and expensive to file photographs, market them, and fulfill orders, so they need saleable work to make it all worthwhile. Most agencies ask for an initial submission of at least 200 strong photographs. Some demand exclusive contracts, but others don't mind if their photographers have work on file with other agencies.

Stock agencies vary greatly, from international companies billing tens of millions of dollars annually to one-person operations run out of home offices. General agencies sell many kinds of images to a variety of markets; specialists concentrate on areas such as sports or nature photography. Many regional agencies have good files of images with local interest—well-known buildings, winter landscapes, and so on.

Most agencies carry only color photographs (almost always 35mm slides), but a few also have significant files of black-and-white prints.

The prevalent trend in stock is toward more commercialization—corporate and advertising sales—because fees are higher and the growth potential is greater. However, some agencies still concentrate on more traditional editorial markets such as textbooks, magazines, greeting cards, and calendars.

When you're shooting for stock, try to get your subjects to sign model releases if they can be identified in the shot. This is particularly necessary for commercial sales. A photo may or may not need releases for editorial use, depending on how the image appears, but not having a release limits the potential for resale.

Many of the books described on page 166, particularly *ASMP Stock*

Photography Handbook and Stock Photo Deskbook, are excellent resources for identifying stock agencies. They include a thorough listing of agencies, including a description of that agency's specialties.

A Mega Agency

Established in 1974, The Image Bank quickly became the model for future high-powered commercial stock agencies. It's generally credited as the first agency to successfully peddle stock to corporate and advertising markets. Before The Image Bank, agencies were content with traditional editorial sales to magazines, textbooks, and the occasional greeting-card company.

The Image Bank is an aggressive, innovative agency with more than 1,000 employees worldwide, 200 of them in sales. It bills over $63 million annually and, as the first agency to license itself, has more than forty offices worldwide selling its images.

The Image Bank is also a leader in combining photography and CD-ROM technology (see page 162), distributing one of the industry's first video-disc systems. The agency is also involved in a variety of related businesses, including workshops (Art Kane Workshops) and book publishing (New Image Press), ever agitating to create new markets for the photographs in its voluminous files.

The agency has always featured high quality work by top photographers; Pete Turner and Jay Maisel were two of the first to sign on. With a file of well over three million images (all color slides) from more than 350 photographers in the New York office alone, The Image Bank is one of the world's largest depositories of fine photography.

The Image Bank, 111 Fifth Avenue, New York, NY 10003. (212) 529-6700.
See pages 165 and 178.

Personal Service

Sheri Blaney started The Picture Cube in 1977, working out of a spare room in her house. Today, despite its location in the heart of Boston's financial district, the agency still has a warm

Stock's Founding Father

The first stock agency was founded by H. Armstrong Roberts (above) in Philadelphia. It's still going strong, in part by handling wholesome images such as these.

Picture Agencies

Stock and picture agencies are close relatives, but they have somewhat different functions. Stock agencies primarily collect and store images; picture agencies accept assignments, almost always for news stories. This distinction is important, but not always clear-cut. Some stock agencies assign photographers to shoot stock to order; in fact, this has become a trend in the past few years. Stock agencies do not, however, agent news stories. Picture agencies do, but they also serve as stock houses, selling usage rights to photographs taken on assignment by their photographers. There are far fewer picture agencies than stock houses. Here are some of the best-known picture agencies.

BLACK STAR
116 East 27th Street, 5th Floor
New York, NY 10016
(212) 679-3288

CONTACT PRESS IMAGES
116 East 27th Street, 8th Floor
New York, NY 10016
(212) 481-6910

GAMMA-LIAISON
150 East 58th Street
New York, NY 10022
(212) 888-7272

IMAGE PRESS SERVICE
22 East 17th Street
New York, NY 10003
(212) 675-3707

LIFE PICTURE SERVICE
Time-Life Building, Room 28-58
Rockefeller Center
New York, NY 10020
(212) 522-4800

MAGNUM
72 Spring Street
New York, NY 10012
(212) 966-9200

OUTLINE PRESS SYNDICATE
594 Broadway
New York, NY 10012
(212) 226-8790

PICTURE GROUP
830 Eddy Street
Providence, RI 02905
(401) 461-9333

SYGMA PHOTO NEWS
225 West 57th Street, 7th Floor
New York, NY 10019
(212) 765-1820

TIME PICTURE SYNDICATION
Time-Life Building
Rockefeller Center
New York, NY 10020
(212) 522-3866

WHEELER PICTURES
145 West 28th Street
New York, NY 10001
(212) 564-5430

WOODFIN CAMP & ASSOCIATES
116 East 27th Street
New York, NY 10016
(212) 481-6900

cies servicing both local and national accounts.

The Picture Cube's more than 200 photographers are an eclectic lot. They include some fine-art photographers, many left over from the agency's early days, and some of New England's best and most commercial shooters. The files cover a wide selection of photographs, including travel, technology, sports, and human interest. Most images are in color (about 150,000 slides), but The Picture Cube also has a strong selection of black-and-white work (about 50,000 images). The agency's total annual billings are under $500,000.

The Picture Cube, 89 Broad Street, Boston, MA 02110. (617) 367-1532.
See page 165.

Other Stock Agencies

Here are a few of the most important and interesting stock agencies, taken from the hundreds of such agencies operating throughout the United States. They appear by category, although this is a bit deceptive because there is considerable crossover. For example, some of the specialty agencies listed below maintain excellent general collections as well.

GENERAL

AFTER IMAGE
6100 Wilshire Boulevard, Suite 240
Los Angeles, CA 90048
(213) 480-1105

APERTUREPHOTOBANK/
ALASKAPHOTO
1530 Westlake Avenue North
Seattle, WA 98109
(206) 282-8116

CLICK
233 East Ontario Street
Chicago, IL 60611
(312) 787-7880

COMSTOCK
30 Irving Place
New York, NY 10003
(800) 225-2727; (212) 353-8600

and friendly feel. All the research is done by a staff of three, including Blaney, who covers client contact and all of the managerial duties yet still finds time to do most of the picture editing. The agency offers excellent service and good photographs, not a hard sell.

Given Blaney's background as a textbook art editor and graphic designer, it's no surprise that her primary clients are publishers and other editorial types. Even so, the agency is making serious inroads into the hot market for corporate and advertising sales. It doesn't hurt that the Boston area is a hotbed of the computer industry and supports plenty of successful ad agen-

FOUR BY FIVE
11 West 19th Street
New York, NY 10011
(212) 633-0300

FPG INTERNATIONAL
251 Park Avenue South
New York, NY 10010
(212) 777-4210

GLOBE PHOTOS
275 Seventh Avenue
New York, NY 10001
(212) 689-1340

THE IMAGE BANK
111 Fifth Avenue
New York, NY 10003
(212) 529-6700
 See page 163.

PHOTO RESEARCHERS
60 East 56th Street
New York, NY 10022
(800) 833-9033; (212) 758-3420

THE PICTURE CUBE
89 Broad Street
Boston, MA 02110
(617) 367-1532
 See page 163.

H. ARMSTRONG ROBERTS
4203 Locust Street
Philadelphia, PA 19104
(215) 386-6300

TOM STACK & ASSOCIATES
3645 Jeannine Drive
Colorado Springs, CO 80917
(719) 570-1000

STILLS
432 East Paces Ferry Road
Atlanta, GA 30305
(404) 233-0022

STOCK BOSTON
36 Gloucester Street
Boston, MA 02115
(617) 266-2300

THE STOCK MARKET
1181 Broadway
New York, NY 10001
(212) 684-7878

The Picture Cube.

Outline Press.

Picture Group.

Books on Stock

ASMP Stock Photography Handbook, American Society of Magazine Photographers, 1984. Available from ASMP, 205 Lexington Avenue, New York, NY 10016. (212) 889-9144.

This is the definitive guide to stock photography, a comprehensive reference for both photographers and buyers. Starting with an overview of the business, the *ASMP Stock Photography Handbook* carries you through the stock process, from suggestions for suitable subjects to using computers to track images and copyright issues. The book has usable forms, releases, and contracts, and discusses the pros and cons of selling stock yourself versus using an agency. It also discusses arcane matters such as preservation and handling a photographer's estate.

Probably the most useful section deals with pricing. Sales, after all, are what stock is all about. The book's U.S. price tables were established through surveys of ASMP members and agencies, providing guidelines for maximum and minimum rates in a variety of categories: magazines, newspapers, catalogs, television commercials, packaging, billboards, annual reports, calendars, books, and many others. (The prices come from a 1983 survey, so today's rates should be somewhat higher.)

A sixty-page listing offers useful information on more than 100 of the largest domestic and overseas agencies. Each entry covers such matters as marketing strategies, commissions, submission guidelines, total file images, owners' names, annual gross billings (when available), and general comments about an agency's strengths and style.

At $24, plus $2.50 for shipping and handling, this book is a must for any stock photographer. Its only major failing is that it's not updated more often.

Stock Photo Deskbook, Fred W. McDarrah, consulting editor, third edition, Photographic Arts Center, 1989.

Stock Photo Deskbook may be the most complete compilation of picture sources. It lives up to its subtitle, "Your Instant Key to Over 150 Million Images," with more than 4,000 entries—a massive amount of data in a relatively compact package. (It was formerly called *Stock Photo and Assignment Source.*)

Aimed primarily at photo buyers, *Stock Photo Deskbook* covers stock houses, news agencies, individual photographers, historical archives, government agencies, television and cable networks, press services, and many other sources. The listings include free or very inexpensive sources, and many located overseas.

Self-marketing photographers will find much valuable information; the listing of stock houses and their specialties is very complete. There are also sections on photo researchers and associations. If you're a working pro, you can request to be listed in the section on individual photographers in future editions for no charge.

Photography Best Sellers: One Hundred Top Moneymaking Stock Photos, by James Ong, Moore & Moore, 1987.

After reading *Photography Best Sellers,* you'll probably ask yourself, "Why didn't I take that picture?" Author Ong is a founder of the Four by Five stock agency in New York City, and this handsomely produced volume makes a nice promotion for the agency and fascinating reading.

The text consists of extended captions, providing the following information for each of the displayed photographs: total sales, times sold, average annual sales, average sale price, and highest single sale. Your

mouth will water to discover that a well executed but not overly unusual skyline of Manhattan has reaped $24,427 to date, been sold thirty-six times with average annual sales of $6,107, has an average sale price of $679, and made $2,750 in its highest single sale. OK, so this photo was selected as the central promotional image for the movie *Splash.* Another shot of a Long Island sunset brings in $2,955 per year.

The text also describes what characteristics make each photograph so saleable. A section in the back of the book that is too brief shows how several of the photographs have been used for book covers, posters, ads, and brochures.

Other Stock Books

The Foreign Syndication Handbook: A Guide to Selling Stock Photos All Over the World, by V.M. Comiskey, Haberman Press, 1986. Available from Bank Station Plaza, Box 71, Merrick, NY 11566. (718) 591-0916.

Green Book: The Directory of Natural History and General Stock Photographers, AG Editions, 1990. Available from 142 Bank Street, New York, NY 10014. (212) 929-0959.

Shooting for Stock, by George Schaub, Amphoto, 1987.

Stock Photography: How to Shoot It, How to Sell It, by Ellis Herwig, Amphoto, 1981.

Stock Workbook, Scott and Daughters Publishing, 1988. Available from 940 Highland Avenue, Los Angeles, CA 90038. (800) 547-2688; (213) 856-0008.

You Can Sell Your Photos, by Henry Scanlon, Harper & Row, 1980.

STOCK SHOP
232 Madison Avenue
New York, NY 10016
(212) 679-8480

TAURUS PHOTOS
118 East 28th Street
New York, NY 10016
(212) 683-4025

UNIPHOTO PICTURE AGENCY
3205 Grace Street N.W.
Washington, DC 20007
(800) 345-0546; (202) 338-5578

WEST LIGHT
2223 South Carmelina Avenue
Los Angeles, CA 90064
(213) 477-0421

HISTORICAL

BETTMANN ARCHIVE
136 East 57th Street
New York, NY 10022
(212) 758-0362

CULVER PICTURES
150 West 22nd Street
New York, NY 10011
(212) 645-1672

FPG HISTORICAL COLLECTION
251 Park Avenue South
New York, NY 10010
(212) 777-4210

HISTORICAL PICTURES SERVICE
921 West Van Buren
Chicago, IL 60607
(312) 346-0599

SPECIALTY

APERTURE/ANIMALS FOR ADVERTISING
1530 Westlake Avenue North
Seattle, WA 98109
(206) 282-8116
—animals

PETER ARNOLD INC.
1181 Broadway
New York, NY 10001
(212) 481-1190
—science, natural history, technology

Peter Arnold Inc.

Comstock.

Custom Medical Stock Photo.

Some Typical Stock Fees

Prices for stock photographs vary, but the following charts represent fairly typical rates.

Annual Reports
Under 10,000 copies.

Maximum Page Size	Black and White	Color
¼ page	$200	$250
½ page	$225	$275
¾ page	$250	$300
full page	$300	$350
front cover	$400	$550
back cover	$350	$450

Trade Slide Show/Video Production
$130 to $150 each (discounts for quantity use).

Newspaper Advertising

Circulation	¼ page	½ page	¾ page	full page
50,000–200,000	$200	$250	$300	$400
200,000–450,000	$300	$350	$400	$500
450,000 plus	$400	$500	$600	$700

Advertising Brochures
Under 20,000 copies.

Maximum Page Size	Black and White	Color
¼ page	$150	$225
½ page	$175	$250
¾ page	$200	$275
full page	$250	$350
front cover	$350	$450

Textbooks
One-time, one-edition English-language rights for U.S. distribution. For world distribution rights, add 50 to 100 percent.

Maximum Page Size	Black and White	Color
¼ page	$100	$140
½ page	$125	$175
¾ page	$150	$200
full page	$175	$225
front cover	$400	$550
back cover	$325	$400
wraparound cover	$500	$650

Source: The Picture Cube

ART RESOURCE
65 Bleecker Street
New York, NY 10012
(212) 505-8700
—fine art

CUSTOM MEDICAL STOCK PHOTO
3819 North Southport Avenue
Chicago, IL 60613
(312) 248-3200
—medical, scientific

FOCUS ON SPORTS
222 East 46th Street
New York, NY 10017
(212) 661-6860
—sports

MEDICHROME
232 Madison Avenue
New York, NY 10016
(212) 679-8480
—medical

NFL PHOTOS
6701 Center Drive West
Los Angeles, CA 90045
(213) 215-1606
—football

SPORTS ILLUSTRATED PICTURE SALES
Time-Life Building
Rockefeller Center
New York, NY 10020
(212) 522-4781
—sports

Selling Yourself

Many photographers choose to sell their stock without using an agency. This gives them total control over their images, and eliminates the agency commission. It also means a lot of hard work, and tough competition from the agencies. Fortunately, some services are available to make the job a little easier.

PHOTONET

Photonet, an on-line computer network, matches up photography buyers and sellers. Buyers place their assignment requests on the network, where subscribing photographers (or agencies) can read the requests and try to

fill them. Here's a typical entry from Harcourt Brace, a leading textbook publisher:

We need 35mm color horizontal slides of the following subjects:
1. Guppy swimming
2. Goose
3. Gazelle running
4. Gorilla
5. Child sick in bed, at home
6. Infant in crib or on blanket on the floor
7. A "friendly looking" bug (such as a ladybug) on a flower or leaf

Photonet subscribers can also list their available stock or their travel itineraries (for possible assignment work) on the network. There is a one-time non-refundable fee of $500, and the monthly fee for subscribers is $24 to $48 depending on how often you access; ASMP members get a discount. *Photonet, 1001 South Bayshore Drive, Miami, FL 33131. (800) 368-6638.*

PHOTOSOURCE INTERNATIONAL
PhotoSource International publishes director Rohn Engh's book and video series *Sell & Re-Sell Your Photos,* as well as several newsletters. One of the newsletters is *Photoletter,* an eight-page monthly with up-to-date information about such matters as pricing, model releases, and agency news. The other publications, billed as "market services," publish specific stock requests from major publishers, agencies, and other buyers. *Photomarket,* a three-page update of "fresh photo needs," is published twice per month; *Photobulletin,* limited to 350 subscribers, is a weekly. *Photodaily,* as you might imagine, comes every day via computer to an exclusive group of no more than 150 subscribers.

Photoletter, the cheapest offering, is $75 annually; *Photodaily,* the most expensive, asks a $175 membership fee and $800 for a year's subscription. *PhotoSource International, Pine Lake Farm, Osceola, WI 54020. (715) 248-3800.*

© MIKE MAZZASCHI

Stock Boston.

© LOU JONES

The Image Bank.

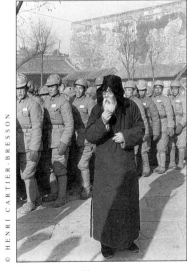
© HENRI CARTIER-BRESSON

Magnum.

Viewpoint: Stock Photography

HENRY SCANLON
PRESIDENT
COMSTOCK, NEW YORK CITY

"One of the first stock photographers was Mathew Brady, who photographed the Civil War expressly to sell the pictures and hired others to do the same. He went broke doing it, because he failed to realize that people didn't want photographs of a brutal war they were trying to forget. Brady's fiasco, brought on by poor market research, cast a pall over the idea of stock photography for nearly 100 years.

"Until about twenty years ago, stock photography largely consisted of warehouses of images assembled and catalogued by librarians. The business was driven by the subject matter; you gathered as much diverse material as you could, knowing that some saleable pictures would emerge. In a time of low overhead, such warehousing was affordable. But image quality was low, because most photos came from estates and the outtakes of editorial photographers. The only real market for these pictures were book publishers, small magazines, and calendar companies.

"Advertising agencies hired talented photographers and gave them large budgets to create the quality, subject-specific pictures the industry needed. Stock photographs couldn't compete, and were generally held in low esteem by art directors and graphic designers.

"In the 1970s, stock's modern era began when the demand for commercial photography increased and agency budgets started to shrink. Part of the cause was inflation, but competition also increased as many small design firms sprang up, not just in New York, but in large and small cities all across the country.

"In response, a new kind of stock house emerged. The Image Bank signed up some of the world's most successful commercial shooters and offered its stock to the industry at large. That step alone raised the image of this business, and everybody has profited by it.

"At Comstock, we decided to set aside the kind of money the ad industry normally uses to create situations, and shoot material for ourselves. My partner, Tom Grill, was one of the most successful commercial photographers at the time, and he certainly knew what the market was buying. We'd identify a concept, go on location, hire the stylists and models, and emerge with all the pictures free and clear. We could then offer designers in New York City or Greenville, South Carolina, a $350 image that would have cost them over $10,000 to produce. In most cases, neither they nor their clients could afford to spend thousands with no guarantee of the quality we could provide, so the market for commercial photography took off.

"Some technical innovations helped the business, too. Kodak's 6120 duping stock (it's been further improved and is now called 6121) made it possible to create top-quality duplicates relatively inexpensively, a fact that improved our distribution.

"The industry also developed professional marketing techniques, improving the way we promoted our product and used brochures and catalogues. Today, the stock photography business is very sophisticated and costly to maintain. Comstock has eighty people involved in direct sales, market research, location production, studio and darkroom work, cataloguing, billing, collection, and management. We also keep a bunch of lawyers busy protecting our rights and, by example, the copyrights of all photographers.

"If I were thinking about entering the stock-agency business now, I wouldn't do it. It's extremely difficult to compete with the big agencies, and it's becoming harder all the time. This business will consolidate into a few big agencies, and they already have tremendous advantages of scale and experience.

"This is not to say that young photographers won't be able to place their work at a stock agency—there's always room for real innovation—but they should know that the level of work in the files is very high. Some very talented pros shoot exclusively for stock, and many more who would like to do so.

"My advice to a young photographer would be to study what stock agencies do, look at what is selling, and then do it better. Come up with a better approach, technique, or perspective. Don't try to duplicate what you see; being as good isn't enough. In my fifteen years in this business I've met many technicians, but only a few photographers.

"Still, some tremendous opportunities loom on the horizon. As technology evolves, more and more people will be calling for good photography and discovering new uses for it. I built a business on only 15,000 customers, but the consumer market has yet to be tapped. Desktop publishing and other digital systems will make it possible to use quality images in, say, home decoration, gifts, or personalized cards. Photography is no longer a slide or a print; it's visual information and a communication device. The emerging avenues for the distribution and use of these devices will spark an explosion in the stock photography business."

Legal Issues

Photographers are in business, and like any other businesspeople they face certain legal issues. Some questions are common to all businesses, such as whether or not to incorporate; other issues are specific to photography. The most common ones relate to copyrights and model releases.

The laws and the way they're interpreted are constantly changing. Lawyers for the American Society of Magazine Photographers and the Advertising Photographers of America do an excellent job of keeping their members informed about changes and trends. *Photo District News* (see page 185) is another good source of legal news. Still, from time to time you may need to hire your own lawyer. Make sure you get one with specific experience in areas relating to photography. Copyright law, in particular, is a specialty that shouldn't be left to just any lawyer. If you don't have a specialist in mind, call your local ASMP or APA branch for a recommendation.

© **ARNOLD NEWMAN**
THIS PHOTOGRAPH CANNOT BE COPIED TELEVISED OR REPRODUCED IN ANY FORM WITHOUT THE EXPRESSED AND WRITTEN PERMISSION OF THE PHOTOGRAPHER, IT CAN BE USED FOR EXHIBIT PURPOSES ONLY.
39 WEST 67th ST., N.Y.C. 10023

Arnold Newman has used this copyright stamp since the late 1940s. It not only establishes his copyright, but it spells out the terms under which the print can be used.

Copyrights

The most discussed, and most misunderstood, legal issue in photography is, who owns the picture—the photographer or the client? Not too long ago, if a photographer was paid to do a job, the client retained all rights to the photos that were made, unless a written provision gave them back to the photographer. But the copyright law of 1978 changed that. In much abbreviated form, this law says that, regardless of who pays to make a photograph, the creator—that is, the photographer—retains the copyright for his or her lifetime, plus fifty years (or sometimes longer). That copyright may be transferred to the client, or to anyone else, only in written form. Without such a transfer, the photographer owns all photos he or she makes, except when the photographer is an employee creating the photos within the scope of his or her employment— then the employer is considered the "author".

The laws are more complicated than this—and there are exceptions. The 1978 law allows a photograph to be used for certain noncommercial purposes without the permission of the copyright holder. For example, under the "fair use" rule, a critic, teacher, or reporter may use a photo to examine, discuss, or explain. Nonprofit educational institutions are more likely to qualify for "fair use" than commercial entities, but deciding whether you can rely on fair use is usually difficult. Also, libraries can make a limited number of copies of a photograph and make them available for research or study purposes.

Why own the copyright? For fine-art photographers, this question hardly needs asking. It's rare for anyone to challenge the copyright of fine-art photographers; their ownership rights are

Legal Self-Help

Legal Guide for the Visual Artist, by Tad Crawford, F&W Publications, 1987. Available from 1507 Dana Avenue, Cincinnati, OH 45207. (513) 531-2222.

Written by a copyright attorney, this book is aimed at photographers as well as painters, designers, illustrators, and other visual artists. It includes information on copyrights, privacy and model releases, sales of original and reproduction rights, contracts, taxation, and estate planning. The sample forms (releases, estimates, invoices, etc.) are particularly useful.

Other Legal Books

ASMP Guide to Professional Business Practices in Photography, edited by Arie Kopelman, 1986. Available from ASMP, 205 Lexington Avenue, New York, NY 10016. (212) 889-9144.
 See pages 100, 157, 166, 171, and 194.

ASMP Stock Photography Handbook, American Society of Magazine Photographers, 1984. Available from ASMP, 205 Lexington Avenue, New York, NY 10016. (212) 889-9144.
 See pages 100, 157, 166, 171, and 194.

Copyright: What Photographers and Photography Buyers Need to Know About Licensing Reproduction Rights to an Image, by Helen Marcus, ASMP White Paper. Available only to members of the American Society of Magazine Photographers, 205 Lexington Avenue, New York, NY 10016. (212) 889-9144.
 See pages 100, 157, 166, 171, and 194.

Copyright Basics, Library of Congress, Circular R1, Copyright Office, Library of Congress, Washington, DC 20059.

The Copyright Book, by William S. Strong, second edition, MIT Press, 1986.

Photography: What is the Law?, by Robert M. Cavallo and Stuart Kahan, Crown, 1980.

VLA Guide to Copyright for Visual Artists, by Timothy Jensen, Volunteer Lawyers for the Arts, 1285 Avenue of the Americas, New York, NY 10019. (212) 977-9271.

commonly understood, especially since artists usually pay for the creation of their own work. A commercial photographer is more likely to fight this battle, because a client almost always pays—and people can get pretty testy when money is involved.

Some commercial photographers see this as a matter of principle. They created the work, so they are entitled to own it. However, construction workers don't get part ownership of a skyscraper just because they helped build it. The argument that photography, as a creative act, deserves extra protection under the law may hold for Ansel Adams, but what about the guy who shoots for tractor-trailer catalogs?

The driving force behind this issue is economic. A photographer's library of images is potentially worth a lot of money in resales, through stock agencies or even to the original client, who may decide to use a photo in a brochure five years after it was taken. Many professional photographers gross tens and even hundreds of thousands of dollars annually from residual sales. To complete such sales, the photographer must own the copyright.

Although the law is mostly on the photographer's side, a client may still insist on ownership. Sometimes this is a matter of ignorance; other times, it's a matter of convenience. It's a pain for clients to go back to the photographer and renegotiate every time they want to use the photograph.

To prevent this, some clients ask a photographer to sign a work-for-hire agreement, making the employer the "author" under copyright law. Photographers should fight this at all costs. Suggest instead a limited buy-out agreement, where for a larger fee clients get the rights they need but not the actual copyright. This should satisfy both the client's need to use a photo repeatedly and the photographer's need to retain the copyright (and the commercial potential it guarantees).

This may sound easy enough, but it can get very sticky when you sit down to negotiate. Sophisticated photo buyers such as advertising agencies generally understand the law and are more likely to work with a photographer to come to a satisfactory agreement. However, many clients are not sophisticated—or they're plain unreasonable—and couldn't care less about a photographer's rights. Even if they will never need a photo in the future, they may demand the rights to it just in case, or simply because they believe that if they paid for it, they own it.

When faced with such a demand, many pros refuse to sign away their rights and risk losing the job. Photographers who need the work will find

Help with Copyright Notices

These companies make products designed to mark prints and slides with your copyright.

JACKSON MARKING PRODUCTS
Jackson has a particularly complete line of rubber stamps and marking devices, including fast-drying inks for RC papers and plastic slide mounts. The company also sells stamps especially for photographers, some for decoration and others for practical uses such as defining rights and slide filing. *Brownsville Road, Mount Vernon, IL 62864. (800) 851-4945; (618) 242-1334.*

PHOTOMARK
Photomark makes two copyright-marking products for slides and prints. Its Slide-Marker uses ink to neatly identify 35mm slide mounts (plastic or cardboard) with your copyright notice and any other information you specify. The Travis Stamp embosses all sizes of film and paper. *1344 Martine Avenue, Plainfield, NJ 07060. (201) 756-9200.*

this a tough call, and, as in other businesses, will sometimes agree to terms they don't like.

The law is complex and subject to change. The above information, while substantially accurate, does not explain all the contingencies. The books listed on page 172 should help, but if you have a critical question about copyright matters, consult a lawyer.

Registering a Copyright
The law says that you own what you shoot, but how do you guarantee your rights? You have several weapons. First, use a stamp and/or sticker to identify every print and slide you send out to clients. The legend should read:

Copyright © by [photographer's name]
19—. All rights reserved.

The date should reflect when the photograph was taken.

Your copyright is established by the act of taking the photograph. But if your copyright isn't registered before the date of infringement (or within a three-month grace period after publication), you can only collect damages based on illegal profit made or any other loss you suffer, and the

infringer's profits that can be tied to the infringement. If your copyright is registered in time, you can claim statutory damages (an alternative way of calculating harm, ranging from $500 to $100,000 per infringed work), and the judge may order the defendant to pay the cost of your attorney.

Registering a copyright costs only $10, but registering images individually takes a lot of time and quickly adds up. Some photographers get around

this by registering a copyright only for their best known (and best selling) photographs. Others make a group photograph of several images. You can register a collection of photographs in unpublished form if they are presented in an organized manner, such as in a book or portfolio.

To register a copyright, send in a completed application form (Form VA), $10 for each registration, and one copy of each photograph or collection being registered. The Copyright Office will accept copy slides, prints, or high-quality photocopies. For work that's been published, send a copy of the printed page or pages.

Order the required forms by calling (202) 287-9100 and asking for Kit 107. You can also get forms from the Copyright Office at the address listed below. Also ask for the free publication *Copyright Basics* (Circular R1).
Register of Copyrights, Library of Congress, Washington, DC 20559. (202) 479-0700.

Model Releases
Photographers often talk about their rights being abused, but what about the poor subject? Without prior permission, a photograph of a wary or even unwilling person can show up in a magazine or newspaper article, and

Limited Model Release

For valuable consideration, the receipt of which is hereby acknowledged, I hereby irrevocably grant permission to [*photographer's name*], his legal representatives and assignees to use my image for [*book, article, or other purpose of photo session*]. This permission extends to all editions published by the publisher and to all editions licensed by the publisher and to any use the publisher may grant in connection with any rights authorized and granted to it by [*photographer's name*], and to any promotional materials or publicity pertaining to the aforementioned project.

I hereby release, discharge, and acquit [*photographer's name*] from any and all claims, demands, or causes of action that I may hereafter have by reason of anything contained in the photographs.

_____ photographic subject

_____ address

Viewpoint: Professionalism

© MICHAEL O'NEILL

JAY MAISEL
PHOTOGRAPHER
NEW YORK CITY

"The biggest issue facing photographers today is the preservation of their rights to their pictures. It's a battle I thought we had won, but now I find myself back in the position I was in thirty-five years ago. The copyright law of 1978 made it quite clear that photographers were the exclusive owners of their pictures unless they specifically signed them away in a work-for-hire agreement.

"Today, so many photographers routinely sign away these rights that it's becoming standard procedure among the big advertising agencies: 'If you don't work for hire, you don't get work.' As more photographers succumb to this pressure, the gains made by the law are all but wiped away.

"Many commercial photographers fail to recognize that although they may be artists or craftsmen, they are businesspeople, too. They may feel there's something vulgar about having to think about money, so they let others dictate to them. They walk into a client's office and let the conversation open with 'We have a limited budget for this job...' Already, the photographer is playing catch-up ball because of an inability to negotiate.

"While your whole reason for being a photographer is to make pictures, you do that *after* you get the job. Clients are in the business of getting the best possible value for their money; photographers' business should be to get the best possible value for their talent. Once that's established to the satisfaction of both, then you can go off and have fun making photographs.

"The danger is that, in a buyer's market, clients know that if they can't get the first photographer they call to work for hire, the second one they call will fall into line. But if enough photographers resist, and buyers reach the tenth name on the list and still have no takers, they will stop and employ the best photographer for the job, not the cheapest. Then everyone benefits—photographer, client, and consumer, by the fact that the level of the work remains high.

"If photographers ignore this issue, then they're essentially saying that their work is indistinguishable from the work of others. If you believe that you have something to offer, something of value, then it should be worth fighting for. But selling off all rights, for all time, for all media, devalues that work and, in time, the work of all photographers. The irony is that the cost of photography is minuscule compared to the total cost of an ad and its placement—and the revenues it generates for the agency and advertiser.

"Buyers can demand rights because of the very deep well of talent they can choose from in nearly all parts of the country. This kind of competition may discourage some photographers, but it forces them to work at improving their skills so they can distinguish themselves from the crowd. If you allow people to think that you're interchangeable with all the others, you will have little chance at negotiating. If you have something different and better to offer, however, you will be able to get fair value for your photographs.

"If enough photographers not only improve the level of their work but have the courage to stick to some sound business practices, the market will be healthier and the quality of photography will improve all around."

that person has no way to prevent it. From the photographer's perspective, it's safest to seek protection by getting a model release whenever possible. When you're shooting on assignment, paid models expect to sign releases. When you're shooting for yourself, you have to talk the subject into it.

You probably need a model release if a photograph will be used for advertising or promoting a product, or if it might be construed to defame, libel, or misrepresent the subject in any way. You especially need a release if the image will be altered significantly, pre-

senting the subject out of the original setting or context of the shoot. If the photograph is neither promotional nor libelous, you don't need a release if the subject is a public figure, if the photograph is taken in a public place, or if it is used editorially in a newspaper, magazine, book, or similar publication. You can't always control where a photograph will wind up—especially if you sell it for stock—so a model release is good insurance.

The law is more complex than this, of course. For example, even though public places are generally considered fair game

for photographers, some courts have held that places that charge admission may require permission to shoot. The American Society of Magazine Photographers recommends these guidelines in its *Stock Photography Handbook:*

1. Get a release whenever possible.

2. If you have no release, obscure the face or figure if the usage includes paid ads, promotional matter, or an even remotely embarrassing context.

3. Take out liability insurance to cover possible legal action against you.

4. Never tell a client that a release is available when it is not.

PUBLISHING

Book Publishers

Many companies publish the occasional photography book, but only a few publish such books consistently and well. Photography books are expensive to produce and few have a broad market; publishers that don't know what they're doing can take a financial beating.

One successful area is the expensive gift book market—books that use sumptuous photographs to illustrate an idea or style, such as how to cook, entertain, or plan a garden. Although the photography is often well done and the books handsomely produced, these don't strictly qualify as photography books; they're more about a particular subject than the photographs themselves. Some of the publishers listed below sometimes produce such books, but most of their projects focus on the photography.

ABBEVILLE PRESS

Abbeville mostly publishes visual books and calendars on such subjects as art, travel, pop culture, and fashion. These books use a lot of photography, but rarely concentrate on it. When they do, however, they're often some of our most important and controversial collections, such as *New Color/New Work; Photography and Art: Interactions Since 1946; L'Amour Fou: Photography and Surrealism;* and *Fabrications: Staged, Altered, and Appropriated Photographs.* Naomi Rosenblum's fine *A World History of Photography* was also published by Abbeville.
Abbeville Press, 488 Madison Avenue, New York, NY 10022. (212) 888-1969.

HARRY N. ABRAMS

One of the world's leading art-book publishers, Abrams produces a large list of beautiful illustrated books, ranging from scholarly work to commercial books on popular culture. The photography offerings are just as varied, including work by such important photographers as Harold Edgerton, Carl Mydans, and Pete Turner.
Harry N. Abrams, 100 Fifth Avenue, New York, NY 10011. (212) 206-7715.

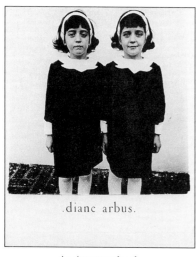

An Aperture book.

An Abbeville Press book.

A New York Graphic Society book.

AMPHOTO

Amphoto, the most prominent publisher of how-to books on photography, has gone through some ownership and editorial changes in the past few years. It's now owned by Billboard Publications, and its recent titles look and read better than ever. Most are printed in color and aim at a serious amateur and professional audience. Amphoto books are varied, upbeat, and for the most part authoritative.

The list includes publications on technique and creativity as well as those dealing with business issues such as how to run a studio, market your work, and sell stock photographs. Amphoto doesn't publish portfolio or art books, just those that appeal to an identifiable audience and a specific market.

Amphoto, 1515 Broadway, New York, NY 10036. (212) 764-7300.

APERTURE

Aperture is the largest all-fine-art photography book publisher, and also produces the fine quarterly journal of the same name. Its titles range from classics such as *Diane Arbus* and *The Americans* by Robert Frank to new works by promising younger photographers. The company also publishes posters and limited-edition prints, books, and portfolios.

The production in most Aperture books is first-rate, though some recent titles have been printed to slightly lower (but still very good) standards so they can be priced more moderately. Editorially, the quality remains high; Aperture books are universally interesting with good selections of high-quality photographs generally accompanied by an informed text.

Aperture, 20 East 23rd Street, New York, NY 10010. (212) 505-5555.

See pages 193 and 201.

BULFINCH PRESS/NEW YORK GRAPHIC SOCIETY BOOKS

Bulfinch Press and New York Graphic Society Books are both imprints of Little, Brown and Company, which, in turn, is owned by Time Inc. Most new photography titles will be published under the Bulfinch Press imprint, which was created early in 1989.

Unlike Aperture, which publishes only photography, Bulfinch produces art books (titles such as *Georgia O'Keeffe: Arts and Letters* and *Treasures of American Folk Art*), with a specialty in photography. Best known as the publisher of Ansel Adams, it has also produced many fine and classic photography titles, including books by Paul Caponigro, Joel Meyerowitz, Eliot Porter, and Edward Weston. Bulfinch also distributes books published by New York's Museum of Modern Art (see below).

Bulfinch Press, 34 Beacon Street, Boston, MA 02108. (617) 227-0730.

CENTER FOR CREATIVE PHOTOGRAPHY

The Center for Creative Photography at the University of Arizona sponsors major exhibitions, houses important collections, and runs a small but active publication program. The center resembles a university press, publishing important fine-art books with a narrow market. Sometimes the books cover interesting photographers who don't have a huge following; sometimes they feature a little-known work from a well-known photographer. The center also publishes more arcane books of serious research, bibliographies, and guides to the university's collections. It does posters, too.

Center for Creative Photography, University of Arizona, Tucson, AZ 85721. (602) 621-7968.

See pages 113 and 118.

CHRONICLE BOOKS

Chronicle Books was founded in 1967, but only recently made a concerted effort to publish books of fine photography, particularly nature and travel books. Its recent publication of Peter Beard's classic *The End of the Game*, which had long been unavailable, hopefully indicates good things to come. Chronicle's books are well produced, almost exclusively in color.

Chronicle Books, 275 Fifth Street, San Francisco, CA 94103. (415) 777-7240.

FOCAL PRESS

Along with Amphoto, Focal Press is the primary publisher of technical books on photography. Focal's books are more academic, however, and most are denser and more expensive. The backlist includes many texts and reference books that have become classics, such as Leslie Stroebel's *View Camera Technique* and Michael Langford's *Advanced Photography*, as well as many books on obscure topics. Several Focal Press titles originated in the United Kingdom and have a decidedly British tone.

Butterworth Publishers, 80 Montvale Avenue, Stoneham, MA 02180. (617) 438-8464.

GALLERY MIN

Tokyo-based Gallery Min produces exhibition catalogs. Each has about forty images, and all are well designed, impeccably printed, and graced with both English and Japanese text. Photographers include Judy Dater, Robert Heinecken, and others, mostly living on the West Coast.

Gallery Min, 4-3-12 Himonya Meguro-ku, Tokyo 152, Japan.

KODAK

The largest publisher on photography is without a doubt Eastman Kodak. Big Yellow's publishing department cranks out countless books each year, not to mention pamphlets, brochures, and newsletters. Naturally, these books feature Kodak materials, but along with the product hype you'll find a lot of useful information. Some Kodak publications, especially those aimed at professional and scientific markets, contain information not available anywhere else.

Eastman Kodak, Department 412L-209-AP, Rochester, NY 14650. (800) 233-1650.

See page 208.

MORGAN & MORGAN

Best known for its *Photo Lab Index*, Morgan & Morgan publishes a variety of technical and how-to titles, and occasionally a fine picture book.

Morgan & Morgan, 145 Palisade

Street, Dobbs Ferry, NY 10706. (914) 693-0023.

MUSEUM OF MODERN ART
MOMA's titles are either related to its permanent collections or catalogues of exhibitions at the museum, making it one of the most important publishers of fine-art photography books. The museum also publishes monographs of historical, established, or promising photographers, as well as collections and scholarly works. The books are distributed by Bulfinch Press/Little, Brown (see above).
Museum of Modern Art, 11 West 53rd Street, New York, NY 10019. (212) 708-9400.
See page 107.

NEW IMAGE PRESS
This recently established publishing arm of The Image Bank stock agency produces subject-oriented titles, not monographs, for a variety of trade publishers. These books showcase the work of major contemporary photographers—most but not all of them associated with the agency.
The Image Bank, 220 Fifth Avenue, New York, NY 10001. (212) 545-7445.
See page 163.

NEWSAGE PRESS
A small press with a feminist and political bent, NewSage specializes in the photographic essay, publishing such titles as *A Portrait of American Mothers & Daughters; Women & Work;* and *The New Americans* (about immigrants and refugees).
NewSage Press, Box 41029, Pasadena, CA 91104. (818) 795-0266.

NORTH BEACH PRESS
This relative newcomer concentrates on fine-art photography. To combat high production costs and thus high retail prices, North Beach has opted to produce shorter books, which they call "photographic novellas." These are very well produced, about twenty-four pages each, and sell for under $10.
North Beach Press, 524 Union Street, San Francisco, CA 94133. (415) 982-8432.

Fringe Benefits

These books in the Untitled series are published for members of Friends of Photography.

PEREGRINE SMITH BOOKS
For a small publisher, Peregrine Smith has broad interests, publishing books on such varied subjects as nature, fine arts, architecture, and conservation. It has several photography titles from authors such as Beaumont Newhall and Eliot Porter. The primary emphasis is on nature photography.
Peregrine Smith Books, Box 667, Layton, UT 84041. (801) 544-9800.

SIERRA CLUB BOOKS
True to its conservationist sponsors, Sierra Club Books specializes in titles spotlighting the natural environment. Most are beautifully produced, large-format gift books.
Sierra Club Books, 730 Polk Street, San Francisco, CA 94109. (415) 776-2211.

THOMASSON-GRANT
Thomasson-Grant was a regional publisher until it produced *Odyssey: The Art of Photography at National Geographic* in 1988. The company's list is still small, but all the titles are photographic and subject oriented, with specialties such as sports, the military, and nature.
Thomasson-Grant, 1212 Wisconsin Avenue N.W., Washington, DC 20007. (202) 342-9334.

TWELVETREES PRESS
Started in 1980 with titles of a homoerotic bent, Twelvetrees has expanded and broadened its offerings, occasionally publishing nonphotography art books as well. Its trademark is high-quality production, and most of its black-and-white titles are printed in short runs on sheet-fed gravure presses. Recent offerings in its very eclectic list include titles by Matt Mahurin, Duane Michals, and Herb Ritts, as well as poet Allen Ginsberg and actor Dennis Hopper.

Twelvetrees was the first to publish full-length books of important photographers such as Robert Mapplethorpe, Bruce Weber, and Joel-Peter Witkin—not a bad record for a publisher with only about thirty titles on its backlist.

Viewpoint: Publishing

JANET SWAN BUSH
EXECUTIVE EDITOR
BULFINCH PRESS/LITTLE, BROWN
BOSTON

"It may be distressing to those of us who love pure fine-art photography, but there's a limited market for books such as the traditional monograph. At Bulfinch Press, we can sell only a few thousand copies of most of these titles, unless a major exhibition accompanies the book's publication. While we still continue to publish books of important fine-art photography, we have to be very careful when we do so.

"Unfortunately, this does not bode well for photographers working on their own, doing exciting and innovative personal work, who want to see it in book form. For most book buyers, fine-art photography is obscure. It just doesn't translate beyond that small market, and this makes it very difficult to publish.

"We've actually seen a drop in the market in the last ten years for fine photography books. I find that a little surprising, since there's so much interest in photography in workshops, schools, and so forth. Perhaps it's because we've run out of so-called masters to publish; just about all the classic photographers are represented by at least one book by now, and only contemporary photographers are left unpublished—most of whom have not been around long enough to establish a large following as of yet.

"The photography books that do best are those with a specific subject, because they will attract a broader audience. Such books can do very well indeed. Assuming that the photographs and reproduction quality are outstanding, those who usually buy fine photography books will consider it, and added sales come from those who are attracted to the subject rather than photography as an art.

"Cost is always a factor. Some people can't understand why a photography book must cost $40, $50, even $60, and I admit it's hard to fathom. But if you consider that hardcover non-fiction with no illustrations can cost from $20 to $25 these days, and that many people wouldn't think twice about spending $50 to $75 for a nice dinner out, then a $50 book of compelling photographs doesn't seem too extravagant.

"The plain fact is that these books are expensive to produce. Sometimes content rather than print tonality is most important—for example, with photojournalism—and for this kind of book you might opt for good but not extraordinary reproduction to keep the price down. However, the work of some photographers so depends on the subtlety of their prints that you have to go all out in the reproduction or you lose the point of publishing the work at all. This kind of quality is very expensive, especially for the small runs you're likely to be printing—again, for those few thousand buyers. It's a bit of a catch-22: If you don't choose fine reproduction quality, the audience for the book is not going to be interested; if you do, you've priced it beyond a limited market.

"One major change we've seen in the last decade—a very positive change—is an increase in the number of books printed in color. This is largely because foreign printers have come in, especially when the dollar was strong in the early 1980s, and offered high-quality printing at an affordable price. Now that these printers are in the market, even though the dollar has weakened, color books are here to stay. Of course, it also helps that there is much more excellent color photography these days. Ten to fifteen years ago most serious work was still done in black and white."

Twelvetrees Press, distributed by Twin Palms Publishers, 2400 North Lake Avenue, Altadena, CA 91001. (818) 798-3116.

UNIVERSITY OF NEW MEXICO PRESS
Several university presses dabble in photography, but this one specializes in it. New Mexico publishes many scholarly works and collections, with an emphasis on the history of photography, as well as monographs by outstanding classic and contemporary photographers.
University of New Mexico Press, Albuquerque, NM 87131. (505) 277-7564.

UNTITLED
Among the benefits of joining Friends of Photography is the joy of receiving three free books from the unique *Untitled* series. These are either original books or abridged editions of recently published titles, and almost all are worth owning, if only for their fine design and reproduction. *Untitled* authors include Harry Callahan, Mary Ellen Mark, and Edward Weston; most titles are available exclusively through Friends of Photography.
Friends of Photography, 101 The Embarcadero, San Francisco, CA 94105. (415) 391-7500.
See pages 94, 125, and 149.

Self-Publishing

It's the dream of many photographers to publish a book of their own work. Unfortunately, publishers are rarely interested. Photography books—that is, portfolio books or monographs—are expensive to produce and generally sell poorly, and most publishers are not in business to lose money.

However, it's quite possible to publish a book yourself; all you need is the time and money. Many more photographers than you might imagine take this route; recent examples include Ralph Gibson and Eugene Richards, both of whom independently published their first efforts. Self-publishing is an excellent way of getting your work seen by a broad audience, and, of course, there's a certain amount of ego gratification involved. On the practical side, a book can be a sound investment in your career.

One advantage of self-publishing is that you retain full control of the product. In a traditional publishing arrangement, you give your work to a publisher and it designs and manufactures the book. The editors may choose to include you in the decision-making process—or they may not—but they reserve the right to make the final decisions as to the design and the production quality of the book based on their own values and budget.

A self-published book by fashion photographer Arthur Elgort.

Practical Matters

Once you decide to self-publish, your most important decision is choosing a graphic designer. This is the person who will help you make all the major decisions relating to the look of the book—critical matters such as trim size, typefaces, and picture layout. You can probably find a designer with sufficient production experience to shepherd the book all the way through the printing and binding stages. Not all designers are equipped to do this. In fact, publishers usually hire separate staff for design and production.

Most graphic designers handle a wide variety of printed matter such as brochures, advertisements, and catalogs. In theory, any capable designer can do the job, but it's best to pick a book designer—or at least one with book experience. Most publishers use free-lancers who are generally available for hire. Look through some photography books and identify the ones with a look you like. Then call the publisher and ask for the designer's name and address, and write or call. Request more work samples and make your decision accordingly, factoring in the fee and your personal compatibility. If you live in a large city, finding a good designer should be no problem. If not, you may have to hire long-distance, but be prepared to travel to meet with the designer periodically.

Once chosen, a designer can pretty much take over the project—with your help at key points in the process. Here's a likely scenario. You make an initial selection of photographs, choosing maybe 25 to 50 percent more than you'll ultimately use. At the same time, write or hire a writer to prepare whatever text is necessary—introduction, running text throughout, captions. Meet with the designer to show what you have and discuss the general layout. Ask for a rough design concept; this can be a pencil sketch showing a suggested trim size and how photographs and text will be handled. At the same time, you should discuss such matters as choice of typefaces, paper, binding (cloth or paper), and the size of the print run. Let the designer lead

you and make suggestions; that's what he or she is there for. However, don't be afraid to disagree at any point. After all, you're paying for it—and it *is* your book.

The designer, acting as production coordinator, should contact printers to bid for the job. This can be a lengthy process, and unless money is not an issue you'll want to consider different estimates and approaches, and how each affects the overall cost. For example, the designer may suggest a heavy 100-pound paper stock, but an 80-pound stock will cost considerably less and may do just fine. Or, cutting one-half inch from the suggested horizontal trim of the book may allow a printer to do the job on a smaller, less expensive press.

Ask for samples that match the specifications the printer is quoting on—paper stock, reproduction quality, binding. When you select a printer, it should be willing to supply you with a blank dummy—an unprinted book with the quoted trim size and paper stock—so you can better visualize the physical qualities of the book.

Once the text is written, it must be edited. If someone else is writing it, you may want to do this yourself, or hire a professional editor. Most photography books have minimal text, and a good copyeditor can probably do the job. A copyeditor edits for style and correct use of language—such things as syntax, spelling, and punctuation. Your designer should know of a good copyeditor. If not, call a book publisher, magazine, or newspaper and ask for the name of free-lancers.

Once copyedited, the designer specs the type, directing the typesetter on such matters as what kinds and sizes of typefaces to use, how wide the columns should be, and whether there is any bold or italic type. The typesetter will produce galleys—sheets of printed text—which you must check for errors and last-minute changes. It's best to hire a proofreader (sometimes this is the copyeditor) to read the galleys as well; it's too easy for one pair of eyes to miss small errors. When changes are made, they are sent back

Distribution

These companies sell and distribute books from small presses, and sometimes from self-publishing authors. If they agree to distribute your book, they'll work on a consignment basis—taking and fulfilling orders from bookstores, libraries, and schools, then paying you once they've received payment.

BOOKSLINGER
502 North Prior Avenue
St. Paul, MN 55104
(612) 649-0271

THE DISTRIBUTORS
702 South Michigan Street
South Bend, IN 46618
(219) 232-8500

INLAND BOOKS
Box 261
East Haven, CT 06512
(203) 467-4257

PUBLISHERS GROUP WEST
4065 Hollis Street
Emeryville, CA 94662
(415) 658-3453

QUALITY BOOKS
918 Sherwood Drive
Lake Bluff, IL 60044
(312) 295-2010

UNIQUE BOOKS
4200 Grove Avenue
Gurnee, IL 60031
(312) 623-9171

to the typesetter for "repro"—corrected, camera-ready text on glossy paper stock for the crispest possible reproduction.

Meanwhile, using a copy of the original galleys, the designer prepares a dummy—a page-by-page layout of the book with photographs and text in place. At this point you should work with the designer and make the final choices of photographs and sequencing. A good designer, not being as personally involved, is often better at making these decisions than the photographer, but few photographers can give up that much control. Someone has to take ultimate responsibility and, again, it's your book.

Once the dummy has been prepared, look it over carefully. Any changes made after this point can be costly. The same goes for the repro. Changes—called AAs (author's alterations)—are expensive.

Once the repro and dummy are approved, a mechanical is prepared. This consists of clean boards with repro laid down in place and the location of photographs indicated. On approval, the mechanical is sent to the printer and you'll next see either blue prints (a proof of the job in blue tones), press proof (a first uncorrected printing), or some combination of the two, depending on where the job is printed and whether it's a black-and-white or color book. At this stage, you should inspect the results and suggest changes—darker or lighter, more or less contrast, additional red or less blue, or whatever. You may ask to see additional proofs if you feel the first try is way off. Again, let your designer guide you as to what is reasonable.

The final stage is going to press. The designer should go and you should too, if possible. There, the printer will pull sheets off the press and request your approval. Press time is extremely expensive and you'll want to limit your changes at this point; all the more reason to be very careful in the pre-press approvals. This is, of course, a very anxiety-producing time, since what happens here determines what the final product will look like.

Some advice: The printed page is always a compromise. It rarely looks as good as the original, at least not without spending more money on the printing process than most can afford. Make sure the photographs look good, but don't expect miracles.

Sales and Distribution

Aside from raising the money, the biggest problems with self-publishing are sales and distribution. It's impossible to carry your book around to the thousands of booksellers in the country, and, even if you could, store buyers rarely want to take the time and effort to deal with an individual author.

The key is to hone down the possible outlets to a reasonable and reachable group of stores. Most photography books are handled by independent booksellers; chain stores such as Waldenbooks, Barnes & Noble, and B. Dalton sell relatively few books of this sort. To contact those that sell a lot of photography titles, consult the *Specialty Booksellers Directory* (by John Kremer, Marie Kiefer, and Melinda-Carol Ballou, available from Ad-Lib Publications, 51 North Fifth Street, Fairfield, IA 52556; (800) 624-5893). This directory lists over 2,000 independent book retailers with a guide to their areas of specialty; look under the art and photography categories.

Prepare a flyer—your designer can do this for you—and mail it to the independent stores you've decided to target, announcing the book and offering terms for sale. Also, send the flyer and a sample copy to the mail-order catalog companies that specialize in photography books (see page 201). These catalogs are extremely important, not only for sales but for publicizing the book. If your book appears in a catalog, many thousands of potential buyers will at least know about it, even if they don't buy it from that catalog.

For direct sales to booksellers, financial arrangements vary, but they will typically pay you 40 to 50 percent of the list price of the book and reserve the right to return unsold copies for a full refund, usually after six months. Then there's the matter of getting paid on time—or at all. Many independent booksellers are constantly fighting cash-flow problems, and inevitably they'll pay Random House before they'll pay you.

Some self-publishing authors successfully sell their books by direct mail. This usually works best if the

A Self-Published Book

Dorchester Days *by Eugene Richards.*

book is fairly expensive; it costs just as much to advertise and fulfill orders for a $5 book as for one that costs $50, and naturally your profit will be higher with the higher-priced book. It also helps to narrow your audience as much as possible. If your book is about, say, the Hudson River, buy a mailing list of people involved in conservation efforts to preserve that waterway; don't mail to photographic educators throughout the United States.

The independent book distributors who handle self-published books are few and far between, but some are listed in the box on page 181.

Since you're footing the bill, you may be able to convince a small publisher, which might otherwise be uninterested, to put your book on its list. The publisher gets to offer a good title for little or no investment; you get someone else to take care of sales and distribution. It must be a book the publisher likes, of course, and such arrangements generally must be made before the book is manufactured so it can bear the publisher's imprint.

Very few self-published books make money. You should go ahead only if the noneconomic advantages are worth the likely financial loss. Besides the money, publishing is an incredible drain of time and energy. But it can also be fun and exciting, and the result—a good-looking book of your own work—is a compelling incentive to give it a try.

Printers

Practically any printer, even your local copy shop, is capable of printing a book. However, reproducing fine photography well requires special skills, so hire a printer with experience. Of course, this is a costly proposition, and the printers listed below—some of those most commonly used for fine photography books—do strictly high-end (expensive) work. Many are based overseas and the listed addresses are for their U.S. representatives.

ACME PRINTING COMPANY
30 Industrial Way
Wilmington, MA 01887
(508) 658-0800

BALDING AND MANSELL INTERNATIONAL
Park Works, Wisbech
Cambs PE132AX, England
011-44-945-582011

DAI NIPPON PRINTING
2 Park Avenue
New York, NY 10016
(212) 686-1919

FRANKLIN GRAPHICS
85 Corliss Street
Providence, RI 02904
(401) 351-1540

GARDNER LITHOGRAPH
8332 Commonwealth
Buena Park, CA 90621
(714) 521-5920

IMPRIMERIE JEAN GENOUD
Case Postale 440
Lausanne 1001, Switzerland
011-41-21-329965

MERIDAN-STINEHOUR PRESS
47 Billard Street
Meridan, CT 06450
(203) 235-7929

MONDADORI
740 Broadway
New York, NY 10003
(212) 505-7900

NISSHA PRINTING COMPANY
149 Madison Avenue
New York, NY 10016
(212) 889-6970

PIZZI AMERICAN OFFSET
141 East 44th Street
New York, NY 10017
(212) 986-1658

PRINCETON POLYCHROME PRESS
861 Alexander Road
Princeton, NJ 08540
(609) 452-9300

RAPPAPORT PRINTING
195 Hudson Street
New York, NY 10013
(212) 226-5501

REMBRANDT PRESS
232 Amity Road
Woodbridge, CT 06525
(203) 389-9799

SOUTH CHINA PRINTING COMPANY
196 East 75th Street
New York, NY 10021
(212) 744-1369

H. STÜRTZ AG
467 Central Park West
New York, NY 10025
(212) 864-3173

TIEN WAH PRESS
574 Broome Street
New York, NY 10013
(212) 206-8090

TOPPAN PRINTING COMPANY
680 Fifth Avenue
New York, NY 10019
(212) 975-9060

The Cost of Self-Publishing

The cost of publishing a book depends on several factors, making any kind of general estimate impossible. However, here are the cost figures for a sample book to give you some idea. These prices apply to a high-quality, though not extraordinary, printing job on a duotone (two color) black-and-white book. The trim size is 8×9½ inches (vertical). It has ninety-six pages, fifty photographs, a short introduction of about 1,000 words, and one-line captions for each photo. The paper stock is a popular one used for many fine photography books—eighty-pound Warren Lustro Dull. The print run is 3,000 copies.

Design/dummy/mechanicals/production	$ 7,000
Typesetting	800
Copyediting/proofreading	400
Printing/binding/shipping	18,000
Total cost	**$26,200**

To this, you should add the cost of going on press to oversee the printing of the book (travel, hotel, and food for your designer and/or yourself), as well as any costs associated with selling and distributing the book, such as advertising.

These factors most affect the cost of the printing:

Paper stock. The best quality and most expensive papers are generally heavier, more opaque, and better coated.

Color. The more colors you use, the more it will cost. Books of color photography generally use four colors (occasionally five or six); black-and-white photographs need a one- or two-color press (duotone is two color—for example, black and gray).

Trim size. As a rule, large-sized books cost more to print and bind, and odd sizes are especially pricey.

Length of book and number of photographs. As you might imagine, the cost goes up with every additional page and photograph.

Casing. Hardcover books cost more to produce than paperbacks—and some cloths and papers are more expensive than others.

Unusual techniques. Any unusual printing requirements, such as fold-outs, dyecutting, and hand tipping, will result in considerably higher printing prices.

Domestic Magazines

There are photography magazines for all types of photographers, from wedding specialists to fine-artists. Some magazines are slickly produced and have a wide audience; others are pretty much handmade and sell to a limited few.

Many magazines specialize in technical matters and offer hints on how to improve your shooting or printing. Others are visually oriented and feature portfolios of fine photography. More application-minded magazines reach a specific audience, such as scientific photographers.

A lot of people read magazines for product information, to find out what's available and how good it is. Although most photo magazines carry new-product announcements, you should read product reviews with care. Some magazines review only products they feel are of high quality or otherwise notable, but others deliberately hype products to make their advertisers happy. Magazines make their money from advertising and many are reluctant to slam an advertiser's wares.

Even so, magazines remain the best place to keep up on what's current in photography—technically, visually, and product-wise.

AMERICAN PHOTOGRAPHER/ AMERICAN PHOTO

From the beginning, *American Photographer* has been dedicated to the proposition that, in the words of founder and former editor Sean Callahan, "Cameras don't take pictures, photographers do." In an approach radically different from that of its competitors, *American Photographer* concentrates on personalities, trends, and the creative process rather than on products. It does this with in-depth profiles and portfolios of photographers, plus regular columns that examine working methods.

The result is a blend of fine art, fashion, advertising, history, and photojournalism. The magazine's interest in professional photography has drawn some flak from those in the fine-art community who feel uncomfortable seeing a portfolio by, say, Edward Weston followed by one from Helmut Newton.

The editorial mix now puts a bit more emphasis on photojournalism and technique. For a non–how-to publication, it has some of the best technical sections and most objective product reviews around. However, as we go to press big changes are in store, including a name change—to *American PHOTO*. Many of the regular features are expected to remain, but the emphasis will be more visual and international. Stay tuned.
American Photographer/American PHOTO, 1515 Broadway, New York, NY 10036. (212) 719-6000.

DARKROOM AND CREATIVE CAMERA TECHNIQUES

Of all the how-to magazines, *Darkroom and Creative Camera Techniques* may be the most informative. Its format is rather dry, with a foreboding layout, but its contents are authoritative. With articles by excellent writers and photographers, the magazine is must reading for darkroom and view-camera junkies, and for anyone interested in finding out how things work, not just how to work them.

This is no publication for the timid—or the novice. In-depth articles

on such topics as photochemistry and sensitometry make it much more than a casual read. Although it clearly stresses technique, the magazine does publish portfolios and fine photography, mostly in black and white but sometimes in color.

Darkroom and Creative Camera Techniques is one of the few photography magazines with serious product reviews, and it also devotes much space to reader questions and new-product announcements. It appears every two months, with an additional issue most years that focuses on specific issues such as the chemistry of photography or mastering black-and-white techniques.

Darkroom and Creative Camera Techniques, 7800 Merrimac Avenue, Niles, IL 60648. (312) 965-0566.

DARKROOM PHOTOGRAPHY

A somewhat misnamed monthly, *Darkroom Photography* covers far more than ventilation and plumbing. It's one of the best sources of technical information for the beginning and advanced amateur. Professionals will like it, too. The magazine's technical articles have depth, and it's well designed and produced.

Mixed in with the how-to darkroom articles is a combination of portfolios, interviews, and features on specific genres, such as panoramic photography. The product reviews are useful and authoritative, and even the question-and-answer section is surprisingly well informed.

Darkroom Photography, Box 16928, North Hollywood, CA 91615. (818) 760-8983.

OUTDOOR PHOTOGRAPHY

This well-made magazine is aimed at travel, sports, wildlife, and nature photographers. *Outdoor Photography* has the usual columns on technical tips and product reviews, but the quality of its feature articles and photographs is a notch above most consumer-oriented photography magazines.

You'll find articles by top outdoor photographers, packed full of anecdotes, technical advice, and outstand-

American Photographer.

Photo District News.

ing, well-reproduced photographs. Subject areas include wilderness, seashore, and underwater shooting, plus sailing, skiing, trekking, river running, flying, and fishing. *Outdoor Photography* is published monthly (actually, ten issues per year).

Outdoor Photography, 16000 Ventura Boulevard, Encino, CA 91436. (818) 986-8400.

PHOTO DISTRICT NEWS

Photo District News began as a newsletter called *New York Photo District News,* serving New York–based professional photographers. It's now a relatively large international magazine (about 125 pages in an oversized 11×16-inch format) with several regional editions. Along with its growth in size came a growth in stature; *Photo District News* is the single most important publication for professional photographers.

Amateurs should also like this monthly. It covers a breadth of information from product announcements to feature articles about individual photographers, as well as classifieds and a professional-services directory. Each issue has a theme such as advertising, stock photography, fashion, or computers, and this theme stays constant from year to year—equipment is featured every January, and every June issue explores the world of fashion and beauty.

Industry news, such as activities at local and regional chapters of the American Society of Magazine Photographers and Advertising Photographers of America, get a lot of play. Business articles such as how to run a studio or plan your estate are also common. In addition, *Photo District News* sponsors the annual trade shows Photo East, Photo Midwest, and Photo West.

This magazine does not cover fine-art photography, and its newsprint-like pages do little to enhance the look of its photographs. Except for the cover and an occasional advertising insert, the magazine is printed in muddy black and white. But the goal of *Photo District News* is not to present beautiful portfolios (though this is part of the

Eyeing the Pros

Photography magazines can be informative, but they're not always the best place to see outstanding photography, especially professional photography. That distinction belongs to general-interest magazines, which employ talented art directors and photo editors who seek out and hire the best shooters.

Though day rates for editorial work are not high compared to rates for advertising or corporate work, most photographers, no matter how well known, take on assignments of the right sort for the right magazine. Even busy advertising photographers generally have some downtime, and magazine assignments can fill that time and pay some of the overhead. Also, magazine work, especially for photojournalists, may offer an opportunity to shoot a long-term project of interest that no one else will fund. On the practical side, magazine work gives a photographer visibility—good for the ego and even better for the promotional value. Hundreds of thousands, or even millions of people may see a photo published in *Life*, for example, including people in the photography, design, journalism, or advertising community that a photographer might want to contact for future, better-paying work.

Of the dozens of high-quality general-interest magazines published in the United States, the ones listed here feature some of the best professional camera work. Foreign editions of these and other magazines are often even stronger photographically; for example, the British, French, and Italian editions of *Vogue* have long been considered more visually striking than U.S. *Vogue*.

Arbitare
Audubon
Connoisseur
Country Journal
Elle
Esquire
Fortune
GQ
Graphis
Interview
Harper's Bazaar
House & Garden
LA Style
Life
National Geographic
Natural History
New England Monthly
New York
New York Times Magazine
Newsweek
Outside
People
Rolling Stone
Sports Illustrated
Texas Monthly
Time
Town & Country
Travel & Leisure
Traveller
Vanity Fair
Vogue

POPULAR PHOTOGRAPHY

Whether *Popular Photography* is the most popular of all photography magazines is debatable, but it *does* have the most subscribers—about 730,000. It's also one of the longest running photo magazines, started more than fifty years ago. Multiple ownership changes in the last few years have put the magazine through painful editorial adjustments, but it's finally settled down to a consistent style. Ironically, the current *Popular Photography* bears more than a passing resemblance to its former (and now defunct) arch competitor *Modern Photography*—no big surprise since the current publishing director, editorial director, and several staff members were part of the crowd that ran *Modern* for many years.

Pop's strength lies in its product reviews and how-to features. Though many regular columnists have departed in recent years, some good ones remain and one or two have been added. Also, the new *Pop* has more articles from outside sources, adding a broader and less predictable point of view. Though it rarely ventures into realms beyond the camera, occasional pieces on history and the creative process continue to creep in and enliven the magazine.

One good reason to read *Popular Photography* each month is the ads in the back from mail-order firms specializing in photography and electronics equipment. Many of the biggest operations take ads in these magazines, offering great variety and some excellent prices.
Popular Photography, 1515 Broadway, New York, NY 10036. (212) 719-6000.

SHUTTERBUG

An equipment hound's dream, *Shutterbug* is filled with hundreds of classified ads from individuals and dealers. Its tabloid format (10×13 inches) helps make it a breezy read, and its density (almost 200 pages) guarantees hours of wishful thinking per issue.

You'll find equipment of all sorts in *Shutterbug*'s pages, some new, but most used. There's the usual plethora of Nikons and Leicas, but what's fun

editorial mix); it aims to deliver hard information and news to the professional photographer, and it succeeds admirably.

Photo District News, 49 East 21st Street, New York, NY 10010. (212) 677-8418.
See pages 171, 158, and 202.

about *Shutterbug* is its obscure equipment—long-forgotten uncoated lenses, banquet cameras, and even Polavision systems. Here are some samples from a recent issue:

—Voightlander Stereflektoskop with three Heliar 4.5 lenses in stereo Compur shutter. 6×13 cm. Mint—$525.
—Linhof 617 Technorama, SA excellent to excellent+, $3,475.00 postage paid.
—Alpa Switar, shade for 50mm M, Mint, $25, and neck straps for models 10 & 11, new, each $29.
—Omega FC 8×10 condenser enlarger. Serial #1, complete, very good, $1,250.

Shutterbug does have feature articles on equipment and camera collecting in general. Some of these are useful; all are highly opinionated. However, the real reason to buy the magazine each month is for its browsing value. *Shutterbug* junkies will agree that this is reason enough. *Shutterbug, Box 1209, Titusville, FL 32781. (800) 327-9926; (305) 269-3211.*

Short Takes on Other Photo Magazines

COMMUNICATION ARTS
Aimed at art directors and designers, *Communication Arts* spotlights fine photography and illustration done for advertising, design, editorial, and any other communication area. Each year, the monthly invites photographers to submit work for the August issue, which features only photography. *410 Sherman Avenue, Box 10300, Palo Alto, CA 94303. (415) 326-6040.*

GRAPHIS
Billed as the "International Journal of Visual Communication," *Graphis*'s subject is graphic design. The magazine is very visual and beautifully produced, with articles and portfolios on topics from product design to print

Graphis.

Photo/Design.

Communication Arts.

advertising. While *Graphis* is not about photography *per se*, photography plays an important role in its pages, sometimes in the context of the printed piece and sometimes on its own. This is a magazine any photographer interested in corporate and advertising work should look at. *Graphis* is published simultaneously in French, German, and English editions six times per year. An annual subscription costs $59. *141 Lexington Avenue, New York, NY 10016. (212) 532-9387.*

INDUSTRIAL PHOTOGRAPHY
This monthly is aimed primarily at photographers working on staff for companies, universities, and other institutions. It offers industry news, technical tips, and product reviews. Incorporating the former *Functional Photography, Industrial Photography* contains technical articles on subjects such as specialized lighting setups, and special features such as a survey of industry salaries. *PTN Publishing Company, 210 Crossways Park Drive, Woodbury, NY 11797. (516) 496-8000.*

MINOLTA MIRROR
This slick annual is mostly picture oriented, with the occasional profile. For a company publication, it makes surprisingly few references to Minolta cameras or meters. Instead, it showcases outstanding photography—both fine art and professional—including feature portfolios from photographers such as Ansel Adams, who was probably not much of a Minolta user. *101 Williams Drive, Ramsey, NJ 07446. (201) 825-4000.*

PENTAX LIFE
Published quarterly for owners of Pentax equipment, Pentax Life includes portfolios, technical information, and product updates. *35 Inverness Drive East, Englewood, CO 80112. (303) 799-8000.*

PETERSON'S PHOTOGRAPHIC
A popular monthly magazine, *Peterson's Photographic* has a lot of product reviews and how-to articles, plus an

occasional portfolio. Recent issues included a sixteen-page feature on filters and a forty-eight-page insert of the "hottest cameras" of the year. Despite its hobbyist bent, *Peterson's Photographic* also has a surprisingly large following among pros, due to informed articles on advanced matters such as view cameras and special darkroom techniques.

6725 Sunset Boulevard, Los Angeles, CA 90028. (213) 854-2200.

PHOTO/DESIGN
Aimed at art directors and designers, *Photo/Design* has the look and feel of a creative directory (see page 154). This is no coincidence; photographers can buy space in it to advertise their work. It comes out every two months with the occasional feature story, but mostly it runs short portfolios with text by commercial photographers.

1515 Broadway, New York, NY 10036. (212) 764-7300.

PHOTOGRAPHER'S FORUM
This subscription-only quarterly presents feature articles, interviews, portfolios, and book reviews in a clean, well-produced package. *Photographer's Forum* focuses heavily on photographic education.

614 Santa Barbara Street, Santa Barbara, CA 93101. (805) 963-0439.

PHOTOMETHODS
This monthly magazine covers practical, hands-on issues with an emphasis on technical and product information. The main audience is industrial photographers and managers of photography areas in institutions and corporations. Medical and scientific photography is also covered, as are such subjects as video, motion pictures, instrumentation, graphic arts, audiovisual production, computer graphics, and film processing.

1090 Executive Way, Des Plaines, IL 60018. (312) 299-8161.

PROFESSIONAL PHOTOGRAPHER
In line with its billing as the "business magazine of professional photography," each issue of *Professional Pho-*

Popular Photography.

Shutterbug.

Studio Light.

tographer has at least two or three articles about running a studio more profitably. For the most part, this monthly is visually oriented; photographs and portfolios get more attention than does text. As the journal of the Professional Photographers of America, the magazine emphasizes wedding and studio photography, with case histories, technical tips, and product reviews.

1090 Executive Way, Des Plaines, IL 60018. (312) 299-8161.

THE RANGEFINDER
The Rangefinder is yet another monthly for the professional photographer. Its workmanlike format has little color and few in-depth articles. Some of its specialties are wedding, general studio, crime, and "boudoir" photography. Feature articles cover photographers, technical matters, products, and business practices.

1312 Lincoln Boulevard, Santa Monica, CA 90406. (213) 451-8506.

STUDIO LIGHT
This semiannual is a slick but thin Kodak publication (about forty pages) that focuses on professional photography. Feature stories on successful photographers (Kodak users, of course) are illustrated with nicely reproduced images. *Studio Light* also includes a section with news about Kodak products, programs, and publications. Subscriptions are available for working photographers at no cost.

Professional Photography Division, Eastman Kodak, 343 State Street, Rochester, NY 14650. (716) 724-4268.

STUDIO PHOTOGRAPHY
Written for portrait and commercial photographers, *Studio Photography* has a very practical orientation. With no splashy portfolios and very few color pages, it presents case histories and illuminating articles on such matters as effective time management, getting into video, and helicopter safety during a shoot. *Studio Photography* is published monthly.

210 Crossways Park Drive, Woodbury, NY 11797. (516) 496-8000.

International Magazines

Perspektief.

A quick look through some domestic magazines may give the decided impression that no photographer outside the United States is worth publishing. Most international magazines are far more open minded; they'll even publish U.S. photographers. Such magazines are also more graphic and generally more lively, so even if you can't read the language you can still enjoy looking at the package.

On the down side, for U.S. readers, international magazines can be expensive and hard to find. A few mail-order catalogs such as Photo-Eye (see page 202) sell subscriptions to select foreign titles, and certain upscale magazine retail outlets also carry some. Otherwise, you'll have to subscribe directly to the magazine. Fortunately, many encourage subscriptions from the United States, and you can often pay by check in U.S. dollars. Curtis International Press Distributors (433 Hackensack Avenue, Hackensack, NJ 07601, 201-907-5648) distributes and sells subscriptions to some international photography magazines.

Photographies Magazine.

PS.

BRITISH JOURNAL OF PHOTOGRAPHY
Published weekly, the *British Journal of Photography* covers the breadth of photography, including technical matters, history, photojournalism, and fine art. It has a lot of news items, ads (many classified), product reviews, and gallery listings in a well-produced, mostly black-and-white package. The articles and portfolios are mostly U.K. oriented. An overseas subscription costs 56.6 pounds.
244-249 Temple Chambers, Temple Avenue, London EC4Y 0DT, England. 01-583 6463.

CAMERA INTERNATIONAL
Large in format and elegantly produced, *Camera International* is one of the most accessible of all foreign-language magazines. Its text, in both French and English, is informative but not overlong. The published work is truly international in scope and encompasses a well-selected mix of fine arts, journalism, and commercial photography. A listings section covers exhibitions and activities from Paris, Milan, and Amsterdam. A year's worth (five issues) will set you back $70.
51 Rue de l'Amiral Mouchez, Paris 75013, France. (1) 45-65-46-00.

CREATIVE CAMERA
Over the past twenty years, *Creative Camera* has been one of the most visible and consistently interesting of all photography magazines. A typical issue includes portfolios, news, and exhibition and book reviews. The production standards are very good, though not outstanding. Each issue features straightforward writing and photography in a wide variety of styles. Though *Creative Camera* focuses on the state of photography in the United Kingdom, it does run photographs and articles by non-Britons. True to its name, it does not run how-to articles.
Battersea Arts Centre, Old Town Hall, Lavender Hill, London SW11 5TF, England.

EUROPEAN PHOTOGRAPHY
This well-produced quarterly concentrates on contemporary fine-art photog-

British Journal of Photography.

Camera International.

European Photography.

raphy. Each issue examines a theme; recent examples include Dutch staged photography, young European photographers, and the photographic process. The magazine also includes news clips, portfolios, reviews, critical essays, and listings of major exhibitions throughout Europe. The text is in German and English. For a European magazine, *European Photography* publishes many American writers, and also runs ads from U.S. sources. A one-year subscription costs $35. *European Photography* also publishes the *European Photography Guide*, a listing of more than 1,000 galleries, publishers, museums, and magazines all over Europe. The guide costs $14.95, postpaid.
Kurt-Schumacher-Weg 18a, Göttingen D-3400, West Germany.

PS
PS (for *Picture Show*) is about as visual as a magazine can get; it shows one portfolio after another, with very little text. The work is strong and includes much photojournalism. The package creates enormous impact through bold design with lots of photos that bleed to the edge of the page or span two pages. A one-year subscription costs $32.
Luntmakargatan 70, Stockholm S-113 51, Sweden. (0) 8-31-31-80.

PERSPEKTIEF
Plenty of exhibition and book reviews distinguish this nicely designed and produced Dutch quarterly. *Perspektief* is a bilingual publication (Dutch and English) dedicated to creative photography. It includes "Fotodok," a unique and dense eight-page section that indexes recent articles from some twenty-five international photoart magazines. Each entry is accompanied by a succinct description of the article's contents. A one-year subscription costs $20.
Eendrachtsweg 21, Rotterdam 3012 LB, The Netherlands. 010-414-57-66.

PHOTO COMMUNIQUE
One of several good Canadian photography publications. *Photo Communique* has a clear fine-art orientation, but it represents a broad spectrum of

work, both contemporary and historical. It has fairly well-produced portfolios and particularly interesting writing, including in-depth, well-written features, critical pieces, and historical articles. News sections and listings cover events, exhibitions, and grants in Canada, the United States, and, to a limited degree, other parts of the world. *Photo Communique* is bilingual, with a French and English text. It appears quarterly with a cover price of $4 per issue.

Box 129, Station M, Toronto, Ontario, Canada M6S 4T2. (416) 868-1443.

PHOTO LIFE

Photo Life, billed as "Canada's No. 1 Photography Magazine," has a lot in common editorially with *Popular Photography* and *Modern Photography*. It is a hobbyist publication with an emphasis on shooting and darkroom techniques, though *Photo Life* does print some portfolios. Regular features include news briefs, questions and answers, and a video supplement. One year (twelve issues) costs $31.95.

130 Spy Court, Markham, Ontario, Canada L3R 9Z9. (416) 475-8440.

PHOTOGRAPHIES MAGAZINE

Neatly mixing commercial and fine-art photography, *Photographies Magazine* has a lively design and excellent reproduction values. Most of its photographs get a full page or two. Editorially, this monthly resembles *American Photographer*, with a little less text and more product information (including a section on video products). *Photographies* has no pompous critical articles, just good photographs and solid facts. The front section, called "Le Journal," carries news, exhibitions, photographer profiles, and outstanding recent editorial and advertising pages of note. The U.S. cover price is $3.95 per issue.

51 Rue de l'Amiral Mouchez, Paris 75013, France. 45-65-46-00.

PHOTOVISION

This quarterly magazine in Spanish and English stresses European photography, but generally has an internation-

Ten•8.

Soviet Photo.

Zoom.

al slant. Each issue has a theme, such as pinhole photography or the self-portrait, and includes portfolios and written essays.

APTDO, Madrid 2.115, Spain.

SOVIET PHOTO

Soviet Photo, the only photography magazine in the Soviet Union, was established in 1926 and has a circulation of more than 250,000. Although the overall printing quality is only fair, it shows a good representation of Soviet work, which tends toward pictorialism and documentary. The visual quality is quite high—a nice bonus, as we rarely see examples of Soviet photography in this country. Issues include technical, historical, and critical articles, but no advertising, a pleasant change from its Western counterparts. Unfortunately, *Soviet Photo* is not available by subscription in the United States. However, you may be able to find a copy at a university or large public library.

TEN•8

This is *the* hot international high-fine-art quarterly. Combining the excellent reproduction of *Aperture* with the critical and introspective bent of *Afterimage*, *Ten•8* has interviews, reviews, and features (many with political themes) as well as portfolios, mostly in black and white. Each issue also has an education section. *Ten•8*'s dense seventy-odd pages and perfect binding make it feel more like a slim paperback book than a magazine. Given the production quality, the $10 cover price seems fair.

9 Key Hill Drive, Hockley, Birmingham B18 5NY, England. 021-554-2237.

ZOOM

Splashy *Zoom* uses very little text; most of its large-format (9¼×13-inch) pages are filled with bold images, often bled and spread across two pages. It shows a wide variety of work from all over the world, but particularly features fashion photography. Single monthly issues sell for $6.

Box 1138, Madison Square Station, New York, NY 10159.

Viewpoint: Magazine Photography

ELISABETH BIONDI
DIRECTOR OF PHOTOGRAPHY
VANITY FAIR, NEW YORK CITY

"Innovative magazine photography always starts with a group of readers who discover a magazine whose vision appeals to their interests. To respond to those interests, the magazine hires photographers who can portray that vision in an innovative, exciting way. There may be two or three magazines competing for these readers, which is healthy, but the process is the same the world over, even though the kind of photography may differ. In Germany, the action may be in photojournalism; in Italy, it could be in fashion photography.

"In America, I think the most interesting magazine photography is being done in personality portraits, an area Annie Leibovitz dominated for over a decade, first at *Rolling Stone*, then at *Vanity Fair*. She influenced a whole generation of photographers to do what I call 'glitz photography.'

"*People* magazine created the genre of celebrity journalism, which unlike glitz photography remains rooted in conventional photojournalism. (Glitz photography is more flamboyant.) *People* deals with the entire spectrum of society, whereas *Rolling Stone*, which created glitz photography, focuses on entertainment figures, a fact that allows photographers to be more theatrical.

"Although glitz photography still seems to dominate the scene, it's becoming more subdued. Photographers are moving towards a less saturated, more restrained use of color, and pictures are becoming more cerebral, classical, and a little quieter, but still interesting to look at. There's more use of black and white, too. Today's photographers seem to have studied not just the history of photography and film, but the history of art as well. They're creating links between their subject and the past in the way they use pose, setting, and manner.

"As for photojournalism, there isn't much of an outlet for it in magazines. *Life* never regained its reputation when it came back as a monthly. Perhaps the sophistication of television news has reduced the immediacy that photojournalism once had. Nobody has figured out a way to present photojournalism in a meaningful way today, a way that gets people to rush out to buy the magazine each week. *National Geographic* does the best work, but it's not news.

"To find out where photography is going, I look at a lot of magazines. I see all the Condé Nast magazines, especially the overseas editions; there's a Condé Nast language that many magazines speak, and it's important to be familiar with it. In addition, France has *Paris Match*, *Actuel*, *City*, *Egoist*, and *Globe*; England has *Face*, *Blitz*, and the younger people's music magazines; Germany has *Stern*, *Geo*, and *F.A.Z.* magazine; Switzerland has *Du*.

"One of my favorite magazines, *Hola*, comes from Spain; it's a wonderful combination of flash and trash. In America, a good place to discover talent is in the smaller style magazines such as *Paper* and *The Bomb* in New York City, and in *Details* and *LA Style*.

"Sometimes photographers don't realize that editors see a lot of photography and become easily bored. A photographer really has to work hard to create something new in order to get an editor's attention. My initial reaction to a picture is instinctive. I don't want to have to think about a picture; I want to be surprised by it. It has to reach out and grab me immediately. That's what picture editors live for—to be surprised by what we see."

Journals and Newsletters

Most journals and newsletters are published less frequently than magazines and aim at a more specific audience. Some are professionally produced, but others are homemade, little more than photocopied sheets stapled together. (With the spread of affordable desktop publishing, expect to see more of the homemade sort in the near future.) Although several newsletters have been around for years, most come and go—victims of lack of cash or diminishing reader interest.

Newsletters come from manufacturers, nonprofit groups, associations, individuals with a cause, academic institutions, and who knows who else. Few, if any, are out to make a profit, which is a good thing since, as far as we can tell, none do.

© CHARLY FRANKLIN

Photo Metro.

AFTERIMAGE

Published by the Visual Studies Workshop, *Afterimage* has been presenting scholarly work with a national focus (and sometimes a political bent) since 1972. Its net is broad, with heavy focus on video, artists' books, film, and mixed media.

A peek at a typical issue of *Afterimage* turned up a critique of a recent book on the history of photography, an interview with a video artist, a review of an exhibition and book about nineteenth-century French photographer Gustave Le Gray, a feature about the photographer-philosopher Frederick Sommer, a list of National Endowment for the Arts grant winners, various shorter news articles, plus exhibition and book reviews.

The look of *Afterimage* suggests its serious nature. Information is densely packed, with small type and a triple-column layout. Photographs are reproduced in relatively small sizes; this is a journal *about* images, not a magazine to display them. Its tabloid format is very readable, with a smooth paper stock that allows serviceable image reproduction.

The back pages of *Afterimage* alone are worth its price (free with a $28 annual membership to the Visual Studies Workshop). Called "Notices," this section provides as thorough a national listing of exhibitions, events, grants, and jobs as you'll find in one place. *Afterimage* is published monthly, except in July and August.

Afterimage, 31 Prince Street, Rochester, NY 14607. (716) 442-8676.

See pages 98, 136, and 198.

APERTURE

Aperture was founded in 1952 by some of the heaviest hitters in the photographic art world at that, or any other,

time—Ansel Adams, Dorothea Lange, Barbara Morgan, Nancy and Beaumont Newhall, and Minor White. Their stated goal was hardly modest: "To communicate with serious photographers and creative people everywhere." Despite some ups and downs over the years, the current version of *Aperture* does an excellent job of meeting that goal.

In this world of mixed media and postmodernist ponderings, *Aperture* stays remarkably close to its roots. It calls itself "the periodical of fine photography" and means it. It has the occasional long, scholarly, and even dense article, but its focus is the photograph—not theory, not philosophy, not artists' books.

Aperture, like its book publishing counterpart, is dedicated to showing photographs in their best possible light. It uses heavy coated-paper stock and fine-screened duotones for excellent black-and-white and color reproduction. Of course, somebody has to pay for this lavish production. Individual issues cost $12.50 or more, while a year's subscription (four issues) is $36.

Aperture, 20 East 23rd Street, New York, NY 10010. (212) 505-5555.

See pages 177 and 201.

ASMP BULLETIN

This monthly from the American Society of Magazine Photographers provides a refreshing change from the "artspeak" of so many photography publications. It's aimed at ASMP members who want news and practical advice on legal, business, and related issues.

For a photography journal, the *ASMP Bulletin* has remarkably few photographs. It fills its pages with suggestions on retaining rights and copyrights, information on tax changes affecting photographers, and hints on how to run a studio. Interviews with members from across the country deal with such mundane but germane subjects as billable expenses and ethics. The *Bulletin* also carries plenty of news about ASMP events, meetings, and gossip, as well as technical articles and features of general interest to pho-

Afterimage.

Aperture.

ASPP Picture Professional.

tographers and anyone involved in professional photography.

ASMP Bulletin, 419 Park Avenue South, New York, NY 10016. (212) 889-9144.

See pages 100, 157, 166, 171, and 172.

THE GUILFOYLE REPORT

Billed as a quarterly forum for nature photographers, *The Guilfoyle Report* is straightforward in content and design. It has no photographs, just twenty or so pages of text in a double-column layout, printed on three-hole paper. Those pages are packed with useful information—technical articles, news, calls for stock photographs, business advice, and much more.

Even though it targets nature photographers, much of *The Guilfoyle Report* will inform any pro or serious amateur. At $58 per year for four issues, the price is a bit steep, no doubt reflecting the newsletter's small audience. A quarterly marketing supplement published between regular issues is available for another $32 per year, but only to subscribers to the primary publication.

The Guilfoyle Report, AG Editions, 142 Bank Street, New York, NY 10014. (212) 929-0959.

HISTORY OF PHOTOGRAPHY

For a fairly arcane journal, *History of Photography* covers a lot of ground. Its published "outline of scope" spans about twenty-five subject areas, including the discovery of photochemical processes, the history of photojournalism, the relationship between photographic technique and photographic style, the growth of the photographic industry and literature, and the spread of photographic knowledge and practice to distant lands.

The journal takes that last area to heart. It's an international publication, produced in the United Kingdom and edited by an American. The advisory board represents fourteen countries and includes some key historians and curators, notably Beaumont Newhall, Van Deren Coke, and Weston Naef.

History of Photography's main goal

is to publish source materials and assess their significance. Article readability varies inevitably with the individual writers, but the content is generally first rate. The journal also features a lot of photographs that have rarely, if ever, been seen before. It's well reproduced on heavy coated-paper stock. Published quarterly; an annual subscription costs $50.

History of Photography, Taylor & Francis, 242 Cherry Street, Philadelphia, PA 19106. (215) 238-0939.

PHOTO METRO

Photo Metro is not affiliated with any organization. It has no strident point of view—no one way of looking at things—so it features a wide variety of photographic styles. It's serious without being pretentious, and it's free—if you pick it up in San Francisco. If that's not convenient, a subscription costs a modest $15 annually, and back issues are available for $3 each.

Published ten times per year (double issues in June/July and November/December) in runs of 15,000 copies, *Photo Metro* is a nicely designed tabloid, with decent but not great black-and-white and color reproductions. It's very picture oriented; photographs get plenty of space and words play a strictly supporting role.

Photo Metro pays a lot of attention to Bay Area events, but it keeps both eyes on the national front. Its unusual listings section selects exhibitions from all over the country but does not divide them into regions. Otherwise, you get the usual mix of profiles, interviews, criticism, portfolios, and news—a good read and an excellent value.

Photo Metro, 6 Rodgers 207c, San Francisco, CA 94103. (415) 861-6453.

Other Newsletters and Journals

APA NEWSLETTER

This newsletter from the New York chapter of the Advertising Photographers of America contains much good information about professional practices, such as tax tips, self-promotional

Photo Review.

MoPA.

Image.

ideas, and technical information. It also has good classified ads and relevant advertising. It's available only to APA members.

27 West 20th Street, Room 601, New York, NY 10011. (212) 807-0399.
 See page 101.

ASPP PICTURE PROFESSIONAL

The American Society of Picture Professionals' quarterly journal is aimed mostly at photo researchers, but its contents will interest photographers as well, particularly those selling stock images. Articles describe various photo archives and sources, and other features cover researchers, copyright issues, and the latest trends and technologies in stock photography.

Box 5283, Grand Central Station, New York, NY 10163. (212) 732-0977.
 See page 101.

CMP BULLETIN

This excellent, serious journal of historical and contemporary photography from the California Museum of Photography is published quarterly. It is illustrated, authoritative, and well produced.

California Museum of Photography, University of California, Riverside, CA 92521. (714) 784-3686.
 See page 110.

CENTER QUARTERLY

This is a nicely produced publication of the Center for Photography at Woodstock, with critical reviews, portfolios, and other articles of interest to center members and the wider fine-art photography community.

59A Tinker Street, Woodstock, NY 12498. (914) 679-9957.
 See pages 95, 125, and 152.

EXPOSURE

A classic academic journal, *Exposure* is published quarterly by the Society for Photographic Education. It covers serious issues in fine-art photography, from criticism to history, and also has many book and exhibition reviews. Despite the fact that *Exposure*'s readership consists mostly of photography instructors, it presents remarkably few

articles about teaching.
*Box BBB, Albuquerque, NM 87196.
(505) 243-2578.*
See pages 103 and 134.

GRUMP

Grump, billed as "a fact and opinion
and complaint and appreciation letter,"
is homemade and published sporadi-
cally by one of photography's most
outspoken writers, David Vestal. It
covers technical, aesthetic, newswor-
thy, or any other subjects about which
Vestal has a strong opinion.
*Box 309, Bethlehem, CT 06751. (203)
266-7225.*

IMAGE

This journal of photography and
motion pictures, started in 1952, comes
out twice a year for members of the
International Museum of Photography.
It includes articles on the history of
photography and film and is nicely
designed and produced, sometimes
featuring color plates.
*International Museum of Photography
at George Eastman House, 900 East
Avenue, Rochester, NY 14607. (716)
271-3361.*
See pages 106 and 150.

MICHIGAN PHOTOGRAPHY JOURNAL

A nice combination of critical articles,
interviews, portfolios, and exhibition/
book reviews, this journal is published
periodically by the Michigan Friends
of Photography.
*313 East University, Royal Oak, MI
48067. (313) 398-2428.*
See page 98.

MoPA

MoPA, one of the best-looking photo-
graphic publications around, reports on
the activities of the Museum of Photo-
graphic Arts. Though short (about ten
pages), its articles have depth and the
news pieces are of general interest.
*Museum of Photographic Arts, 1649
El Prado, Balboa Park, San Diego, CA
92101. (619) 239-5262.*
See page 111.

THE NEW ENGLAND JOURNAL

The New England Journal, published

A Handy Summary

PhotoInfo, a quarterly publica-
tion, provides categorized
abstracts of recent articles from
fifteen different photography
magazines, including *Popular
Photography, Shutterbug, Dark-
room and Creative Camera
Techniques,* and *New Photogra-
pher.* A one-year subscription is
$14.95.
*Foto Ink, Box BCD, Bisbee, AZ
85603.*

by the Photographic Historical Society
of New England, is devoted to preserv-
ing "our photographic heritage."
Although it's similar in look and con-
tent to *Photographica Journal* (see
below), *The New England Journal* is
more for the serious collector and hob-
byist than the academic. It's a well-
illustrated and informational quarterly,
with news, feature stories, and reports
on members' activities.
*Box 189, West Newton Station, MA
02165. (617) 731-6603.*

NEWS PHOTOGRAPHER

This publication of the National Press
Photographers Association covers mat-
ters of interest to newspaper and maga-
zine photographers, as well as video
and film journalists. Monthly issues
include news, profiles, listings, and
much emphasis on NPPA events,
issues, and awards.
*3200 Croasdaile Drive, Suite 306,
Durham, NC 27705. (800) 289-6772;
(919) 383-7246.*
See page 102.

NEWSLETTER

This succinctly named publication
from the Daytona Beach Community
College Photographic Society offers
criticism, interviews, and photographer
profiles, as well as news items and list-
ings of national and local interest.
*DBCC Photographic Society, Box
1111, Daytona Beach, FL 32115. (904)
255-8131.*
See pages 96 and 145.

NUEVA LUZ

Nueva Luz is published by En Foco,
the Hispanic-based photography cen-
ter. The journal features portfolios of
minority photographers, with minimal
text in both Spanish and English.
*32 East Kingsbridge Road, Bronx, NY
10468. (212) 584-7718.*
See page 96.

OCCASIONAL READINGS IN PHOTOGRAPHY

With no set publication schedule, this
journal presents articles and essays
written by students in the graduate
program of photography at Columbia
College. It covers topics of concern to
fine-art graduates, such as how the
National Endowment for the Arts fel-
lowships work and how to market art.
*Photography Department, Columbia
College, 600 South Michigan Avenue,
Chicago, IL 60605. (312) 663-1600.*
See pages 111 and 143.

PHOTIQUE

Published ten times a year, *Photique* is
a buy-sell-trade magazine for antique,
classic, and used photographic equip-
ment and images. It was started in
1988 as an alternative to *Shutterbug,*
which began as a collector's publica-
tion but now carries more and more
ads for new equipment.
*1 Magnolia Hill, West Hartford, CT
06117. (203) 233-9922.*

PHOTO REVIEW

Though it reports on photography in
the Mid-Atlantic states, *Photo Review*
has a national scope and an interna-
tional readership. Published since
1976, the quarterly contains a solid
mix of critical articles, book and exhi-
bition reviews, and portfolios in a very
readable package. A subscription also
gets you the *Photo Review Newsletter,*
published eight times per year.
*301 Hill Avenue, Langhorne, PA
19047. (215) 757-8921.*

PHOTOGRAPHIC INSIGHT

This new journal contains scholarly
and critical articles about historical and
contemporary photography. It's pub-
lished quarterly by The Bristol Work-

shops in Photography.
474 Thames Street, Bristol, RI 02809.
(401) 253-2351.

PHOTOGRAPHICA JOURNAL

Photographica Journal is produced by
the American Photographic Historical
Society of New York and cosponsored
by a number of historical societies. Its
similarity in both look and content to
The New England Journal (see above)
is not surprising, since the two used to
copublish.
*520 West 44th Street, New York, NY
10036.*

PHOTOLETTER

PhotoLetter, a theme-oriented journal,
is a highly illustrated, oversized publi-
cation of the Texas Photographic Soci-
ety. It emphasizes fine-art photography
and photojournalism and has plenty of
features and book reviews.
*Texas Photographic Society, Box 3109,
Austin, TX 78764. (512) 462-0646.*
See page 98.

SF CAMERAWORK

This quarterly with a national orienta-
tion from San Francisco Camerawork
combines feature articles, book
reviews, and portfolios in a well-pro-
duced package.
*70 12th Street, San Francisco, CA
94103. (415) 621-1001.*
See pages 98 and 125.

SHOTS

Shots is an upbeat tabloid-style quar-
terly with a handmade look. It's eclec-
tic in taste and design, featuring fine
photography of various sorts but
emphasizing documentary and photo-
journalistic work.
*304 South 4th Street, Danville, Ken-
tucky 40422.*

SPOT

Produced quarterly by the Houston
Center for Photography, *Spot* serves its
local community with extensive list-
ings of local events. Overall, however,
the publication has a distinctly national
focus. *Spot* is an oversized package
printed on heavy coated-paper stock,
packed with critical articles, reviews,

News Photographer.

Shots.

The Guilfoyle Report.

and features on both the history of
photography and contemporary mat-
ters.
*1441 West Alabama, Houston, TX
77006. (713) 529-4755.*
See pages 96 and 125.

VIEW CAMERA

A highly informative publication for
large-format photographers, *View
Camera* includes profiles of photogra-
phers, technical features, book re-
views, product comparisons, and much
more.
*Box 18-8166, Sacramento, CA 95818.
(916) 451-4867.*
See page 17.

VIEWS

Although *Views* calls itself "The Jour-
nal of Photography in New England,"
it has a strong national focus. This
quarterly from the Photographic
Resource Center does cover New Eng-
land happenings extensively, particu-
larly in the Boston area. By emphasiz-
ing historical and critical issues, it has
quietly become one of the most impor-
tant academic-style journals in photog-
raphy.
*Photographic Resource Center, 602
Commonwealth Avenue, Boston, MA
02215. (617) 353-0700.*
See pages 95, 125, and 209.

VIEWS

Yes, another *Views.* This one, a quar-
terly publication of the Toronto Pho-
tographers Workshop, includes feature
articles and exhibition reviews with a
strong emphasis on what's happening
in Canadian photography, especially in
the Toronto area.
*80 Spadina Avenue, Suite 310, Toron-
to, Ontario, Canada M5V 2J3. (416)
362-4242.*
See page 98.

ZONE VI NEWSLETTER

A quarterly review of concepts, tech-
niques, and products that reflects the
personal tastes and philosophy of pho-
tographer and Zone VI founder Fred
Picker.
Putney, VT 05346. (802) 257-5161.
See pages 57 and 152.

Artists' Books

Artists' books are those created entirely by the artist, who exercises total control from idea to execution. Such books are art works in their own right, quite unlike a monograph, which is essentially a document of an artist's work. Although artists' books have been around for a long time, they've only recently attracted what amounts to a cult following; there are now courses, symposia, and grants devoted exclusively to the genre. The field of artists' books is also sometimes referred to as visual books or book arts.

Artists' books have several common elements. Almost all are interdisciplinary, using a combination of media—for example, text, drawings, photographs, paintings, and Xerography. Artists' books are typically offset-printed in small editions and many are one of a kind. They tend to be eclectic and loosely organized; individuals attracted to this medium prefer freedom to rigidity.

Lumiere Press

At Lumiere Press, bookmaking means taking great care at all steps, in content, form, and presentation. The slipcase and binding (left) of Aurora, *by Lumiere owner Michael Torosian, gets as much attention as the insides.*

Artists' Book Sources

Since the field is so small, artists' book people are very dependent on a narrow but growing network of schools, publications, and distributors. These are some of the primary sources of information about artists' books.

AFTERIMAGE
A quarterly journal of the Visual Studies Workshop (see below), *Afterimage* covers artists' books with listings of events, an occasional feature story, and many reviews of current titles.
31 Prince Street, Rochester, NY 14607. (716) 442-8676.
See pages 98 and 193.

ARTWORKS
This distributor of artists' books that have been printed in multiple runs also operates a retail store.
170 South La Brea Avenue, Los Angeles, CA 90036. (213) 934-2205.

Artists' Books: A Critical Anthology and Sourcebook, edited by Joan Lyons, Peregrine Smith/Visual Studies Workshop, 1985.
The first and (at press time) only such anthology, *Artists' Books* features essays by prominent participants and critics, as well as bibliographies and lists of collections.

CENTER FOR BOOK ARTS
The Center for Book Arts offers an exhibition space for artists' books, as well as various courses in printing and related subjects.
626 Broadway, New York, NY 10012. (212) 460-9768.

CENTER FOR EDITIONS/SUNY AT PURCHASE
The State University of New York (SUNY) at Purchase offers an M.F.A. in book arts. Its publishing arm is the Center for Editions, a well-equipped printing shop, which currently produces about twelve artists' books per year for SUNY students.
Visual Arts Division, State University of New York, Purchase, NY 10577. (914) 253-5014.

HIGH PERFORMANCE

This magazine of performance art provides excellent regular coverage of artists' books.

240 South Broadway, Los Angeles, CA 90012. (213) 687-7362.

LUMIERE PRESS

Michael Torosian, owner of Lumiere Press, produces fine limited editions, doing the printing and binding himself. This is old-fashioned bookmaking at its best, valued as much for its form as its content. Current titles include books on Edward Weston (by his son, Cole) and by Aaron Siskind, David Heath, and Torosian himself.

19 Fermanagh Avenue, Toronto, Ontario, Canada M6R 1M1. (416) 535-7978.

MILLS COLLEGE

There is a lot of artists' book activity in the San Francisco area, and Mills College is in the thick of it. It offers a Master of Arts degree; sponsors visiting artists, lectures, workshops, and exhibitions; and maintains an active collection of fine printing and artists' books (about 11,000 pieces).

Graduate Program in Book Arts, 5000 MacArthur Boulevard, Oakland, CA 94613. (415) 430-2001.

NEXUS PRESS

Nexus Press, a nonprofit experimental visual arts press, is dedicated to the use of the offset-print medium as a primary artistic tool. It helps artists produce books, and publishes and distributes those books it sponsors. The staff at Nexus Press provides technical support, leading the artist but not dominating the process.

608 Ralph McGill Boulevard, Atlanta, GA 30312. (404) 577-3579.

Offset: A Survey of Artists' Books, by Gary Richman, New England Foundation for the Arts, 1984. Available from 678 Massachusetts Avenue, Cambridge, MA 02139.

A catalog for a major exhibition of artists' books, *Offset* shows spreads from dozens of books, with publication information and listings of resources,

Janet Zweig, Heinz and Judy, a play, *Photographic Resource Center, 1985.*

Phil Zimmerman, Interference, *Nexus Press, 1982.*

including magazines, publishers, workshops, distributors, and related services.

PACIFIC CENTER FOR BOOK ARTS

This is a professional organization for anyone working in the field who is interested in any phase of fine book production. It sponsors lectures, workshops, exhibitions, and the occasional publication, and publishes *Ampersonal*, a quarterly newsletter.

Box 6209, San Francisco, CA 94101.

THE PRINT COLLECTOR'S NEWSLETTER

This newsletter deals with collecting prints and photographs, and also covers artists' books, some of which are very collectable.

72 Spring Street, New York, NY 10012. (212) 219-9722.

See page 125.

PRINTED MATTER

Cofounded by artists, Printed Matter is a mail-order firm, retail store, and wholesale distributor of artists' books.

It handles over 3,000 titles by more than 1,500 artists in areas such as graphic arts, typography, humor, and photography.

7 Lispenard Street, New York, NY 10013. (212) 925-0325.

PYRAMID ATLANTIC

Pyramid Atlantic offers a myriad of courses on making artists' books—including paper making and printing—and also has a fledgling publishing program.

6925 Willow Street N.W., #226, Washington, DC 20012. (202) 291-0088.

Structure of the Visual Book, by Keith A. Smith, Visual Studies Workshop Press, 1984. Available from Visual Studies Workshop Press (see below) or from 22 Cayuga Street, Rochester, NY 14620.

The closest thing to a how-to manual for artists' books. *Structure of the Visual Book* deals with such issues as grouping, sequencing, pacing, and rhythm, as well as the various ways of presenting the final product.

A Photographer's Artists' Book

When Bill Burke flew to Thailand for the first time, he had no intention of making a book. But one thing led to another and, two more trips and several upsetting incidents later (including a broken neck suffered in a car accident), Burke set about making a book on his experiences in Southeast Asia.

He had help from Nexus Press (see page 199), a nonprofit organization in Atlanta supported largely by grants from the National Endowment for the Arts. Nexus Press provides artists with the space, materials, and, most importantly, the technical expertise they need to create a book, with the stipulation that the artist be fully involved and come to Atlanta to oversee the process. That's not much of a stipulation, as control of the process is what artists' books are all about.

Burke and Nexus were old friends, having collaborated on his first book, *They Shall Cast Out Demons* (total cost: $1,000 and a lot of labor). For the Asia book, Burke received a grant from the Massachusetts Council for the Arts, showing them a rough handmade dummy combining his exhaustive journal of the trips with his pictures. The grant paid for time off from his teaching job at the School of the Museum of Fine Arts in Boston, as well as travel expenses and materials. Nexus Press kicked in some of its own grant money to cover press time.

From the beginning, Burke stresses, "the form of the book was more important than mass production." One look at *I Want to Take Picture* shows that its form, not to mention structure, is a striking and unique combination of words and pictures—a very personal journey that, as one reviewer noted, is "part documentary and part travelogue."

Bill Burke, I Want to Take Picture, *Nexus Press, 1987.*

UMBRELLA

This information-packed journal, published twice annually, covers art books of all types, with much emphasis on photography books, experimental arts, and artists' books. It also has newsworthy stories about artists and artistic happenings, emphasizing those related to bookmaking, as well as information on new journals, magazines, and periodicals. An annual subscription to *Umbrella* costs $15.
Box 3692, Glendale, CA 91104 and Box 40100, Pasadena, CA 91114. (818) 882-6108; (818) 797-0514.

VISUAL STUDIES WORKSHOP

Graduate students at the Visual Studies Workshop can specialize in artists' books. The program is highly regarded and loosely structured. The Visual Studies Workshop Press is a not-for-profit printshop where artists, photographers, and independent publishers can work with a professional staff to produce books. It sells these books at its retail bookstore and through a mail-order catalog.
31 Prince Street, Rochester, NY 14607. (716) 442-8676.
See pages 98, 136, 152, 193, and 198.

TONY ZWICKER

Ms. Zwicker distributes one-of-a-kind and small-edition artists' books by mail and by appointment. She carries a lot of European work and unusual titles.
15 Grammercy Park, New York, NY 10003. (212) 982-7441.

Mail-Order Books

The most reliable suppliers of photography titles are mail-order houses. Few retail bookstores maintain an excellent photography section; such titles are expensive, don't sell especially well, and damage easily. Many publishers sell their books through the mail, but few actively promote this side of their business. Mail-order companies generally carry the best inventory, and some offer discounts that help offset shipping charges. Also, books shipped to a state in which the firm doesn't have a store or office are not subject to sales tax.

Some mail-order houses sell new titles, others old. Some specialize in fine-art books; others carry mostly books on professional photography. Even if you don't buy regularly through the mail, browsing in the catalogs is the best way to keep up on what's currently being published.

The main disadvantages to mail order are that you have to wait to get the book, and that you can't browse through it before buying. But if you've already browsed elsewhere, or if you're otherwise certain you want to buy, one of the following mail-order houses should meet your needs. (Mail-order firms specializing in rare books are listed on pages 127 and 128.)

APERTURE

Aperture sells only its own books, posters, and other products through the mail—but that adds up to a lot of books, and most of them are first rate. Catalog orders qualify for a 10 to 20 percent discount.
20 East 23rd Street, New York, NY 10010. (212) 505-5555.
See pages 177 and 193.

INTERNATIONAL CENTER OF PHOTOGRAPHY

The ICP catalog includes newly published books and backlist titles. Its offerings aren't wide, but they represent many of the best books available. Members receive a 15 percent discount.
1130 Fifth Avenue, New York, NY 10128. (212) 860-1767.
See pages 95, 106, 151, 213, and 230.

LIGHT IMPRESSIONS

A book division at Light Impressions publishes several catalogs throughout the year, offering new titles, limited editions, and one of the most complete backlists anywhere. A master index, available by request, presents a reasonably complete compendium of in-print photographic literature. Most titles are discounted 15 percent.
439 Monroe Avenue, Rochester, NY 14607. (800) 828-6216; (800) 828-9629 in New York State; (716) 271-8960.
See pages 54, 85, and 206.

NATIONAL GEOGRAPHIC PUBLICATIONS CATALOG

One of the largest specialty publishers of photography books, the National Geographic Society sells its own titles, mostly photographic essays for adults and children. Many of these photogra-

phy publications are difficult to find elsewhere.
National Geographic Society, Washington, DC 20036. (800) 638-4077.

PDN/Books

This slick catalog, published by *Photo District News* magazine, features a variety of titles but has a particularly strong selection of books related to professional photography.
49 East 21st Street, New York, NY 10010. (800) 323-9335; (212) 995-7225.
See pages 171 and 185.

Photo-Eye Books

Photo-Eye emphasizes new fine-art photography books, many from small presses and hard to find elsewhere. It publishes informative quarterly catalogs and an exhaustive annual one with over 1,300 titles, including books on history, technique, commercial photography, and so forth. Books ordered from prepublication announcements are discounted 15 percent, and Photo-Eye offers a good selection of sale books and publishers' remainders.
Box 1504, Austin, TX 78767. (512) 480-8409.

A Photographer's Place

With perhaps the largest stock of photography books anywhere, and certainly the most eclectic, A Photographer's Place features a wild mix of new, used, out-of-print, and sale titles, many hard to find elsewhere. Its catalog is published six or more times a year.
133 Mercer Street, New York, NY 10012. (212) 431-9358.
See page 128.

ReSource

ReSource focuses on new books, but sells backlist titles as well. Its selection is a welcome mix of monographs and collections, plus historical, critical, and technical books. The catalog appears twice per year and orders over $50 are discounted 10 percent.
The Maine Photographic Workshops, 2 Central Street, Rockport, ME 04856. (800) 227-1541; (207) 236-4788.
See pages 12, 56, and 206.

The Rotkin Review

Billed as a "unique reporting service on photography, art and communications books for libraries and book users," this quarterly is a good read for anyone who loves photography books. Charles E. Rotkin, a veteran photographer and author, compiles a substantial amount of information in a no-nonsense, three-hole-punched format, containing reviews but also short features by contributing writers, such as a particular writer's favorite books (and why) and a list of books on the development of documentary photography.

The reviews are generally thorough, opinionated, and informed. Some are by Rotkin, others by a variety of distinguished professionals. *The Rotkin Review* is also a book-ordering service, with subscribers receiving discounts (generally around 20 percent) on their orders.
The Rotkin Review, 1697 Broadway, New York, NY 10019. (212) 757-9255.

The Photo-Eye Books catalog.

Photography Book Club

This is the only club that exclusively sells photography titles. Originally called the Popular Photography Book Club, it has a membership of about 20,000 professional and serious amateur photographers. The club sells all types of books, but specializes in those treating technical, commercial, and business matters.

Like most book clubs, the Photography Book Club offers an introductory package with a minimum purchase obligation. You then accumulate bonus points that can lead to as much as a 50 percent discount on most titles. All books routinely carry discounts of about 20 percent or more.
Photography Book Club, Box 2003, Lakewoods, NJ 08701. (212) 536-5112.

MISCELLANY

Archival Care

Photographic materials deteriorate over time. Stains appear; colors fade. Some materials are more stable than others—for example, black-and-white prints will last longer than Polaroids —but to some degree the process is inevitable. However, some steps can be taken to make images last longer.

Good processing technique is very important, particularly in the fixing, washing, and drying stages. So are good storage and presentation procedures. Negatives, slides, and prints should be kept in sleeves and boxes that won't harm them; mattes and frames should also be made of safe materials. Conditions in the storage area are also important; high humidity and heat can be very harmful, as can prolonged exposure to light.

Of course, you can drive yourself crazy worrying about all these factors. Since most films and prints will last for a long time without much special care, you might reasonably ask whether your pictures are worth the extra time and expense of archival care. Maybe they're not, but anyone who's dug into their file of photographs or family albums and come up with damaged goods surely knows the sense of loss this can cause.

Years ago, most people gave little thought to the care of photographs. Today, due partly to the growth of interest in photography as a collectable art, there's a tremendous amount of published information about it, as well as dozens of suppliers providing special archival materials and products. Much of this energy is generated by professional archivists—those entrusted with safely maintaining collections of photography. But serious concern has grown among individual photographers, many of whom now take great pains and expense to see that their photographs will stick around, unfaded and unstained, for generations to come.

Archival Publications

Plenty of books, many of them quite technical, deal with issues of image permanence. The following are authoritative, yet still accessible.

Care and Identification of 19th-Century Photographic Prints, by James M. Reilly, Kodak Publication G-2S, 1986. This is a clearly written, highly illustrated, and very complete guide to identifying and preserving nineteenth-century photographic and photomechanical prints. A full-color wall-sized chart is enclosed, showing how to identify major print types.

The Care of Photographs, by Siegfried Rempel, N. Lyons Books, 1987. In the most current book on the subject, Rempel covers both practical concerns and more general issues in the field of photographic conservation. The book stresses the handling of existing photographs, not processing.

Conservation of Photographs, by George T. Eaton, Kodak Publication F-40, 1985. The latest revision of this classic provides up-to-date information on the

Image Permanence Institute

The Image Permanence Institute is the world's largest independent laboratory devoted to studying photographic preservation. It was founded in 1985 and is sponsored jointly by the Rochester Institute of Technology and the Society for Imaging Science and Technology. The institute's mission involves research, training preservation specialists, testing, and consulting to cultural organizations and the photographic industry. It strives to set technical standards for curators and archivists. *RIT City Center, 50 West Main Street, Rochester, NY 14614. (716) 475–5199.*

stability factors for both black-and-white and color materials. It includes chapters on conserving early photographs and managing a collection.

The Life of a Photograph, by Laurence E. Keefe, Jr. and Dennis Inch, Focal Press, 1984.
This practical guide on archival handling of films and prints is one of the most thorough books on the subject. Sections include processing for permanence, mounting, and storage.

More Archival Publications

Administration of Photographic Collections, by Mary Lynn Ritzenthaler, Gerald J. Munoff, and Margery S. Long, Society of American Archivists, 1984. Available from 600 South Federal, Chicago, IL 60605. (312) 922-0140.

Caring for Photographs: Display, Storage, Restoration, Life Library of Photography, Time-Life Books, 1982.

Evaluating the Processing of Black-and-White Photographic Papers with Respect to the Stability of the Resultant Image, Method 4, PH4.32, American National Standards Institute (ANSI), 1986.

Processed Films, Plates, and Paper —Filing Enclosures and Containers for Storage, PH1.53, ANSI, 1986.

Processed Safety Film Storage, PH1.43, ANSI, 1985.

Shoots: A Guide to Your Family's Photographic Heritage, by Thomas L. Davies, Addison House, 1977.

Storing, Handling, and Preserving Polaroid Photographs: A Guide, edited by Pamela Duffy, Focal Press, 1983.

American National Standards Institute publications are available from ANSI at 1430 Broadway, New York, NY 10018. (212) 354-3300.
Kodak Publications are available at many camera stores or directly from

Eastman Kodak, 343 State Street, Rochester, NY 14650. (800) 233-1650; (800) 233-1647 in New York State.

Archival Suppliers

Many mail-order firms offer products for archival care, but the ones listed below specialize in such products. Customers include photographers, but most orders come from archives, libraries, and other institutions that collect negatives, slides, or prints.

CONSERVATION RESOURCES INTERNATIONAL

Conservation Resources makes dozens of products such as matte boards, boxes, and negative and slide envelopes, as well as obscure items such as envelopes for glass plates. Its catalog is quite informative about the products and archival concerns in general.
8000-H Forbes Place, Springfield, VA 22151. (800) 634-6932; (703) 321-7730.

D. ANDREW EDDY

Mr. Eddy, a maker of archival print cases, is also a bookbinder. His specialty is custom design; his products are hand-crafted of fine materials. *99 Glendower Road, Roslindale, MA 02131. (617) 325-8754.*

FRANKLIN DISTRIBUTORS

Franklin offers a broad line of archival and nonarchival storage and retrieval systems. Its Saf-T-Stor sleeves were developed in association with the Library of Congress, which uses them to protect part of its slide collection. *Box 320, Denville, NJ 07834. (201) 267-2710.*

HOLLINGER

Hollinger's catalog includes stock and custom-made archival products, but specializes in storage boxes. It offers several types, as well as a box maker so you can design your own. *Box 8360, Fredericksburg, VA 22401. (703) 898-7300.*

LIGHT IMPRESSIONS

As the foremost supplier to individual photographers, Light Impressions' archival offerings are immense, from storage boxes and envelopes to metal

A Preservation Seminar

The Technical and Education Center of the Graphic Arts at the Rochester Institute of Technology runs seminars for anyone interested in archival issues. The annual offering, called Preservation of Black-and-White Photographs, features many of the experts in this field and has two components that can be taken individually: Identifying, Handling, and Storing Photographs (five days) and Copying and Duplicating (three days). An intense schedule awaits attendees—mornings through evenings of lectures, labs, tours, and special workshops. Subject areas include cleaning, displaying, and housing early and contemporary materials, and there are many opportunities for hands-on activities, such as making protective sleeves from scratch. The seminar also includes such topics as the chemistry of nineteenth-century negative processes, care of daguerreotypes, a technological history of early printing papers, and optimum processing of modern photographic materials. Some of this may seem obscure, but these are the issues that archivists, especially those guarding nineteenth-century collections, must deal with. Sign up early; this seminar sells out.

Technical and Education Center of the Graphic Arts, Rochester Institute of Technology, One Lomb Memorial Drive, Rochester, NY 14623. (716) 475-2757.

The Right Archival Stuff

Storage containers and matte board made from the products listed below are considered safe for archival storage of slides, negatives, and prints. However, this is a bit of a simplification. Just because a material is acid-free, for example, doesn't guarantee total safety; it must also be lignin-free with a high alpha cellulose content. Got that? Those who are especially picky might want to run a Photographic Activity Test (IT9.2), which you can get from the American National Standards Institute at 1430 Broadway, New York, NY 10018. (212) 354-3300.

cellulose tri-acetate
glass
metals coated with baked enamel
polyethylene
polyester
porcelain
rag or acid-free paper, board, or
 boxes
stainless steel

files and shelves—plus obscure items such as ultraviolet filters for fluorescent lamps. Some prices run a bit high, but the products and service are first rate.
439 Monroe Avenue, Rochester, NY 14607. (800) 828-6216; (800) 828-9629 in New York State; (716) 271-8960.
 See pages 54, 85, and 201.

THE MAINE PHOTOGRAPHIC RESOURCE
This excellent catalog presents a variety of books, materials, and products. Archival items include envelopes and boxes, print washers, matte board, and smaller items such as linen tape for overmatting.
Rockport, ME 04856. (800) 227-1541; (207) 236-4788.
 See pages 12, 56, and 202.

PHOTOFILE
Photofile has developed unique products for negative and slide storage. Its offerings include transparency display mounts and index cards with preattached sleeves for originals. The prime customers are businesses, but Photofile products are also used by professional and serious amateur photographers.
2000 Lewis Avenue, Zion, IL 60099. (312) 872-7557.

POHLIG BROS.
Specializing in archival storage supplies, the Pohlig Bros. catalog features a wealth of boxes, albums, folders, and accessories.
Century Division, 2419 East Franklin Street, Richmond, VA 23223. (804) 644-7824.

PORTFOLIOBOX
This company was established to manufacture custom presentation boxes, folios, and cases. It now offers a wide variety of standard products, all of very high quality.
166 Valley Street, Building 3-402, Providence, RI 02909. (401) 272-9490.

SPINK AND GABORC
This maker of fine storage boxes is perhaps best known for its sturdy and handsome presentation cases and portfolios, not always of archival quality.
11 Troast Court, Clifton, NJ 07011. (201) 478-4551.

TALAS
Talas offers both commonplace and esoteric products for disciplines such as bookbinding, calligraphy, papermaking, and art conservation, restoration, and repair. Its catalog also carries museum, library, and office supplies, plus about thirty pages devoted to photography and archival storage. Products include acid-free and 100 percent–rag matte boards, several matte-board cutters, safe storage boxes, and systems for keeping and viewing slides. Talas charges $4 for its catalog.
213 West 35th Street, New York, NY 10001. (212) 736-7744.

UNIVERSITY PRODUCTS
This large mail-order supplier of archival materials for conservation, restoration, and preservation focuses more than forty pages of its catalog on photographic products, including those for processing, matting, and storage.
517 Main Street, Holyoke, MA 01041. (800) 628-1912; (413) 532-9431 (call collect in Massachusetts).

WESTFALL FRAMING
Not strictly an archival supplier, Westfall offers a wide supply of matting and framing materials at a good price. Some of its matte board meets archival standards.
Box 13524, Tallahassee, FL 32317. (800) 334-1652; (800) 874-3164 in Florida.

Quick Tips for Archival Care

1. Use fresh chemicals for processing.

2. Fix the image completely, but don't overfix. Use a non-hardening fixer for prints.

3. Wash film and paper thoroughly, using a fixer-remover solution followed by a water wash using an archival washer (see pages 48–50) that provides regular recycling of running water.

4. Air-dry film and prints by hanging them up, or, with prints, by laying them on a fiberglass screen.

5. Store negatives, slides, and prints with care, using polyethylene, polypropylene, or polyester sleeves for negatives and slides, and acid-free boards and boxes for prints. *Avoid negative and slide sleeves made of vinyl.*

6. Avoid high temperature, high humidity, and excess light in storage and display environments.

Awards

Aside from an ego boost, awards bring professional credibility and cash prizes (or products). Anything that helps your career *and* your bottom line can't be all bad. Dozens of organizations honor individual photographers in a variety of categories. Awards run the gamut from fine-art photographers to wedding specialists. High-school students compete, as do senior citizens.

For some awards you must be nominated; for others, you apply by submitting samples of your work to be judged by a panel of experts. Sometimes cash grants honor particular projects, but often they simply recognize an individual's accomplishments to date.

Aside from grants, you can apply for fellowships, residences, prizes, and other types of awards. Here is a summary of some of the most important and prestigious awards currently offered in photography.

GUGGENHEIM FELLOWSHIPS

A Guggenheim is the most sought-after award for fine-art photographers. The Guggenheim Foundation, established by Senator and Mrs. Simon Guggenheim as a memorial to their son, supports the future projects of "men and women who have already demonstrated exceptional capacity for productive scholarship or exceptional creative ability in the arts."

Photographers make up a small percentage of Guggenheim recipients. Fellowships also go to historians, novelists, filmmakers, poets, choreographers, and other creative types. In 1988, 262 Guggenheims were awarded, but only seven in photography (to six photographers and one photographic curator). Those 262 winners were chosen from 3,265 high-level applicants. The prestige is great, but the cash isn't bad either—the foundation gave out $6,343,000 in 1988, in average grants of $24,210.

To qualify for a Guggenheim, applicants must have four very strong recommendations and must develop a detailed plan for using the fellowship. If they get beyond the initial selection stage, they must then submit a project budget.

Some very significant work has sprung directly from the funding provided by Guggenheims. In photography, notable examples include two landmark books—*California and the West* by Edward Weston, and *The Americans* by Robert Frank. Both photographers received rare back-to-back fellowships, in 1937–38 and 1955–56, respectively.

John Simon Guggenheim Memorial Foundation, 90 Park Avenue, New York, NY 10016. (212) 687-4470.

Sebastiao Salgado, Ecuador, 1982. *The W. Eugene Smith Grant, 1982.*

NEA/Visual Artists Fellowships

Created in 1965 as an independent agency of the federal government, the National Endowment for the Arts has a mandate "to encourage and support American arts and artists." It does that by providing direct funding to individual artists and matching funding to nonprofit arts organizations, state and local arts agencies, and other arts groups.

Through its Visual Arts Program, the NEA currently offers individual grants of $5,000 and $20,000. Award categories include sculpture, crafts, painting, works on paper (printmaking, drawing, artists' books), new genres (such as performance art and video), and photography. Photography grants are awarded every two (even-numbered) years.

The NEA has become the single largest funding source for fine-art photographers, and the competition is fierce. In 1988, 1,721 photographers applied for sixty fellowships.

It's surprisingly easy to apply for an NEA fellowship. Just fill out the simple form and send it in, along with ten 35mm slides of your photographs—no original prints. A panel of six experts will review the work and decide your fate. Recipients must file a final report when the one-year fellowship ends.

National Endowment for the Arts, Room 729, Nancy Hanks Center, 1100 Pennsylvania Avenue, Washington, DC 20506. (202) 682-5448; (202) 682-5496 for the hearing impaired.

Pulitzer Prizes

These annual awards, endowed by newspaper publisher Joseph Pulitzer, honor fourteen categories for journalism, including two in photography —one for spot news (a single image), the other for feature photography (generally a series). Anyone can apply for work that has appeared in a U.S. daily, Sunday, or weekly newspaper. The cash prize is only $3,000, but the prestige is enormous. A Pulitzer is the most vaunted honor that a photojournalist can hope to receive.

The first photography Pulitzer Prize was awarded in 1942, to Milton Brooks of the *Detroit News* for his dramatic photograph depicting picket-line violence during a strike at the Ford Motor Company. Since then, Pulitzer winners have included many icons of American life.

Columbia University, 702 Journalism, New York, NY 10027. (212) 854-3841.

Other Awards

Kate Carter Fellowships

This resident fellowship, awarded twice a year, is designed to help fine-art, editorial, or commercial photographers complete a body of work. The fellowship includes a cash stipend of $5,000, accommodations in Rockport, a private darkroom, and a part-time technical assistant.

The Maine Photographic Workshops, Rockport, ME 04856. (800) 227-1541; (207) 236-8581.

See pages 56, 149, 202, and 213.

Ferguson Grant

Established in 1972, the Ferguson Grant awards one $2,000 grant to an emerging fine-art photographer who has "demonstrated excellence in and commitment to the field of creative photography."

Friends of Photography, 101 The Embarcadero, Suite 210, San Francisco, CA 94105. (415) 391-7500.

See pages 94, 125, 149, 212, and 213.

Leopold Godowsky, Jr. Color Photography Awards

A biennial award sponsored by Kodak and named after the coinventor of Kodachrome. Every two years, this award honors international photographers for excellence in color photography. Each grant cycle focuses on photographers in a specific region of the world. You can't apply for the award; you must be nominated. Winners each receive about $2,000 to $3,000.

Photographic Resource Center, 602 Commonwealth Avenue, Boston, MA 02215. (617) 353-0700.

See pages 95, 125, 177, 197, and 209.

Golden Light Awards

These recognition awards (no cash) are given each year in four categories: photographer of the year, best photographic book, lifetime achievement, and service to photography. In the book category, authors and publishers can submit entries; in the other categories, winners are nominated by committee and chosen by judges.

The Maine Photographic Workshops, Rockport, ME 04856. (800) 227-1541; (207) 236-8581.

See pages 56, 149, 202, 213, and 222.

Grand Prix International Henri Cartier-Bresson

Every other year, the *Centre National de la Photographie* awards a prize to enable the winner to complete a specific project—reportage in black and white, Cartier-Bresson style. The competition, cosponsored by American Express, is open to photographers of all nationalities, but candidates must be nominated by an institution. The prize money is 250,000 French francs—about $40,000. *Bonne chance!*

Centre National de la Photographie, 42 Avenue des Gobelins, Paris 75013, France. (1) 45-35-43-03.

Ernst Haas Grant

This relatively new award is one of the largest for individuals—$10,000 cash. The Haas grant goes to mid-career photographers, to enable them to continue or complete a body of work. It's funded by Kodak, and is one of several awards in the Maine Photographic Workshops' Annual Grant Program.

The Maine Photographic Workshops, Rockport, ME 04856. (800) 227-1541; (207) 236-8581.

See pages 56, 149, 202, 213, and 222.

Kodak International Newspaper Snapshot Awards

KINSA, started in 1935, is limited to amateur photographers. It honors prizewinners of local competitions sponsored by approximately 150 newspapers throughout the United States, Canada, Mexico, and the United King-

dom. Participating newspapers submit the winning photographs from their contests. KINSA winners receive a total of over $45,000 in prizes, including one grand award of $10,000.

Eastman Kodak, Department 841, 343 State Street, Rochester, NY 14650. (716) 724-5615.

KODAK PROFESSIONAL PHOTOGRAPHY SCHOLARSHIP PROGRAM

Kodak recently started this scholarship with twenty-five colleges, universities, and other schools. Kodak provides a $25,000 endowment to each school, and the schools pick the scholarship winner—one per year, for about $2,000. Applicants must be full-time photography majors at participating schools.

Eastman Kodak, Photographic Trade Relations, 343 State Street, Rochester, NY 14650. (716) 724-4650.

DOROTHEA LANGE FELLOWSHIP

This fellowship was established in 1981 and annually awards $1,600. Lange, who died in 1965, was best known for her photographs documenting social conditions in the United States during the 1930s and 1940s. The award's sponsor, the Oakland Museum, owns the most substantial collection of her photographs.

The Oakland Museum, 1000 Oak Street, Oakland, CA 94607. (415) 273-3005.

LEICA MEDAL OF EXCELLENCE

Open to all, this competition has several categories, including photojournalism, commercial work, fine-art photography, and student efforts. A panel of experts nominates candidates for person of the year, master of photography, and educator of the year awards. Winners receive a medal, Leica equipment, and a trip to the gala awards evening in New York City.

Leica USA, 156 Ludlow Street, Northvale, NJ 07647. (201) 767-7500.

REVA AND DAVID LOGAN GRANTS IN SUPPORT OF NEW WRITING IN PHOTOGRAPHY

Established in 1983, the Logan awards

Pulitzer Moments

Moments is a compelling book featuring all the Pulitzer Prize–winning photographs throughout the years. The text includes many reminiscences by the winners. An appendix offers technical information about each photograph, such as what kind of camera, lens, and film were used. The book has been updated once, but the most recent edition (1982) is out of print. (Copies may still be available through the Outlet Book Company, 225 Park Avenue South, New York, NY 10003.) Until it's updated, this edition will do just fine. Here are some examples of what you'll find.

• Marines placing the flag on Iwo Jima (Joe Rosenthal, 1945)
• Babe Ruth's farewell at Yankee Stadium (Nat Fein, 1949)
• Sequence of the sinking of the liner *Andrea Doria* (Harry Trask, 1957)
• Jack Ruby murdering Lee Harvey Oswald (Bob Jackson, 1964)
• Execution of a Vietcong prisoner (Eddie Adams, 1969)
• Girl screaming over the body of a Kent State student (John Filo, 1971)
• Children running from napalm raid (Nick Ut, 1973)
• Reagan assassination attempt (Ron Edmonds, 1982)

Moments: The Pulitzer Prize Photographs, by Sheryle and John Leekley, Crown, 1982.

John Paul Filo, Kent State. *Pulitzer Prize, 1971.*

honor new writing on photographic "criticism, history, aesthetics, theory, and issues of contemporary importance to the field." Applicants submit proposals for manuscripts, and a panel selects up to three winners. The grants total $5,000 each year, and the work that results is published in a special supplement of *Views: The Journal of Photography in New England.*

Photographic Resource Center, 602 Commonwealth Avenue, Boston, MA 02215. (617) 353-0700.

See pages 95, 125, 197, and 208.

Guggenheim Fellows in Photography

1937
Edward Weston
1938
Edward Weston *
1940
Walker Evans
1941
Walker Evans *
Dorothea Lange
Eliot F. Porter
1942
Wright Morris ***
1945
Jack Delano
Theodore Brett Weston
1946
Ansel Adams
Wayne Miller
Wright Morris */***
Eliot F. Porter *
G.E. Kidder Smith
1947
Wayne Miller *
Beaumont Newhall **
1948
Ansel Adams *
James A. Fitzsimmons
1949
Homer Gordon Page
1952
Roy DeCarava
1953
William A. Garnett
Max Yavno
1954
John Szarkowski
1955
Robert Louis Frank
Todd Webb
1956
Robert Louis Frank *
William A. Garnett *
W. Eugene Smith
Todd Webb *
1957
John Collier, Jr. **
W. Eugene Smith *

1959
Ansel Adams *
Walker Evans *
Helen Levitt
1960
Lee Norman Friedlander
Helen Levitt *
1961
Bruce Landon Davidson
John Szarkowski *
1962
Lee Norman Friedlander *
Geraldine Sharpe
1963
Diane Arbus
Dave Heath
1964
Robert Adelman
William R. Current
Dave Heath *
Garry Winogrand
1965
Scott Hyde
Lisette Model
1966
Diane Arbus *
Paul Caponigro
William Gale Gedney
Ray K. Metzker
Aaron H. Siskind
David Vestal
1967
Marie Cosindas
George Krause
Rose Mandel
Marion Palfi
Jerry N. Uelsmann
1968
Richard F. Conrat
David Plowden
W. Eugene Smith *
1969
Chauncey Ross Hare
Danny Lyon
Art Sinsabaugh
Garry Winogrand *
1970
Sheila Maureen Bisilliat
Imogen Cunningham
Benedict J. Fernandez
Joel Meyerowitz
Tod Papageorge
Minor Martin White

1971
Mark Cohen
Len Gittleman
Chauncey Ross Hare *
Claudia Andujar Love
Enrico Natali
Cervin Robinson
Henry Wessel, Jr.
1972
Harry M. Callahan
Liliane de Cock
Kenneth B. Josephson
Fred W. McDarrah
Roger Minick
Thomas Porett
Keith A. Smith
Geoffrey L. Winningham
1973
Robert H. Adams
William T. Dane
Eugenia Parry Janis **
Wendy Snyder MacNeil
Sonia Sheridan
George A. Tice
John Vachon
David Vestal *
1974
William Brooks Clift III
Van Deren Coke **
Michael Di Biase
James Dow
William J. Eggleston
Emmet Gowin
André Kertész
Roger Mertin
Ken T. Ohara
Tetsu Okuhara
Frederick Sommer
Alwyn Scott Turner
Don Worth
1975
Manuel Alvarez Bravo
Paul Caponigro *
Paul Diamond
William A. Garnett *
Laura Gilpin
Frank W. Gohlke
Robert F. Heinecken
Leon Levinstein
Beaumont Newhall */**
Stephen Shore
1976
Lewis Baltz

Mark Cohen *
Laurence Fink
Chauncey Hare *
George Krause *
Jerome Liebling
John McWilliams
Nicholas Nixon
Bill Owens

1977
Claudia Andujar (Love) *
Jerry Dantzic
Lee Friedlander *
Mark Goodman
John Gutmann
Sandy Hume
Tod Papageorge *
Sylvia Plachy
Edward Ranney
Jerry Thompson

1978
Richard Benson
William Burke
Judy Dater
Jan Groover
Benjamin Lifson
Joel Meyerowitz *
Richard Misrach
Walter Rosenblum
Joel Sternfeld
Marco Antonio Valdivia
Henry Wessel, Jr. *
Geoffrey L. Winningham *
Garry Winogrand *

1979
Peter C. Bunnell **
Linda Connor
Barbara Crane
Louis Faurer
Laurence Fink *
Alexander E. Harris
Stuart D. Klipper
Larry E. McPherson
Ray K. Metzker *
Leland Rice
Rosalind Solomo

1980
Robert Adams *
William Clift *
Robert Cumming
Susan Jane Felter
Joseph D. Jachna
Len Jenshel
Herbert Matter

Eugene Richards
Marcos Santilli
Keith A. Smith *
Hiroshi Sugimoto

1981
Jerry Dantzic *
Jay Dusard
Paul Kwilecki
Helen Levitt *
Jerome Liebling *
William Maguire
Paul A. McDonough
Meridel Rubenstein
Henry Wilhelm **
David Wing

1982
Marilyn Bridges
William T. Dane *
Estelle Jussim **
Barbara Kasten
William Larson
Anne Noggle
Thomas Roma
Leo Rubinfien
Joel Sternfeld

1983
Kenneth Baird
Joe Deal
John Harding
Bruce Horowitz
Terry Husebye
Jeff McAdory
Cindy Sherman
Larry Sultan
Anne Tucker **

1984
Zeke Berman
William Christenberry
Lois Connor
Donigan Cumming
Mary Frey
Frank Gohlke *
Nancy Hellebrand
Baldwin S. Lee
Barbara Pugh Norfleet
Sage Sohier
Michael Spano

1985
John Coplans
Ralph Gibson
Jim Goldberg
David T. Hanson
Ulrich F. Keller **

Robert Mahon
Antonio Mendoza
Judith Joy Ross
Jo Ann Walters

1986
Richard Benson *
Judith Black
John Edward Devine
John Divola, Jr.
Frank Herrera
Nicholas Nixon *
Art Rogers
Allan Sekula **
JoAnn Verburg

1987
Joseph Bartscherer
Leon A. Borenzstein
Philip–Lorca di Corcia
James Enyeart **
Sally Mann
Richard Pare
Catherine Wagner
William Wegman
Neil Winokur

1988
Jack Carnell
Roy David Colmer
William Klein
Jane S. Livingston **
Reagan Louie
Dana A. Salvo
Laura Volkerding

1989
Diane Blell
Jo Ann Callis
Gregory Connis
Bruce Cratsley
Geoffrey James
Stuart Klipper *
Jean N. Locey

* *renewal*
** *for writing*
*** *for writing and photography*

Regional Fellowships

In addition to the nationally oriented Visual Artists Fellowships, the National Endowment for the Arts offers regional fellowships—some in photography. Visual artists residing in these regions who have not received a national fellowship are eligible to apply.

ARTS MIDWEST
Hennepin Center for the Arts
528 Hennepin Avenue, Suite 310
Minneapolis, MN 55403
(612) 341-0755
(Illinois, Indiana, Iowa, Michigan, Minnesota, North Dakota, Ohio, South Dakota, Wisconsin)

CONSORTIUM FOR PACIFIC ARTS & CULTURES
2141C Atherton Road
Honolulu, HI 96822
(808) 946-7381
(American Samoa, Guam, Northern Mariana Islands)

MID-AMERICA ARTS ALLIANCE
912 Baltimore Avenue, Suite 700
Kansas City, MO 64105
(816) 421-1388
(Arkansas, Kansas, Missouri, Nebraska, Oklahoma, Texas)

MID-ATLANTIC ARTS FOUNDATION
11 East Chase Street, Suite 1-A
Baltimore, MD 21202
(301) 539-6656
(Delaware, District of Columbia, New Jersey, New York, Pennsylvania, Virginia, West Virginia)

NEW ENGLAND FOUNDATION FOR THE ARTS
678 Massachusetts Avenue
Cambridge, MA 02139
(617) 492-2914
(Connecticut, Maine, Massachusetts, New Hampshire, Rhode Island, Vermont)

SOUTHERN ARTS FEDERATION
1401 Peachtree Street N.E., Suite 122
Atlanta, GA 30309
(404) 874-7244
(Alabama, Florida, Georgia, Kentucky, Louisiana, Mississippi, North Carolina, South Carolina, Tennessee)

WESTERN STATES ARTS FOUNDATION
207 Shelby Street, Suite 200
Santa Fe, NM 87501
(505) 988-1166
(Arkansas, Arizona, California, Colorado, Hawaii, Idaho, Montana, Nevada, New Mexico, Oregon, Utah, Washington, Wyoming)

NPPA/NIKON DOCUMENTARY SABBATICAL GRANT

This annual grant, cosponsored by the National Press Photographers Association and Nikon, goes to a photojournalist (particularly one working for a daily newspaper) to shoot a self-chosen long-term project. Winners take a sabbatical of about three months and receive $10,000 to cover expenses.
1622 Forest Hill Drive, Louisville, KY 40205. (502) 582-4607; (502) 452-9471.
See pages 102 and 196.

NPPA PICTURES OF THE YEAR COMPETITION

One of the oldest continuing awards in photography, the NPPA Pictures of the Year Competition was started in 1943. The award is one of several granted by the NPPA, in association with Canon and the University of Missouri School of Journalism. It's open to any photojournalist, with the highest honors for newspaper photographer of the year, magazine photographer of the year, and best photoessayist. Winners each receive a cash award of $1,000 and Canon equipment.
National Press Photographers Association, 3200 Croasdaile Drive, Suite 306, Durham, NC 27705. (919) 383-7246.
See pages 102 and 196.

PEER AWARDS IN CREATIVE PHOTOGRAPHY

These annual awards recognize individuals who have made substantial contributions to the field of fine-art photography. Two $1,000 prizes are given—one to an established photographer whose work has set high standards and advanced the art, and another to a photographer in mid-career, as a recognition of past accomplishments and an encouragement to pursue new work. The winners are chosen by a poll of experts, including photographers, educators, and curators.
Friends of Photography, 101 The Embarcadero, Suite 210, San Francisco, CA 94105. (415) 391-7500.
See pages 94, 125, 149, 208, and 213.

PHOTOGRAPHER SUPPORT GRANTS
This award consists of three $1,250 grants intended to help developing photographers complete a specific project or further their careers. It is part of the Maine Photographic Workshops' Annual Grant Program, cosponsored by Kodak.
The Maine Photographic Workshops, Rockport, ME 04856. (800) 227-1541; (207) 236-8581.
See pages 149, 208, and 222.

PHOTOGRAPHER WORK GRANTS
Photographers on all levels can compete for these three $2,500 grants from the Annual Grant Program. The grants help winners travel, buy materials, or support themselves as they complete a body of work or finish a specific project. Applicants are judged by the quality of the work they submit, as well as by a written project statement.
The Maine Photographic Workshops, Rockport, ME 04856. (800) 227-1541; (207) 236-8581.
See pages 149, 208, and 222.

RUTTENBERG FOUNDATION AWARD
The Ruttenberg, established in 1982, grants one $2,000 purchase award —the foundation buys a photograph each year from an emerging fine-art photographer who concentrates on portraiture.
Friends of Photography, 101 The Embarcadero, Suite 210, San Francisco, CA 94105. (415) 391-7500.
See pages 94, 125, 149, 208, and 212.

THE W. EUGENE SMITH GRANT
Since 1980, this annual award has supported photographers working in the humanistic tradition of famed photojournalist Gene Smith (1918–1978). The $15,000 grant, sponsored by Nikon, lets the winner complete a personal project already underway. Past recipients include some of the world's outstanding working photojournalists.
International Center of Photography, 1130 Fifth Avenue, New York, NY 10028. (212) 860-1781.
See pages 95, 106, 151, 201, and 230.

Alex Webb, Mexico, 1986. Leopold Godowsky, Jr., Color Photography Award, 1988.

David Graham, Piano, Hot Springs, Arkansas, 1985. NEA photography fellowship, 1985.

Harry Benson, "We Are the World" recording session, 1985. NPPA Magazine Photographer of the Year, 1981 and 1985.

WORLD PRESS PHOTO CONTEST

As the most prestigious international competition in photojournalism, the World Press Photo Contest draws close to 1,200 entries and 10,000 photographs from more than sixty countries. It consists of two awards: the Press Photo of the Year, worth 5,000 Dutch guilders (about $2,500 U.S.), and the Oskar Barnack Award from Leitz, worth 10,000 guilders, for the picture essay that best illustrates the relationship between man and the environment.

Contact Press Images, 116 East 27th Street, 8th Floor, New York, NY 10016. (212) 481-6919.

State Arts Agencies

Many state arts councils have programs that support individual artists, including photographers. Sometimes these awards are given directly by the state agency, and other times money is given to local arts organizations to administer the programs. State policies vary widely; New York, Massachusetts, Illinois, Minnesota, and California have some of the most active programs, but most others offer some sort of support. Check with your local state arts council for information.

ALABAMA STATE COUNCIL ON THE ARTS & HUMANITIES
1 Dexter Avenue
Montgomery, AL 36130
(205) 261-4076

ALASKA STATE COUNCIL ON THE ARTS
610 Warehouse Avenue, Suite 220
Anchorage, AK 99501
(907) 279-1558

AMERICAN SAMOA COUNCIL ON CULTURE, ARTS & HUMANITIES
Office of the Governor
Box 1540
Pago Pago, AS 96799
(9-011) (684) 633-5613

ARIZONA COMMISSION ON THE ARTS
417 West Roosevelt
Phoenix, AZ 85003
(602) 255-5882/5884

ARKANSAS ARTS COUNCIL
The Heritage Center, Suite 200
225 East Markham Street
Little Rock, AR 72201
(501) 371-2539

CALIFORNIA ARTS COUNCIL
1901 Broadway, Suite A
Sacramento, CA 95818
(916) 445-1530

COLORADO COUNCIL ON THE ARTS & HUMANITIES
Grant-Humphreys Mansion
770 Pennsylvania Street
Denver, CO 80203
(303) 866-2617

CONNECTICUT ARTS COMMISSION
190 Trumbull Street
Hartford, CT 06103
(203) 566-4770

DELAWARE STATE ARTS COUNCIL
State Office Building
820 North French Street
Wilmington, DE 19801
(302) 571-3540

DISTRICT OF COLUMBIA COMMISSION ON THE ARTS & HUMANITIES
1111 E Street N.W., Suite 500B
Washington, DC 20004
(202) 724-5613

FLORIDA ARTS COUNCIL
Division of Cultural Affairs
Department of State
The Capitol
Tallahassee, FL 32399
(905) 487-2980

GEORGIA COUNCIL FOR THE ARTS & HUMANITIES
2082 East Exchange Place, Suite 100
Tucker, GA 30084
(404) 493-5780

GUAM COUNCIL ON THE ARTS & HUMANITIES
Office of the Governor, Box 2950
Agana, GU 96910
(011) (671) 477-9845
Mainland office:
1729 Longworth House Office Building

Washington, DC 20515
(202) 225-1188

HAWAII STATE FOUNDATION ON CULTURE & THE ARTS
335 Merchant Street, Room 202
Honolulu, HI 96813
(808) 548-4145

IDAHO COMMISSION ON THE ARTS
304 West State Street
c/o Statehouse Mail
Boise, ID 83720
(208) 334-2119

ILLINOIS ARTS COUNCIL
State of Illinois Center
100 West Randolph, Suite 10-500
Chicago, IL 60601
(312) 917-6750

INDIANA ARTS COMMISSION
47 South Pennsylvania Street
Sixth Floor
Indianapolis, IN 46204
(317) 232-1268

IOWA ARTS COUNCIL
Capitol Complex
Des Moines, IA 50319
(515) 281-4451

KANSAS ARTS COMMISSION
Jayhawk Towers, Suite 1004
700 Jackson
Topeka, KS 66603
(913) 296-3335

KENTUCKY ARTS COUNCIL
Berry Hill
Louisville Road
Frankfort, KY 40601
(502) 564-3757

LOUISIANA DEPARTMENT OF CULTURE, RECREATION, & TOURISM
Division of the Arts
Box 44247
Baton Rouge, LA 70804
(504) 342-8180

MAINE ARTS COMMISSION
55 Capitol Street
State House Station 25
Augusta, ME 04333
(207) 289-2724

MARYLAND STATE ARTS COUNCIL
15 West Mulberry Street
Baltimore, MD 21201
(301) 685-6740

MASSACHUSETTS COUNCIL ON THE ARTS & HUMANITIES
80 Boylston Street, 10th Floor
Boston, MA 02116
(617) 727-3668

MICHIGAN COUNCIL FOR THE ARTS
Executive Plaza
1200 Sixth Avenue
Detroit, MI 48226
(313) 256-3735

MINNESOTA STATE ARTS BOARD
432 Summit Avenue
St. Paul, MN 55102
(612) 297-2603

MISSISSIPPI ARTS COMMISSION
301 North Lamar Street, Suite 400
Jackson, MS 39201
(601) 354-7336

MISSOURI STATE COUNCIL ON THE ARTS
Wainwright Office Complex
111 North Seventh Street, Suite 105
St. Louis, MO 63101
(314) 444-6845

MONTANA ARTS COUNCIL
48 North Last Chance Gulch
New York Block
Helena, MT 59620
(406) 443-4338

NEBRASKA ARTS COUNCIL
1313 Farnam on the Mall
Omaha, NE 68102
(402) 554-2122

NEVADA STATE COUNCIL ON THE ARTS
329 Flint Street
Reno, NV 89501
(702) 789-0225

NEW HAMPSHIRE STATE COUNCIL ON THE ARTS
40 North Main Street
Concord, NH 03301
(603) 271-2789

Award Sources

The first step toward winning an award is to find out who gives prizes for what. The following publications carry the most complete listings.

AFTERIMAGE
"Etc.," a section in the back of each issue of *Afterimage*, lists grants, fellowships, and residencies available to photographers, as well as to those working in related media such as video and handmade books. The monthly journal is published by the Visual Studies Workshop.
31 Prince Street, Rochester, NY 14607. (716) 442-8676.
See pages 98, 136, 152, 193, 198, and 200.

ENTRY
This newsletter is a comprehensive guide to photographic competitions and juried exhibitions worldwide. Published ten times per year, it provides a full description of each entry, with information on eligibility, fee (if any), submission information, and judges.
Box 7648-B, Ann Arbor, MI 48107.

FOR YOUR INFORMATION
This newsletter comes from New York Foundation for the Arts (a good resource itself if you're a New Yorker). It includes a national listing of grants and awards available to artists in all media, including photography.
5 Beekman Street, Suite 600, New York, NY 10038. (212) 233-3900.

THE FOUNDATION CENTER
Befitting its national focus, The Foundation Center provides complete information on grants from some 25,000 private sources. Only a small number of these grants go to photographers, but enterprising readers may unearth some hidden sources of funding. The center runs four reference collections (in New York, Cleveland, San Francisco, and Washington) and shares information with over 100 organizations.
79 Fifth Avenue, New York, NY 10003. (800) 424-9836; (212) 620-4230.

NEW JERSEY STATE COUNCIL ON THE ARTS
109 West State Street
Trenton, NJ 08625
(609) 292-6130

NEW MEXICO ARTS DIVISION
224 East Palace Avenue
Santa Fe, NM 87501
(505) 827-6490

NEW YORK STATE FOUNDATION FOR THE ARTS
5 Beekman Street, Room 600
New York, NY 10038
(212) 233-3900

NEW YORK STATE COUNCIL ON THE ARTS
915 Broadway
New York, NY 10010
(212) 614-2900

NORTH CAROLINA ARTS COUNCIL
Department of Cultural Resource
Raleigh, NC 27611
(919) 733-2821

NORTH DAKOTA COUNCIL ON THE ARTS
Black Building, Suite 606
Fargo, ND 58102
(701) 237-8962

Stan Grossfeld, Ethiopia: Famine and Flight, 1984.
Pulitzer Prize, 1985.

Mary Ellen Mark, The Damm Family, 1987. *Photographer of
the Year, Peer Awards in Creative Photography, 1987.*

Nicholas Nixon, C.C. Boston, 1983.
Guggenheim Fellowships, 1976 and 1986.

**COMMONWEALTH COUNCIL FOR
ARTS & CULTURE**
CNMI Convention Center
Capitol Hill, Saipan
Box 553 CHRB
Commonwealth of the Northern
 Mariana Islands 96950
 (011) (670) 322-9982
 Mainland office:
 2121 R Street N.W.
 Washington, DC 20008
 (202) 328-3847

OHIO ARTS COUNCIL
727 East Main Street
Columbus, OH 43205
(614) 466-2613

STATE ARTS COUNCIL OF OKLAHOMA
Jim Thorpe Building, Room 640
2101 North Lincoln Boulevard
Oklahoma City, OK 73105
(405) 521-2931

OREGON ARTS COMMISSION
835 Summer Street N.E.
Salem, OR 97301
(503) 378-3625

**COMMONWEALTH OF PENNSYLVANIA
COUNCIL ON THE ARTS**
Finance Building, Room 216
Harrisburg, PA 17120
(717) 787-6883

**INSTITUTE OF PUERTO RICAN
CULTURE**
Apartado Postal 4184
San Juan, PR 00905
(809) 723-2115

**RHODE ISLAND STATE COUNCIL
ON THE ARTS**
95 Cedar Street, Suite 103
Providence, RI 02903
(401) 277-3880

SOUTH CAROLINA ARTS COMMISSION
1800 Gervais Street
Columbia, SC 29201
(803) 734-8696

SOUTH DAKOTA ARTS COUNCIL
108 West 11th Street
Sioux Falls, SD 57102
(605) 339-6646

TENNESSEE ARTS COMMISSION
320 Sixth Avenue North, Suite 100
Nashville, TN 37219
(615) 747-1701/6395

TEXAS COMMISSION ON THE ARTS
Box 13406
Capital Station
Austin, TX 78711
(512) 463-5535

UTAH ARTS COUNCIL
617 East South Temple Street
Salt Lake City, UT 84102
(801) 533-5895

VERMONT COUNCIL ON THE ARTS
136 State Street
Montpelier, VT 05602
(802) 828-3291

VIRGINIA COMMISSION FOR THE ARTS
James Monroe Building
101 North 14th Street, 17th Floor
Richmond, VA 23219
(804) 225-3132

VIRGIN ISLANDS COUNCIL
ON THE ARTS
41-42 Norregade, Second Floor
St. Thomas, VI 00802
(809) 774-5984

WASHINGTON STATE ARTS
COMMISSION
Ninth & Columbia Building
Mail Stop GH-11
Olympia, WA 98504
(206) 753-3860

WEST VIRGINIA DEPARTMENT OF
CULTURE & HISTORY
Arts and Humanities Division
Capitol Complex
Charleston, WV 25305
(304) 348-0240

WISCONSIN ARTS BOARD
131 West Wilson Street, Suite 301
Madison, WI 53702
(608) 266-0190

WYOMING COUNCIL ON THE ARTS
2320 Capitol Avenue
Cheyenne, WY 82002
(307) 777-7742

Viewpoint: Arts Grants

KAREN MUELLER
ARTIST ASSISTANCE PROGRAM ASSOCIATE
MINNESOTA STATE ARTS BOARD, ST. PAUL

"We are fortunate in Minnesota, in that both public and private agencies recognize how important it is to support individual artists. The Minnesota State Arts Board awards funds to photographers as well as other visual, performing and literary artists who are Minnesota residents through several programs.

"Artist Assistance Fellowships of $6,000 essentially help an artist buy time to focus on making art. Career Opportunity Grants provide smaller amounts to help people take advantage of unique opportunities for professional advancement. We also enable one or two artists to live and work in another location. Currently, we're supporting artists' residencies at an art center, P.S. 1 in Long Island City, New York, which allows artists to participate in the New York art environment. Approximately thirty state arts councils across the country offer similar kinds of programs.

"Strong support for Minnesota photographers is also available from the Bush Foundation, the Jerome Foundation, Film in the Cities, Intermedia Arts and Arts Midwest. This support takes the form of fellowships and project grants as well as exhibition programs, artists exchanges and educational opportunities.

"In a typical year, we receive approximately 750 applications, about 75 from photographers. The process is fairly simple. In the case of photographers, we ask for fifteen slides, a resume and a one-page essay describing their artistic or professional goals for the year. Applications are evaluated by a panel of five reviewers in one- or two-day meetings that are open to the public. The panel recommends grantees, and the State Arts Board makes the final decisions.

"The various panels are appointed by the board through an open nomination process. We're interested in articulate people who know a lot about photography—photographers, curators or other professionals who represent differing aesthetic points of view.

"Sometimes we see certain themes emerging in an artist's work, such as the recent farm crisis or homelessness. We do not, however, make awards based on any preconceived criteria regarding themes or artistic trends. Our primary concern in selecting grantees is the artistic quality or strength of the work itself.

"We are reexamining our annual grants, however. In recent years we've noted that there is a need for sustained support of exceptional artists, and we're currently developing a multi-year fellowship program as an addition to our regular programs. This idea is modeled after the longer-term research and development grants being given to worthy scientists."

Entrepreneurs

Who hasn't seen an innovative product and asked, "Why didn't I think of that?" The brave souls featured here not only thought of an invention, but went ahead and invented it. Identifying needs ignored by larger manufacturers, they forged ahead with designing, producing, and marketing products of particular interest and usefulness to the photographic community.

Of course, the failure rate for such dreams is high; many small-business owners will tell you they're sorry they ever entered the entrepreneurial rat race. All such ventures risk long hours and poor cash-flow, as well as strained relationships with partners, employees, and investors. But those who succeed reap tremendous personal satisfaction, pride, and, with a little luck, profit. Here are some successful companies and the entrepreneurs behind them.

CHIMERA PHOTOGRAPHIC LIGHTING
Gary Regester first met Tom Frost in 1973. Regester, still a student at the Art Center in Pasadena, California, was photographing a catalog for Chouinard Equipment, a manufacturer of hiking and climbing goods, where Frost was the designer.

Regester went on to pursue a career in location photography, working primarily with musicians and traveling extensively. Like other location photographers, he was well aware of the need to lighten the load, and began to think about ways to solve perhaps the biggest problem that location photographers face—how to travel with studio-quality lighting.

Regester started toying with a diffusion material based on the design of a mountain tent. He knew he needed help and thought of Tom Frost, a mechanical engineer by trade and also an experienced motion-picture cameraman. Together they developed the portable lightbank that began the Chimera product line.

That was in 1979. Today, Chimera offers a system of lighting materials it bills as "lighting software," including several sizes of lightbanks and accessories, louvers, diffusion frames, scrims, and duffel bags to carry them all. Regester left Chimera on friendly terms in 1985 to start Plume Ltd., which makes Wafer, Studiowall, and other lighting materials.

Chimera Photographic Lighting, 1812 Valtec Lane, Boulder, CO 80301. (800) 424-4075; (303) 444-8000.
See page 53.

Lighting software from Chimera.

DOMKE

In 1976, when Jim Domke was a photographer for the *Philadelphia Inquirer,* he received his most challenging assignment: find a sturdy camera bag for the staff. He couldn't, so he made his own—first for coworkers and then, through word of mouth and a short mention in *Popular Photography,* for the rest of us.

Besides a successful business, Domke created a whole new product—the professional camera bag. Rugged and highly functional, it was made by a pro for pros, with modular parts so it could be customized for individual users.

It took a while, but several other manufacturers, including some large ones, jumped into the market; the Domke Bag now has competition. But Domke has improved his bag many times and also expanded into tripod cases, equipment vests, filter files, portable lighting panels, screens, loupes, and magnifiers, all made with the professional photographer in mind.

J.G. Domke Enterprises, 950 Calcon Hook Road #3, Sharon Hill, PA 19079. (215) 522-0502.
See pages 35 and 51.

KOSTINER PHOTOGRAPHIC PRODUCTS

Like so many entrepreneurs, Ed Kostiner drifted from career to career—photographer, retailer, film producer, art-gallery owner. Working in film, making commercials and packaging TV shows, had resulted in his greatest success until he rediscovered the darkroom.

In 1980, Kostiner launched a business venture by filling a vacuum. A company in Grinnell, Iowa, called East Street Gallery had pioneered sales of an archival print washer, but went out of business, leaving hundreds of photographers, some with washers on order at East Street, looking for another supplier. Kostiner designed his own version and began by selling them directly to customers.

From print washers, Kostiner moved on to professional-quality film washers, standard and vacuum easels, enlargers, print tongs, drying screens, and antistatic brushes. In all his products, he has striven for functionality and classic design, and apparently he's succeeded. Kostiner products are sold in camera stores and through mail-order catalogs worldwide.

Kostiner Photographic Products, 12 Water Street, Box 322, Leeds, MA 01053. (413) 586-7030.
See pages 42, 49, and 50.

LIGHTWARE

Paul Peregrine, a hard-traveling commercial photographer, used to wonder why his cases had to be as heavy as the equipment in them. Working with advanced foam materials, he built his first lightweight shipping case in 1983, and thereby started Lightware.

A typical Lightware case weighs about five pounds. It's compact, sturdy, shippable, and carries a lot of equipment. This matter of making equipment easier to tote around may sound familiar; Peregrine worked as a consultant to Chimera before he launched Lightware.

Although Peregrine still works as a photographer, the success of Lightware has cut into his shooting time considerably. The product line has expanded to include such products as cases for various format cameras, portfolio cases, and a briefcase.

Useful products sometimes find strange bedfellows, allowing companies to find profit from unexpected sources. The FBI has been using Lightware cases not for cameras, but to transport tear-gas guns and delicate surveillance equipment. "These markets have been finding us," says Peregrine. "We haven't been looking for them."

Lightware, 1541 Platte Street, Denver, CO 80202. (303) 455-4556.
See page 36.

SPRINT SYSTEMS OF PHOTOGRAPHY

Paul Krot was eleven years old when he started messing with photographic chemicals. By ninth grade, he had invented his first formulas. Some years later as a photography teacher, Krot set out to put his early experience to work. Deciding that one of the major problems faced by schools involves developing a smooth darkroom system, he dug back to his chemical roots to address that problem.

Using existing formulas as a base, Krot started making changes. He replaced Metol—the standard developing agent in most formulas—with the less toxic phenidone; he made a vanilla-scented stop bath to reduce its noxious odor; he added indicators to make the baths turns color when they were depleted (now indicators are available only in Sprint Block, the stop bath). He also concocted some unusual formulas, such as converters that allow black-and-white chemicals to be used for color processing, and an excellent direct-positive kit for making black-and-white slides.

Going up against competitors like Kodak is no easy task, but Sprint's great appeal is that it offers a system of components that work together simply and easily. Many Sprint chemicals can be used when working in black and white, color, or with non-silver processes. All come as liquid concentrate in collapsible plastic containers, and most mix up in the same way—one part concentrate to nine parts water. Sprint sells its chemicals to camera stores and by mail-order to individuals and institutions; schools form an important part of its customer base.

Krot splits his time between research duties at Sprint and teaching responsibilities at the Rhode Island School of Design. At RISD, he teaches courses called Photo Principles and Photo Procedures, where, among other things, he makes students create their own chemical formulas from scratch—a task tedious enough to make them appropriately thankful for the ease of the Sprint system.

Sprint Systems of Photography, 100 Dexter Street, Pawtucket, RI 02860. (401) 728-0913.

See pages 67 and 85.

VISUAL DEPARTURES

In 1981, Allen Green was shooting an assignment in London when he spotted the product that put him in a new business. It was a portable light reflector, a simple but incredibly useful item for location photography. Green secured U.S. distribution rights and redesigned the reflector, calling it Flexfill.

New products followed naturally, most born of practical problem-solving ideas from other shooters. Dewitt Jones, a *National Geographic* photographer, came up with Dewitt's Strap, an unusual belt that secures a camera tightly to one's body. Steady Bag, a flexible camera support, was West Coast videographer David Lent's brainstorm. Jim Egan, a Rhode Island photographer, thought up Quick Stick, a device that factors the effect of bellows extension on exposure, and the Visualizer, which determines camera angle and lens focal length.

Visual Departures now grosses $500,000 annually. President Green remains a photographer, shooting mostly for corporate clients such as Pepsi Cola and The Morgan Bank, and therein lies the soul of his company. "We are photographers talking to photographers," says Green.

Visual Departures, 1641 Third Avenue, Suite 202, New York, NY 10128. (800) 628-2003; (212) 534-1718.

Special Events

It doesn't happen often, but photographers occasionally gather for various events—trade shows, symposia, or out-and-out celebrations. The following events have two things in common: all are held regularly (most annually), and all are tax deductible if photography is your profession.

Les Rencontres Internationales de la Photographie/Arles.

AMERICAN PHOTOGRAPHY INSTITUTE
Sensible New Yorkers leave the city in the summer, but here's one reason to stay, or even visit: six weeks of workshops, conferences, and seminars with some of the world's top fine-art and professional photographers, as well as editors, curators, and other industry professionals. The American Photography Institute covers nothing less than the current state of photography, from developments in digitized imaging to corporate involvement in fine-art photography.

The atmosphere is serious, not festive as at some other summer events and workshops. The well-considered programs take place in a modern, air-conditioned building with excellent darkrooms for workshop participants. Students and recent graduates will find the structure and school setting comforting, and also appreciate the available low-cost university housing.
American Photography Institute, New York University, Office of Summer Sessions, Tisch School of the Arts, 721 Broadway, 7th Floor, New York, NY 10003. (212) 998-1795.
See page 151.

FOTOFEST
Houston is seldom identified as the center of the photography universe, but for an entire month every other year it becomes just that. The city hosts FotoFest, a highly ambitious international event with a strong emphasis on fine-art photography. In true Texas style, FotoFest is huge, presenting dozens of exhibitions, lectures, meetings, and workshops for more than 200,000 attendees.

FotoFest takes place in the winter—not a bad time to visit Houston—and the city has a very active photography community that includes

Photo: International Conference of Professional Photographers.

the Houston Center for Photography and Museum of Fine Arts. A unique feature called Meeting Place is an informal forum for personal interchange with the 100 or so invited guests, including photographers, editors, curators, and other shakers in the fine-art photo world.

FotoFest, 4200 Montrose, Suite 370, Houston, TX 77006. (713) 522-9766.

THE INTERNATIONAL PHOTOGRAPHY CONGRESS

For one week every August, photo-buffs gather in Maine to show their work, participate in seminars, and generally ponder the state of the industry. According to its brochure, the congress is "a conference for people who create and use photographs." Practical matters such as career development and the business of photography get covered in great detail, technical issues are ignored, and loftier topics are bandied about. Recent congresses included panels on "The Symbol and the Photograph" and "Do Photographs Tell the Truth?"

Interest in this event has grown markedly since its inception in 1986. At last count it had more than 400 participants, some staying for a day but many lasting out the week. In a very pleasant location, you'll have the unique opportunity to meet and hear from some of the most distinguished shooters, picture editors, curators, stock agents, and other professionals in the world of photography.

The Maine Photographic Workshops, Rockport, ME 04856. (207) 236-8581. See pages 56, 149, 202, 208, and 213.

ORACLE

Since 1983, about 100 of the most influential people in the not-for-profit fine-art photography world (including directors of arts organizations, museum curators, and historical-society representatives) have met once a year for a weekend in a secluded spot to thrash out some of the pressing issues of their profession. It's a chance to let some hair down and think through the big picture without the everyday pressures of looking at portfolios, meeting with staff, and getting that presentation to the board of directors polished off. At least this is what we're told happens. There's no way of knowing for sure, since attendance is by invitation only.

PMA ANNUAL CONVENTION AND TRADE SHOW

Held every February, the Photo Marketing Association's convention is the showcase event for photographic manufacturers to exhibit their new and existing products to photo

retailers, photofinishers, and related businesses. It's primarily an industry event—a chance to shmooze with important customers, solicit orders, and find out what everyone's been up to for the past year.

Photo Marketing Association International, 3000 Picture Place, Jackson, MI 49201. (517) 788-8100.

PP OF A ANNUAL CONVENTION AND TRADE SHOW

This event, sponsored by the Professional Photographers of America but not limited to its membership, is one of the oldest photo trade shows in the world; the first one was held in 1880 in Chicago. In a different location every summer, PP of A members gather to see the latest products (most photo manufacturers exhibit) and learn about trends in visual styles and studio management. A large educational component offers more than 100 seminars and workshops on such subjects as retouching negatives, dimensional contrast in portraiture, bridal environmental illustration, and ways to boost business through direct mail. PP of A

Photokina.

© TOMAS MUSCIONICO

The International Photography Congress.

members include representatives from all areas of commercial photography, especially portrait and wedding specialists.
Professional Photographers of America, 1090 Executive Way, Des Plaines, IL 60018. (312) 299-8161.
 See page 102.

PHOTO: INTERNATIONAL CONFERENCE OF PROFESSIONAL PHOTOGRAPHERS

Billed as "the world's largest pro show," Photo is actually three weekend events held annually in varying California sites in the spring (Photo West), in Chicago also in the spring (Photo Midwest), and in New York City in the fall (Photo East). Tens of thousands of attendees view wares from more than 200 manufacturers from all over the world. Famous photographers and other industry people present about eighty programs on subjects such as shooting for stock, problem solving, and self-promotion.

The atmosphere, especially in New York, can be zooish, with lots of people crammed into a huge convention hall. Nevertheless, the show is worth a trip from out of town, because it's an efficient way to become familiar with current products and get some tips on such matters as taking more compelling pictures or running a photography business. The show and programs are reasonably priced, but sign up early for the seminars with well-known photographers; these sell out early.
CMC, 200 Connecticut Avenue, Nor-

walk, CT 06856. (203) 852-0500, ext. 124.

PHOTOKINA

Photokina is *the* international trade show in photography. It's been held every other year since 1953, and photographic manufacturers from all over the world come to display their goods. Many new products are introduced, some of which will never make it to America.

A lot goes on besides product introductions—dozens of large-scale exhibitions, lectures, and panel discussions—but the emphasis is on industry matters. Orders are written; the press is wowed; expense accounts are blown. Photokina sprawls across fourteen buildings and is fascinating if you can manage to navigate through the maze and the people—over 150,000 attend. It can be a little frustrating, too, unless you speak several languages; the show is geared for a European audience.

Plan your trip early. Hotel reservations are scarce, and you'll probably wind up staying miles from the exhibition sites.
Cologne Messe, Cologne 5000, West Germany.

LES RENCONTRES INTERNATIONALES DE LA PHOTOGRAPHIE/ARLES

Every year since 1970, Arles, an ancient city in southern France, has hosted a week-long festival of panels, lectures, portfolio reviews, exhibitions, and workshops—plus late-night heated arguments and great food and wine. The atmosphere at *Les Rencontres Internationales de la Photographie* is pretty loose, or, as a recent festival program says, the event has "a certain fluidity."

All types of photography are represented, along with related dance events, films, historical tours, and whatever else suits the organizers' fancy. Many thousands attend, including some of the world's great photographers. Though there are many Americans, *Les Rencontres* is one of the few places where you can get a good perspective on photographic developments in the rest of the world. Besides, it's held in France in July. *Tout est dit.*
16 Rue des Arènes, BP 96, Arles 13362, France. (90) 96-76-06.

FotoFest.

Films by Photographers

Many photographers dream of making movies, but the transition from stills to motion pictures is not an easy one. In photography, one person or a small crew does all the work. Movies always require a crew, usually a large one, and movies also cost much more than stills. Even if such practical issues can be resolved, sustaining an audience's interest over a long period of time is much more difficult than holding the attention of one viewer for a few seconds.

Many photographers have made an occasional movie without abandoning still photography altogether. Usually these are independent efforts involving a relatively small budget and crew. Most are short in length and scope, but a few are features. Although some photographer-shot films have become classics, many are mediocre. Still, most are worth seeing, if only because they represent a dying art; video now provides photographers with a much more immediate and less expensive way to satisfy this apparently insatiable urge to make pictures that move.

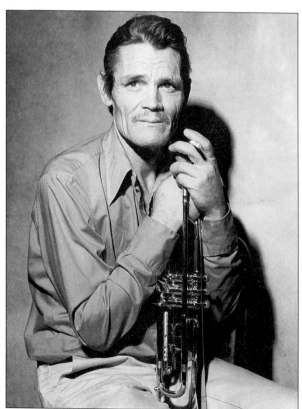

© BRUCE WEBER

Trumpet great Chet Baker, New York City, 1987, from Let's Get Lost.

Eve Arnold
Behind the Veil, 1971

Margaret Bourke-White
Eyes on Russia, 1934
Our Daily Bread, 1934
Red Republic, 1934

Rudy Burckhardt
Haiti, 1938
Shoot the Moon (with Red Grooms), 1950
The Aviary (with Joseph Cornell), 1954
What Mozart Saw on Mulberry Street (with Joseph Cornell), 1954
Under the Brooklyn Bridge, 1955
Lurk, 1965
Daisy, 1966
The Apple, 1967
Paradise Arms (with Neil Welliver), 1967
Money, 1968
Tarzam, 1969
Summer, 1970
Inside Dope, 1971
Doldrums, 1972
Avenues of Communication, or Information Please, 1973
Caterpillar, 1973

Rene Burri
Kunstgewerbeschule Zurich, 1953
The Physical Face of China, 1965
Three Villages of China, 1965
The Industrial Revolution, China, 1967
What's it All About?, 1967
Jerusalem, 1967
The Two Faces of China, 1968
Braccia Si, Uomini No, 1970
Xerox in Color, 1971
Jean Tinguely, Kinetic Sculptor, 1972
Indian Summer, 1973

Henri Cartier-Bresson
Victoire de la Vie, 1937
Le Retour, 1946
Midlands at Play and at Work, 1963
Five films on Germany, for the Suddeutscher Rundfunk, Munich, 1963–64
Québec, 1964
Flagrants Délits, 1967
Impressions of California, 1969
Southern Exposures, Mississippi, 1970
Images de France, 1970
Why New Jersey?, 1975

Bruce Davidson
Living Off the Land, 1970
*Isaac Singer's Nightmare and Mrs.
 Pupko's Beard*, 1974

Raymond Depardon
Ian Pallach, 1961
50.81%, 1974
Tibesti Tou, 1976
Numerous Zero, 1977
Tibstz, 1979
San Clemente, 1980
Reporters, 1981
Faits Divers, 1983
Les Années Déclic, 1983
New York, NY, 1984
Empty Quarter, 1985
Urgences, 1988

Elliot Erwitt
Prague Spring, 1969
Arthur Penn, The Director, 1970
The Many Faces of Dustin Hoffman,
 1970
Beauty Knows No Pain, 1971
Red, White and Bluegrass, 1973
The Glassmakers of Herat, 1977
The Magnificent Marching 100, 1979
Beautiful, Baby, Beautiful, 1980
Suzuki's Children, 1981
The Great Pleasure Hunts
 (five one-hour films), 1982–86
Eros International
 (five 30-minute films), 1982–86
Pleasure International
 (five 30-minute films), 1982–86
Good Nudes, 1983

Jean Gaumy
La Boucane, 1984
Jean Jacques (Cronique Villageoise),
 1987

David Kennerly
*The Taking of Flight 847: The Uli
 Derickson Story*, 1988
Shooters, 1988

William Klein
Cassius: Le Grand, 1964
Mode en France, 1985
Fashion, 1986

Helen Levitt
In the Street, 1952

Mary Ellen Mark's Streetwise.

Bert Stern's Jazz on a Summer Day.

A Very Independent Filmmaker

Robert Frank gave up still photography to concentrate on filmmaking soon after the publication of his highly influential photoessay, *The Americans*. Though he returned to make stills from time to time, Frank persevered with film (and video), making him the most prolific, and some say most interesting independent filmmaker *cum* photographer ever.

Frank's films, like his photographs, are mostly documentaries with a healthy mix of quirkiness, moodiness, and introspection. The style of both his stills and movies has become more personal with time. Some films he directed alone, others he collaborated on, and for a few he did camera work for other directors. Interesting characters show up in several of the films, including Allen Ginsberg (*Pull My Daisy*, written by Jack Kerouac, *Me and My Brother*, and others), Jessica Lange (her first film role in *Home Is Where the Heart Is*), and Tom Waits (*Candy Mountain*).

Frank's best-known film is the one that's least shown. The Rolling Stones hired him to document their 1972 North American tour, but they didn't much like the result, entitled *Cocksucker Blues*. The film was such a negative view that the Stones refused to release it. Unfortunately, today the film is screened only on rare occasions.

Pull My Daisy (Alfred Leslie, codirector), 1959
The Sin of Jesus, 1961
O.K. End Here, 1963
Wholly Communion (Peter Whitehead, director), 1966
Chappaqua (Conrad Rooks, director), 1967
Me and My Brother, 1965–68
Life-Raft Earth, 1969
Conversations in Vermont, 1969
Home Is Where the Heart Is (Danny Seymour, director), 1971
About Me: A Musical, 1971
About Us, 1972
Cocksucker Blues, 1972
Keep Busy (Rudy Wurlitzer, codirector), 1975
Life Dances On, 1980
Energy and How to Get It (Rudy Wurlitzer and Gary Hill, codirectors),1981
This Song for Jack, 1983
Home Improvements (video), 1985
Date d'échéance (Marc Paulin, director), 1986
Candy Mountain, (Rudy Wurlitzer, codirector), 1987

Robert Frank on location for The Sin of Jesus, *1961.*

Mick Jagger in Cocksucker Blues, *1972.*

Candy Mountain, *1987*.

Me and My Brother, *1965–68*.

Me and·My Brother, *1965–68*.

Pull My Daisy, *1959*.

PBS Programs on Photography

Through the years, many programs about photography have aired on public television; several are listed below. PBS has copies of most of them, but does not publish a comprehensive list. The films aren't for rent, but some can be purchased with the permission of the filmmakers. PBS will give you their names, and, with written permission, will make duplicates of the requested films. You pay costs, of course.
Public Broadcasting Service, 1320 Braddock Place, Alexandria, VA 22314. (703) 739-5014.

A Day in the Life of Photography
American Masters: André Kertész of the Cities
The Annual NPPA Awards: Television News Photography
Consumer Survival Kit: Photo Equipment
Creativity with Bill Moyers: The Photographer's Eye
The Dick Cavett Show: Ansel Adams
A Day in the Life of Hawaii
Edgerton and His Incredible Seeing Machines (Nova)
Hodgepodge Lodge: Nature Photography
Light in the West: Photography and the American Frontier
The Making of a Natural History Film (Nova)
Media Probes: Photography
Moving Still (Nova)
The Photo Show
Poet With a Camera
Steichen... A Century in Photography
The Story of American Photography
Time Lapse High-Speed Photography
Visions of the Deep (Nova)
Wild America: Photographing Wildlife

Photographers on Display

Media Loft produces high-quality original presentations, featuring outstanding photographers, and distributes them as slide shows. A few are also available on video. Most of the shows have commentary by the photographer, and they make excellent teaching tools in schools or for camera clubs and photo-center libraries. Featured photographers include Mary Ellen Mark, Ralph Gibson, Ernst Haas, Burke Uzzle, and Jerry Uelsmann. General programs on commercial photography, technical matters, and photojournalism are also available. Prices range from $50 to $205.

Media Loft, 10720 40th Avenue North, Minneapolis, MN 55441. (612) 375-1086.

Jerome Liebling
A Tree is Dead (with Allen Downs), 1955
The Old Man (with Allen Downs), 1965

Danny Lyon
Social Sciences 127, 1969
Llanito, 1971
El Mojado, 1974
Los Niños Abandonados, 1975
Little Boy, 1977
El Otro Lado, 1978
"Dear Mark" (A Film for Mark DiSuvero), 1981
Born to Film, 1986

Robert Mapplethorpe
Patti Smith: Still Moving, 1978
Lady (video), 1983

Mary Ellen Mark
Streetwise (with Martin Bell and Cheryl McCall), 1985

Susan Meiselas
Living at Risk (Alfred Guzzetti and Richard P. Rogers, codirectors), 1986

Lázló Moholy-Nagy
Berliner Stilleben, 1926
Ein Lichtspiel: Schwartz, Weiss, Grau, 1930
The Life of a Lobster, 1935

Hans Namuth
Jackson Pollock, 1951

Gordon Parks
The Learning Tree, 1968
The Diary of a Harlem Family, 1969
Shaft, 1971
Shaft's Big Score, 1972
Leadbelly, 1976

Man Ray
Le Retour à la Raison, 1923
Emak-Bakia, 1927
L'Étoile de Mer, 1928
Les Mystères du Château du Dèce, 1929

Leni Riefenstahl
The Blue Light, 1932
Sieg Des Glaubens, 1933

The Triumph of the Will, 1934–36
Tag Der Freiheit, 1935
Olympia, 1938
Tiefland, 1945

Charles Sheeler
Manhatta (with Paul Strand), 1921

Michael Snow
One Second in Montreal, 1969

Ralph Steiner
H_2O, 1929
Surf and Seaweed, 1931
Pie in the Sky, 1935
The Plow That Broke the Plains (with
 Paul Strand and Leo Hurwitz), 1936
The City (with Willard Van Dyke),
 1939

Bert Stern
Jazz on a Summer Day, 1958

Paul Strand
Manhatta (with Charles Sheeler), 1921
The Wave, 1934
The Plow That Broke the Plains (with
 Ralph Steiner and Leo Hurwitz),
 1935
Heart of Spain (with Leo Hurwitz),
 1938–40
Native Land (with Leo Hurwitz), 1942

Willard Van Dyke
Frontline Cameras, 1935–1965
The River (Pare Lorentz, director),
 1937
The City (with Ralph Steiner), 1939
Valley Town, 1940
The Bridge, 1944
Pacific Northwest, 1944
Frontiers of News, 1964
Rice, 1964

Bruce Weber
Broken Noses, 1987
Let's Get Lost, 1988

Weegee
Weegee's New York, 1948

Kinetic sculpture used by Lázló Moholy-Nagy in
Ein Lichtspiel: Schwartz, Weiss, Grau
(Lightplay: Black, White, Gray), *1930.*

Bruce Davidson's Isaac Singer's Nightmare, *1974.*

Distributors

One of the major problems independent filmmakers face is distribution—getting the work out to be seen. Most of the films listed in this section were independently produced and are hard to find. Fortunately, quite a few of them are handled by film libraries; others are distributed by the individual photographers themselves. Here are some of the best places to inquire if you're trying to rent or buy a copy of an independent film.

AMERICAN FILM INSTITUTE
The John F. Kennedy Center
Washington, DC 20566
(202) 828-4070

ANGELIKA FILMS
645 Madison Avenue
New York, NY 10022
(212) 838-1820
(Mary Ellen Mark's film)

CBS NEWS
Office of Film and Video Licensing
524 West 57th Street
New York, NY 10019
(212) 975-3200

CENTER FOR CREATIVE PHOTOGRAPHY
University of Arizona
Tucson, AZ 85721
(602) 621-7968

CHELSEA HOUSE
70 West 40th Street
New York, NY 10018
(212) 563-3600

DONNELL FILM LIBRARY
20 West 53rd Street
New York, NY 10019
(212) 790-6418

FILMMAKERS' COOPERATIVE
175 Lexington Avenue
New York, NY 10016
(212) 889-3820

FILMS INC.
440 Park Avenue South
New York, NY 10016
(212) 889-7910

HARVARD FILM ARCHIVE
Carpenter Center for the Visual Arts
24 Quincy Street
Cambridge, MA 02139
(617) 495-4700

INTERNATIONAL CENTER OF PHOTOGRAPHY
1130 Fifth Avenue
New York, NY 10028
(212) 860-1777

INTERNATIONAL MUSEUM OF PHOTOGRAPHY AT THE GEORGE EASTMAN HOUSE
900 East Avenue
Rochester, NY 14607
(716) 271-3361

MACMILLAN FILMS/AUDIO BRANDON FILMS
34 MacQuester Parkway South
Mount Vernon, NY 10550
(800) 431-1994

MAGNUM
72 Spring Street
New York, NY 10012
(212) 966-9200

MUSEUM OF FINE ARTS
1001 Bissonnet
Houston, TX 77005
(713) 526-1361
(works by Robert Frank)

THE MUSEUM OF MODERN ART
Circulation Director
Department of Film
11 West 54th Street
New York, NY 10019
(212) 708-9400

NEW YORKER FILMS
16 West 61st Street
New York, NY 10023
(212) 247-6110

PENNSYLVANIA STATE UNIVERSITY
Audiovisual Services
University Park, PA 16802
(814) 865-6314

ROCHESTER INSTITUTE OF TECHNOLOGY
Wallace Memorial Library
Audiovisual Services
One Lomb Memorial Drive
Rochester, NY 14623
(713) 464-2555

Films About Photographers

A whole new generation of photographers was created soon after David Hemmings played the sexy (some say sexist) photographer/detective in Michelangelo Antonioni's *Blow-Up*. No other film in recent memory has had such an impact on photography, but the subject keeps cropping up on the silver screen—sometimes in great movies, often in turkeys. To find out what Hollywood thinks about photographers and their world, visit your local revival cinema or video rental store and check these out.

COURTESY OF THE ACADEMY OF MOTION PICTURE ARTS AND SCIENCES

AMERICAN FRIEND, 1977.
Dennis Hopper, a photographer in real life, becomes obsessed with a Polaroid camera.

ANNIE HALL, 1977.
In this multiple Academy Award winner, Diane Keaton (another celebrity photographer) plays a photographer and Woody Allen's sidekick.

APOCALYPSE NOW, 1979.
Here's Dennis Hopper again—this time as a crazed photojournalist.

BELLY OF AN ARCHITECT, 1987.
Peter Greenway's film about a dying architect (Brian Dennehy) with a "thing" for reproducing photographs.

BATMAN, 1989.
Kim Basinger's photojournalist Vicki Vale is pursued through the sleazy streets of Gotham City by Jack Nicholson's leering Joker, and rescued by Michael Keaton's black-caped crusader.

BLOW-UP, 1966.
Michelangelo Antonioni's psychological puzzler features a fashion photographer (David Hemmings) who believes he's been an accidental witness to a murder.

THE CAMERAMAN, 1928.
In this classic, Buster Keaton plays a photographer with grander ambitions—to become a news cameraman and win the girl.

THE CHINA SYNDROME, 1979.
Michael Douglas plays a minicam photographer working with TV reporter Jane Fonda in a story about an accident at a nuclear power plant.

Blow-Up, *1966.*

COCKTAIL, 1988.
Tom Cruise's first girlfriend is a photographer in this made-for-summertime film.

THE CONVERSATION, 1974.
Francis Ford Coppola's drama features Gene Hackman as a spy who makes good use of surveillance tapes and photographs.

DEAD OF WINTER, 1987.
Photographic evidence provided by her husband almost helps Mary Steenburgen out of a tight spot in this Arthur Penn thriller.

DEATH OF A CENTERFOLD, 1981.
One of two movies based on the life of murdered *Playboy* model Dorothy Stratten (see *Star 80,* page 234).

DOUBLE EXPOSURE, 1982.
A photographer suffers from bad dreams that somehow turn into tomorrow's news.

EASY MONEY, 1983.
Rodney Dangerfield plays a children's photographer, but spends most of his time eating, smoking, drinking, and gambling.

EXPOSED, 1983.
Nastassia Kinski is a fashion model who gets entangled with a gang of terrorists.

THE EYES OF LAURA MARS, 1978.
Faye Dunaway stars as a fashion photographer who shoots ads portraying fabricated crime scenes replete with sex and violence, and then gets carried away with the idea.

FUNNY FACE, 1957.
A fashion photographer (Fred Astaire) discovers a bookstore clerk (Audrey Hepburn) and turns her into a successful model, accompanied by a lively George Gershwin score.

GANDHI, 1983.
Candice Bergen plays Margaret Bourke-White in this epic directed by Richard Attenborough.

GIRLFRIENDS, 1978.
Director Claudia Weill tells a bittersweet story about a young woman photographer trying to make it in the jungles of Manhattan.

GORILLAS IN THE MIST, 1988.
Gorilla observer Dian Fossey, played by Sigourney Weaver, falls for a *National Geographic* photographer, then dumps him.

HIGH SEASON, 1988.
Jacqueline Bissett as a photographer living on a Greek island with her wayward husband.

I HEAR THE MERMAIDS SINGING, 1987.
An amusing story about a young photographer's struggle against the pompous gallery crowd. Nice stills by Toronto-based photographer Debra Friedman.

THE IMMORTAL MR. TEASE, 1959.
In this first film by the immortal king of porno, Russ Meyer, a delivery man who fancies himself a photographer likes to look at naked women.

INVASION USA, 1986.
This is a particularly violent Chuck Norris film, in which Melissa Prophet plays a pesky photojournalist.

JENNY, 1970.
Alan Alda, a hip young filmmaker, wants out of the draft and meets Marlo Thomas, who is unwed and pregnant.

THE KILLING FIELDS, 1984.
This outstanding film about war-torn Cambodia in the late 1970s includes John Malkovich as a sympathetic, albeit drunk and drugged, photographer.

THE LADY SAYS NO, 1951.
A magazine photographer gets involved with his subject.

LITTLE MURDERS, 1971.
In this film adapted from a Jules Feiffer play, Elliott Gould portrays a laidback photographer involved with a woman named Patsy.

LA MACHINA AMMAZZACATICI, 1944.
Roberto Rossellini's tale of a photographer who inadvertently kills his subjects when he photographs them.

THE MAGIC BOX, 1952.
This is the biography of William Friese-Greene, a pioneer in the motion-picture industry.

MY FAVORITE BRUNETTE, 1947.
Bob Hope is a photographer by trade, but turns detective to help out Dorothy Lamour.

NO SMALL AFFAIR, 1985.
A sixteen-year-old aspiring photographer looks through his lens and falls in love with an older woman of twenty-two.

THE ODD COUPLE, 1968.
The film version of Neil Simon's hit play about two divorced middle-aged men who decide to room together. Felix, played by Jack Lemmon, is a photographer.

PEEPING TOM, 1961.
A crazed photographer murders his models and photographs them while they're dying.

PRETTY BABY, 1978.
Louis Malle directed this story based loosely on the life on New Orleans photographer E.J. Belloq (best known for his *Storyville Portraits*). Keith Carradine is the Belloq character and Brooke Shields plays the young prostitute he falls for.

REAR WINDOW, 1954.
This Alfred Hitchcock thriller features Jimmy Stewart as a newspaper photographer laid up with a broken leg. He uses a camera with a telephoto lens to snoop on his neighbors and discovers some shady goings-on, which he explores with the help of Grace Kelly.

SALVADOR, 1986.
John Savage plays the heroic photojournalist to James Woods's not-so-heroic one. "You gotta get close to the

Rear Window, *1954 (top)*.

The Killing Fields, *1984 (left)*.

Salvador, *1986 (right)*.

The Eyes of Laura Mars, *1978 (bottom)*.

truth—you get too close you die," says Savage, paraphrasing Robert Capa, before proceeding to get too close.

THE SEDUCTION, 1982.
Morgan Fairchild as a TV anchorwoman chased by a crazed photographer who keeps looking through his telephoto lens.

SIESTA, 1987.
Matt Mahurin's still photographs grace this thriller, helping it sustain its surrealistic tone.

STAR 80, 1983.
Mariel Hemingway plays Dorothy Stratten, an aspiring model whose husband arranges for her to pose for *Playboy,* then becomes jealous and murders her. (See *Death of a Centerfold,* page 232.)

THE UNBEARABLE LIGHTNESS OF BEING, 1988.
Based on the Milan Kundera novel. The film's female lead is a photojournalist who witnesses the Russian invasion of Czechoslovakia.

UNDER FIRE, 1983.
Nick Nolte as a photojournalist in a political film about Nicaragua at the height of the 1979 Sandinista rebellion. Despite his protestations to the contrary ("I don't take sides. I take pictures."), the Nolte character sides shamelessly with the Sandinistas.

THE YEAR OF LIVING DANGEROUSLY, 1982.
Linda Hunt won an Oscar for her portrayal of Billy Kwan, a Chinese-Australian cameraman.

Under Fire, *1983.*

Pretty Baby, *1978.*

Novelties

Who says photographs must always be slides or prints? They can have many other fates, some even functional. Photographs in nonstandard forms may stand little chance of ending up on the wall of a museum, but they make good gifts and party favors. They're not for your average family album.

Many of these companies deal primarily with photographers who sell these novelties to their clients and customers as a business, and are not set up to handle individual orders.

Magazine cover and trading cards from Ashton Photo.

Photo Buttons

You can wear your art with a photo button. Maybe you've bought one at the local county fair or flea market. It's easy to make your own if you have the right tools, and Badge-A-Minit will sell you the equipment—from a $30 starter kit to an $800 machine for production work. Essentially, you take an existing photograph (Polaroid sheet film works well if you're making buttons on the spot—just make sure the print surface is completely dry), press it between a piece of clear plastic and a metal button, and add a pin.

If you just need something to wear and don't want to go into the button business, Ashton Photo, Neil Enterprises, and Sports Photos are some companies that make buttons to order.

ASHTON PHOTO
Box 7077
Salem, OR 97303
(800) 547-9165
(800) 452-0280 in Oregon

BADGE-A-MINIT
348 North 30th Road
La Salle, IL 61301
(815) 224-2090

NEIL ENTERPRISES
5145 North Clark Street
Chicago, IL 60640
(800) 621-5584; (312) 275-9550

SPORTS PHOTOS
1500 105th Avenue
Oakland, CA 94603
(415) 569-0211

Magazine Covers

If *Sports Illustrated* won't buy your shot of little Johnny at bat, you can make your own cover using the photo-

graph of your choice by contacting Ashton Photo. You get a real magazine, complete with stories inside and a choice of titles such as *Sports, Scouts, Style, Comic Relief,* and *Big Byte.*

ASHTON PHOTO
Box 7077
Salem, OR 97303
(800) 547-9165
(800) 452-0280 in Oregon

Postcards

This is the cheapest way to send photographs through the mail. Though they may arrive a little bruised, it's easy to do and a good way to keep friends informed about your work. Postcards are also an affordable way to announce an exhibition—or a party.

The simplest method is simply to make a print on double-weight paper and send it through the mail with your message and the address on the back. To qualify for the lower postcard postage rate, your card must measure between 3½×5 inches and 4¼×6 inches. Larger cards can be sent at the regular first-class letter rate, but odd sizes draw a ten-cent surcharge.

Kodak makes a postcard paper—double-weight Kodabromide measuring 3½×5⁷⁄₁₆ inches, with a neutral-black image tone and "Post Card" printed on the back. It comes in glossy surface only in either grade 2 or 3, and you may need to order it specially.

You can also buy printed postcards or notecards that attach with an adhesive to the back of a print. Such cards come in a variety of sizes with any number of preprinted and custom messages. Paper Moon Graphics makes the wildest versions, but these and other companies offer similar products.

MERRY MARY
Box 241637
Los Angeles, CA 90024

PAPER MOON GRAPHICS
Box 34672
Los Angeles, CA 90034

POST PIX
615 North Berry Street, Unit A
Brea, CA 92621

SPECIAL EFFECTS
Box 34014
Cleveland, OH 44134

VIA-FOTO
Box 720
New York, NY 10113

Posters

For $13.95 or $17.95 (list price), Kodak will turn your photograph into a

Photo button from Ashton Photo.

12×18-inch or 20×30-inch poster. It may not be exhibition quality, but it's big and cheap. Just bring your negative or slide to any Kodak dealer, or buy a poster-print mailer and send it in yourself.

Puzzles

Send in any 8×10-inch photograph, and this company will send you a 110-piece jigsaw puzzle of the image for $6.95, plus $1.25 postage.

NEIL ENTERPRISES
5145 North Clark Street
Chicago, IL 60640
(800) 621-5584; (312) 275-9550

Stamps

In addition to puzzles, Neil Enterprises offers a self-inking stamp. This gadget creates a halftone, 1½-inch round image of your photograph. Send in a small print (maximum size, 5×7 inches) and $5.50 per stamp. Postage is $2.00 for the first three stamps.

NEIL ENTERPRISES
5145 North Clark Street
Chicago, IL 60640
(800) 621-5584
(312) 275-9550

Timepieces

Here's a practical option—a working watch that uses any photograph you select as the faceplate. It costs $30 or less. Just send your photograph to either Kodak or Image Watches, and they'll reduce it to size and squeeze it into the watch for you.

EASTMAN KODAK
(see your camera dealer)

IMAGE WATCHES
2623 West Via Campo
Montebello, CA 90640
(213) 726-8050

Trading Cards

Ashton Photo, a company of inexhaustible resources, offers two lines of trading cards using the photograph of your choice—the Trader and the Little Trader. Both feature a printed photograph on the front and vital stats on the back. Sports Photos also makes such cards.

ASHTON PHOTO
Box 7077
Salem, OR 97303
(800) 547-9165
(800) 452-0280 in Oregon

SPORTS PHOTOS
1500 105th Avenue
Oakland, CA 94603
(415) 569-0211

Index

INDEX

INDEX

About the Author

Henry Horenstein is a photographer, author, and teacher. His many books include *Black and White Photography* and *Beyond Basic Photography,* both widely used texts; *Racing Days,* a photoessay about life at the racetrack; and various titles for children. He is on the faculty at the Rhode Island School of Design in Providence.